Dychwelir erbyn y dyddiad a nodir isod
Please return by date stamped below

COLEG LLYFRGELLWYR CYMRU
COLLEGE OF LIBRARIANSHIP WALES

Literature and the Arts: The Moral Issues

Harry Girvetz
University of California, Santa Barbara

Ralph Ross
Scripps College

Wadsworth Publishing Company, Inc., Belmont, California

It exceeds all imagination to conceive what would have been the moral condition of the world if the poets had never been born. . . . What were our consolations on this side of the grave, and what were our aspirations beyond it—if poetry did not ascend to bring light and fire from those eternal regions where the owl-winged faculty of calculation dare not ever soar?

—Shelley

The world about us is, as it has always been, full of gross evils and appalling misery, but it is a fatal delusion and a shocking over-estimation of the importance of the artist in the world, to suppose that, by making works of art, we can do anything to eradicate the one or alleviate the other. The political and social history of Europe would be what it has been if Dante, Shakespeare, Goethe, Titian, Mozart, Beethoven, *et al.*, had never existed. . . .Art is impotent.

—W. H. Auden

L. C. Cat. Card No.: 71-150363

ISBN 0-534-00060-6

Printed in the United States of America

1 2 3 4 5 6 7 8 9 10—75 74 73 72 71

Preface

Writers are notoriously verbal; words, after all, are their stock-in-trade. It should not be surprising, therefore, if most of the selections in an anthology dealing with the arts have been written by novelists, poets, and belletrists rather than, say, painters or musicians. Although a number of the selections refer to imaginative literature, especially to poetry (poets in our time seem to have become unusually voluble), our hope is that they will be found applicable to all the arts. Within this book, however, the reader will find discussions of painting (John Canaday, Sir Kenneth Clark), of music (Dimitri Shostakovich, Milton Babbitt), and of theater (Stanley Kauffmann, Walter Kerr).

The selections are divided into four groups, each with its own introduction which provides the rationale for these groupings. For the most part we have sought authors who are critics or themselves creative writers and artists. Since much of the material deals in controversy we have enlisted a broad and, we hope, representative spectrum of opinion. Wherever possible we have used articles which directly join the issues, as in the articles on John Harrison's book, *The Reactionaries*, the frontal collisions caused by the award of the Bollingen prize to Ezra Pound, the differences between Sartre and Camus regarding the relationship of means and ends, George Steiner's comment on Susan Sontag's essay on pornography, etc.

We believe that an issue-oriented anthology of this kind will not only illuminate some of the basic moral predicaments of our time, but kindle an interest in ideas and, above all, in good writing. There is no reason why the aroused moral conscience of this generation of students should not lead them to great literature and great art as well as to good works. In any case, our hope is that it will.

The labor of assembling and editing these selections was greatly lightened by the able assistance of Eric Brauss, at present a graduate student at the University of California, Santa Barbara. His invaluable help has persuaded us that, if two heads are better than one (as we would like to believe), three are better than two.

Contents

General Introduction

Harry K. Girvetz

I

The interaction of art and morals, of man's aesthetic and his moral conscience, has occupied the attention of artists, writers, critics, and philosophers since the time of Plato, but a comprehensive anthology of their central utterances in this crucial area is curiously lacking, despite the proliferation of anthologies on almost every conceivable subject. "Art" and "morals" are used here in the broadest possible sense: "art" to include the visual and performing arts as well as music and imaginative literature; "morals" as extending beyond conventional morality to embrace all those deliberations in which men try to relate or, where there is conflict, to evaluate and reconcile diverse interests—in satisfying creature needs, in art and play, in the needs of others, in God, whoever they think He is—so as to achieve a happy, harmonious, meaningful, morally responsible life. Such a life may or may not be in accord with conventional notions of right conduct, since these are themselves subject, among free men, to the same evaluative process.

The selections in this volume are not directly concerned with the nature of the moral or the aesthetic experience. We know that men create and relish works of art and that, as they do, they become involved in problems which they have no difficulty in recognizing as "moral"or "ethical." Let us therefore take these experiences for granted, take them as our starting point, as given. For the concern here is with simpler matters than those which occupy theoretical treatises on ethics and aesthetics, although we no sooner touch upon such matters than we discover that they have their own hidden and disconcerting complexities.

Let us begin by asking: Can a work of art be evaluated apart from consideration of (a) the character and personality of the artist who creates it and the particular motives that govern him in creating it; and (b) its social consequences? Many (including perhaps the great majority of artists) would answer affirmatively as far as the *artistic* merit of a work of art is concerned. But people do in fact rely on such considerations even in judging the aesthetic merit of a work of art and, indeed, much of what is said and written about works of art deals with the artist rather than his work. It is often remarked that Wagner was a cad, Shelley was a man of conscience and compassion, Wordsworth became a conservative, Coleridge was a Kantian, Van Gogh was mentally deranged, Wilde was a homosexual, etc., etc. Most, especially exponents of the so-called "New Criticism," would argue that such biographical details are irrelevant to an aesthetic judgment; others might respond that, if irrelevant, our persistence in referring to them is astonishing.

Apart from the personality or character of the artist, consider his specific purposes as he embarks on his task. Take the case of David Slavitt, an honors graduate of Yale, said to be a writer of considerable talent, and author of *The Exhibitionist,* a book commissioned by the publishers of *Valley of the Dolls,* who gave it chapter-by-chapter guidance so that it would contain the needed sex ingredients (which it has, ranging from near-incest to lesbianism). Can such antecedents be ignored in an aesthetic evaluation of the book? Or in an evaluation of motion pictures, most of which nowadays almost routinely introduce at least one copulation scene (still between sheets, to be sure), with an eye to the box office and the voyeurism of the customers?

It is well known that several of our leading playwrights are homosexuals. It can be, and has been, argued that when they portray heterosexual love their treatment, like Slavitt's, is inspired by other than aesthetic considerations, albeit of a different kind. Heterosexual love is lampooned, or it is portrayed in its most dreary and aberrational manifestations. If what we have here is a perhaps unconscious desire to get revenge on the "straight" world which ridicules and ostracizes them, or to sour for others what they cannot have for themselves, can the intrusion of such motives, which are hardly aesthetic, be ignored in appraising the artistic value of their work? No responsible critic would suggest that homosexuality is a literary disqualification. The exquisite novels of E. M. Forster were written by a homosexual, but that would surely be regarded as irrelevant to their quality. Whether one distinguishes appropriately between an artist, homosexual or whatever, and his work will depend, no doubt, on the extent to which and the *manner* in which his personality enters into what he does. Can this be ascertained? And, if the testimony of the artist himself is notoriously unreliable, will the techniques of psychoanalysis help us? Conflicting answers to these critical questions will be found in the pages that follow.

Quite apart from the admittedly controversial examples just cited, it is commonly observed that a large number, if not the majority, of our artists are alienated from society, hating civilization, to borrow Saul Bellow's words, "as only its subtlest, most pampered children can hate." The consequence may be a conversion of the chaos and confusion they find in life into work that is chaotic and confusing or, when their work is intelligible, an exclusive emphasis on the sordid and seamy side of life. Alienation is not of itself an aesthetic category. But can the critic ignore it in his evaluation of the artistic merit and his analysis of the aesthetic quality of a work of art? Can alienation be ignored, even if the critic blames the audience, or society, for the estrangement rather than the artist? For it is still there, manifesting itself, as such estrangement does, in a total rejection within each art of tradition, an esotericism disdainful of the art public, and vocabularies consisting of dissonances, distortions, and symbols that signify nothing. Clearly, if we are concerned with the interaction of aesthetic and other values, this is a topic we can hardly ignore.

Finally, in this same area one must reckon with a massive issue which will provoke differences on a large scale so long as the world is divided into Marxists and non-Marxists. All art, according to doctrinaire Marxists, is "ideologically" conditioned so that its aesthetic quality cannot be judged apart from the class origins of the artist or author and the role it plays in the class struggle. We may or may not be witnessing a revival in this country of the "socially conscious" art that preoccupied the 1930s but, in any case, a world that includes China and Russia requires us to confront the Marxist position.

To reckon with such considerations is really quite canonical, despite much protestation to the contrary. Thus T. S. Eliott in writing about Dante observes that, while we may distinguish between the poet's belief *qua* poet and his beliefs as a man, "we are forced to believe that there is a particular relation between the two, and that the poet *'means what he says'*. If we learned, for instance, that *De Rerum Natura* was a Latin exercise which Dante had composed for relaxation after completing *The Divine Comedy,* and published under the name of one Lucretius, I am sure that our capacity for enjoying either poem would be mutilated . . ."[1]

Whatever our decision concerning admittedly controversial issues such as those raised above, where both Catholics and Communists would probably be arraigned

[1]T. S. Eliot, *Dante* (London: Faber and Faber, 1929), pp. 57–58.

against many artists and art critics in insisting that aesthetic merit cannot be determined in a cultural or moral vacuum, it is clear that there is enough difference of opinion to interest readers in an exchange of views. However, even if the difficult question of aesthetic relevance is decided in favor of excluding reference to the artist and his character and motives (even his name?) from evaluation of the *artistic* merit of his work,[2] a second and even more basic question remains to be resolved.

Should aesthetic criteria alone be used in judging a work of art? If the artist's work inescapably involves people who are deeply offended by it, as when a piece of sculpture depicts *fellatio* or Christ in the act of masturbating (as in a recent college exhibit), or a play simulates sexual intercourse or sexual "perversions," is it immune, assuming it has artistic merit, from moral judgment and from the consequences (censorship, sanctions) attendant on such judgment? If it has consequences that would encourage the persecution of religious or ethnic groups, does artistic quality confer immunity from regulation or control? How, in other words, are we to respond to the (often implicit) assumption that, if a work qualifies aesthetically and therefore gives the creator and beholder (or reader) aesthetic satisfaction, no other consequence can justify rejecting or condemning it? The assumption sometimes includes granting the artist immunity from sanctions no matter what his crimes as a person, as in the case of Ezra Pound when he was tried after World War II as a fascist traitor.[3]

Those who defend the immunity of art from other than aesthetic criticism rarely come to grips with the fundamental question. They emphasize the bigotry and ignorance of the censorious and their censors; they refer to the art now universally recognized as great *and* inoffensive that was found deeply offensive in its day; they point out that no one is compelled to see a play or read a book that offends him, and that "obscenity," the chief offender, is in the eye of the beholder; they stress the relativity of moral standards; they note that art can flourish only in an atmosphere free of restraint. Those who make these arguments rightfully fear consequences adverse to art. Censorship can, and has, banned real art while it left conformist trash untouched. That is part of the history of totalitarianism and has existed in lesser degree elsewhere. But what if the adverse consequences of freedom from restraint are greater once one takes into account other areas of interest? The arguments cited fail to reckon with this crucial possibility.

It is of course possible to deny that a work of art can have important extra-aesthetic consequences, at any rate, of the kind that can be socially harmful (or, presumably, beneficent). No woman, it has been said, was ever ruined by a book. Santayana seems to argue this way, albeit more elegantly. Nothing, he observes, concerns art less than to influence the world. Nor, he adds, "does it do so in a notable degree." Thus,

[2] W. H. Auden once observed that in theory, the author of a good book should remain anonymous. One is reminded of the late B. Traven (*The Death Ship, The Treasure of Sierra Madre*), whose passion for anonymity became legendary.

[3] Shaw, in a now forgotten essay, concedes that it may be necessary for the welfare of society "that genius should be privileged to utter sedition, to blaspheme, to outrage good taste, to corrupt the youthful mind, and generally to scandalize one's uncles." However, "such license is accordable only on the assumption that men of genius are saner, sounder,...deeper fathoming than the uncles; and it is idle to demand unlimited toleration of apparently outrageous conduct on the plea that the offender is a genius, even if by the abnormal development of some specific talent he may be highly skilled as an artist." *Major Critical Essays, Works* (London: Constable and Co., 1932), p. 289. First published separately, 1907.

Art registers passions without stimulating them; on the contrary, in stopping to depict them it steals away their life; and whatever interest and delight it transfers to their expression it subtracts from their vital energy. This appears unmistakably in erotic and in religious art. Though the artist's avowed purpose here be to arouse a practical impulse, he fails insofar as he is an artist in truth; for he then will seek to move the given passions only through beauty, but beauty is a rival object of passion itself. Lascivious and pious works, when beauty has touched them, cease to give out what is wilful and disquieting in their subject and become altogether intellectual and sublime. There is a high breathlessness about beauty that cancels lust and superstition.[4]

Plato would not agree. On pain of expulsion, we must compel our poets "to make their poetry the express image of noble character," he tells us. "We would not have our Guardians grow up among representations of moral deformity, as in some foul pasture where, day after day, feeding on every poisonous weed they would, little by little, gather insensibly a mass of corruption in their souls."[5] And, despite the passage cited and his verdict that art "ends in itself" and hence is "inconsequential," Santayana does face the problem as it must in the end be faced by every whole and civilized person: "It is in the world, however, that art must find its level. It must vindicate its function in the human commonwealth. What direct acceptable contribution does it make to the highest good?"[6]

To agree with Santayana we need not (and in my judgment we cannot) assume that there is a specifically definable "highest good" from which we can derive or deduce the answers to our doubts and perplexities. There is conventional morality, which art can and often does affront ("those habits of the majority," as Shaw said, "which it pretentiously calls its morals"); and there is ethical evaluation which, in the sense that it appraises their competing claims, can be said to be above art and above conventional morality (and in this sense be the "highest" good). It comes into play when goods conflict and must somehow be reconciled with one another. Thus, art must be no slave to conventional morality (as it often has been), and no emancipated person would try to make out a case that it should be. But neither may conventional morality, which has its own promise and its own claims on our interests and loyalty—often undiscerned and undefended in art and intellectual circles—be submitted completely to the mercies of a sovereign art. If this be so, then both, when they come into conflict, must yield to the deliberative process in which by a kind of progressive comparison opposed values are weighed against each other, perhaps sacrificed, perhaps reinforced, and perhaps merged in new values bred of their conflict. Those who despise censorship and decry the evaluation of art by reference to extra-aesthetic criteria unfortunately have in mind only those standards which derive from the prevailing morality whose claims to absolute finality they properly brand as dogmatic and unfounded. But the alternative is not to substitute one set of absolutes—in this case aesthetic ones—for another.

Apart from the strains it may impose on conventional morality, art may become involved in conflicts with other values. It may have questionable economic and political costs, for example, if it flourishes at the expense of suffering and sacrifices imposed by wealthy and autocratic patrons on unwilling slaves (as in Greece) or exploited peasants and artisans (as in Florence). Art is an exacting mistress. The

[4]*The Life of Reason,* Vol. IV, *Reason in Art,* (New York: Charles Scribner's Sons, Triton edition, 1936), pp. 330–331.

[5]*Republic,* Cornford translation (London: Oxford University Press, 1941), Part III, p. 401.

[6]op. cit., p. 329.

artist may subordinate his family to his work, exploit his friends, ignore his responsibilities as a member of the community. How are such competing values to be weighed? Can such conflicts be ignored?

The man who submits undeviatingly and unquestioningly to conventional morality is rigid and stunted; so, too, is the single-minded social reformer exclusively preoccupied with liberating the exploited masses or uplifting everyone else. But we often fail to see that this may also be true of those who ignore all values except the values residing in art—where art is thought of in the amoral sense that enabled Sartre to canonize a thief and pervert as "Saint" Genet. Whatever admiration is due Genet's art does not make his conduct more moral.

In short, where there are diverse interests and values, each with its valid claim on us and each of which in the fullness of time has civilized and humanized us, all must be acknowledged and weighed; and those who aspire to wholeness will insist that each, in Santayana's felicitous phrase, "vindicate its function in the human commonwealth."

Part I Aestheticism: Pro and Con

Like religion, art in some form exists in all societies. It ranges from decoration or simple pottery to the thunder and anguish of Aeschylean drama; from the simple musical notes played on an aeolian lyre to the soaring beauty of a Gothic cathedral. It has been closely allied to religion, and some would argue that it brings to human life a touch of divinity. Elsewhere one of us has written:

> *Art is as primary as religion and probably appears equally early in the development of human society. That men find some things beautiful and some ugly is as much a part of their nature as that they find some things sacred and some common. Human response to the beautiful is often very much like response to the sacred. . . .*[1]

What accounts for the universal appeal of art? What purpose does it serve? Why does man want or need art so much that he takes infinite pains to make it? Is the mystery of man creating art like the mystery of God creating the world?

It will help dispel the mystery to see that art has served many purposes. It can be a special kind of cognition, a window on the world through which we see what is not otherwise seen; it may be a form of play providing sheer entertainment or pleasure; it may be used to form character or improve society; it may yield what we call aesthetic enhancement, a unique, not further analyzable experience with its own special quality. However, to recognize such multiple roles is not to solve the problem of the purpose of art, for their significance has been assessed differently, and some have rejected one or other of these roles altogether as in conflict with the integrity of art. Above all, the question posed in Plato's *Republic*[2] has been raised again and again: Does the artist have a responsibility to instruct the community, to be its conscience?

In the introduction to a new volume of his plays Edward Albee writes: "A playwright unless he is creating escapist romances...has two obligations: first to make some statement about the condition of 'man' (as it is put) and, second, to make some statement about the nature of the art form with which he is working." One is prompted to ask: what kind of statement about the condition of man? A merely descriptive one? Certainly all art serves such a cognitive purpose, although the pejorative qualifier "merely" could be quite misleading. Great art gives us

[1]Ralph Ross, *Symbols and Civilization*, (New York: Harcourt Brace Jovanovich, 1957), p. 225.

[2]Cf. *The Dialogues of Plato*, Vol. 3, third edition translated by B. Jowett (London: Oxford University Press, 1924); also, Plato's *Ion, loc. cit.* Vol. 1.

insight into the nature and condition of man which in its way matches or exceeds knowledge gleaned from science—all too often thought of as the sole gateway to knowledge. "Merely" is not meant to minimize this role but to remind us that in commenting on the condition of man art may be prescriptive as well as descriptive.

Albee does not leave us in doubt about his own view. "In both instances he [the playwright] must attempt change. In the first instance—since very few plays are written to glorify the status quo—the playwright must try to alter his society. In the second instance—since he must move or wither—the playwright must try to alter the forms within which his precursors have had to work." It is with Albee's "first instance" that we are here concerned.

Two main standpoints about the responsibilities of the artist and the place of art in society can be distinguished, although there are, of course, all sorts of intermediate positions. In one view, art is regarded not only as a powerful force for good or evil—no one would deny the importance of its role in shaping our view of life—but the aesthetic and moral, not to mention the didactic, values inherent in a work of art are said to be inseparable, as when Yvor Winters wrote that "a poem, in so far as it is good, represents the comprehension on a moral plane of a given experience," adding that "it should...increase the intelligence and strengthen the moral temper."[3] The other view insists on the autonomy of art, contending, with Baudelaire, that the aesthetic quality of a work of art is debased when it serves "extraneous" purposes, so its merit should be determined exclusively by reference to internal criteria. Less extreme are those who say, like T. S. Eliot, that art, while serving ends beyond itself, "is not required to be aware of these ends, and indeed performs its functions whatever they may be...much better by indifference to them."[4]

Eliot wavered, and his views varied. For the purist position we must go to others: "The struggle against a purpose in art is always a struggle against the moral tendency in art—against its subordination to morality. L' art pour l' art means: let morality go to the devil." Thus spoke Neitzsche, strangely bedded with Oscar Wilde who wrote, albeit less vehemently, in the preface to *The Picture of Dorian Grey:* "There is no such thing as a moral or unmoral book. Books are well written, or badly written. That is all." And again: "No artist has ethical sympathies. An ethical sympathy in an artist is an unpardonable mannerism of style."

In a famous passage, Walter Pater, aestheticist and epicurean, gave us perhaps the most eloquent affirmation of art for art's sake when he reminded us that

we are all condamnes...we are all under a sentence of death but with a sort of indefinite reprieve...: we have an interval, and then our place knows us no more. Some spend this interval in listlessness, some in high passions, the wisest...in art and song. For our one chance lies in expanding that interval, in getting as many pulsations as possible into the given time. Great passions may give us this quickened sense of life, ecstacy and sorrow of love, the various forms of enthusiastic activity...which comes naturally to many of us. Only be sure it is passion—that it does yield you this fruit of a quickened, multiplied consciousness. Of such wisdom, the poetic passion, the desire of beauty, the love of art for its own sake, has most. For art comes to you proposing frankly to give nothing but the highest quality to your moments as they pass, and simply for those moments' sake.[5]

[3]*Primitivism and Decadence* (New York: Arrow Editions, 1937), pp. 10, 13.

[4]"The Function of Criticism" (1923), reprinted in *Selected Essays* (New York: Harcourt, Brace Jovanovich, 1950), p. 13. Cf. below, pp. 37–44.

[5]*The Renaissance*, (London: Macmillan Co., 1901), pp. 238–239. First published in 1868.

Clearly, all this is a far cry from Shelley's famous dictum that "Poets are the unacknowledged legislators of the world."

The call for freedom from extraneous interests and preoccupations sometimes includes the artist as well as his work, for if the artist is, as the French say, engagé, his work will no doubt reflect his commitment. George Orwell, himself a committed man, observed in an essay on W. B. Yeats that "a writer's politics and religious beliefs are not excrescences to be laughed away, but something that will leave their mark on the smallest detail of his work."[6] Perhaps even the most involved artist might by a feat of detachment keep his work free of moral comment, separating, as it were, his moral from his aesthetic self. But some aesthetic purists would deny that this is possible. Stephen Spender observes that, during the reign of Bloomsbury aestheticism, Kipling, Wells, Shaw, and others actually damaged their reputations as artists because they wrote freely about politics. Politicians, he notes, were regarded as philistine and the artist in politics as betraying the pure cause of individualist art. Political action, at any rate in England, came to be regarded as vulgar. "Ever since the nineteeth century [Shelley, Arnold, Clough, Ruskin, Morris] it has been the case that the English poet mixed up in politics may spend a lifetime divided between two voices: that of the social and that of the aesthetic conscience; Shelley calling on the world to dethrone kings and Keats claiming that his poetry is unshadowed by any trace of public thought."[7] Even Orwell, activist though he was, noted that "acceptance of *any* political discipline seems to be incompatible with literary integrity," adding: "Group loyalties are necessary, and yet they are poisonous to literature, as long as literature is the product of individuals. As soon as they are allowed to have any influence, even a negative one, on creative writing, the result is not only falsification, but often the actual drying up of the inventive faculties."[8] Orwell, who had his own bitter experiences as a Communist, emphatically rejected the thought that writers should therefore repudiate politics—he contented himself with advising that "we should draw a sharper distinction than we do at present between our political and our literary loyalties"—but most aesthetes, whether obliquely or directly, would counsel avoidance of politics.

Others will not go that far. They would concentrate on the work itself and would support I. A. Richards' dictum that "it is never what a poem *says* that matters, but what it is." Nevertheless, Richards himself would join Eliot in rejecting Shelley's election of poets as mankind's legislators and, with Eliot, deplore the "dubious frontiers" upon which some poets encroach.

Even Pater concluded that "the distinction between great art and good art [rests] immediately, as regards literature at all events, not on its form, but on the matter," adding that "It is on the quality of the matter it informs or controls, its compass, its variety, *its alliance to great ends*...that the greatness of literary art depends, as *The Divine Comedy, Paradise Lost, Les Miserables,* the English *Bible,* are great art."[9] This has been the verdict of Arnold, Ruskin, Tolstoy, Maritain, and other great figures, some of whose comments are reprinted here.

In truth, the positions taken in the controversy between those who defend commitment and edification in art and the aesthetes is determined not so much by theoretical considerations as by the reactions of the protagonists to the social

[6]"Writers and Leviathan," reprinted in *Collected Essays,* (London: Secker and Warburg, 961), p. 448.

[7]"Writers and Politics," *Partisan Review* (Summer 1967), pp. 368–378.

[8]*Loc. cit.*

[9]*Appreciations* (London: Macmillan Co., 1922 edition), p. 38.

situations in which they find themselves. Thus, hostility to modern industrialism and his view concerning whether its assertedly baneful consequences are remediable or irremediable may determine whether the artist retreats into an "ivory tower" or uses his art as critical commentary. Obviously, novels of social protest, such as Steinbeck's *Grapes of Wrath,* and ideologically inspired painting of the kind exemplified by Diego Rivera's murals were given an enormous impetus by the depression of the 1930s. No doubt some of the recent revulsion felt for the literature of social protest resulted from a new sense of futility in the presence of social abuses, prompting a rejection of subject matter in the arts and a retreat into the self.

What might be called the neo-aestheticism of recent years was probably a multiple reaction: against the so-called "socially conscious" art of the 1930s, which often tended to accept moralizing as a substitute for competence and proved to be simplistic in its solutions to social problems; against the preoccupation of non-verbal art with anecdote and narrative (e.g., Delacroix's "Liberty Leading the People," or a ballet like "Giselle"); against the didactic role assigned to art in totalitarian countries; and against the tendency in criticism to concentrate on almost everything—the artist, the milieu, the "influence" of the artist and his work—everything except the work itself.[10] The "New Criticism"—in accord with Eliot's dictum that "when we are considering poetry we must consider it primarily as poetry and not another thing"[11]—was in this sense a reaffirmation of the autonomy of art, of aestheticism, of *formalism.*

At its extreme, formalism reaches the point not merely of divorcing a work from its author and its milieu, but from content. Art that engages in social comment is outre in formalistic circles: for a work of art to contain a "message" (the very word becomes pejorative) is fatal. To be sure, all this is generally accompanied by disavowals of the doctrine of "art for art's sake," perhaps because the *fin de siecle* version of aestheticism was notoriously mannered and meretricious, perhaps because, politically, the chief beneficiary of the defection of art from social criticism is the *status quo,* and artists—who are often radical in their social outlook—become uneasy when they discover that they have become the darlings of tories and reactionaries.

It may well be that an art eschewing social comment and divorced from moral involvements, since it has nothing to feed upon except itself, becomes superficial, effete, and decadent in its content. This might lead some to abandon content altogether, as in some of Mondrian's geometric studies, the blank canvases of Motherwell or Reinhardt, plays without stories by Ionesco, novels in the manner of Robbe-Grillet, aptly described by a critic as exercises in non-communication,[12] John Cage's random sound configurations, sculptures (Stankiewicz, Chamberlain) that are aggregates of trash and junk—in sum, the so-called minimal art[13] which tolerates content only provided it has nothing to do with subject matter.

[10]For example, does it add to our appreciation of Picasso's *Demoiselles d'Avignon* that it established his reputation as a great painter, or that the title, given to it by an art dealer, is misleading, since it really represents a brothel in the Calle d'Avignon of his native Barcelona?

[11]*The Sacred Wood,* Preface to the 1928 edition (London: Methuen, 1928), p. vii.

[12]"To believe that the novelist has 'something to say,' and that he then seeks *how* to say it, is wrong. For it is precisely this 'how,' this search for a way of saying something, which constitutes the writer's task." A. Robbe-Grillet, "The New Novel," *New Statesman* (February 17, 1961), p. 264.

[13]The term has come into vogue in connection with recent trends in sculpture. Richard Wollheim in *Arts Magazine* (both take minimal art seriously) tells us that, increasingly, over the last fifty years, "acceptance has been afforded to a class of objects which, though disparate in many ways—in looks. in intention, in moral impact—have also an identifiable feature or aspect

When formalism becomes irrelevant to content or results in the merely decorative, the artist's attention may shift. The art *object* recedes and is no longer the subject, becoming rather a means through which the artist creates *himself: he* is the subject. Thus, to recall Harold Rosenberg's well-known celebration of the abstract expressionists, the canvas presents itself as an area upon which to *act:*

> *If the ultimate subject matter of all art is the artist's state of tension...that state may be represented either through the image of a thing or through an abstract sign. The innovation of Action Painting was to dispense with the* representation *of the state in favour of* enacting *it in physical movement.*[14]

The artist, it would appear, is not merely engaged in "self-revelation" or "self-discovery," or, as Clement Greenberg says, in *finding* himself. To cite Rosenberg again: "Action painting has to do with self-creation or self-definition or self-transcendence; but this disassociates it from self-expression, which assumes the acceptance of the ego as it is."[15] Elsewhere, in his widely read essay, "The American Action Painters," he explains that when what is to go on the canvas is not a picture but an "event" or an "encounter" between the artist (material in hand) and the canvas, the result is a "moment" in the biography of the artist: "The act-painting has broken down every distinction between art and life."[16] Have we returned at this point to the romantic notion that "life" is the only true work of art, that art, in essence, is a celebration of the self?

If painting and sculpture must avoid becoming "literary" so, too, paradoxically, must literature. Almost by its very nature, Thomas Mann has said, the novel is a social critique. Not so with the new novel, according to Richard Gilman, literary editor of the *New Republic.* Novelists, as they go about their business these days, avoid trying "to deal with the core of things." It is, he says, "a matter of observation, not theory, to say that fiction has found it increasingly difficult to base itself on the significance of emotions, attitude, life values, ideas about society, all the things we thought the novel had been perfected to deal with." Mr. Gilman is not alarmed. All this may mean that "the novel can be on the way to recovering its own significance as an invention, something out of the air, a series of inimitable ways of looking at things." Presumably, it should no longer be asked "to go on being a kind of arsenal of informational weapons, the aesthetic counterpart of the social sciences," nor to continue providing us "with overarching unitary schemes for existence and with narratives whose clear courses and decisive endings can atone for the discontinuous, unpurposeful careers of our own *romances."* All this belongs to its "classic phase" as "reports from imaginative beholders of society and men's communal activities..."[17] Similarly, in a discussion of the aesthetics of Norman

in common. And this might be expressed by saying that they have a minimal art-content: in that either they are to an extreme degree undifferentiated in themselves and therefore possess very low content of any kind, or else the differentiation that they do exhibit, which may in some cases be very considerable, comes not from the artist but from a non-artistic source, like nature or the factory." The canvases of Ad Reinhardt and Robert Rauschenberg are cited as examples (January, 1965, p. 26). Looking at their blank canvases, a few may agree with Reinhardt that "less is more." Most will reaffirm the ancient dictum *'Ex nihilo nihil fit''*—nothing comes from nothing—unless they are young, in the event of which they may prefer Bob Dylan: "Too much nothing just makes a feller mean."

14"Hans Hofmann: Nature in Action," *Art News* (May 1957).

15Cited by Max Kozloff, "The Critical Reception of Abstract-Expressionism," *Arts Magazine* (December 1965), p. 30.

16*The Tradition of the New* (New York: McGraw-Hill, 1965), pp. 25, 28.

17"News from the Novel," *New Republic,* (August 17, 1968), pp. 27- 36. For a view challenging the interpretation of the "new" novel as a revival of aestheticism, cf. Stanley E.

Mailer, Jack Richardson notes that "again and again readers have discovered that, at its best, the modern novel often *deals with the adventure of its own making,* and that, while celebrating itself, it more than insinuates that *its real hero is its creator,* whose passion and agony we, for convenience, simply call his 'style.'"[18] At this point we have not only lost the novelist who exposes evil and seeks to remedy it (e.g., Dos Passos, Sinclair)[19] but the novelist who portrays the social scene with a view to understanding the human condition (e.g., E. M. Forster).

Turning to the "theater of the absurd" (Ionesco, Pinter, Adamov, *et al.*) we find Martin Esslin, an able advocate, commenting as follows:

As the Theater of the Absurd is not concerned with conveying information or presenting the problems or destinies of characters that exist outside the author's inner world, as it does not expound a thesis or debate ideological propositions, it is not concerned with the representation of events, the narration of the fate or the adventures of characters, but instead with the presentation of one individual's basic situation. It is a theatre of situation as against a theatre of events in sequence, and therefore it uses a language based on patterns of concrete images rather than argument and discursive speech. And since it is trying to present a sense of being, it can neither investigate nor solve problems of conduct or morals.[20]

We thus arrive at plays without stories, coherent dialogue, recognizable characters, beginnings, or endings. What does the author give us? According to Esslin, "his own *sense of being,* his individual vision of the world." This, he says, "is the *subject matter* of the Theatre of the Absurd, and it determines its form, which must, of necessity, represent a convention of the stage basically different from the 'realistic' theatre of our time."[21] Here words have replaced canvas or junkyard as the area upon which to "act."

Not unexpectedly the avant-garde film is following suit. The new cinema exhibits a growing preference for depicting unstructured experience and has a disdain for story line, character development, and other literary values. *Last Year at Marienbad* or *8½* may not have initiated a trend, but a new film genre is clearly with us.

Tendencies such as those just described are no doubt inspired in part by an existentialist quest for self-identity or, less commendably, by a quest for novelty, or, least commendably, by a confusion of freakishness and eccentricity with originality. The question raised here is whether these tendencies are not also and perhaps primarily an outcome of the rejection of content involving comment, then of content itself, and finally, of form, so that nothing is left except the artist and the formless raw material of his "art"—words, sounds, metals, stone—and his personal encounter with his material in an *acte gratuit* through which he affirms his being by venting the feelings—often the chaos—in himself. Kandinsky, having decided that the aim of representing a concrete object was irrelevant, stopped

Gray, "The Social Meaning of the New Novel in France," in *Literature and Society,* Bernice Slote, ed., pp. 241–252.

[18]*The New York Review of Books* (May 8, 1969), p. 3. My emphasis.

[19]Granville Hicks quite properly distinguishes between the novel of social protest, aimed at a specific evil *(Uncle Tom's Cabin)* and highly ephemeral, and the novel of social criticism which is "concerned in a larger way with the social structure" and has had far more significance as literature. A novel may be both (e.g., *The Grapes of Wrath).* "Fiction and Social Criticism," *The English Journal* (April 1952), pp. 173–179.

[20]*The Theatre of the Absurd* (New York: Anchor Books, 1961), pp. 293–294.

[21]*Ibid.* His emphasis.

painting portraits and landscapes: "The real landscape was *in the soul.*"[22] When Hans Hofmann, a leading exponent of Cubism, first met Jackson Pollock and saw his work, he is reported to have commented: "You do not work from nature." Pollock's response was, "I am nature." That about sums up the more extreme manifestations of the major—if probably declining—aestheticist tendency of recent decades.

As we enter the 1970s we may be embarking on a new phase even before the old one is played out. The "New Theatre" (e.g., Living Theatre, Minneapolis Firehouse Company, Open Theatre, Performing Group) is dedicated to using the theatre as an instrument of social change and self-purification. Norman Mailer has unabashedly taken his literary art into the world of war, peace marches, and political conventions in his novel *Why Are We in Vietnam?* and his more recent *Miami and the Siege of Chicago.* There are evidences elsewhere in the arts of a similar revival of what Mannheim called the utopian mentality. Even "rock," if art may be stretched to include it, hurls messages at us. Some among the new activist generation of students calling for "relevance" in the classroom will soon become critics, authors, and assistant professors. They are bound to be heard in the lofts of New York and the attics and ateliers of London and Paris. In our wild oscillation from one extreme to another we could smother discipline in the arts from the opposite direction, not by abandoning form, as did the abstract expressionists, but by burdening it, as was done in the thirties, with a content bred of a renewed moral fervor and a new sense of moral outrage.

[22]Herbert Read, "The Social Significance of Abstract Art," in *A Letter to a Young Painter* (New York: Horizon Press, 1962), p. 239. My emphasis.

Aestheticism:
The Autonomy of Art

Preface to Mademoiselle de Maupin

Theophile Gautier

Theophile Gautier (1811–1872), French novelist and critic, was a leader of the small group of artists and intellectuals who proclaimed the doctrine "l' Art pour l'Art," which is usually translated as "Art for Art's Sake." Gautier and his friends were probably influenced in their views by the far more important Victor Hugo, whom they revered.

The revolutionary and anti-philistine attitudes of Gautier and his circle have influenced people in all the arts and prepared audiences to enjoy art with no pretense to social or moral content. Baudelaire spoke of him as "a writer whose talent is both new and unique," adding that "he has no understudy."

An ironical note is sounded by Gautier's use of this essay as a preface to his novel Mademoiselle de Maupin, *for that book was commissioned by Gautier's publisher as a sensational novel and so is far removed from "Art for Art's Sake." Still, like William Faulkner's novel* Sanctuary, *which was written as a potboiler to make money,* Mademoiselle de Maupin *was a better book than might have been expected, thanks in part to the delightful extravagances of its preface.*

Under a shower of homilies comparable to summer rain in a park, there has sprung up...a band of mushrooms of a new and curious kind, whose natural history we shall now examine.

They are the utilitarian critics,—poor fellows whose noses are so diminutive that spectacles cannot stay on them, and who yet cannot see as far as the end of their noses.

When an author threw a book on their desk, novel or volume of verse, these gentlemen leaned nonchalantly back in their arm-chair, balanced it on its hindlegs, and with a pompous air, swelled out and said,—

"What is the good of this book? In what way can it be applied to the moral and physical improvement of our most numerous and poorest class? Why, there is not a

From Preface to *Mademoiselle de Maupin* by Theophile Gautier, 1835. Based on a translation by Professor F. C. de Sumichrast.

word in it on the needs of society, nothing civilising, nothing progressive. How is it that men write verse and novels that lead to nothing, which do not advance our generation on the road of the future...? How can one trouble about form, style, rime, in presence of such grave interests? What do *we* care for style, rime, and form? We have nothing to do with them...Society is suffering; it is torn by fierce internal convulsions...It is the poet's business to seek out the cause of this disturbance and to cure it. He will find means to do so by sympathising with his heart and soul with humanity. (Philanthropic poets!—how rare and delightful they would be!) We are awaiting that poet, we long for him. When he appears, he shall have the acclaim of the crowd, the palms, the abode in the Prytaneum...."

That is all right, but, as we want our reader to keep awake to the end of this...preface, we shall not pursue further this...faithful imitation of the utilitarian style, which is by its nature soporific, and might advantageously be substituted for laudanum and the discourses of the Academy.

No, dolts, fools, and asses that you are, a book cannot be turned into gelatine soup, a novel is not a pair of boots, a sonnet is not a syringe, a drama is not a railway,—all of which things are essentially civilising and carry mankind along the road of progress.

No! by the bowels of all popes, past, present, and future, no,—two thousand times no!

You cannot make a nightcap out of a metonymy, a pair of slippers out of a simile, an unbrella out of an antithesis; and unfortunately, you cannot wear a few variegated rimes on your stomach like a waistcoat. I am firmly convinced that an ode is too light a garment for winter, and that if one put on a strophe, an antistrophe, and an epode, one would not be more fully clothed than that Cynic's wife who, history tells us, was content with her virtue for a shift, and went about naked as a new-born babe....

People who claim to be economists, and who propose to reconstruct society from top to bottom, gravely put forward such nonsense....Indeed it is enough to make one laugh a horse-laugh to hear those republican or Saint-Simonian utilitarians talk. First and foremost I should like to know the exact meaning of that great fool of a word with which they daily fill up their empty columns, and which is to them at once a shibboleth and a consecrated expression? Utility—what is this word? And to what does it apply?

There are two sorts of utility, and the meaning of the word itself is always relative. What is useful to one man is of no use to another. You are a cobbler, and I am a poet. It is of use to me that my first line of verse should rime with my second. A dictionary of rimes is of great use to me; it would be of no use whatever to you in patching an old pair of boots, and I am bound to say that a cobbler's knife would not be of any profit to me in the writing of an ode. Of course you may reply that a cobbler is far above a poet, and that one can dispense with the latter more easily than with the former. Without venturing to cast discredit upon the illustrious profession of the cobbler, which I honor as highly as the profession of constitutional monarchs, I humbly confess that I would rather have a gaping seam in my shoe than a false rime to my verse, and that I would rather do without shoes than without poems....

I am aware that there are those who prefer mills to churches, and the bread of the body to the bread of the soul. I have nothing to say to such people. They deserve to be economists in this world and in the next....

Is there anything absolutely useful on this earth and in this life of ours? To begin with, there is mighty little use in our being on this earth and living. I challenge the wisest of the company to tell us what we are good for....

Next, admitting that, *a priori*, our being in existence is of use, what are the things really necessary to sustain that existence? Soup and meat twice a day are all that is needed to fill our bellies in the strict sense of the word. Man, to whom a coffin six feet long and two feet wide is more than sufficient after his death, does not need much more room while alive. A hollow cube, seven to eight feet each way, with a hole for fresh air, one cell in the hive, that is all he needs for a lodging and to keep out the rain. A blanket properly draped round his body will shield him against the cold as well as would the most stylish and well-fitting frockcoat....Better, indeed.

Thus provided for he can survive. It is said that one can live on a shilling a day, but to barely keep from dying is not living, and I do not see in what respect a city organized on utilitarian lines would be a pleasanter residence than the cemetery of Pere-Lachaise.

There is no one beautiful thing indispensable to life. Flowers might be suppressed without the world suffering materially from their loss, and yet who would be willing that there should be no more flowers? I would rather do without potatoes than without roses, and I believe there is no more than one utilitarian in the world capable of rooting up a bed of tulips and replacing them with cabbages.

Of what use is beauty in woman? Provided a woman is physically adequate and capable of bearing children, she will always be good enough in the opinion of economists. What is the use of music?—of painting?...

There is nothing really beautiful save what is of no possible use. Everything useful is ugly, for it expresses a need, and man's needs are gross and disgusting, like his own poor, wretched nature. The most useful place in a house is the toilet.

For my part,...I am of those to whom superfluities are necessaries, and I am fond of things and people in inverse ratio to the service they render me. I prefer a Chinese vase with its mandarins and dragons, which is perfectly useless to me, to a utensil which I do use, and the particular talent of mine which I set most store by is my inability to guess logogriphs and charades. I would very willingly renounce my rights as a Frenchman and a citizen for the sight of an authentic painting by Raphael, or of a beautiful nude woman,—Princess Borghese, for instance, when she posed for Canova, or Julia Grisi entering her bath. I would most willingly consent to the return of that cannibal, Charles X., if he brought me, from his residence in Bohemia, a case of Tokai or Johannisberg; and the electoral laws would be quite liberal enough, to my mind, were some of our streets broader and some other things less broad....I would sell my breeches for a ring, and my bread for jam. The occupation which best befits a civilised man seems to me to be idleness or reflectively smoking a pipe or a cigar. I think highly of those who play skittles, and also of those who write verse. You perceive that my principles are not utilitarian, and that I shall never be the editor of a virtuous paper, unless I am converted, which would be very comical.

Instead of founding a Monthyon prize for the reward of virtue, I would rather bestow—like Sardanapalus, that great, misunderstood philosopher—a large reward to him who should invent a new pleasure; for to me enjoyment seems to be the end of life and the only useful thing on this earth. God willed it to be so, for He created women, perfumes, light, lovely flowers, good wine, spirited horses, lapdogs, and Angora cats; for He did not say to his angels, "Be virtuous," but, "Love," and gave us lips more sensitive than the rest of the skin that we might kiss women, eyes looking upward that we might behold the light, a subtle sense of smell that we might breathe in the soul of flowers, muscular limbs that we might press the flanks of stallions and fly swift as thought without railway or boiler, delicate hands that we might stroke the long heads of greyhounds, the velvety fur of cats, and the soft shoulder of women of easy virtue, and, finally, granted to us alone the triple and

glorious privilege of drinking without being thirsty, striking fire, and making love in all seasons, whereby we are much more distinguished from brutes than by the custom of reading newspapers and framing constitutions.

Art for Art's Sake

E. M. Forster

One of the most distinguished novelists of the twentieth century, E. M. Forster (1879–1970) was born in England, educated at Kings College, Cambridge, lived in Italy, and visited India in 1912 and 1922. His early novels and some of his short fiction contrasted the Victorian or pedantic Englishman with the free, sensual Italian. His last and most famous novel, A Passage to India *(1924), contrasted India with the West. Among his works, in addition to* A Passage to India, *are* Where Angels Fear to Tread *(1905),* The Longest Journey *(1907), and* Howard's End *(1910). Since 1924 he published one volume of short stories, plus essays and criticism. The world is poorer for his decision to write no more novels. There is a fine book about his fiction by Lionel Trilling. He is aptly described by Reed Whittsmore as one who "was a great literary craftsman,...a profound observer of the social condition, and...one of England's great moralists." There are other important values, but art, Forster contends here, is self-contained, with a life of its own; it needs no external source to nourish it.*

I believe in art for art's sake. It is an unfashionable belief, and some of my statements must be of the nature of an apology. Sixty years ago I should have faced you with more confidence. A writer or a speaker who chose "Art for Art's Sake" for his theme sixty years ago could be sure of being in the swim, and could feel so confident of success that he sometimes dressed himself in aesthetic costumes suitable to the occasion—in an embroidered dressing-gown, perhaps, or a blue velvet suit with a Lord Fauntleroy collar; or a toga, or a kimono, and carried a poppy or a lily or a long peacock's feather in his mediaeval hand. Times have changed. Not thus can I present either myself or my theme to-day. My aim rather is to ask you quietly to reconsider for a few minutes a phrase which has been much misused and much abused, but which has, I believe, great importance for us—has, indeed, eternal importance.

Now we can easily dismiss those peacock's feathers and other affectations—they are but trifles—but I want also to dismiss a more dangerous heresy, namely the silly idea that only art matters, an idea which has somehow got mixed up with the idea of art for art's sake, and has helped to discredit it. Many things besides art, matter. It is merely one of the things that matter, and high though the claims are that I make for it, I want to keep them in proportion. No one can spend his or her life entirely in the creation or the appreciation of masterpieces. Man lives, and ought to live, in a complex world, full of conflicting claims, and if we simplified them down into the aesthetic he would be sterilised. Art for art's sake does not mean that only

Aestheticism: The Autonomy of Art

art matters and I would also like to rule out such phrases as, "The Life of Art," "Living for Art," and "Art's High Mission." They confuse and mislead.

What does the phrase mean? Instead of generalising, let us take a specific instance—Shakespeare's *Macbeth,* for example, and pronounce the words, *"Macbeth for Macbeth's sake."* What does that mean? Well, the play has several aspects—it is educational, it teaches us something about legendary Scotland, something about Jacobean England, and a good deal about human nature and its perils. We can study its origins, and study and enjoy its dramatic technique and the music of its diction. All that is true. But *Macbeth* is furthermore a world of its own, created by Shakespeare and existing in virtue of its own poetry. It is in this aspect *Macbeth for Macbeth's* sake, and that is what I intend by the phrase "art for art's sake." A work of art—whatever else it may be—is a self-contained entity, with a life of its own imposed on it by its creator. It has internal order. It may have external form. That is how we recognise it.

Take for another example that picture of Seurat's which I saw two years ago in Chicago—*"La Grande Jatte."* Here again there is much to study and to enjoy: the pointillism, the charming face of the seated girl, the nineteenth-century Parisian Sunday sunlight, the sense of motion in immobility. But here again there is something more; *"La Grande Jatte"* forms a world of its own, created by Seurat and existing by virtue of its own poetry: *"La Grande Jatte" pour "La Grande Jatte":* *l'art pour l'art.* Like *Macbeth* it has internal order and internal life.

It is to the conception of order that I would now turn. This is important to my argument, and I want to make a digression, and glance at order in daily life, before I come to order in art.

In the world of daily life, the world which we perforce inhabit, there is much talk about order, particularly from statesmen and politicians. They tend, however, to confuse order with orders, just as they confuse creation with regulations. Order, I suggest, is something evolved from within, not something imposed from without; it is an internal stability, a vital harmony, and in the social and political category it has never existed except for the convenience of historians. Viewed realistically, the past is really a series of *dis*orders, succeeding one another by discoverable laws, no doubt, and certainly marked by an increasing growth of human interference, but disorders all the same. So that, speaking as a writer, what I hope for to-day is a disorder which will be more favourable to artists than is the present one, and which will provide them with fuller inspirations and better material conditions. It will not last—nothing lasts—but there have been some advantageous disorders in the past—for instance, in ancient Athens, in Renaissance Italy, eighteenth-century France, periods in China and Persia—and we may do something to accelerate the next one. But let us not again fix our hearts where true joys are not to be found. We were promised a new order after the first world war through the League of Nations. It did not come, nor have I faith in present promises, by whomsoever endorsed. The implacable offensive of Science forbids. We cannot reach social and political stability for the reason that we continue to make scientific discoveries and to apply them, and thus to destroy the arrangements which were based on more elementary discoveries. If Science would discover rather than apply—if, in other words, men were more interested in knowledge than in power—mankind would be in a far safer position, the stability statesmen talk about would be a possibility, there could be a new order based on vital harmony, and the earthly millennium might approach. But Science shows no signs of doing this: she gave us the internal combustion engine, and before we had digested and assimilated it with terrible pains into our social system, she harnessed the atom, and destroyed any new order that seemed to be evolving. How can man get into harmony with his surroundings

when he is constantly altering them? The future of our race is, in this direction, more unpleasant than we care to admit, and it has sometimes seemed to me that its best chance lies through apathy, uninventiveness, and inertia. Universal exhaustion might promote that Change of Heart which is at present so briskly recommended from a thousand pulpits. Universal exhaustion would certainly be a new experience. The human race has never undergone it, and is still too perky to admit that it may be coming and might result in a sprouting of new growth through the decay.

I must not pursue these speculations any further—they lead me too far from my terms of reference and maybe from yours. But I do want to emphasize that order in daily life and in history, order in the social and political category, is unattainable under our present psychology.

Where is it attainable? Not in the astronomical category, where it was for many years enthroned. The heavens and the earth have become terribly alike since Einstein. No longer can we find a reassuring contrast to chaos in the night sky and look up with George Meredith to the stars, the army of unalterable law, or listen for the music of the spheres. Order is not there. In the entire universe there seem to be only two possibilities for it. The first of them—which again lies outside my terms of reference—is the divine order, the mystic harmony, which according to all religions is available for those who can contemplate it. We must admit its possibility, on the evidence of the adepts, and we must believe them when they say that it is attained, if attainable, by prayer. "O thou who changest not, abide with me," said one of its poets. *"Ordina questo amor, o tu che m'ami,"* said another: "Set love in order thou who lovest me." The existence of a divine order, though it cannot be tested, has never been disproved.

The second possibility for order lies in the aesthetic category, which is my subject here: the order which an artist can create in his own work, and to that we must now return. A work of art, we are all agreed, is a unique product. But why? It is unique not because it is clever or noble or beautiful or enlightened or original or sincere or idealistic or useful or educational—it may embody any of those qualities—but because it is the only material object in the universe which may possess internal harmony. All the others have been pressed into shape from outside, and when their mould is removed they collapse. The work of art stands up by itself, and nothing else does. It achieves something which has often been promised by society, but always delusively. Ancient Athens made a mess—but the *Antigone* stands up. Renaissance Rome made a mess—but the ceiling of the Sistine got painted. James I made a mess—but there was *Macbeth*. Louis XIV—but there was *Phedre*. Art for art's sake? I should just think so, and more so than ever at the present time. It is the one orderly product which our muddling race has produced. It is the cry of a thousand sentinels, the echo from a thousand labyrinths; it is the lighthouse which cannot be hidden: *c'est le meilleur temoignage que nous puissions donner de notre dignite. Antigone* for *Antigone's* sake, *Macbeth* for *Macbeth's*, *"La Grande Jatte" pour "La Grande Jatte."*

If this line of argument is correct, it follows that the artist will tend to be an outsider in the society to which he has been born, and that the nineteenth century conception of him as a Bohemian was not inaccurate. The conception erred in three particulars: it postulated an economic system where art could be a full-time job, it introduced the fallacy that only art matters, and it overstressed idiosyncracy and waywardness—the peacock-feather aspect—rather than order. But it is a truer conception than the one which prevails in official circles on my side of the Atlantic—I don't know about yours: the conception which treats the artist as if he were a particularly bright government advertiser and encourages him to be friendly and matey with his fellow citizens, and not to give himself airs.

Estimable is mateyness, and the man who achieves it gives many a pleasant little drink to himself and to others. But it has no traceable connection with the creative impulse, and probably acts as an inhibition on it. The artist who is seduced by mateyness may stop himself from doing the one thing which he, and he alone, can do—the making of something out of words or sounds or paint or clay or marble or steel or film which has internal harmony and presents order to a permanently disarranged planet. This seems worth doing, even at the risk of being called uppish by journalists. I have in mind an article which was published some years ago in the London *Times,* an article called "The Eclipse of the Highbrow," in which the "Average Man" was exalted, and all contemporary literature was censured if it did not toe the line, the precise position of the line being naturally known to the writer of the article. Sir Kenneth Clark, who was at that time director of our National Gallery, commented on this pernicious doctrine in a letter which cannot be too often quoted. "The poet and the artist," wrote Clark, "are important precisely because they are not average men; because in sensibility, intelligence, and power of invention they far exceed the average." These memorable words, and particularly the words "power of invention," are the Bohemian's passport. Furnished with it, he slinks about society, saluted now by a brickbat and now by a penny, and accepting either of them with equanimity. He does not consider too anxiously what his relations with society may be, for he is aware of something more important than that—namely the invitation to invent, to create order, and he believes he will be better placed for doing this if he attempts detachment. So round and round he slouches, with his hat pulled over his eyes, and maybe with a louse in his beard, and—if he really wants one—with a peacock's feather in his hand.

If our present society should disintegrate—and who dare prophesy that it won't?—this old-fashioned and démodé figure will become clearer: the Bohemian, the outsider, the parasite, the rat—one of those figures which have at present no function either in a warring or a peaceful world. It may not be dignified to be a rat, but many of the ships are sinking, which is not dignified either—the officials did not build them properly. Myself, I would sooner be a swimming rat than a sinking ship—at all events I can look around me for a little longer—and I remember how one of us, a rat with particularly bright eyes called Shelley, squeaked out, "Poets are the unacknowledged legislators of the world," before he vanished into the waters of the Mediterranean.

What laws did Shelley propose to pass? None. The legislation of the artist is never formulated at the time, though it is sometimes discerned by future generations. He legislates through creating. And he creates through his sensitiveness and his power to impose form. Without form the sensitiveness vanishes. And form is as important to-day, when the human race is trying to ride the whirlwind, as it ever was in those less agitating days of the past, when the earth seemed solid and the stars fixed, and the discoveries of science were made slowly, slowly. Form is not tradition. It alters from generation to generation. Artists always seek a new technique, and will continue to do so as long as their work excites them. But form of some kind is imperative. It is the surface crust of the internal harmony, it is the outward evidence of order.

My remarks about society may have seemed too pessimistic, but I believe that society can only represent a fragment of the human spirit, and that another fragment can only get expressed through art. And I wanted to take this opportunity, this vantage ground, to assert not only the existence of art, but its pertinacity. Looking back into the past, it seems to me that that is all there has ever been: vantage grounds for discussion and creation, little vantage grounds in the changing chaos, where bubbles have been blown and webs spun, and the desire to

create order has found temporary gratification, and the sentinels have managed to utter their challenges, and the huntsmen, though lost individually, have heard each other's calls through the impenetrable wood, and the lighthouses have never ceased sweeping the thankless seas. In this pertinacity there seems to me, as I grow older, something more and more profound, something which does in fact concern people who do not care about art at all.

In conclusion, let me summarise the various categories that have laid claim to the possession of Order.

(1) The social and political category. Claim disallowed on the evidence of history and of our own experience. If man altered psychologically, order here might be attainable: not otherwise.

(2) The astronomical category. Claim allowed up to the present century, but now disallowed on the evidence of the physicists.

(3) The religious category. Claim allowed on the evidence of the mystics.

(4) The aesthetic category. Claim allowed on the evidence of various works of art, and on the evidence of our own creative impulses, however weak these may be or however imperfectly they may function. Works of art, in my opinion, are the only objects in the material universe to possess internal order, and that is why, though I don't believe that only art matters, I do believe in Art for Art's Sake.

Art-as-Art

Ad Reinhardt

Ad (Adolph F.) Reinhardt (1913–1967), a New York painter, taught at Hunter and Brooklyn Colleges. His work is represented in most of the major museums in this country. He had some twenty-five one-man shows in the major art capitals of Europe and the U.S.A. The best comment on his reductionist, art-for-art's sake aesthetic are the two reproductions which accompany his remarks. Susan Sontag singled him out as one of the few "articulate and intelligent painters who write." The New York editor for Art International *found these controversial paintings "extremely moving." We are told that "The fact that it takes so long to perceive the forms and colors in the black paintings forces the viewer into an appropriate mood, if he doesn't just shrug and move on. Once in the mood, it is difficult to escape. An intimacy is established, a kind of secret bond between the patient, concentrating viewer, whose mind and eye are slowly opening to nuance and undertone, and the impassive but self-conscious object waiting to be penetrated, implying that there is something there for those who will work for it. There is."*

Some, probably most, will fail to get into the mood. For them his canvases are the reductio ad absurdum *of the aestheticist position.*

The one thing to say about art is that it is one thing. Art is art-as-art and everything else is everything else. Art-as-art is nothing but art. Art is not what is not art.

From *Art International* (December 20, 1962), pp. 36–37. Copyright 1962 by Ad Reinhardt. Reprinted by permission of the publisher.

The one object of fifty years of abstract art is to present art-as-art and as nothing else, to make it into the one thing it is only, separating and defining it more and more, making it purer and emptier, more absolute and more exclusive—non-objective, non-representational, non-figurative, non-imagist, non-expressionist, non-subjective. The only and one way to say what abstract art or art-as-art is, is to say what it is not.

The one subject of a hundred years of modern art is that awareness of art of itself, of art preoccupied with its own process and means, with its own identity and distinction, art concerned with its own unique statement, art conscious of its own evolution and history and destiny, toward its own freedom, its own dignity, its own essence, its own reason, its own morality and its own conscience. Art needs no justification in our day with "realism" or "naturalism", "regionalism" or "nationalism", "individualism" or "socialism" or "mysticism", or with any other ideas.

The one content of three centuries of European or Asiatic art and the one matter of three millenia of Eastern or Western art, is the same "one significance" that runs through all the timeless art of the world. Without an art-as-art continuity and art-for-art's-sake conviction and unchanging art-spirit and abstract point of view, art would be inaccessible and the "one thing" completely secret.

The one idea of art as "fine", "high", "noble", "liberal", "ideal" of the seventeenth century is to separate fine and intellectual art from manual art and craft. The one intention of the word "esthetics" of the eighteenth century is to isolate the art-experience from other things. The one declaration of all the main movements in art of the nineteenth century is of the "independence" of art. The one question, the one principle, the one crisis in art of the twentieth century centers in the uncompromising "purity" of art, and in the consciousness that art comes from art only, not from anything else.

The one meaning in art-as-art, past or present, is art-meaning. When an art-object is separated from its original time and place and use and is moved into the art-museum, it gets emptied and purified of all its meanings except one. A religious object that becomes a work of art in an art-museum loses all its religious meanings. No one in his right mind goes to an art-museum to worship anything but art, or to learn about anything else.

The one place for art-as-art is the museum of fine art. The one reason for the museum of fine art is the preservation of ancient and modern art that cannot be made again and that does not have to be done again. A museum of fine art should exclude everything but fine art, and be separate from museums of ethnology, geology, archaeology, history, decorative-arts, industrial-arts, military-arts, and museums of other things. A museum is a treasure-house and tomb, not a counting-house or amusement-center. A museum that becomes an art-curator's personal-monument or an art-collector-sanctifying-establishment or an art-history-manufacturing-plant or an artists'-market-block, is a disgrace. Any disturbance of a true museum's soundlessness, timelessness, airlessness and lifelessness is a disrespect.

The one purpose of the art-academy-university is the education and "correction of the artist"-as-artist, not the "enlightenment of the public" or the popularization of art. The art college should be a cloister-ivyhall-ivory-tower-community of artists, an artists' union and congress and club, not a success-school or service-station or rest-home or house of artists' ill-fame. The notion that art or an art-museum or art-university "enriches life" or "fosters a love of life" or "promotes understanding and love among men", is as mindless as anything in art can be. Anyone who speaks of using art to further any local, municipal, national or international relations is out of his mind.

The one thing to say about art and life is that art is art and life is life. A "slice-of-life" art is no better or worse than a "slice-of-art" life. Fine art is not a "means of making a living" or a "way of living a life", and an artist who dedicates his life to his art or his art to his life, burdens his art with his life and his life with his art. Art that is a matter of life and death is neither fine nor free.

The one assault on fine art is the ceaseless attempt to subserve it as a means to some other end or value. The one fight in art is not between art and non-art, but between true and false art, between pure art and action-assemblage-art, between abstract art and surrealist-expressionist-anti-art, between free art and servile art. Abstract art has its own integrity, not someone else's "integration" with something else. Any combining, mixing, adding, diluting, exploiting, vulgarizing or popularizing abstract art deprives art of its essence and depraves the artist's artistic consciousness. Art is free, but it is not a free-for-all. The one struggle in art is the struggle of artists against artists, of artist against artist, of the artist-as-artist within and against the artist-as-man, -animal, or -vegetable. Artists who claim their art-work comes from nature, life, reality, earth or heaven, as "mirrors of the soul" or "reflections of conditions" or "instruments of the universe", who cook up "new images of man"—figures and "nature-in-abstraction"—pictures, are subjectively and objectively, rascals or rustics. The art of "figuring" or "picturing" is not a fine art. An artist who is lobbying as a "creature of circumstances" or log-rolling as a "victim of fate" is not a fine master-artist. No one ever forces an artist to be pure.

The one art that is abstract and pure enough to have the one problem and possibility in our time and timelessness of the "one single grand original problem", is pure abstract painting. Abstract painting is not just another school or movement or style but the first truly unmannered and untrammelled and unentangled, styleless universal painting. No other art or painting is detached or empty or immaterial enough.

The one history of painting progresses from the painting of a variety of ideas with a variety of subjects and objects, to one idea with a variety of subjects and objects, to one subject with a variety of objects, to one object with a variety of subjects, then to one object with one subject, to one object with no subject, and to one subject with no object, then to the idea of no object and no subject and no variety at all. There is nothing less significant in art, nothing more exhausting and immediately exhausted, than "endless variety".

The one evolution of art-forms unfolds in one straight logical line of negative actions and reactions, in one predestined, eternally recurrent stylistic cycle, in the same all-over pattern, in all times and places, taking different times in different places, always beginning with an "early" archaic schematization, achieving a climax with a "classic" formulation, and decaying with a "late" endless variety of illusionisms and expressionisms. When late stages wash away all lines of demarcation, framework and fabric, with "anything can be art", "anybody can be an artist", "that's life", "why fight it", "anything goes", and "it makes no difference whether art is abstract or representational", the artists' world is a mannerist and primitivist art-trade and suicide-vaudeville, venal, genial, contemptible, trifling.

The one way in art comes from art-working and the more an artist works the more there is to do. Just as artists come from artists and art-forms from art-forms, painting comes from painting. The one direction in fine or abstract art today is in the painting of the same one form over and over again. The one intensity and the one perfection comes only from long and lonely routine preparation and attention and repetition. The one originality exists only where all artists work in the same tradition and master the same convention. The one freedom is realized only through the strictest art-discipline and through the most similar studio-ritual. Only

Aestheticism: The Autonomy of Art

a standardized, prescribed and proscribed form can be imageless, only a stereotyped image can be formless, only a formalized art can be formulaless. A painter who does not know what or how or where to paint is not a fine artist.

The one work for a fine artist now, the one thing in painting to do, is to repeat the one-size-canvas—the single-scheme, one colour-monochrome, one linear-division in each direction, one symmetry, one texture, one formal device, one free-hand-brushing, one rhythm, one working everything into one dissolution and one indivisibility, painting everything into one overall uniformity and non-irregularity. No lines or imaginings, no shapes or composings or representings, no visions or sensations or impulses, no symbols or signs or impastos, no decoratings or colouring or picturings, no pleasures or pains, no accidents or readymades, no things, no ideas, no relations, no attributes, no qualities—nothing that is not of the essence. Everything into irreducibility, unreproducibility, imperceptibility. Nothing "use-able", "manipulatable", "saleable", "dealable", "collectable", "graspable". No art as a commodity or a jobbery. Art is not the spiritual side of business.

The one standard in art is oneness and fineness, rightness and purity, abstractness and evanescence. The one thing to say about the best art is the breathlessness, lifelessness, deathlessness, contentlessness, formlessness, spacelessness and time-lessness. This is always the end of art.

Reinhardt. Abstract Painting, Black, 1954. Oil on canvas. 78" x 78"

Who Cares If You Listen?

Milton Babbitt

Milton Babbitt (1916–) is Conant Professor of Music at Princeton University, where he teaches mathematics as well as music. He is one of the major figures in the field of modern music and through numerous articles, recordings, and lectures has done much to advance the musical innovations of Arnold Schoenberg. He is a composer as well as critic and musicologist and among the first to exploit the potentialities of electronic machines in such compositions as Philomel *(1963–1964) and* Ensembles for Synthesizer *(1961–1963) Columbia Records, MS 7051 (1967). It has been suggested that his compositions exemplify tendencies in music analogous to the work of Jackson Pollock and Willem de Kooning in painting. He is, in any case, a leading spokesman for the so-called "anti-audience position" in vogue among contemporary composers. For diverging views concerning the relationship of composer and audience, the reader should consult the comments of Shostakovitch and Sartre reprinted below.*

This article might have been entitled "The Composer as Specialist" or, alternatively, and perhaps less contentiously, "The Composer as Anachronism." For

From *High Fidelity*, VIII/2 (February 1958), pp. 38–40, 126–127. Copyright 1958 by Milton Babbitt. Reprinted by permission of the publisher.

I am concerned with stating an attitude towards the indisputable facts of the status and condition of the composer of what we will, for the moment, designate as "serious," "advanced," contemporary music. This composer expends an enormous amount of time and energy—and, usually, considerable money—on the creation of a commodity which has little, no, or negative commodity value. He is, in essence, a "vanity" composer. The general public is largely unaware of and uninterested in his music. The majority of performers shun it and resent it. Consequently, the music is little performed, and then primarily at poorly attended concerts before an audience consisting in the main of fellow professionals. At best, the music would appear to be for, of, and by specialists.

Towards this condition of musical and societal "isolation," a variety of attitudes has been expressed, usually with the purpose of assigning blame, often to the music itself, occasionally to critics or performers, and very occasionally to the public. But to assign blame is to imply that this isolation is unnecessary and undesirable. It is my contention that, on the contrary, this condition is not only inevitable, but potentially advantageous for the composer and his music. From my point of view, the composer would do well to consider means of realizing, consolidating, and extending the advantages.

The unprecedented divergence between contemporary serious music and its listeners, on the one hand, and traditional music and its following, on the other, is not accidental and—most probably—not transitory. Rather, it is a result of a half-century of revolution in musical thought, a revolution whose nature and consequences can be compared only with, and in many respects are closely analogous to, those of the mid-nineteenth-century revolution in theoretical physics. The immediate and profound effect has been the necessity for the informed musician to reexamine and probe the very foundations of his art. He has been obliged to recognize the possibility, and actuality, of alternatives to what were once regarded as musical absolutes. He lives no longer in a unitary musical universe of "common practice," but in a variety of universes of diverse practice.

This fall from musical innocence is, understandably, as disquieting to some as it is challenging to others, but in any event the process is irreversible; and the music that reflects the full impact of this revolution is, in many significant respects, a truly "new" music. Apart from the often highly sophisticated and complex constructive methods of any one composition, or group of compositions, the very minimal properties characterizing this body of music are the sources of its "difficulty," "unintelligibility," and—isolation. In indicating the most general of these properties, I shall make reference to no specific works, since I wish to avoid the independent issues of evaluation. The reader is at liberty to supply his own instances; if he cannot (and, granted the condition under discussion, this is a very real possibility), let him be assured that such music does exist.

First. This music employs a tonal vocabulary which is more "efficient" than that of the music of the past, or its derivatives. This is not necessarily a virtue in itself, but it does make possible a greatly increased number of pitch simultaneities, successions, and relationships. This increase in efficiency necessarily reduces the "redundancy" of the language, and as a result the intelligible communication of the work demands increased accuracy from the transmitter (the performer) and activity from the receiver (the listener). Incidentally, it is this circumstance, among many others, that has created the need for purely electronic media of "performance." More importantly for us, it makes ever heavier demands upon the training of the listener's perceptual capacities.

Second. Along with this increase of meaningful pitch materials, the number of functions associated with each component of the musical event also has been

multiplied. In the simplest possible terms, each such "atomic" event is located in a five-dimensional musical space determined by pitch-class, register, dynamic, duration, and timbre. These five components not only together define the single event, but, in the course of a work, the successive values of each component create an individually coherent structure, frequently in parallel with the corresponding structures created by each of the other components. Inability to perceive and remember precisely the values of any of these components results in a dislocation of the event in the work's musical space, an alternation of its relation to all other events in the work, and—thus—a falsification of the composition's total structure. For example, an incorrectly performed or perceived dynamic value results in destruction of the work's dynamic pattern, but also in false identification of other components of the event (of which this dynamic value is a part) with corresponding components of other events, so creating incorrect pitch, registral, timbral, and durational associations. It is this high degree of "determinacy" that most strikingly differentiates such music from, for example, a popular song. A popular song is only very partially determined, since it would appear to retain its germane characteristics under considerable alteration of register, rhythmic texture, dynamics, harmonic structure, timbre, and other qualities.

The preliminary differentiation of musical categories by means of this reasonable and usable criterion of "degree of determinacy" offends those who take it to be a definition of qualitative categories, which—of course—it need not always be. Curiously, their demurrers usually take the familiar form of some such "democratic" counterdefinition as: "There is no such thing as 'serious' and 'popular' music. There is only 'good' and 'bad' music." As a public service, let me offer those who still patiently await the revelation of the criteria of Absolute Good an alternative criterion which possesses, at least, the virtue of immediate and irrefutable applicability: "There is no such thing as 'serious' and 'popular' music. There is only music whose title begins with the letter 'X,' and music whose title does not."

Third. Musical compositions of the kind under discussion possess a high degree of contextuality and autonomy. That is, the structural characteristics of a given work are less representative of a general class of characteristics than they are unique to the individual work itself. Particularly, principles of relatedness, upon which depends immediate coherence of continuity, are more likely to evolve in the course of the work than to be derived from generalized assumptions. Here again greater and new demands are made upon the perceptual and conceptual abilities of the listener.

Fourth, and finally. Although in many fundamental respects this music is "new," it often also represents a vast extension of the methods of other musics, derived from a considered and extensive knowledge of their dynamic principles. For, concomitant with the "revolution in music," perhaps even an integral aspect thereof, has been the development of analytical theory, concerned with the systematic formulation of such principles to the end of greater efficiency, economy, and understanding. Compositions so rooted necessarily ask comparable knowledge and experience from the listener. Like all communication, this music presupposes a suitably equipped receptor. I am aware that "tradition" has it that the lay listener, by virtue of some undefined, transcendental faculty, always is able to arrive at a musical judgment absolute in its wisdom if not always permanent in its validity. I regret my inability to accord this declaration of faith the respect due its advanced age.

Deviation from this tradition is bound to dismiss the contemporary music of which I have been talking into "isolation." Nor do I see how or why the situation should be otherwise. Why should the layman be other than bored and puzzled by what he is unable to understand, music or anything else? It is only the translation of this boredom and puzzlement into resentment and denunciation that seems to me indefensible. After all, the public does have its own music, its ubiquitous music: music to eat by, to read by, to dance by, and to be impressed by. Why refuse to recognize the possibility that contemporary music has reached a stage long since attained by other forms of activity? The time has passed when the normally well-educated man without special preparation could understand the most advanced work in, for example, mathematics, philosophy, and physics. Advanced music, to the extent that it reflects the knowledge and originality of the informed composer, scarcely can be expected to appear more intelligible than these arts and sciences to the person whose musical education usually has been even less extensive than his background in other fields. But to this, a double standard is invoked, with the words "music is music," implying also that "music is *just* music." Why not, then, equate the activities of the radio repairman with those of the theoretical physicist, on the basis of the dictum that "physics is physics"? It is not difficult to find statements like the following, from the *New York Times* of September 8, 1957: "The scientific level of the conference is so high...that there are in the world only 120 mathematicians specializing in the field who could contribute." Specialized music on the other hand, far from signifying "height" of musical level, has been charged with "decadence," even as evidence of an insidious "conspiracy."

It often has been remarked that only in politics and the "arts" does the layman regard himself as an expert, with the right to have his opinion heard. In the realm of politics he knows that this right, in the form of a vote, is guaranteed by fiat. Comparably, in the realm of public music, the concertgoer is secure in the knowledge that the amenities of concert going protect his firmly stated "I didn't like it" from further scrutiny. Imagine, if you can, a layman chancing upon a lecture on "Pointwise Periodic Hemeomorphisms." At the conclusion, he announces: "I didn't like it." Social conventions being what they are in such circles, someone might dare inquire: "Why not?" Under duress, our layman discloses precise reasons for his failure to enjoy himself; he found the hall chilly, the lecturer's voice unpleasant, and he was suffering the digestive aftermath of a poor dinner. His interlocutor understandably disqualifies these reasons as irrelevant to the content and value of the lecture, and the development of mathematics is left undisturbed. If the concertgoer is at all versed in the ways of musical lifesmanship, he also will offer reasons for his "I didn't like it"—in the form of assertions that the work in question is "inexpressive," "undramatic," "lacking in poetry," etc., etc., tapping that store of vacuous equivalents hallowed by time for: "I don't like it, and I cannot or will not state why." The concertgoer's critical authority is established beyond the possibility of further inquiry. Certainly he is not responsible for the circumstance that musical discourse is a never-never land of semantic confusion, the last resting place of all those verbal and formal fallacies, those hoary dualisms that have been banished from rational discourse. Perhaps he has read, in a widely consulted and respected book on the history of music, the following: "to call him (Tchaikovsky) the 'modern Russian Beethoven' is footless, Beethoven being patently neither modern nor Russian. . . ." Or, the following, by an eminent "nonanalytic" philosopher: "The music of Lourie is an ontological music. . . .It is born in the singular roots of being, the nearest possible juncture of the soul and the spirit. . . ."

How unexceptionable the verbal peccadilloes of the average concertgoer appear beside these masterful models. Or, perhaps, in search of "real" authority, he has acquired his critical vocabulary from the pronouncements of officially "eminent" composers, whose eminence, in turn, is founded largely upon just such assertions as the concertgoer has learned to regurgitate. This cycle is of slight moment in a world where circularity is one of the norms of criticism. Composers (and performers), wittingly or unwittingly assuming the character of "talented children" and "inspired idiots" generally ascribed to them, are singularly adept at the conversion of personal tastes into general principles. Music they do not like is "not music," composers whose music they do not like are "not composers."

In search of what to think and how to say it, the layman may turn to newspapers and magazines. Here he finds conclusive evidence for the proposition that "music is music." The science editor of such publications contents himself with straight-forward reporting, usually news of the "factual" sciences; books and articles not intended for popular consumption are not reviewed. Whatever the reason, such matters are left to professional journals. The music critic admits no comparable differentiation. He may feel, with some justice, that music which presents itself in the market place of the concert hall automatically offers itself to public approval or disapproval. He may feel, again with some justice, that to omit the expected criticism of the "advanced" work would be to do the composer an injustice in his assumed quest for, if nothing else, public notice and "professional recognition." The critic, at least to this extent, is himself a victim of the leveling of categories.

Here, then, are some of the factors determining the climate of the public world of music. Perhaps we should not have overlooked those pockets of "power" where prizes, awards, and commissions are dispensed, where music is adjudged guilty, not only without the right to be confronted by its accuser, but without the right to be confronted by the accusations. Or those well-meaning souls who exhort the public "just to *listen* to more contemporary music," apparently on the theory that familiarity breeds passive acceptance. Or those, often the same well-meaning souls, who remind the composer of his "obligation to the public," while the public's obligation to the composer is fulfilled, manifestly, by mere physical presence in the concert hall or before a loudspeaker or—more authoritatively—by committing to memory the numbers of phonograph records and amplifier models. Or the intricate social world within this musical world, where the salon becomes bazaar, and music itself becomes an ingredient of verbal canapes for cocktail conversation.

I say all this not to present a picture of a virtuous music in a sinful world, but to point up the problems of a special music in an alien and inapposite world. And so, I dare suggest that the composer would do himself and his music an immediate and eventual service by total, resolute, and voluntary withdrawal from this public world to one of private performance and electronic media, with its very real possibility of complete elimination of the public and social aspects of musical composition. By so doing, the separation between the domains would be defined beyond any possibility of confusion of categories, and the composer would be free to pursue a private life of professional achievement, as opposed to a public life of unprofessional compromise and exhibitionism.

But how, it may be asked, will this serve to secure the means of survival for the composer and his music? One answer is that after all such a private life is what the university provides the scholar and the scientist. It is only proper that the university, which—significantly—has provided so many contemporary composers with their professional training and general education, should provide a home for the "complex," "difficult," and "problematical" in music. Indeed, the process has

begun; and if it appears to proceed too slowly, I take consolation in the knowledge that in this respect, too, music seems to be in historically retarded parallel with now sacrosanct fields of endeavor. In E. T. Bell's *Men of Mathematics,* we read: "In the eighteenth century the universities were not the principal centers of research in Europe. They might have become such sooner than they did but for the classical tradition and its understandable hostility to science. Mathematics was close enough to antiquity to be respectable, but physics, being more recent, was suspect. Further, a mathematician in a university of the time would have been expected to put much of his effort on elementary teaching; his research, if any, would have been an unprofitable luxury...." A simple substitution of "musical composition" for "research," of "academic" for "classical," of "music" for "physics," and of "composer" for "mathematician," provides a strikingly accurate picture of the current situation. And as long as the confusion I have described continues to exist, how can the university and its community assume other than that the composer welcomes and courts public competition with the historically certified products of the past, and the commercially certified products of the present?

Perhaps for the same reason, the various institutes of advanced research and the large majority of foundations have disregarded this music's need for means of survival. I do not wish to appear to obscure the obvious differences between musical composition and scholarly research, although it can be contended that these differences are no more fundamental than the differences among the various fields of study. I do question whether these differences, by their nature, justify the denial to music's development of assistance granted these other fields. Immediate "practical" applicability (which may be said to have its musical analogue in "immediate extensibility of a compositional technique") is certainly not a necessary condition for the support of scientific research. And if it be contended that such research is so supported because in the past it has yielded eventual applications, one can counter with, for example, the music of Anton Webern, which during the composer's lifetime was regarded (to the very limited extent that it was regarded at all) as the ultimate in hermetic, specialized, and idiosyncratic composition; today, some dozen years after the composer's death, his complete works have been recorded by a major record company, primarily—I suspect—as a result of the enormous influence this music has had on the postwar, nonpopular, musical world. I doubt that scientific research is any more secure against predictions of ultimate significance than is musical composition. Finally, if it be contended that research, even in its least "practical" phases, contributes to the sum of knowledge in the particular realm, what possibly can contribute more to our knowledge of music than a genuinely original composition?

Granting to music the position accorded other arts and sciences promises the sole substantial means of survival for the music I have been describing. Admittedly, if this music is not supported, the whistling repertory of the man in the street will be little affected, the concert-going activity of the conspicuous consumer of musical culture will be little disturbed. But music will cease to evolve, and, in that important sense, will cease to live.

Art and Religious Perception

Leo Tolstoy

Leo Tolstoy (1828–1910) is thought by some critics to be the only writer whose stature matched Shakespeare's. His greatest works are War and Peace, *which he completed in 1866, and* Anna Karenina, *published in 1875.*

Tolstoy was a nobleman who fought against England and France at Sebastopol. But he became more and more interested in the plight of the Russian peasants, and he retired early in his career to the family estate, Yasnaya Polyana, to lead a peasant's life. As he grew older, he adopted what he believed to be the actual teaching of Christ as it appeared in the Gospels. He preached a simple, religious life and an art accessible to all men. People who knew him—the novelist and playwright Maxim Gorky was a good example—often venerated him even more as a moral prophet than as a great novelist.

In the following selection Tolstoy, noting that every society has its own religious perception, contends that art must be judged by reference to whether it makes this perception operative in actual life.

Art in our society has become so perverted that not only has bad art come to be considered good, but even the very perception of what art really is has been lost. In order to be able to speak about the art of our society it is, therefore, first of all necessary to distinguish art from counterfeit art.

There is one indubitable sign distinguishing real art from its counterfeit—namely, the infectiousness of art. If a man without exercising effort and without altering his standpoint, on reading, hearing, or seeing another man's work experiences a mental condition which unites him with that man and with others who are also affected by that work, then the object evoking that condition is a work of art. And however poetic, realistic, striking, or interesting, a work may be, it is not a work of art if it does not evoke that feeling (quite distinct from all other feelings) of joy and of spiritual union with another (the author) and with others (those who are also infected by it)....

From *What Is Art? and Essays on Art* by Leo Tolstoy, translated by Aylmer Maude (London: Oxford University Press, World's Classics Series, 1938), pp. 227–250. Reprinted by permission of the publisher, Oxford University Press. (Editors' title.)

The chief peculiarity of this feeling is that the recipient of a truly artistic impression is so united to the artist that he feels as if the work were his own and not someone else's—as if what it expresses were just what he had long been wishing to express. A real work of art destroys in the consciousness of the recipient the separation between himself and the artist, and not that alone, but also between himself and all whose minds receive this work of art. In this freeing of our personality from its separation and isolation, in this uniting of it with others, lies the chief characteristic and the great attractive force of art.

If a man is infected by the author's condition of soul, if he feels this emotion and this union with others, then the object which has effected this is art; but if there be no such infection, if there be not this union with the author and with others who are moved by the same work—then it is not art. And not only is infection a sure sign of art, but the degree of infectiousness is also the sole measure of excellence in art....

And the degree of the infectiousness of art depends on three conditions:—

(1) On the greater or lesser individuality of the feeling transmitted; (2) on the greater or lesser clearness with which the feeling is transmitted; (3) on the sincerity of the artist; that is, on the greater or lesser force with which the artist himself feels the emotion he transmits....

But most of all is the degree of infectiousness of art increased by the degree of sincerity in the artist. As soon as the spectator, hearer, or reader, feels that the artist is infected by his own production and writes, sings, or plays, for himself, and not merely to act on others, this mental condition of the artist infects the recipient; and, on the contrary, as soon as the spectator, reader, or hearer, feels that the author is not writing, singing, or playing, for his own satisfaction—does not himself feel what he wishes to express, but is doing it for him, the recipient—resistance immediately springs up, and the most individual and the newest feelings and the cleverest technique not only fail to produce any infection but actually repel.

I have mentioned three conditions of contagion in art, but they may all be summed up into one, the last, sincerity; that is, that the artist should be impelled by an inner need to express his feeling. That condition includes the first; for if the artist is sincere he will express the feeling as he experienced it. And as each man is different from every one else, his feeling will be individual for every one else; and the more individual it is—the more the artist has drawn it from the depths of his nature—the more sympathetic and sincere will it be. And this same sincerity will impel the artist to find clear expression for the feeling which he wishes to transmit.

Therefore this third condition—sincerity—is the most important of the three. It is always complied with in peasant art, and this explains why such art always acts so powerfully; but it is a condition almost entirely absent from our upper-class art, which is continually produced by artists actuated by personal aims of covetousness or vanity.

Such are the three conditions which divide art from its counterfeits, and which also decide the quality of every work of art considered apart from its subject-matter....But how are we to define good and bad art with reference to its content or subject-matter?

How in the subject-matter of art are we to decide what is good and what is bad?

Art like speech is a means of communication and therefore of progress, that is, of the movement of humanity forward towards perfection. Speech renders accessible to men of the latest generations all the knowledge discovered by the experience and reflection both of preceding generations and of the best and foremost men of their own times; art renders accessible to men of the latest generations all the feelings

experienced by their predecessors and also those felt by their best and foremost contemporaries. And as the evolution of knowledge proceeds by truer and more necessary knowledge dislodging and replacing what was mistaken and unnecessary, so the evolution of feeling proceeds by means of art—feelings less kind and less necessary for the well-being of mankind being replaced by others kinder and more needful for that end. That is the purpose of art. And speaking now of the feelings which are its subject-matter, the more art fulfills that purpose the better the art, and the less it fulfills it the worse the art.

The appraisement of feelings (that is, the recognition of one or other set of feelings as more or less good, more or less necessary for the well-being of mankind) is effected by the religious perception of the age.

In every period of history and in every human society there exists an understanding of the meaning of life, which represents the highest level to which men of that society have attained—an understanding indicating the highest good at which that society aims. This understanding is the religious perception of the given time and society. And this religious perception is always clearly expressed by a few advanced men and more or less vividly perceived by members of the society generally. Such a religious perception and its corresponding expression always exist in every society. If it appears to us that there is no religious perception in our society, this is not because there really is none, but only because we do not wish to see it. And we often wish not to see it because it exposes the fact that our life is inconsistent with that religious perception.

Religious perception in a society is like the direction of a flowing river. If the river flows at all it must have a direction. If a society lives, there must be a religious perception indicating the direction in which, more or less consciously, all its members tend.

And so there always has been, and is, a religious perception in every society. And it is by the standard of this religious perception that the feelings transmitted by art have always been appraised. It has always been only on the basis of this religious perception of their age, that men have chosen from amid the endlessly varied spheres of art that art which transmitted feelings making religious perception operative in actual life. And such art has always been highly valued and encouraged, while art transmitting feelings already outlived, flowing from the antiquated religious perceptions of a former age, has always been condemned and despised. All the rest of art transmitting those most diverse feelings by means of which people commune with one another was not condemned and was tolerated if only it did not transmit feelings contrary to religious perception. Thus for instance among the Greeks, art transmitting feelings of beauty, strength, and courage (Hesiod, Homer, Phidias) was chosen, approved, and encouraged, while art transmitting feelings of rude sensuality, despondency, and effeminacy, was condemned and despised. Among the Jews, art transmitting feelings of devotion and submission to the God of the Hebrews and to His will (the epic of Genesis, the prophets, the Psalms) was chosen and encouraged, while art transmitting feelings of idolatry (the Golden Calf) was condemned and despised. All the rest of art—stories, songs, dances, ornamentation of houses, of utensils, and of clothes—which was not contrary to religious perception, was neither distinguished nor discussed. Thus as regards its subject-matter has art always and everywhere been appraised and thus it should be appraised, for this attitude towards art proceeds from the fundamental characteristics of human nature, and those characteristics do not change.

I know that according to an opinion current in our times religion is a superstition humanity has outgrown, and it is therefore assumed that no such thing exists as a

Commitment in Art: The Case Against Aestheticism

religious perception common to us all by which art in our time can be appraised. I know that this is the opinion current in the pseudo-cultured circles of today. People who do not acknowledge Christianity in its true meaning because it undermines their social privileges, and who therefore invent all kinds of philosophic and aesthetic theories to hide from themselves the meaninglessness and wrongfulness of their lives, cannot think otherwise. These people intentionally, or sometimes unintentionally, confuse the notion of a religious cult with the notion of religious perception, and think that by denying the cult they get rid of the perception. But even the very attacks on religion and the attempts to establish an idea of life contrary to the religious perception of our times, most clearly demonstrate the existence of a religious perception condemning the lives that are not in harmony with it.

If humanity progresses, that is, moves forward, there must inevitably be a guide to the direction of that movement. And religions have always furnished that guide. All history shows that the progress of humanity is accomplished no otherwise than under the guidance of religion. But if the race cannot progress without the guidance of religion,—and progress is always going on, and consequently goes on also in our own times,—then there must be a religion of our times. So that whether it pleases or displeases the so-called cultured people of to-day, they must admit the existence of religion—not of a religious cult, Catholic, Protestant, or another, but of religious perception—which even in our times is the guide always present where there is any progress. And if a religious perception exists amongst us, then the feelings dealt with by our art should be appraised on the basis of that religious perception; and as has been the case always and everywhere, art transmitting feelings flowing from the religious perception of our time should be chosen from amid all the indifferent art, should be acknowledged, highly valued, and encouraged, while art running counter to that perception should be condemned and despised, and all the remaining, indifferent, art should neither be distinguished nor encouraged.

The religious perception of our time in its widest and most practical application is the consciousness that our well-being, both material and spiritual, individual and collective, temporal and eternal, lies in the growth of brotherhood among men—in their loving harmony with one another. This perception is not only expressed by Christ and all the best men of past ages, it is not only repeated in most varied forms and from most diverse sides by the best men of our times, but it already serves as a clue to all the complex labour of humanity, consisting as this labour does on the one hand in the destruction of physical and moral obstacles to the union of men, and on the other hand in establishing the principles common to all men which can and should unite them in one universal brotherhood. And it is on the basis of this perception that we should appraise all the phenomena of our life and among the rest our art also: choosing from all its realms and highly prizing and encouraging whatever transmits feelings flowing from this religious perception, rejecting whatever is contrary to it, and not attributing to the rest of art an importance that does not properly belong to it....

It is true that art which satisfies the demands of the religious perception of our time is quite unlike former art, but notwithstanding this dissimilarity, to a man who does not intentionally hide the truth from himself, what forms the religious art of our age is very clear and definite. In former times when the highest religious perception united only some people (who even if they formed a large society were yet but one society among others—Jews, or Athenian or Roman citizens), the feelings transmitted by the art of that time flowed from a desire for the might, greatness, glory, and prosperity, of that society, and the heroes of art might be

people who contributed to that prosperity by strength, by craft, by fraud, or by cruelty (Ulysses, Jacob, David, Samson, Hercules, and all the heroes). But the religious perception of our times does not select any one society of men; on the contrary it demands the union of all—absolutely of all people without exception—and above every other virtue it sets brotherly love of all men. And therefore the feelings transmitted by the art of our time not only cannot coincide with the feelings transmitted by former art, but must run counter to them...the Christian ideal changed and reversed everything.

The ideal is no longer the greatness of Pharaoh or of a Roman emperor, not the beauty of a Greek nor the wealth of Phoenicia, but humility, purity, compassion, love. The hero is no longer Dives, but Lazarus the beggar; not Mary Magdalene in the day of her beauty but in the day of her repentance; not those who acquire wealth but those who have abandoned it; not those who dwell in palaces but those who dwell in catacombs and huts; not those who rule over others, but those who acknowledge no authority but God's. And the greatest work of art is no longer a cathedral of victory with statues of conquerors, but the representation of a human soul so transformed by love that a man who is tormented and murdered yet pities and loves his persecutors....

Art, all art, has this characteristic, that it unites people. Every art causes those to whom the artist's feeling is transmitted to unite in soul with the artist and also with all who receive the same impression. But non-Christian art while uniting some people, makes that very union a cause of separation between these united people and others; so that union of this kind is often a source not merely of division but even of enmity towards others. Such is all patriotic art, with its anthems, poems, and monuments; such is all Church art, that is, the art of certain cults, with their images, statues, processions, and other local ceremonies. Such art is belated and non-Christian, uniting the people of one cult only to separate them yet more sharply from the members of other cults, and even to place them in relations of hostility to one another. Christian art is such only as it tends to unite all without exception, either by evoking in them the perception that each man and all men stand in a like relation towards God and towards their neighbour, or by evoking in them identical feelings, which may even be the very simplest, provided that they are not repugnant to Christianity and are natural to every one without exception.

Good Christian art of our time may be unintelligible to people because of imperfections in its form or because men are inattentive to it, but it must be such that all men can experience the feelings it transmits. It must be the art not of some one group of people, or of one class, or of one nationality, or of one religious cult; that is, it must not transmit feelings accessible only to a man educated in a certain way, or only to an aristocrat, or a merchant, or only to a Russian, or a native of Japan, or a Roman Catholic, or a Buddhist, and so on, but it must transmit feelings accessible to every one. Only art of this kind can in our time be acknowledged to be good art, worthy of being chosen out from all the rest of art and encouraged.

Christian art, that is, the art of our time, should be catholic in the original meaning of the word, that is, universal, and therefore it should unite all men. And only two kinds of feeling unite all men: first, feelings flowing from a perception of our sonship to God and of the brotherhood of man; and next, the simple feelings of common life accessible to every one without exception—such as feelings of merriment, of pity, of cheerfulness, of tranquillity, and so forth. Only these two kinds of feelings can now supply material for art good in its subject-matter....

Sometimes people who are together, if not hostile to one another, are at least estranged in mood and feeling, till perhaps a story, a performance, a picture, or

Commitment in Art: The Case Against Aestheticism

even a building, but oftenest of all music, unites them all as by an electric flash, and in place of their former isolation or even enmity they are conscious of union and mutual love. Each is glad that another feels what he feels; glad of the communion established not only between him and all present, but also with all now living who will yet share the same impression; and, more than that, he feels the mysterious gladness of a communion which, reaching beyond the grave, unites us with all men of the past who have been moved by the same feelings and with all men of the future who will yet be touched by them. And this effect is produced both by religious art which transmits feelings of love of God and one's neighbour, and by universal art transmitting the very simplest feelings common to all men....

If I were asked to give modern examples of...the highest art flowing from love of God and man...in literature I should name *The Robbers* by Schiller; Victor Hugo's *Les Pauvres Gens* and *Les Miserables;* the novels and stories of Dickens—*The Tale of Two Cities, The Christmas Carol, The Chimes,* and others—*Uncle Tom's Cabin;* Dostoevski's works—especially his *Memoirs from the House of Death*—and *Adam Bede* by George Eliot....

To give examples from the modern art of our upper classes...: good universal art, or even of the art of a whole people, is yet more difficult, especially in literature and music. If there are some works which by their inner contents might be assigned to this class (such as *Don Quixote,* Moliere's comedies, *David Copperfield* and *The Pickwick Papers* by Dickens, Gogol's and Pushkin's tales, and some things of Maupassant's), these works for the most part—owing to the exceptional nature of the feelings they transmit, and the superfluity of special details of time and locality, and above all on account of the poverty of their subject-matter in comparison with examples of universal ancient art (such, for instance, as the story of Joseph)—are comprehensible only to people of their own circle. That Joseph's brethren, being jealous of his father's affection, sell him to the merchants; that Potiphar's wife wishes to tempt the youth; that having attained to highest station he takes pity on his brothers, including Benjamin the favourite—these and all the rest are feelings accessible alike to a Russian peasant, a Chinese, an African, a child, or an old man, educated or uneducated; and it is all written with such restraint, is so free from any superfluous detail, that the story may be told to any circle and will be equally comprehensible and touching to everyone. But not such are the feelings of Don Quixote or of Moliere's heroes (though Moliere is perhaps the most universal, and therefore the most excellent, artist of modern times), nor of Pickwick and his friends. These feelings are not common to all men but very exceptional, and therefore to make them contagious the authors have surrounded them with abundant details of time and place. And this abundance of detail makes the stories difficult of comprehension to all who do not live within reach of the conditions described by the author....

It is therefore impossible in modern literature to indicate works fully satisfying the demands of universality. Such works as exist are to a great extent spoilt by what is usually called "realism," but would be better termed "provincialism," in art.

In music the same occurs as in verbal art, and for similar reasons. In consequence of the poorness of the feeling they contain, the melodies of the modern composers are amazingly empty and insignificant. And to strengthen the impression produced by these empty melodies the new musicians pile complex modulations on each trivial melody, not only in their own national manner, but also in the way characteristic of their own exclusive circle and particular musical school. Melody— every melody—is free and may be understood of all men; but as soon as it is bound

up with a particular harmony, it ceases to be accessible except to people trained to such harmony, and it becomes strange, not only to common men of another nationality, but to all who do not belong to the circle whose members have accustomed themselves to certain forms of harmonization. So that music, like poetry, travels in a vicious circle. Trivial and exclusive melodies, in order to make them attractive, are laden with harmonic, rhythmic, and orchestral complications and thus become yet more exclusive, and far from being universal are not even national, that is, they are not comprehensible to the whole people, but only to some people.

In music, besides marches and dances by various composers which satisfy the demands of universal art, one can indicate very few works of this class: Bach's famous violin *aria,* Chopin's nocturne in E flat major, and perhaps a dozen bits (not whole pieces, but parts) selected from the works of Haydn, Mozart, Schubert, Beethoven, and Chopin.[1]

Although in painting the same thing is repeated as in poetry and in music—namely, that in order to make them more interesting, works weak in conception are surrounded by minutely studied accessories of time and place which give them a temporary and local interest but make them less universal—still in painting more than in other spheres of art may be found works satisfying the demands of universal Christian art; that is to say, there are more works expressing feelings in which all men may participate.

In the arts of painting and sculpture, all pictures and statues in so-called genre style, representations of animals, landscapes, and caricatures with subjects comprehensible to every one, and also all kinds of ornaments, are universal in subject-matter. Such productions in painting and sculpture are very numerous (for instance, china dolls), but for the most part such objects (for instance, ornaments of all kinds) are either not considered to be art or are considered to be art of a low quality. In reality all such objects if only they transmit a true feeling experienced by the artist and comprehensible to every one (however insignificant it may seem to us to be), are works of real, good, Christian, art.... All the rest of art should be acknowledged to be bad art, deserving not to be encouraged but to be driven out, denied, and despised, as being art not uniting but dividing people. Such in literary art are all novels and poems which transmit ecclesiastical or patriotic feelings, and also exclusive feelings pertaining only to the class of the idle rich: such as aristocratic honour, satiety, spleen, pessimism, and refined and vicious feeling flowing from sex-love—quite incomprehensible to the great majority of mankind.

In painting we must similarly place in the class of bad art all ecclesiastical, patriotic, and exclusive pictures; all pictures representing the amusements and allurements of a rich and idle life; all so-called symbolic pictures in which the very meaning of the symbol is comprehensible only to those of a certain circle; and above all pictures with voluptuous subjects—all that odious female nudity which

[1]While offering as examples of art those that seem to me best, I attach no special importance to my selection; for, besides being insufficiently informed in all branches of art, I belong to the class of people whose taste has been perverted by false training. And therefore my old, inured habits may cause me to err, and I may mistake for absolute merit the impression a work produced on me in my youth. My only purpose in mentioning examples of works of this or that class is to make my meaning clearer and to show how, with my present views, I understand excellence in art in relation to its subject-matter. I must moreover mention that I consign my own artistic productions to the category of bad art, excepting the story *God Sees the Truth but Waits,* which seeks a place in the first class, and *A Prisoner of the Caucasus,* which belongs to the second.—L.T.

(Both the stories mentioned are included in *Twenty-Three Tales* in the "World's Classics" Tolstoy series.—A.M.)

Commitment in Art: The Case Against Aestheticism

fills all the exhibitions and galleries. And to this class belongs almost all the chamber and opera music of our times,—beginning especially with Beethoven (Schumann, Berlioz, Liszt, Wagner),—by its subject-nature devoted to the expression of feelings accessible only to people who have developed in themselves an unhealthy nervous irritation evoked by this exclusive, artificial, and complex music....

And just in this same way, in all branches of art, many and many works considered great by the upper classes of our society will have to be judged. By this one sure criterion we shall have to judge the celebrated *Divine Comedy* and *Jerusalem Delivered,* and a great part of Shakespeare's and Goethe's work, and in painting every representation of miracles, including Raphael's Transfiguration, etc.

Whatever the work may be and however it may have been extolled, we have first to ask whether this work is one of real art, or a counterfeit. Having acknowledged, on the basis of the indication of its infectiousness even to a small class of people, that a certain production belongs to the realm of art, it is necessary on this basis to decide the next question, Does this work belong to the category of bad exclusive art opposed to religious perception, or of Christian art uniting people? And having acknowledged a work to belong to real Christian art, we must then, according to whether it transmits feelings flowing from love of God and man, or merely the simple feelings uniting all men, assign it a place in the ranks of religious art, or in those of universal art....

Religion and Literature

T. S. Eliot

For almost half a century until his recent death, T. S. Eliot (1888–1965) was the towering literary eminence of the English-speaking world, as poet, critic, and belletrist. John Crowe Ransom calls The Waste Land *(1922) "the most famous poem of our age." Edmund Wilson wrote in* Axel's Castle *that Eliot, in ten years' time, "has left upon English poetry a mark more unmistakable than that of any other poet writing English," and "he has probably affected literary opinion, during the period since the War, more profoundly than any other critic writing English."*

It is not necessary to enter here into the controversies concerning whether there was an "early" and a "late" Eliot divided by the appearance of "Ash Wednesday" (1930) and "For Lancelot Andrewes" (1934), with their intense spiritual commitment; or two Eliots, one a critic and the other a poet, although Eliot himself partly conceded this when he observed in After Strange Gods *(1934) that in one's prose one may be concerned with ideals, whereas in the writing of poetry one must "deal with actuality." Certainly there is a great difference, at least on the surface, between the early innovator, who broke dramatically with current conventions in poetry and criticism, and the Eliot who announced himself, in 1934,*

as royalist in politics, classicist in literature, and Anglo-Catholic in religion,[1] and became thenceforth a spokesman for tradition and religious orthodoxy; as there is between the Eliot who wrote that "when you judge poetry it is as poetry you must judge it, and not as another thing," and the author of the essay reprinted here.

In the preface to the 1928 edition of "The Sacred Wood" Eliot reports an "expansion or development of interests"; poetry, while still a "superior amusement," is now seen as having "something to do with morals, and with religion, and even with politics perhaps, though we cannot say what." Thus, in After Strange Gods, he can deplore the absence in D. H. Lawrence's men and women of a moral or social sense: "... the characters..., who are supposed to be recognizably human beings, betray no respect for, or even awareness of, moral obligations, and seem to be unfurnished with even the most commonplace kind of conscience."[2] This is in rather striking contrast to the Eliot who warned that the poet should not find his utility in meddling with the tasks of the theologian or sociologist but should "write poetry, poetry not defined in terms of something else."[3] All this may account for Yvor Winters' acerbic comment that Eliot "has repeatedly contradicted himself on every important issue that he has touched."[4]

Clearly, during the last decades of his life Eliot, apart from the Four Quartets (1940–1942), became less interested in the writing of pure poetry and much more engrossed in religious and social commentary, some of it expressed in his plays (e.g., The Rock, 1934; Murder in the Cathedral, 1935; The Cocktail Party, 1950), some in his contributions to The Criterion, of which he was editor, and a great deal in his Notes Toward the Definition of Culture (1948) and The Idea of a Christian Society (1940). All this must be kept in mind by the reader who is given only one or even several samples of the Eliot corpus. Eliot's best known early critical essays are "Tradition and the Individual Talent" (1917), "Hamlet and His Problems" (1919), "The Metaphysical Poets" (1921), and "The Function of Criticism" (1923). The essay reprinted here is selected not because it is one of Eliot's most important critical statements but because it expresses his mature views on aestheticism—more specifically, on the relation between literature and morality, whether "morality" be designated as such or as "religion" or as "Christianity." After all: "Our religion imposes our ethics, our judgment and criticism of ourselves, and our behaviour toward our fellow men."[5]

Eliot was born in St. Louis in 1888 and was graduated from Harvard in 1909. "Prufrock," published in 1915, first called him to the attention of the literary world, and The Waste Land (1922) established his reputation. He became a British citizen in 1927, joining a distinguished company of American literary expatriates which included Henry Adams, Henry James, and Ezra Pound. He won the Nobel Prize for literature in 1948.

[1]In the Preface to the first edition of "For Lancelot Andrewes." The preface was omitted in a later edition (1942) because it had "more than served its turn" and had misled readers into supposing that "all these three are inextricable and *of equal importance*" (his emphasis). The religious emphasis had become for him all-important.

[2]P. 37.

[3]*The Use of Poetry and the Use of Criticism* (London: Faber and Faber, 1933), pp. 152–154.

[4]*The Anatomy of Nonsense* (Norfolk, Conn.: New Directions. 1943), p. 120.

[5]Cf. below, p. 40.

What I have to say is largely in support of the following propositions: Literary criticism should be completed by criticism from a definite ethical and theological standpoint. In so far as in any age there is common agreement on ethical and theological matters, so far can literary criticism be substantive. In ages like our own, in which there is no such common agreement, it is the more necessary for Christian readers to scrutinize their reading, especially of works of imagination, with explicit ethical and theological standards. The "greatness" of literature cannot be determined solely by literary standards; though we must remember that whether it is literature or not can be determined only by literary standards.

We have tacitly assumed, for some centuries past, that there is *no* relation between literature and theology. This is not to deny that literature—I mean, again, primarily works of imagination—has been, is, and probably always will be judged by some moral standards. But moral judgements of literary works are made only according to the moral code accepted by each generation, whether it lives according to that code or not. In an age which accepts some precise Christian theology, the common code may be fairly orthodox: though even in such periods the common code may exalt such concepts as "honour," "glory" or "revenge" to a position quite intolerable to Christianity. The dramatic ethics of the Elizabethan Age offers an interesting study. But when the common code is detached from its theological background, and is consequently more and more merely a matter of habit, it is exposed both to prejudice and to change. At such times morals are open to being altered *by* literature; so that we find in practice that what is "objectionable" in literature is merely what the present generation is not used to. It is a commonplace that what shocks one generation is accepted quite calmly by the next. This adaptability to change of moral standards is sometimes greeted with satisfaction as an evidence of human perfectibility: whereas it is only evidence of what unsubstantial foundations people's moral judgements have.

I am not concerned here with religious literature but with the application of our religion to the criticism of any literature. It may be as well, however, to distinguish first what I consider to be the three senses in which we can speak of "religious literature." The first is that of which we say that it is "religious literature" in the same way that we speak of "historical literature" or of "scientific literature." I mean that we can treat the Authorized translation of the Bible, or the works of Jeremy Taylor, as literature, in the same way that we treat the historical writing of Clarendon or of Gibbon—our two great English historians—as literature, or Bradley's *Logic,* or Buffon's *Natural History.* All of these writers were men who, incidentally to their religious, or historical, or philosophic purpose, had a gift of language which makes them delightful to read to all those who can enjoy language well written, even if they are unconcerned with the objects which the writers had in view. And I would add that though a scientific, or historical, or theological, or philosophic work which is also "literature," may become superannuated as anything but literature, yet it is not likely to be "literature" unless it had its scientific or other value for its own time...

The second kind of relation of religion to literature is that which is found in what is called "religious" or "devotional" poetry....the religious poet is not a poet who is treating the whole subject matter of poetry in a religious spirit, but a poet

who is dealing with a confined part of this subject matter: who is leaving out what men consider their major passions, and thereby confessing his ignorance of them.... Since the time of Chaucer, Christian poetry (in the sense in which I shall mean it) has been limited in England almost exclusively to minor poetry.

I repeat that when I am considering Religion and Literature, I speak of these things only to make clear that I am not concerned primarily with Religious Literature. I am concerned with what should be the relation between Religion and all Literature. Therefore the third type of "religious literature" may be more quickly passed over. I mean the literary works of men who are sincerely desirous of forwarding the cause of religion: that which may come under the heading of Propaganda. I am thinking, of course, of such delightful fiction as Mr. Chesterton's *Man Who Was Thursday,* or his *Father Brown*.... But my point is that such writings do not enter into any serious consideration of the relation of Religion and Literature: because they are conscious operations in a world in which it is assumed that Religion and Literature are not related. It is a conscious and limited relating. What I want is a literature which should be *un*consciously, rather than deliberately and defiantly, Christian....

I am convinced that we fail to realize how completely, and yet how irrationally, we separate our literary from our religious judgements. If there could be a complete separation, perhaps it might not matter: but the separation is not, and never can be, complete. If we exemplify literature by the novel—for the novel is the form in which literature affects the greatest number—we may remark this gradual secularization of literature during at least the last three hundred years...

Now, do people in general hold a definite opinion, that is to say religious or anti-religious; and do they read novels, or poetry for that matter, with a separate compartment of their minds? The common ground between religion and fiction is behaviour. Our religion imposes our ethics, our judgement and criticism of ourselves, and our behaviour toward our fellow men. The fiction that we read affects our behaviour towards our fellow men, affects our patterns of ourselves. When we read of human beings behaving in certain ways, with the approval of the author, who gives his benediction to this behaviour by his attitude toward the result of the behaviour arranged by himself, we can be influenced towards behaving in the same way. When the contemporary novelist is an individual thinking for himself in isolation, he may have something important to offer to those who are able to receive it. He who is alone may speak to the individual. But the majority of novelists are persons drifting in the stream, only a little faster. They have some sensitiveness, but little intellect.

We are expected to be broadminded about literature, to put aside prejudice or conviction, and to look at fiction as fiction and at drama as drama. With what is inaccurately called "censorship" in this country—with what is much more difficult to cope with than an official censorship, because it represents the opinions of individuals in an irresponsible democracy, I have very little sympathy; partly because it so often suppresses the wrong books, and partly because it is little more effective than Prohibition of Liquor; partly because it is one manifestation of the desire that state control should take the place of decent domestic influence; and wholly because it acts only from custom and habit, not from decided theological and moral principles. Incidentally, it gives people a false sense of security in leading them to believe that books which are *not* suppressed are harmless. Whether there *is* such a thing as a harmless book I am not sure: but there very likely are books so utterly unreadable as to be incapable of injuring anybody. But it is certain that a book is not harmless merely because no one is consciously offended by it. And if

Commitment in Art: The Case Against Aestheticism

we, as readers, keep our religious and moral convictions in one compartment, and take our reading merely for entertainment, or on a higher plane, for aesthetic pleasure, I would point out that the author, whatever his conscious intentions in writing, in practice recognizes no such distinctions. The author of a work of imagination is trying to affect us wholly, as human beings, whether he knows it or not; and we are affected by it, as human beings, whether we intend to be or not. I suppose that everything we eat has some other effect upon us than merely the pleasure of taste and mastication; it affects us during the process of assimilation and digestion; and I believe that exactly the same is true of anything we read.

The fact that what we read does not concern merely something called our *literary taste,* but that it affects directly, though only amongst many other influences, the whole of what we are, is best elicited, I think, by a conscientious examination of the history of our individual literary education. Consider the adolescent reading of any person with some literary sensibility. Everyone, I believe, who is at all sensible to the seductions of poetry, can remember some moment in youth when he or she was completely carried away by the work of one poet. Very likely he was carried away by several poets, one after the other. The reason for this passing infatuation is not merely that our sensibility to poetry is keener in adolescence than in maturity. What happens is a kind of inundation, of invasion of the undeveloped personality by the stronger personality of the poet. The same thing may happen at a later age to persons who have not done much reading. One author takes complete possession of us for a time; then another; and finally they begin to affect each other in our mind. We weigh one against another; we see that each has qualities absent from others, and qualities incompatible with the qualities of others: we begin to be, in fact, critical; and it is our growing critical power which protects us from excessive possession by any one literary personality. The good critic—and we should all try to be critics, and not leave criticism to the fellows who write reviews in the papers—is the man who, to a keen and abiding sensibility, joins wide and increasingly discriminating reading. Wide reading is not valuable as a kind of hoarding, an accumulation of knowledge, or what sometimes is meant by the term "a well-stocked mind." It is valuable because in the process of being affected by one powerful personality after another, we cease to be dominated by any one, or by any small number. The very different views of life, cohabiting in our minds, affect each other, and our own personality asserts itself and gives each a place in some arrangement peculiar to ourself.

It is simply not true that works of fiction, prose or verse, that is to say works depicting the actions, thoughts and words and passions of imaginary human beings, *directly* extend our knowledge of life. Direct knowledge of life is knowledge directly in relation to ourselves, it is our knowledge of *how* people behave in general, of *what* they are like in general, in so far as that part of life in which we ourselves have participated gives us material for generalization. Knowledge of life obtained through fiction is only possible by another stage of self-consciousness. That is to say, it can only be a knowledge of other people's knowledge of life, not of life itself. So far as we are taken up with the happenings in any novel in the same way in which we are taken up with what happens under our eyes, we are acquiring at least as much falsehood as truth. But when we are developed enough to say: "This is the view of life of a person who was a good observer within his limits, Dickens, or Thackeray, or George Eliot, or Balzac; but he looked at it in a different way from me, because he was a different man; he even selected rather different things to look at, or the same things in a different order of importance, because he was a different man; so what I am looking at is the world as seen by a particular

mind"—then we are in a position to gain something from reading fiction. We are learning *something* about life from these authors direct, just as we learn something from the reading of history direct; but these authors are only really helping us when we can see, and allow for, their differences from ourselves.

Now what we get, as we gradually grow up and read more and more, and read a greater diversity of authors, is a variety of views of life. But what people commonly assume, I suspect, is that we gain this experience of other men's views of life only by "improving reading." This, it is supposed, is a reward we get by applying ourselves to Shakespeare, and Dante, and Goethe, and Emerson, and Carlyle, and dozens of other respectable writers. The rest of our reading for amusement is merely killing time. But I incline to come to the alarming conclusion that it is just the literature that we read for "amusement," or "purely for pleasure" that may have the greatest and least suspected influence upon us. It is the literature which we read with the least effort that can have the easiest and most insidious influence upon us. Hence it is that the influence of popular novelists, and of popular plays of contemporary life, requires to be scrutinized most closely. And it is chiefly *contemporary* literature that the majority of people ever read in this attitude of "purely for pleasure," of pure passivity.

The relation to my subject of what I have been saying should now be a little more apparent. Though we may read literature merely for pleasure, of "entertainment" or of "aesthetic enjoyment," this reading never affects simply a sort of special sense: it affects us as entire human beings; it affects our moral and religious existence. And I say that while individual modern writers of eminence can be improving, contemporary literature as a whole tends to be degrading. And that even the effect of the better writers, in an age like ours, may be degrading to some readers; for we must remember that what a writer does to people is not necessarily what he intends to do. It may be only what people are capable of having done to them. People exercise an unconscious selection in being influenced. A writer like D. H. Lawrence may be in his effect either beneficial or pernicious. I am not sure that I have not had some pernicious influence myself.

At this point I anticipate a rejoinder from the liberal-minded, from all those who are convinced that if everybody says what he thinks, and does what he likes, things will somehow, by some automatic compensation and adjustment, come right in the end. "Let everything be tried," they say, "and if it is a mistake, then we shall learn by experience." This argument might have some value, if we were always the same generation upon earth; or if, as we know to be not the case, people ever learned much from the experience of their elders. These liberals are convinced that only by what is called unrestrained individualism will truth ever emerge. Ideas, views of life, they think, issue distinct from independent heads, and in consequence of their knocking violently against each other, the fittest survive, and truth rises triumphant. Anyone who dissents from this view must be either a mediaevalist, wishful only to set back the clock, or else a fascist, and probably both.

If the mass of contemporary authors were really individualists, every one of them inspired Blakes, each with his separate vision, and if the mass of the contemporary public were really a mass of *individuals* there might be something to be said for this attitude. But this is not, and never has been, and never will be. It is not only that the reading individual today (or at any day) is not enough an individual to be able to absorb all the "views of life" of all the authors pressed upon us by the publishers' advertisements and the reviewers, and to be able to arrive at wisdom by considering one against another. It is that the contemporary authors are not individuals enough either. It is not that the world of separate individuals of the

liberal democrat is undesirable; it is simply that this world does not exist. For the reader of contemporary literature is not, like the reader of the established great literature of all time, exposing himself to the influence of divers and contradictory personalities; he is exposing himself to a mass movement of writers who, each of them, think that they have something individually to offer, but are really all working together in the same direction. And there never was a time, I believe, when the reading public was so large, or so helplessly exposed to the influences of its own time. There never was a time, I believe, when those who read at all, read so many more books by living authors than books by dead authors; there never was a time so completely parochial, so shut off from the past. There may be too many publishers; there are certainly too many books published; and the journals ever incite the reader to "keep up" with what is being published. Individualistic democracy has come to high tide: and it is more difficult today to be an individual than it ever was before.

Within itself, modern literature has perfectly valid distinctions of good and bad, better and worse: and I do not wish to suggest that I confound Mr. Bernard Shaw with Mr. Noel Coward, Mrs. Woolf with Miss Mannin. On the other hand, I should like it to be clear that I am not defending a "high"-brow against a "low"-brow literature. What I do wish to affirm is that the whole of modern literature is corrupted by what I call Secularism, that it is simply unaware of, simply cannot understand the meaning of, the primacy of the supernatural over the natural life: of something which I assume to be our primary concern.

I do not want to give the impression that I have delivered a mere fretful jeremiad against contemporary literature. Assuming a common attitude between my readers, or some of my readers, and myself, the question is not so much, what is to be done about it? as, how should we behave towards it?

I have suggested that the liberal attitude towards literature will not work. Even if the writers who make their attempt to impose their "view of life" upon us were really distinct individuals, even if we as readers were distinct individuals, what would be the result? It would be, surely, that each reader would be impressed, in his reading, merely by what he was previously prepared to be impressed by; he would follow the "line of least resistance," and there would be no assurance that he would be made a better man. For literary judgement we need to be acutely aware of two things at once: of "what we like," and of "what we *ought* to like." Few people are honest enough to know either. The first means knowing what we really feel: very few know that. The second involves understanding our shortcomings; for we do not really know what we ought to like unless we also know why we ought to like it, which involves knowing why we don't yet like it. It is not enough to understand what we ought to be, unless we know what we are; and we do not understand what we are, unless we know what we ought to be. The two forms of self-consciousness, knowing what we are and what we ought to be, must go together.

It is our business, as readers of literature, to know what we like. It is our business, as Christians, *as well as* readers of literature, to know what we ought to like. It is our business as honest men not to assume that whatever we like is what we ought to like; and it is our business as honest Christians not to assume that we do like what we ought to like. And the last thing I would wish for would be the existence of two literatures, one for Christian consumption and the other for the pagan world. What I believe to be incumbent upon all Christians is the duty of maintaining consciously certain standards and criteria of criticism over and above those applied by the rest of the world; and that by these criteria and standards

everything that we read must be tested. We must remember that the greater part of our current reading matter is written for us by people who have no real belief in a supernatural order, though some of it may be written by people with individual notions of a supernatural order which are not ours. And the greater part of our reading matter is coming to be written by people who not only have no such belief, but are even ignorant of the fact that there are still people in the world so "backward" or so "eccentric" as to continue to believe. So long as we are conscious of the gulf fixed between ourselves and the greater part of contemporary literature, we are more or less protected from being harmed by it, and are in a position to extract from it what good it has to offer us.

There are a very large number of people in the world today who believe that all ills are fundamentally economic. Some believe that various specific economic changes alone would be enough to set the world right; others demand more or less drastic changes in the social as well, changes chiefly of two opposed types. These changes demanded, and in some places carried out, are alike in one respect, that they hold the assumptions of what I call Secularism: they concern themselves only with changes of a temporal, material, and external nature; they concern themselves with morals only of a collective nature. In an exposition of one such new faith I read the following words:

"In our morality the one single test of any moral question is whether it impedes or destroys in any way the power of the individual to serve the State. [The individual] must answer the questions: 'Does this action injure the nation? Does it injure other members of the nation? Does it injure my ability to serve the nation?' And if the answer is clear on all those questions, the individual has absolute liberty to do as he will."

Now I do not deny that this is a kind of morality, and that it is capable of great good within limits; but I think that we should all repudiate a morality which had no higher ideal to set before us than that. It represents, of course, one of the violent reactions we are witnessing, against the view that the community is solely for the benefit of the individual; but it is equally a gospel of this world, and of this world alone. My complaint against modern literature is of the same kind. It is not that modern literature is in the ordinary sense "immoral" or even "amoral"; and in any case to prefer that charge would not be enough. It is simply that it repudiates, or is wholly ignorant of, our most fundamental and important beliefs; and that in consequence its tendency is to encourage its readers to get what they can out of life while it lasts, to miss no "experience" that presents itself, and to sacrifice themselves, if they make any sacrifice at all, only for the sake of tangible benefits to others in this world either now or in the future. We shall certainly continue to read the best of its kind, of what our time provides; but we must tirelessly criticize it according to our own principles, and not merely according to the principles admitted by the writers and by the critics who discuss it in the public press.

Commitment in Art: The Case Against Aestheticism

Create Dangerously

Albert Camus

Albert Camus (1913–1960), Algerian-born French novelist, short-story writer, and essayist, was a close friend of Jean-Paul Sartre and collaborated with him in developing French existentialism. A more gifted writer of fiction than Sartre, he won the Nobel Prize for Literature in 1957 and had a genuine influence on contemporary fiction. His novel The Stranger, *and a short story,* The Myth of Sisyphus, *have become contemporary classics.*

Camus broke with Sartre over the Communist issue. When Sartre became a Communist, Camus thought he had betrayed the existentialist philosophy both men shared, especially the existentialist emphasis on freedom. Compare, for example, Camus' statement p. 53: "...it is not true that culture can be, even temporarily, suspended in order to make way for a new culture. Man's ...nobility cannot be suspended; the act of breathing cannot be suspended," with Sartre's: "...if that deportation [of a million persons in certain countries occupied by the Russians] took place it is profoundly blameworthy, but it is a means for arriving at an end. I don't say that that excuses it, but in these days one must consider it from this angle." A fascinating if biased description of the Camus-Sartre relationship may be found in a novel, The Mandarins, *by Simone de Beauvoir, although fictitious names are used.*

Camus' talents as a writer never came to full fruition. His untimely death in an automobile accident ironically and tragically underscored the absurdity which he regarded as an ubiquitous feature of the human condition.

An Oriental wise man always used to ask the divinity in his prayers to be so kind as to spare him from living in an interesting era. As we are not wise, the divinity has not spared us and we are living in an interesting era. In any case, our era forces us to take an interest in it. The writers of today know this. If they speak up, they are criticized and attacked. If they become modest and keep silent, they are vociferously blamed for their silence.

In the midst of such din the writer cannot hope to remain aloof in order to pursue the reflections and images that are dear to him. Until the present moment, remaining aloof has always been possible in history. When someone did not approve, he could always keep silent or talk of something else. Today everything is changed and even silence has dangerous implications. The moment that abstaining from choice is itself looked upon as a choice and punished or praised as such, the artist is willy-nilly impressed into service. "Impressed" seems to me a more accurate term in this connection than "committed." Instead of signing up, indeed, for voluntary service, the artist does his compulsory service....

To tell the truth, it is not easy, and I can understand why artists regret their former comfort. The change is somewhat cruel. Indeed, history's amphitheater has always contained the martyr and the lion. The former relied on eternal consolations

Condensed from *Resistance, Rebellion and Death* by Albert Camus. Translated by Justin O'Brien, pp. 249–272. Copyright © 1960 by Alfred A. Knopf, Inc. Reprinted by permission of Alfred A. Knopf, Inc. and Hamish Hamilton Ltd. (Lecture given at the University of Uppsala in December 1957.)

and the latter on raw historical meat. But until now the artist was on the sidelines. He used to sing purposely, for his own sake, or at best to encourage the martyr and make the lion forget his appetite. But now the artist is in the amphitheater. Of necessity, his voice is not quite the same; it is not nearly so firm.

It is easy to see all that art can lose from such a constant obligation. Ease, to begin with, and that divine liberty so apparent in the work of Mozart. It is easier to understand why our works of art have a drawn, set look and why they collapse so suddenly.... Of course, one can always meet that state of things with a humanistic lamentation and become...a living reproach.... It is better, in my opinion, to give the era its due, since it demands this so vigorously, and calmly admit that the period of the revered master, of the artist with a camellia in his buttonhole, of the armchair genius is over. To create today is to create dangerously. Any publication is an act, and that act exposes one to the passions of an age that forgives nothing. Hence the question is not to find out if this is or is not prejudicial to art. The question, for all those who cannot live without art and what it signifies, is merely to find out how, among the police forces of so many ideologies (how many churches, what solitude!), the strange liberty of creation is possible.

It is not enough to say in this regard that art is threatened by the powers of the State. If that were true, the problem would be simple: the artist fights or capitulates. The problem is more complex, more serious too, as soon as it becomes apparent that the battle is waged within the artist himself. The hatred for art, of which our society provides such fine examples, is so effective today only because it is kept alive by artists themselves. The doubt felt by the artists who preceded us concerned their own talent. The doubt felt by artists of today concerns the necessity of their art, hence their very existence....

That questioning of art by the artist has many reasons, and only the loftiest need be considered. Among the best explanations is the feeling the contemporary artist has of lying or of indulging in useless words if he pays no attention to history's woes. What characterizes our time, indeed, is the way the masses and their wretched condition have burst upon contemporary sensibilities. We now know that they exist, whereas we once had a tendency to forget them. And if we are more aware, it is not because our aristocracy, artistic or otherwise, has become better—no, have no fear—it is because the masses have become stronger and keep people from forgetting them.

There are still other reasons, and some of them less noble, for this surrender of the artist. But, whatever those reasons may be, they all work toward the same end: to discourage free creation by undermining its basic principle, the creator's faith in himself. "A man's obedience to his own genius," Emerson said magnificently. "is faith in its purest form." And another American writer of the nineteenth century added: "So long as a man is faithful to himself, everything is in his favor, government, society, the very sun, moon, and stars." Such amazing optimism seems dead today. In most cases the artist is ashamed of himself and his privileges, if he has any. He must first of all answer the question he has put to himself: is art a deceptive luxury?

I

The first straightforward reply that can be made is this: on occasion art may be a deceptive luxury. On the poop deck of slave galleys it is possible, at any time and place, as we know, to sing of the constellations while the convicts bend over the oars and exhaust themselves in the hold; it is always possible to record the social

Commitment in Art: The Case Against Aestheticism

conversation that takes place on the benches of the amphitheater while the lion is crunching the victim. And it is very hard to make any objections to the art that has known such success in the past. But things have changed somewhat, and the number of convicts and martyrs has increased amazingly over the surface of the globe. In the face of so much suffering, if art insists on being a luxury, it will also be a lie.

Of what could art speak, indeed? If it adapts itself to what the majority of our society wants, art will be a meaningless recreation. If it blindly rejects that society, if the artist makes up his mind to take refuge in his dream, art will express nothing but a negation. In this way we shall have the production of entertainers or of formal grammarians, and in both cases this leads to an art cut off from living reality. For about a century we have been living in a society that is not even the society of money (gold can arouse carnal passions) but that of the abstract symbols of money. The society of merchants can be defined as a society in which things disappear in favor of signs. When a ruling class measures its fortunes, not by the acre of land or the ingot of gold, but by the number of figures corresponding ideally to a certain number of exchange operations, it thereby condemns itself to setting a certain kind of humbug at the center of its experience and its universe. A society founded on signs is, in its essence, an artificial society in which man's carnal truth is handled as something artificial. There is no reason for being surprised that such a society chose as its religion a moral code of formal principles and that it inscribes the words "liberty" and "equality" on its prisons as well as on its temples of finance. However, words cannot be prostituted with impunity. The most misrepresented value today is certainly the value of liberty. Good minds (I have always thought there were two kinds of intelligence—intelligent intelligence and stupid intelligence) teach that it is but an obstacle on the path of true progress. But such solemn stupidities were uttered because for a hundred years a society of merchants made an exclusive and unilateral use of liberty, looking upon it as a right rather than as a duty, and did not fear to use an ideal liberty, as often as it could, to justify a very real oppression. As a result, is there anything surprising in the fact that such a society asked art to be, not an instrument of liberation, but an inconsequential exercise and a mere entertainment? Consequently, a fashionable society in which all troubles were money troubles and all worries were sentimental worries was satisfied for decades with its society novelists and with the most futile art in the world, the one about which Oscar Wilde, thinking of himself before he knew prison, said that the greatest of all vices was superficiality.

In this way the manufacturers of art (I did not say the artists) of middle-class Europe, before and after 1900, accepted irresponsibility because responsibility presupposed a painful break with their society (those who really broke with it are named Rimbaud, Nietzsche, Strindberg, and we know the price they paid). From that period we get the theory of art for art's sake, which is merely a voicing of that irresponsibility. Art for art's sake, the entertainment of a solitary artist, is indeed the artificial art of a factitious and self-absorbed society. The logical result of such a theory is the art of little cliques or the purely formal art fed on affectations and abstractions and ending in the destruction of all reality. In this way a few works charm a few individuals while many coarse inventions corrupt many others. Finally art takes shape outside of society and cuts itself off from its living roots. Gradually the artist, even if he is celebrated, is alone or at least is known to his nation only through the intermediary of the popular press or the radio, which will provide a convenient and simplified idea of him. The more art specializes, in fact, the more necessary popularization becomes. In this way millions of people will have the

feeling of knowing this or that great artist of our time because they have learned from the newspapers that he raises canaries or that he never stays married more than six months. The greatest renown today consists in being admired or hated without having been read. Any artist who goes in for being famous in our society must know that it is not he who will become famous, but someone else under his name, someone who will eventually escape him and perhaps someday will kill the true artist in him.

Consequently, there is nothing surprising in the fact that almost everything worthwhile created in the mercantile Europe of the nineteenth and twentieth centuries—in literature, for instance—was raised up against the society of its time. It may be said that until almost the time of the French Revolution current literature was, in the main, a literature of consent. From the moment when middle-class society, a result of the revolution, became stabilized, a literature of revolt developed instead. Official values were negated, in France, for example, either by the bearers of revolutionary values, from the Romantics to Rimbaud, or by the maintainers of aristocratic values, of whom Vigny and Balzac are good examples. In both cases the masses and the aristocracy—the two sources of all civilization—took their stand against the artificial society of their time.

But this negation, maintained so long that it is now rigid, has become artificial too and leads to another sort of sterility. The theme of the exceptional poet born into a mercantile society ... has hardened into a presumption that one can be a great artist only against the society of one's time, whatever it may be. Legitimate in the beginning when asserting that a true artist could not compromise with the world of money, the principle became false with the subsidiary belief that an artist could assert himself only by being against everything in general. Consequently, many of our artists long to be exceptional, feel guilty if they are not, and wish for simultaneous applause and hisses. Naturally, society, tired or indifferent at present, applauds and hisses only at random. Consequently, the intellectual of today is always bracing himself stiffly to add to his height. But as a result of rejecting everything, even the tradition of his art, the contemporary artist gets the illusion that he is creating his own rule and eventually takes himself for God. At the same time he thinks he can create his reality himself. But, cut off from his society, he will create nothing but formal or abstract works, thrilling as experiences but devoid of the fecundity we associate with true art, which is called upon to unite. In short, there will be as much difference between the contemporary subtleties or abstractions and the work of a Tolstoy or a Moliere as between an anticipatory draft on invisible wheat and the rich soil of the furrow itself.

II

In this way art may be a deceptive luxury. It is not surprising, then, that men or artists wanted to call a halt and go back to truth. As soon as they did, they denied that the artist had a right to solitude and offered him as a subject, not his dreams, but reality as it is lived and endured by all. Convinced that art for art's sake, through its subjects and through its style, is not understandable to the masses or else in no way expresses their truth, these men wanted the artist instead to speak intentionally about and for the majority. He has only to translate the sufferings and happiness of all into the language of all and he will be universally understood. As a reward for being absolutely faithful to reality, he will achieve complete communication among men.

This ideal of universal communication is indeed the ideal of any great artist. Contrary to the current presumption, if there is any man who has no right to solitude, it is the artist. Art cannot be a monologue. When the most solitary and least famous artist appeals to posterity, he is merely reaffirming his fundamental vocation. Considering a dialogue with deaf or inattentive contemporaries to be impossible, he appeals to a more far-reaching dialogue with the generations to come.

But in order to speak about all and to all, one has to speak of what all know and of the reality common to us all. The sea, rains, necessity, desire, the struggle against death—these are the things that unite us all. We resemble one another in what we see together, in what we suffer together. Dreams change from individual to individual, but the reality of the world is common to us all. Striving toward realism is therefore legitimate, for it is basically related to the artistic adventure.

So let's be realistic. Or, rather, let's try to be so, if this is possible. For it is not certain that the word has a meaning; it is not certain that realism, even if it is desirable, is possible. Let us stop and inquire first of all if pure realism is possible in art. If we believe the declarations of the nineteenth-century naturalists, it is the exact reproduction of reality. Therefore it is to art what photography is to painting: the former reproduces and the latter selects. But what does it reproduce and what is reality? Even the best of photographs, after all, is not a sufficiently faithful reproduction, is not yet sufficiently realistic. What is there more real, for instance, in our universe than a man's life, and how can we hope to preserve it better than in a realistic film? But under what conditions is such a film possible? Under purely imaginary conditions. We should have to presuppose, in fact, an ideal camera focused on the man day and night and constantly registering his every move. The very projection of such a film would last a lifetime and could be seen only by an audience of people willing to waste their lives in watching someone else's life in great detail. Even under such conditions, such an unimaginable film would not be realistic for the simple reason that the reality of a man's life is not limited to the spot in which he happens to be. It lies also in other lives that give shape to his—lives of people he loves, to begin with, which would have to be filmed too, and also lives of unknown people, influential and insignificant, fellow citizens, policemen, professors, invisible comrades from the mines and foundries, diplomats and dictators, religious reformers, artists who create myths that are decisive for our conduct—humble representatives, in short, of the sovereign chance that dominates the most routine existences. Consequently, there is but one possible realistic film: the one that is constantly shown us by an invisible camera on the world's screen. The only realistic artist then, is God, if he exists. All other artists are, *ipso facto*, unfaithful to reality.

As a result, the artists who reject bourgeois society and its formal art, who insist on speaking of reality, and reality alone, are caught in a painful dilemma. They must be realistic and yet cannot be. They want to make their art subservient to reality, and reality cannot be described without effecting a choice that makes it subservient to the originality of an art. The beautiful and tragic production of the early years of the Russian Revolution clearly illustrates this torment. What Russia gave us then, with Blok and the great Pasternak, Maiakovski and Essenine, Eisenstein and the first novelists of cement and steel, was a splendid laboratory of forms and themes, a fecund unrest, a wild enthusiasm for research. Yet it was necessary to conclude and to tell how it was possible to be realistic even though complete realism was impossible. Dictatorship, in this case as in others, went

straight to the point: in its opinion realism was first necessary and then possible so long as it was deliberately socialistic. What is the meaning of this decree?

As a matter of fact, such a decree frankly admits that reality cannot be reproduced without exercising a selection, and it rejects the theory of realism as it was formulated in the nineteenth century. The only thing needed, then, is to find a principle of choice that will give shape to the world. And such a principle is found, not in the reality we know, but in the reality that will be—in short, the future. In order to reproduce properly what is, one must depict also what will be. In other words, the true object of socialistic realism is precisely what has no reality yet.[1]

The contradiction is rather beautiful. But, after all, the very expression of socialistic realism was contradictory. How, indeed, is a socialistic realism possible when reality is not altogether socialistic? It is not socialistic, for example, either in the past or altogether in the present. The answer is easy: we shall choose in the reality of today or of yesterday what announces and serves the perfect city of the future. So we shall devote ourselves, on the one hand, to negating and condemning whatever aspects of reality are not socialistic and, on the other hand, to glorifying what is or will become so. We shall inevitably get a propaganda art with its heroes and its villains—an edifying literature, in other words, just as remote as formalistic art is from complex and living reality. Finally, that art will be socialistic insofar as it is not realistic.

This aesthetic that intended to be realistic therefore becomes a new idealism, just as sterile for the true artist as bourgeois idealism. Reality is ostensibly granted a sovereign position only to be more readily thrown out. Art is reduced to nothing. It serves and, by serving, becomes a slave. Only those who keep from describing reality will be praised as realists. The others will be censured, with the approval of the former. Renown, which in bourgeois society consisted in not being read or in being misunderstood, will in a totalitarian society consist in keeping others from being read. Once more, true art will be distorted or gagged and universal communication will be made impossible by the very people who most passionately wanted it....

The lie of art for art's sake pretended to know nothing of evil and consequently assumed responsibility for it. But the realistic lie, even though managing to admit mankind's present unhappiness, betrays that unhappiness just as seriously by making use of it to glorify a future state of happiness, about which no one knows anything, so that the future authorizes every kind of humbug.

The two aesthetics that have long stood opposed to each other, the one that recommends a complete rejection of real life and the one that claims to reject anything that is not real life, end up, however, by coming to agreement, far from reality, in a single lie and in the suppression of art. The academicism of the Right does not even acknowledge a misery that the academicism of the Left utilizes for ulterior reasons. But in both cases the misery is only strengthened at the same time that art is negated.

III

Must we conclude that this lie is the very essence of art? I shall say instead that the attitudes I have been describing are lies only insofar as they have but little relation to art. What, then, is art? Nothing simple, that is certain. And it is even harder to find out amid the shouts of so many people bent on simplifying

[1]Editors' note: Cf. below, pp. 102–160.

Commitment in Art: The Case Against Aestheticism

everything. On the one hand, genius is expected to be splendid and solitary; on the other hand, it is called upon to resemble all. Alas, reality is more complex. And Balzac suggested this in a sentence: "The genius resembles everyone and no one resembles him." So it is with art, which is nothing without reality and without which reality is insignificant. How, indeed, could art get along without the real and how could art be subservient to it? The artist chooses his object as much as he is chosen by it. Art, in a sense, is a revolt against everything fleeting and unfinished in the world. Consequently, its only aim is to give another form to a reality that it is nevertheless forced to preserve as the source of its emotion. In this regard, we are all realistic and no one is. Art is neither complete rejection nor complete acceptance of what is. It is simultaneously rejection and acceptance, and this is why it must be a perpetually renewed wrenching apart. The artist constantly lives in such a state of ambiguity, incapable of negating the real and yet eternally bound to question it in its eternally unfinished aspects. In order to paint a still life, there must be confrontation and mutual adjustment between a painter and an apple. And if forms are nothing without the world's lighting, they in turn add to that lighting. The real universe which, by its radiance, calls forth bodies and statues receives from them at the same time a second light that determines the light from the sky. Consequently, great style lies midway between the artist and his object.

There is no need of determining whether art must flee reality or defer to it, but rather what precise dose of reality the work must take on as ballast to keep from floating up among the clouds or from dragging along the ground with weighted boots. Each artist solves this problem according to his lights and abilities. The greater an artist's revolt against the world's reality, the greater can be the weight of reality to balance that revolt. But the weight can never stifle the artist's solitary exigency. The loftiest work will always be, as in the Greek tragedians, Melville, Tolstoy, or Moliere, the work that maintains an equilibrium between reality and man's rejection of that reality, each forcing the other upward in a ceaseless overflowing, characteristic of life itself at its most joyous and heart-rending extremes. Then, every once in a while, a new world appears, different from the everyday world and yet the same, particular but universal, full of innocent insecurity—called forth for a few hours by the power and longing of genius. That's just it and yet that's not it; the world is nothing and the world is everything—this is the contradictory and tireless cry of every true artist, the cry that keeps him on his feet with eyes ever open and that, every once in a while, awakens for all in this world asleep the fleeting and insistent image of a reality we recognize without ever having known it.

Likewise, the artist can neither turn away from his time nor lose himself in it. If he turns away from it, he speaks in a void. But, conversely, insofar as he takes his time as his object, he asserts his own existence as subject and cannot give in to it altogether. In other words, at the very moment when the artist chooses to share the fate of all, he asserts the individual he is. And he cannot escape from this ambiguity. The artist takes from history what he can see of it himself or undergo himself, directly or indirectly—the immediate event, in other words, and men who are alive today, not the relationship of that immediate event to a future that is invisible to the living artist. Judging contemporary man in the name of a man who does not yet exist is the function of prophecy. But the artist can value the myths that are offered him only in relation to their repercussion on living people. The prophet, whether religious or political, can judge absolutely and, as is known, is not chary of doing so. But the artist cannot. If he judged absolutely, he would arbitrarily divide reality into good and evil and thus indulge in melodrama. The aim

of art, on the contrary, is not to legislate or to reign supreme, but rather to understand first of all. Sometimes it does reign supreme, as a result of understanding. But no work of genius has ever been based on hatred and contempt. This is why the artist, at the end of his slow advance, absolves instead of condemning. Instead of being a judge, he is a justifier. He is the perpetual advocate of the living creature, because it is alive. He truly argues for love of one's neighbor and not for that love of the remote stranger which debases contemporary humanism until it becomes the catechism of the law court. Instead, the great work eventually confounds all judges. With it the artist simultaneously pays homage to the loftiest figure of mankind and bows down before the worst of criminals. "There is not," Wilde wrote in prison, "a single wretched man in this wretched place along with me who does not stand in symbolic relation to the very secret of life." Yes, and that secret of life coincides with the secret of art.

For a hundred and fifty years the writers belonging to a mercantile society, with but few exceptions, thought they could live in happy irresponsibility. They lived, indeed, and then died alone, as they had lived. But we writers of the twentieth century shall never again be alone. Rather, we must know that we can never escape the common misery and that our only justification, if indeed there is a justification, is to speak up, insofar as we can, for those who cannot do so. But we must do so for all those who are suffering at this moment, whatever may be the glories, past or future, of the States and parties oppressing them: for the artist there are no privileged torturers. This is why beauty, even today, especially today, cannot serve any party; it cannot serve, in the long or short run, anything but men's suffering or their liberty. The only really committed artist is he who, without refusing to take part in the combat, at least refuses to join the regular armies and remains a free-lance. The lesson he then finds in beauty, if he draws it fairly, is a lesson not of selfishness but rather of hard brotherhood. Looked upon thus, beauty has never enslaved anyone. And for thousands of years, every day, at every second, it has instead assuaged the servitude of millions of men and, occasionally, liberated some of them once and for all. After all, perhaps the greatness of art lies in the perpetual tension between beauty and pain, the love of men and the madness of creation, unbearable solitude and the exhausting crowd, rejection and consent. Art advances between two chasms, which are frivolity and propaganda. On the ridge where the great artist moves forward, every step is an adventure, an extreme risk. In that risk, however, and only there, lies the freedom of art. A difficult freedom that is more like an ascetic discipline? What artist would deny this? What artist would dare to claim that he was equal to such a ceaseless task? Such freedom presupposes health of body and mind, a style that reflects strength of soul, and a patient defiance. Like all freedom, it is a perpetual risk, an exhausting adventure, and this is why people avoid the risk today, as they avoid liberty with its exacting demands, in order to accept any kind of bondage and achieve at least comfort of soul. But if art is not an adventure, what is it and where is its justification? No, the free artist is no more a man of comfort than is the free man. The free artist is the one who, with great effort, creates his own order. The more undisciplined what he must put in order, the stricter will be his rule and the more he will assert his freedom. There is a remark of Gide that I have always approved although it may be easily misunderstood: "Art lives on constraint and dies of freedom." That is true. But it must not be interpreted as meaning that art can be controlled. Art lives only on the constraints it imposes on itself; it dies of all others. Conversely, if it does not constrain itself, it indulges in ravings and becomes a slave to mere shadows. The freest art and the most rebellious will therefore be the most classical; it will reward the greatest effort. So long as a society and its artists do not accept this long and

Commitment in Art: The Case Against Aestheticism

free effort, so long as they relax in the comfort of amusements or the comforts of conformism, in the games of art for art's sake or the preachings of realistic art, its artists are lost in nihilism and sterility. Saying this amounts to saying that today the rebirth depends on our courage and our will to be lucid.

Yes, the rebirth is in the hands of all of us. It is up to us if the West is to bring forth any anti-Alexanders to tie together the Gordian Knot of civilization cut by the sword. For this purpose, we must assume all the risks and labors of freedom. There is no need of knowing whether, by pursuing justice, we shall manage to preserve liberty. It is essential to know that, without liberty, we shall achieve nothing and that we shall lose both future justice and ancient beauty. Liberty alone draws men from their isolation; but slavery dominates a crowd of solitudes. And art, by virtue of that free essence I have tried to define, unites whereas tyranny separates. It is not surprising, therefore, that art should be the enemy marked out by every form of oppression. It is not surprising that artists and intellectuals should have been the first victims of modern tyrannies, whether of the Right or of the Left. Tyrants know there is in the work of art an emancipatory force, which is mysterious only to those who do not revere it. Every great work makes the human face more admirable and richer, and this is its whole secret. And thousands of concentration camps and barred cells are not enough to hide this staggering testimony of dignity. This is why it is not true that culture can be, even temporarily, suspended in order to make way for a new culture. Man's unbroken testimony as to his suffering and his nobility cannot be suspended; the act of breathing cannot be suspended. There is no culture without legacy, and we cannot and must not reject anything of ours, the legacy of the West. Whatever the works of the future may be, they will bear the same secret, made up of courage and freedom, nourished by the daring of thousands of artists of all times and all nations. Yes, when modern tyranny shows us that, even when confined to his calling, the artist is a public enemy, it is right. But in this way tyranny pays its respects, through the artist, to an image of man that nothing has ever been able to crush....

The time of irresponsible artists is over. We shall regret it for our little moments of bliss. But we shall be able to admit that this ordeal contributes meanwhile to our chances of authenticity, and we shall accept the challenge....

In a Crucial Time, He Plays at Games

John Canaday

John Canaday (1907–) is Senior Art Critic for the New York Times. *He has spoken out boldly against current trends in art, his articles provoking a number of avant gardists and their friends into sending a protest to the* Times *that caused a small temblor in the art world. Some of Canaday's best articles are included in a collection entitled* Embattled Critic *(1959). More recently he has published a four-volume historical work,* The Lives of the Painters *(1969). Mr. Canaday studied art history at Yale, taught art at the University of Virginia, and directed the school of art at Tulane. He was later director of the educational program of the Philadelphia Museum of Art.*

Mr. Canaday has been especially critical of the bias of New York's Museum of Modern Art and of Art News. *For a joining of the issues raised by recent tendencies in painting, Canaday's comments should be read in conjunction with Ad Reinhardt's remarks reprinted above.*

Coincidence with international events of supreme importance cast a disastrous light last week on the opening of "New Media—New Forms: Version II" at the Martha Jackson Gallery. At a time when the front page is filled with the kind of news it is just now, a show like this one is downright embarrassing.

The gallery is on Sixty-ninth Street near Madison Avenue, and to get there by bus from downtown last week you had to push your way through crowds of demonstrators and their audience at the corner of Forty-third and Madison. These particular demonstrators were behaving in a sober manner. They looked intelligent and determined as they held their placards above the crowd. The police, half a dozen on horseback and a dozen or so on foot, were firm and polite to the crowds that wanted to stop and watch. "Move on please. No loitering please. Move on."

Once you got on the bus, you progressed up Madison Avenue by degrees more slowly than usual, in fits and starts between ways cleared for police escorts, their red lights flashing and their sirens crying and followed by black limousines carrying personages to the United Nations. Parts of several cross streets in the area of the gallery itself were closed off. Their short vistas, vacant except for more police, were transformed by the shift of scale and change of emphasis that so curiously affect a New York street when it is emptied of traffic.

The atmosphere of the city was exciting and portentous. You knew that not far away from you, men from all over the world were trying to find means to preserve their countries, their continents and their world, possibly even our planet. Then you reached the gallery, and there you found a bunch of artists playing at sticking string on paper and spraying it white, at covering the surface of a mirror with tacks, glued on head down, at cutting out crudely drawn paper dolls and hanging them from chicken wire, at ripping old nylon stockings and stretching them across odds and ends of wire or stuffing them with trash and tying the ends with string like nasty sausages. The air of the gallery seemed filled with little shrieks of perverse delight, and you were ashamed to be there and a part of it.

There are explanations and defenses for this kind of thing. They have been made thousands of times, but in the end each of them should be humiliating to the artist, although in his naivete and self-love he has yet to realize it. The idea that this is an "art of protest" is most resounding, but it is also most specious, and the politest possible rebuttal is the single word, "baloney."[1]

Back in 1916 we could legitimately say of dada—of which the excesses among the exhibits at Martha Jackson's are coy and bloodless revivals—that its rejection of all reason and esthetics was a protest (of the cut-off-your-nose-to-spite-your-face

[1]Of the "minimalism" represented by Reinhardt, whose views on art are reprinted above (pp. 20–23), Canaday has written: "Mr. Reinhardt is a puzzler. His tenacity over so long a period in the service of an increasingly tight premise is admirable. But the logical application of this premise (apparently, that by infinitely painstaking selection and discarding an artist may extract an irreducible essence from color and geometry, the essence of painting) has led him as it did not lead Mondrian, close to the discovery that not an essence but a void may be at the end of his search."

Commitment in Art: The Case Against Aestheticism

kind) against a world that seemed to have gone mad or senile. But today, even if the world is still in a mess, men are trying as they have never tried before to find their way out of the mess. Negative social protest today is a form of cowardice, and to defend neo-dada at this moment as protest is to call the artists weak, foolish and vicious.[2]

Another defense is the catch-all "art of our time." Let us pass this one by with the comment, obvious to anybody who visits the show, that here is an art created, to be sure, in our time, but by artists who by the bulk of the evidence on display are incapable of social responsibility, or unwilling to assume it, or ignorant of the fact that social responsibility devolves eventually upon the artist whether he wishes or not.

Then there is the point that this is all in good fun, only a divertissement—terribly amusing. Well, it isn't. The show is a repeat, with most of the same names represented, of the gallery's exhibition of last June. Nothing indicates the feebleness of its premise more than that in three months New Media—New Forms has become Stale Media-Stale Forms.

So where are we? We are left, as a matter of fact, with one serious and valid reason for such an exhibition, which is this:

In a century that has not incorporated the artist significantly into its scheme, and has glutted our eyes with billions of images through photography and through reproductions of painting (from billboards to the finest art books), the artist is left to scavenge for whatever means he can find to re-establish himself as a creator, to dissociate his product from the familiar images of the camera and the machine. His hope is to discover an anti-photographic and a mechanically unreproduceable technique of expression by experimenting with innumerable new media and new forms from which one, two, half a dozen, may prove serviceable.

Yet how pathetic this subterfuge is. And how incompetent, in this show, the artist seems as explorer. There are some artists here like Enrico Donati, whose concretions of color, pattern and texture have maintained for years a level of ornamental distinction; like Zoltan Kemeny, whose ingenuity is more than arresting. But it seems to me that they and the handful of others who have reached some solution to the problem would take one look at their neighbors and withdraw. For the company they keep here infers, somehow, that in spite of their achievement they have only gone farther than others toward the end of an impasse, not to mention that they are part of a sideshow in which an artist of imagination and discretion is contaminated.

On its first go-round, "New Media—New Forms" was an engaging end-of-season circus. On its second, it is a disaster. It seems to me that anyone who visits it must abandon whatever interest he has in contemporary art or in collecting it, and spend his time brushing up on world affairs and his money on whatever cause might conceivably alleviate human suffering rather than encouraging human fatuity.

[2]On another occasion (*New York Times*, June 5, 1960) Mr. Canaday's comment was comparably acerbic: "Neo-dada's most engaging stunt to date is the self-destroying work of art," and a select audience gathered recently at the Museum of Modern Art to watch one of these machines do away with itself. With considerable help from its builder,...the contraption—made of bicycle wheels, old bottles, an ancient upright piano, a toy wagon, and other miscellaneous scrap—managed to saw, beat and burn itself to death.

In itself, the idea of the self-destroying work of art is the cleverest and most appropriate postscript to the nihilistic spirit of dada, but the curious and doubly paradoxical feature of the event was that it was sponsored by an art museum and witnessed by the most important collectors and patrons of modern art in a city that has been generous beyond all precedent to contemporary experiments."

Music and the Times

Dmitri Shostakovitch

Dmitri Shostakovitch (1906–) Russia's most renowned composer, has had ups and downs with the regime, especially during Stalin's reign when his music was denounced as "freakish" and "bourgeois," and official criticism forced the withdrawal of his opera Lady Macbeth of Mzensk. *In the 1948 musical purge initiated by Zhdanov, Shostakovitch, along with Prokofiev and Maiakovsky, was denounced for "disregarding the great social role of music." Russia's three greatest composers were not rehabilitated until ten years later. However, his Thirteenth Symphony, based on the heretical texts of Yevtushenko, including the dramatic* Babi Yar *denunciation of anti-Semitism, once again (1962) met with official disapproval.*

Shostakovich has long enjoyed an international reputation, and his works are part of the standard repertoire. His views are in diametric opposition to those of Milton Babbitt, whose comments also appear in this section.

Among the many problems of the musical life of our times that of so-called vanguardism troubles me greatly. I do not know how this term originated but its application to certain phenomena in the art of our days seems to me a fraud of the worst kind. Dodecaphony, serial, pointillist and other kinds of music are one of the greatest evils of 20th century art. The few composers in our land who endeavor to follow these fads are gravely deluding themselves. They are misled both in essence and historically. The so-called vanguardist movement in music is far past its youth. It has come into existence fifty years ago and yet I cannot name a *single* work in this vein which lives and has an influence on the public to this day.

Any movement in art is first and foremost important because of its positive contribution to art. For all their contradictions, this is true of impressionism in painting and verism in music. What, however, will "vanguardism" leave to posterity? Nothing but smouldering cinders which its propagandists, shouting from the housetops, are trying to make us believe are a living forest.

For all the publicity which the "vanguardist" composers give themselves, for all the exposure they receive from musical journals, societies, radio and television abroad, what we witness in reality is an appalling picture. The listeners turn a deaf ear to this music. I have had occasion to visit many countries where so-called vanguardism is officially recognized and is encouraged in every way. And each time I saw how few people attended concerts at which such music was played. This shows how absurd are the efforts to create this kind of music. Surely a composer writing for the public wishes his ideas and thoughts to be grasped by it.

Unfortunately those who grow infatuated with such art are oblivious to the fact that "vanguardist" music is not new music. Moreover, it obliterates individuality, standardizes music and drains it of the least suggestion of content. Often enough as I have listened to the spurious works of the "vanguardists" to this day I cannot tell

From *Music Journal* (January 1965), pp. 33, 85, 86.

the difference between the music say of Boulez and that of Stockhausen, Henze and that of Stuckenschmidt. I am convinced that "vanguardism" is a screen for many composers to hide their lack of talent. There have been several instances when composers having decided to break with "vanguardism" and write realistic music failed to do so because they possessed neither gifts nor skill—nothing but a pitiable void, reminding one of the emperor's new clothes in Andersen's story....

There exists an opinion that the value of "vanguardism," as it were, lies in its experiments in the sphere of the musical idiom. "This is questing," the defenders of "vanguardism" declare. I heartily disagree with this. To strike out for the new is the sacred duty of all artists ... But what do we mean when we speak of the new—creation which has at all times inspired progressive artists, or destruction alone which we can observe among the "vanguardists"?

Part II The Politics of Art

Part IIA Elitism:
Aesthetic of the Right

"It is a strange and disturbing phenomenon," writes John R. Harrison, "that five of the greatest literary figures of this century, Yeats, Lewis, Pound, Eliot and Lawrence, were attracted by Italian and German fascism before the Second World War." In the case of Pound the attraction led him into treason. "Why is it," Harrison asks, "that great creative artists can totally reject a liberal, democratic, humanitarian society, and prefer a cruel, authoritarian, bellicose society?" The question calls for answer, especially for those who, on the one hand, regard these men as the foremost writers of our time and, on the other hand, regard fascism with loathing and horror. Needless to say, the question embraces more than those who write in English. One thinks at once of Stefan George in Germany, Maurras and Celine in France, and D'Annunzio in Italy.

With the exception of Pound, it would be an injustice to call the men about whom Harrison writes in the selection reprinted here fascists or even proto-fascists. They were political conservatives, and conservatives have been notoriously insensitive to the dangers of fascism. On the other hand, when Italian fascism was still young, even liberals such as Charles Beard, Herbert Schneider, Horace Kallen, and the editors of the *New Republic* (to mention only Americans) failed, if only briefly, to understand its import. It is easy, as Mr. Harrison agrees, to be wise after the fact.

Eliot, to take one of the more distinguished members of the group Harrison is criticizing, seemed to reject fascism when he wrote in *The Criterion* in 1929 that "we must prepare a state of mind towards something other than the facile alternative of communist or fascist dictatorship." However, in another article praising the French royalist, proto-fascist, and anti-Semite Charles Maurras

(condemned by his countrymen after World War II to life imprisonment), Eliot, whose prose and peotry both exhibit anti-Semitic prejudice,[1] wrote: "Most of the concepts which might have attracted me in fascism I seem already to have found, in a more digestible form, in the work of Charles Maurras. I say more digestible form because I think they have a closer applicability to England than those of (Italian) fascism." Eliot concludes: "I end by reflecting that the development of fascism in Italy may produce very interesting results in ten or twenty years. And that it is a matter of regret that England has no contemporary and indigenous school of political thought since Fabianism, and as an alternative to it."[2]

The views of Ezra Pound will be noted in detail later. Wyndham Lewis, the least of these writers, who might indeed have been excluded from this galaxy had not Eliot found him to be "the most fascinating personality of our time"[3] and "the most distinguished living novelist,"[4] did a volteface on Hitlerism, praising Hitler's Aryanism, for example, as "the only sane and realistic policy in the midst of a disintegrating world," and then conveniently reversing himself in 1939. In any case, his record is mixed, as it is on anti-Semitism. Yeats, incidentally, wrote of Lewis that "I am in all essentials his most humble and admiring disciple."[5] And echoes of Nietzsche abound in Lawrence: the same contempt for democracy, equated by him with the rule of Jewish financiers, the same glorification of power, the same stress on will, the same call for a superman. ("Give homage and allegiance to a hero, and you become yourself heroic, it is the law of man.")[6]

Men like Eliot and Lawrence were far too individualistic to have accepted the regimentation of the arts which the Nazis called *gleichschaltung,* could they have experienced it at first hand, and an omnicompetent state would no doubt have been repugnant to them. They are best characterized, with varying emphasis, by what might be called the *elitist* syndrome, a constellation of traits which embraces a respect for hierarchy often linked with nostalgia for an idealized past, disdain for the common man, contempt for democracy, hostility for the middle class and the world of commerce, in some cases religiosity and anti-Semitism, and, above all, an aversion to modern industrialism, which to them was an annulment of the creative life of the artist.

[1]Anti-Semitism among non-intellectuals probably has no great significance except as a special, perhaps more dangerous, example of the xenophobia characteristic of the provincial mind. Anti-Semitism is much rarer among intellectuals and, when it occurs, is generally linked with strong authoritarian-elitist tendencies if not with explicit commitments to fascism. Eliot's anti-Semitism is exemplified in his observation that "reasons of race [sic] and religion combine to make any large number of free-thinking Jews undesirable" in the "society that we desire," *(After Strange Gods,* pp. 19–20) and in such lines of poetry as: "My house is a decayed house,/ and the jew squats on the windowsill, the owner,/ spawned in some estaminet of Antwerp..." (Gerontion), although he is quoted by a friend, William Turner Levy, as saying "I am not an anti-Semite and never have been" and complaining that American Jews were too sensitive. *(Affectionately, T. S. Eliot,* Lippincott, Philadelphia, 1968, p. 81). We have earnest assurance from Mr. Levy that Eliot enjoyed reading his poetry at New York's Young Men's Hebrew Association. Others who have sought to exonerate Eliot of anti-Semitism have argued that, since "jew" appears in lower case, Eliot was suggesting a type of businessman rather than a "race" or religious group. Unfortunately for this interesting example of a distinction without a difference, "Jew" appears in upper case in the newest edition of Eliot's poems. It may perhaps be suggested that in any "case" the slur is cruel.

[2]*The Criterion,* December 1928, cited in R. H. Robbins, *The T. S. Eliot Myth* (New York: Henry Schuman, 1951), pp. 10–11.

[3]*The Egoist,* (September 1918).

[4]*The Hudson Review,* (Winter 1955).

[5]Cf. Geoffrey Wagner, *Wyndham Lewis* (New Haven: Yale University Press, 1957), pp. 61–89.

[6]*Selected Literary Criticism* (London: Heinemann, 1955), p. 105.

It has been said that the beliefs of a poet, especially his social and political beliefs, are irrelevant to a judgment of his work. Eliot's own position shifts. He affirms that a poetry prize (to Ezra Pound) should be awarded on the basis of poetic achievement only and without reference to "other considerations,"[7] and yet comments on a poem of Wordsworth's: "I believe you will understand a great poem like *Resolution and Independence* better if you understand the purposes and social passions which animated its author. . ."[8] Eliot says that it is not essential to share Dante's beliefs in order to enjoy his poetry,[9] and that, in the case of Milton, "we can certainly enjoy the poetry and yet be fully aware of the intellectual and moral aberrations of the author."[10] Yet he wrote in "Shelley and Keats,"

When the doctrine, theory, belief, or "view of life" presented in a poem is one which the mind of the reader can accept as coherent, mature, and founded on the facts of experience, it interposes no obstacle to the reader's enjoyment, whether it be one that he accept or deny, approve or deprecate. When it is one which the reader rejects as childish or feeble, it may, for a reader of well-developed mind, set up an almost complete check.[11]

Did Ezra Pound, tried for treason and later found insane—with whose case this group of selections concludes—pass this test?

The recent appearance of a bulky biography (Noel Stock, *The Life of Ezra Pound,* 1970) and the wide comment it has evoked testify to a continuing interest in Pound and his work. Those who believed him dead must have thought on a day in mid-June 1969 that a ghost had appeared in upstate New York. They soon learned that our most notorious literary expatriate, still alive and aged eighty-four, had returned from Italy eleven years after his release from a Washington mental hospital. They were, in fact, witness to a surprise appearance at the commencement exercises of Hamilton College, Pound's alma mater, and it is reported that after his introduction the audience responded with a standing ovation. His appearance revived memories of one of the most dramatic trials of the century.

The trial had no real historic significance. Ezra Pound's treason was an isolated incident of the Second World War. It had human interest, and in pathologically exaggerated form it illustrated the hostility which some of our best writers have felt for their country, but it did not have even the slightest effect on the course of events. It is doubtful that a single American soldier, hearing Pound spew hate over the Rome radio (including defense of the wholesale slaughter of European Jews), was tempted to defect. Yet the trial of Ezra Pound and its surprising sequel have enduring interest because they put into dramatic focus many of the basic issues discussed in this book.

Some additional introductory detail will prove helpful. For many years before World War II Idaho-born Pound had lived as an expatriate in Europe, condemning the country of his birth and finally becoming infatuated with fascism. Near the end of the war he was captured by the American troops, was imprisoned in Pisa in Italy, and later tried for treason and committed to an institution for the insane. In prison

[7]Cf. below, p. 83.

[8]*The Use of Poetry and the Use of Criticism* (London: Faber and Faber, 1933), p. 73.

[9]Cf. "Dante," in *Selected Essays* (New York: Harcourt Brace Jovanovich, 1932), p. 219.

[10]*After Strange Gods* (London: Faber and Faber, 1934), p. 33.

[11]"Shelley and Keats," in *The Use of Poetry and the Use of Criticism,* also, cf. above, p. 44.

he wrote *The Pisan Cantos,* a work that might have gone relatively unnoticed had it not won him this country's most prestigious poetry award, the Library of Congress Bollingen Prize for the best book of poetry published in 1948.

Opinion has always been divided concerning Ezra Pound's poetry. T. S. Eliot said, "Mr. Pound is probably the most important living poet in our language." On the other hand, Yvor Winters referred to him as "a sensibility without a mind, or with as little mind as is well possible." In literary circles the weight of opinion is favorable, at least as far as Pound's early poetry is concerned. However, the Bollingen award caused bitter divisions in the literary world over moral and aesthetic issues which extend far beyond the Pound case: the extent to which great talent (if, indeed, Pound had great talent) excuses great crime; the extent to which a work of art is independent of the character of its author; the extent to which it can be judged *solely with respect to its form and without reference to its content.*

The Pound case came at the end of an era during which artists of all sorts had been deeply involved in political life. Few in the world of arts and letters had embraced or even flirted with fascism, although many had been successfully lured by the left. It therefore came as a shock that Pound should have carried his fascist sympathies to the extreme of supporting Mussolini. Even though Italian fascism was not as efficient in its brutality as Nazism, Mussolini's was the original fascist state, and its blackshirts were remembered bitterly for the ruthlessness with which they had destroyed representative government in Italy. That an American writer of Pound's distinction—his influence probably greater than his actual *corpus*—should speak in wartime on the Italian enemy radio against his own country brought shame and revulsion.

Several circumstances sharpened the issue raised by the Bollingen award. Pound had only tenuous ties to his native land. He was not, like other literary expatriates such as Henry James and T. S. Eliot, either solidly American, as James was in many ways, or a truly great world figure of literature, as both James and Eliot were. Pound's anti-Semitism was cruder and more virulent than Eliot's, and those who had just witnessed the horror of the Nazi concentration camps were outraged. Finally, the Bollingen jury—and it was a distinguished jury—seemed to be dominated by Pound's literary friends and disciples.

Once the supporters and opponents of the Bollingen award chose sides, the issue became even more complicated. For some it reflected the tyranny of the literary Establishment, dominated by Mr. Eliot, over American letters. For others it was not so much a case of rewarding an enemy of our country—Philip Rahv, for example, found it wonderful that we were objective enough to honor an American poet whose politics were anti-American—but a question of whether repugnant ideas, in this case fascist ideas, could be held by a man without corrupting his literary work. As the selections below indicate, some said yes and some said no. How much of the whole man must enter into his verse or fiction, which is supposed to be a product of the whole man—intellect, passions, sensibility, and everything else? Could his work be good if he were not in it totally? On the other hand, might the discipline and compassion necessary to artistic production make the man different in his art and his person? Dostoievsky's right-wing politics disappeared, for instance, in his sympathy for his characters, even those he intended to ridicule. However, in Pound's case, the situation was aggravated because in some instances, including *The Pisan Cantos* which earned him the award, he injected his politics into his work.

Still another confusion arose from Pound's presumed insanity. Was his commitment to an institution a device for sparing a poet the kind of imprisonment a run-of-the-mill traitor could have expected? If he were insane, perhaps he should be spared punishment for his treason, but could an insane man's poetry merit an

award? Was Vincent Van Gogh of the self-amputated ear a worse painter for the aberration that drove him to his surgery? Was he, too, technically insane when he painted his great last canvases? If so, should we distinguish between those, like Van Gogh, who turned their hostilities on themselves and those, like Pound, who turned them on others?

Of course, insanity itself was a special problem. Some kinds of insanity make it impossible for an insane person to work; other kinds make the work gibberish; still other kinds reveal themselves only in some functions, and the technically insane individual seems mad only on some occasions and not on others. Was Pound's madness separate from his verse, or did it penetrate it? Finally, fascist and mad, can one still produce real art? William Blake has been thought mad, and fine poems and paintings have glorified war. And it has been said that all poets are mad. . . .

In the selections that follow, all these problems are present. The case of Ezra Pound obviously has implications extending far beyond the politics of art, whether of the right or left, since it clearly involves the issues considered in Part IB, dealing with the autonomy of art, and Part IV, which is concerned with the relevance to art of the artist's personal morals. The discussion could well have been included under either of these rubrics.

The following selections can be read, quite apart from the merits of the issues involved, as an extraordinary example of impassioned controversy among talented and sensitive men of letters. This is especially true of the controversy that raged about the Pound award. As we turn to the selections themselves three questions must be kept in mind: Can an artist's or creative writer's beliefs about basic moral issues and how he acts on them be kept separate from an evaluation of his work? Can his work be successfully isolated from his moral convictions? Did the authors under discussion attempt to so isolate and insulate their work?

"The Reactionaries"
Reviewed

The Reactionaries

John R. Harrison

*British-born John R. Harrison (1937-) is a lecturer in literature and the
history of ideas in the School of Social Sciences at the University of Bradford,
England. He is too young to have faced the problem, when Yeats, Eliot, Pound, et
al. were still in mid-career, of developing an ethic or aesthetic that would reconcile
their social philosophy with the requirements of great literature. It is therefore
understandable that, encountering these views now, he should ask if there is such an
ethic or aesthetic and, finding none, should insist that the issue be resolved. William
Empson, one of Britain's best-known literary critics, in writing the introduction to
Harrison's book, enabled it to interest reviewers and readers who might otherwise
have ignored it. Two commentaries by distinguished critics are included in the
selections which follow.*

I

The twentieth century has produced extreme forms of society and political
philosophies. In Germany and Italy in the 1920s and thirties, a society was created
which was authoritarian in the extreme, the antithesis of democratic society. It is
unnecessary here to describe the fascist society created by the Nazis; the atrocities
that were committed, and the fear and hatred they aroused, are common
knowledge, although no less horrible for that. It is a strange and disturbing
phenomenon, however, that five of the greatest literary figures of this century,
Yeats, Lewis, Pound, Eliot and Lawrence, were attracted by Italian and German
fascism before the Second World War; and in Pound's case, during and after the
war. Why is it that great creative artists can totally reject a liberal, democratic,
humanitarian society, and prefer a cruel, authoritarian, bellicose society? The
question is important for the student of literature, for these writers' views are
bound to affect their creative work, and unless the reader is himself lacking in
human sympathy, his judgement of this work will be clouded. Literature cannot be

judged simply on what the writer says, but neither can it be judged satisfactorily if we ignore what the writer says. The writer's views may, as in the case of Yeats, help to work some wonderful transformation in technique; but the reader's enjoyment is almost certainly reduced by his antipathy to the content of what he is reading. It might also be argued that the writer's achievement is lessened. Menon, referring to Yeats, writes, "I think a measure of the greatness of a writer is how significant his interpretation of the present is for future generations."[1] The conclusions which these five writers reached regarding authoritarianism are difficult to accept; so are their views on democracy and its effect on literature, which are even more important for us today.

Only since the end of the last century has there been any separation between the artist's activities and the study of society. The idea still persists to some extent that a man must choose between poetry, for example, and sociology; that he cannot pursue both. The common conception of the poet is still of a languid, "sensitive" person, who is baffled by the world of affairs and at a loss in any activity not connected with poetry. Any radio play or popular novel shows this, if it includes a poet. . . . This conception would have surprised the Romantic poets. Wordsworth wrote political pamphlets, Blake was tried for sedition, Coleridge and Shelley wrote social philosophy, and Byron died fighting for a political cause. The refusal to take notice of what a poet says about the society in which he lives is good neither for literature nor for criticism. To say that a poet ought not to meddle in politics, and that if he does we ought to ignore that part of his work, is bound to produce a one-sided view and likely to lead to misinterpretations of the poetry itself. . . .

Professor Wind, in the 1960 Reith Lectures, says that it is important to the aesthetic appreciation of a work of art to know exactly what the artist means, what is his "message." He . . . believes that a knowledge of the theory makes a difference to one's visual impression of the painting. The relationship of the forms is fully appreciated only if we know what the painting means. That is, aesthetic appreciation of a work of art is heightened by understanding of its intellectual content. Since the Industrial Revolution, much of the intellectual content of literature has been concerned with social problems. It is only possible, therefore, to appreciate this literature fully if we study what the writers have to say about politics and society.

Moreover, Yeats, Pound, Lewis, Lawrence and Eliot all saw themselves as leaders of society, and they put forward their recommendations as practical policies. It is in this light that their views should be examined, not as the mildly interesting or amusing ramblings of eccentric genius. This latter approach presupposes a rejection of the poet's social function. F. R. Leavis, for example, writes of Lawrence's social criticism, "[These conclusions] were Lawrence's and Lawrence was an artist of genius: that is why they are to be considered."[2] This presumably means that the conclusions are of no real importance in themselves, and that Leavis is discussing them only because he thinks Lawrence wrote good novels. Lawrence would not have been very pleased with this attitude to his work. Moreover, how on earth can anyone appreciate Lawrence's novels without taking his social criticism seriously? One has not only to understand Lawrence's ideas but to make some attempt to sympathise with them, before one can begin to appreciate a novel such as *The Rainbow.*

[1]N. Menon, *The Development of W. B. Yeats* (Edinburgh: Oliver and Boyd, 1942), p. 1.
[2]F. R. Leavis, *For Continuity* (Cambridge: Minority Press, 1933), p. 119.

"The Reactionaries" Reviewed

Much of what Lewis and Pound wrote about democracy and fascism is likely to arouse anger and contempt; but it is important to know why they rejected democracy and were attracted to fascism. It is easy to be wise after the event and say that these writers ought to have recognised the dangers of fascism. As I shall show later, the fascist system attracted a great number of European intellectuals; Chesterton, for example, was especially pro-Mussolini, as a Catholic and Distributist. It is useless to condemn these writers simply because they supported fascism, and because fascists were largely responsible for terrible atrocities and the Second World War. In that case, we must condemn Auden and Spender and their associates for supporting communism. The question whether or not Yeats, Eliot and Lawrence, for example, were fascists seems to me unimportant. People who write letters to the *Times Literary Supplement* saying that Eliot said such and such a thing, *therefore* he is a fascist, *therefore* he is a bad man, are wasting their time. What is important is to find out why they held such views. This leads one to examine not only their social and political principles but their artistic principles. In the very close connection between those two sets of principles, and their very deep concern for the arts, lies the answer to this question.

George Orwell, in *Critical Essays* (1946), wrote, "The relationship between fascism and the literary intelligentsia badly needs investigating, and Yeats might well be the starting-point. He is best studied by someone . . . who knows that a writer's political and religious beliefs are not excrescences to be laughed away, but something that will leave their mark even on the smallest detail of his work."[3] First, however, a certain amount of background needs to be filled in.

Once the current of the French Revolution had begun to flow, few of the romantic writers who experienced the Revolution were not converted to reaction. Chateaubriand, who had been deeply influenced by the writers of the Enlightenment, became one of the founders of the aesthetic, neo-medieval Catholicism which attracted many devout people in the nineteenth century. Joseph de Maistre and de Bonald, advocates of absolute order and authority, became the theorists of this movement, and before 1830 Lamartine and Hugo followed Chateaubriand in their political and religious beliefs.

English romantic writers never succumbed to the creed of political reaction as completely as did the French and Germans, although Scott's novels provided a romantic view of the past, an imaginative medieval setting, and Wordsworth and Southey, eager supporters of the French Revolution at the start, later changed their minds. Realising that the doctrines of the Enlightenment had not made men good, they assumed that they had made men evil, and rejected them. Later romantics embraced the liberal cause. Shelley enshrined the old Jacobin doctrines in *Prometheus Unbound,* and Byron preached a gospel of boundless liberty and hatred of all existing governments. . . .

In Britain the growth of democracy proceeded relatively smoothly, when compared with the continual bitter crises which occurred on the Continent. Nevertheless, there existed a powerful anti-democratic trend of thought, and not only among those with a vested interest in reaction, but among the best writers and thinkers. Burke, deeply influenced by the French Revolution, was appalled by the prospect of a proletariat growing in numbers and increasing in consciousness and power, and put forward the idea of the state as the necessary agent of human perfection. His thinking had a profound influence not only in Britain but on the Continent. Carlyle also was an ardent opponent of democracy, and has been

[3]George Orwell, *Critical Essays* (London: Secker and Warburg, 1946), p. 119.

described as a forerunner of fascism. He adopted Goethe's essentially aesthetic attitude of withdrawal from an increasingly scientific and industrial age. . . .

Although Carlyle was very much concerned with the contemporary scene, his attitude to it was bound to be retrospective. In his later work Carlyle's leading principle is that of the "hero", the strong leader possessed of personal power. In 1853 he published *The History of Frederick II of Prussia* in which he admired Frederick as the ideal kind of hero. He deplored the emptiness of the social and personal relationships of his time, which were based, he said, almost solely on cash payment. He wanted to replace them with a relationship based on the recognition of personal power in the individual.

Critics like Carlyle and Ruskin were forced to look to the past to find the ordered, stable society they wanted, which accounts for their "medievalism". This kind of thinking about an organic society resulted, in Ruskin's work, in the idea of the paternal state, with a rigid class structure based on the different functions of individuals. This tradition acquired a future reference rather than a backward look with Morris and the rise of socialism, but particularly in the case of Ruskin, the social criticism would not have taken the form it did if it had not arisen from his views about art. His art criticism and his social criticism are closely related because they are applications in different directions of the same principles. Ruskin believed that good art is impossible in a corrupt society, and his social criticism is directed towards the cause of great art. Ruskin's attitude, reinforced by the aesthetic movement in the nineties, has been reflected in the social criticism of many twentieth-century writers, particularly Yeats, Lewis, Pound and Eliot.

II

The aesthetic movement, ostensibly the least political of all literary "movements", nevertheless had a profound effect on the political beliefs of many writers and artists. Shelley, although a passionate democrat, stressed the autonomy of the artist and of poetry in particular; public opinion was no longer to be the ultimate criterion of literary worth. Poets in the early nineteenth century tended to retire to a private world where they cultivated the belief in their superiority to practical life. This belief in the superiority of the artist, in the autonomy of his work, together with an idealisation of the past, became the accepted belief of a literary movement which spread throughout Europe. Inevitably it implied a dislike of the growth and spread of democracy, socialism and science. Contempt for the taste and judgement of the public can easily become contempt for the public itself, particularly when that public is becoming more numerous and self-assertive. Baudelaire, for instance, actively disliked democracy, and the aristocratic aestheticism of German writers like Geothe, Kant and Schiller helped to strengthen anti-democratic trends. The German aesthetic movement around Stefan George, which was part of a general reaction to the industrialisation and mechanisation of life, came later, but it illustrates the connection between literary aestheticism and political reaction. It was Oscar Wilde who developed the idea that the beautiful contains a higher morality in itself, thus enabling the creative artist to assert his own moral superiority. When the aesthete enters the sphere of politics, he tends, as did Barres, to reject democracy and prefer a hierarchic system where the opinion and judgement of the mass should have no effect on the rules, whom, by virtue of their moral superiority, he would prefer to be creative artists. Thus is produced the concept of the artist-hero in modern politics.

One of the most important causes of anti-democratic feeling among the intelligentsia has been the fear that democracy destroys all cultural standards.

"The Reactionaries" Reviewed

William James in 1908 wrote, "Democracy is on its trial and no one knows how it will stand the ordeal. Fickleness and violence used to be, but are no longer, the vices which they charge to democracy. What its critics now affirm is that its preferences are inveterately for the inferior. . . . Vulgarity enthroned and institutionalised, elbowing everything superior from the highway, this, they tell us, is our irremedial destiny." The critics of democracy believed that the privileged aristocracies of old, despite their iniquities, did preserve a taste for higher human quality and forms of refinement by their traditions. Ortega y Gasset's *Revolt of the Masses* epitomises the fear and hatred aroused by the developing mass society. This attitude was widespread among the literary intelligentsia who gave it its most articulate expression. In an essay entitled *The Younger Generation*,[4] Henry James said he detected the influence of democratic ideals on the work of H. G. Wells, and provided an early statement of the belief that political tendency can directly affect literary style. James equated democracy with formlessness in the novel. Form was to him of paramount importance, particularly in controlling the kind of interest, the choice of material, and the technique of presentation in the novels he was discussing—what he called "slice of life" novels. He thought that order must be imposed on these anarchic tendencies, which he believed resulted from the democratic principle in politics, or there would be a continuing decline in literary and artistic standards, a decline he had already detected. Fifteen years later J. C. Powys was voicing the same view rather more stridently. *The Meaning of Culture*, published in 1930, is an extended diatribe against the destruction of cultural standards occasioned by the spread of democracy: "outworn, misused, misapplied for so long, the aristocratic ideal is now quite dead. There is no escape from machinery and modern inventions; no escape from city vulgarity and money power, no escape from the dictatorship of the uncultured."[5] The only solution for him was to withdraw completely from the world: "An individual man or woman, carrying to a comfortless job through clanging streets the cheapest editions of some immortal book, can mount the stairs of his secret psychic watch-tower and think the whole antheap into invisibility." This indicates the problem which faced men like Powys, and also Yeats and the others; baffled by the complexity of the modern world, they could only withdraw, yearn for some idealised past, or adopt an anti-democratic political ideology. Powys and Yeats astonishingly looked forward to Spengler's prophecy of the destruction of modern civilisation by powerful warring leaders, producing chaos and out of this a great new "Platonic year".

III

A very powerful influence on the whole system of anti-democratic thought has been the development of the idea, and later the theory, of "elites." The word itself was not widely used in social and political writing until the late nineteenth century in Europe, and the 1930s in Britain and America, when it was diffused through the sociological theories of elites, especially in the work of Vilfredo Pareto and Gaetano Mosca.[6] The idea that the community should be ruled by a group of superior individuals is prominent in Plato and even more in the Brahminical caste-doctrines which regulated ancient society. The nineteenth-century European doctrines of rule by an elite of superior individuals, Carlyle's hero and Nietzsche's superman, for

[4]Henry James, *Times Literary Supplement* (March 19 and April 2, 1914).

[5]J. C. Powys, *The Meaning of Culture* (London: Cape, 1930), p. 298.

[6]Editor's note: cf. Pareto's *The Mind and Society,* and Mosca's *The Ruling Class.* The relevant selections are reprinted in H. Girvetz, editor *Democracy and Elitism* (New York: Scribner's 1967).

example, as well as the more prosaic studies of Mosca, Pareto and Burckhardt, are attempts to revive ancient ideas of social hierarchy and erect obstacles to the spread of democratic ideas.

Pareto always emphasised the complete distinction between the governing elite and the masses, and attacked modern notions of democracy, humanitarianism, and progress, and this hostility was even more marked in the case of those, such as Carlyle and Nietzsche, who presented social myths rather than scientific theories of politics. They saw democracy as a stage in the "revolt of the masses", leading inevitably to socialism or anarchy. Men like Mosca, Pareto, Weber and Michels tried to . . . show that a classless society is impossible since in every society there is, and must be, a minority which actually rules, and for the idea of a class that rules by virtue of economic or military power, they substituted the notion of an elite which rules because of the superior quality of its members. . . .

Charles Maurras in particular stressed the distinction between romanticism and classicism, and developed the political reference of those terms. He attacked romanticism in politics as leading to liberalism and anarchy, democracy and Protestantism, and advocated the "classical" ideals of aristocracy and rigid discipline, hierarchy and Catholicism. Terms like "romanticism" and "classicism" are difficult, almost impossible, to define, and Maurras . . . tended to describe as "romantic" anything he did not like, and to call what he did like "classical". He was the dominant figure in French neo-classicism and could claim writers like Hulme, Yeats, Pound, Lewis and Eliot among his intellectual disciples. His attitude was one of bewilderment before the problems of the modern world, in which the traditional authority of political groups, symbols or ideas, rules of form and style had lost its effect, destroyed by romanticism and democracy. The supporter of democracy believed in man's natural goodness, humanism, optimism, progress and challenge to external authority; against these the neo-classicists stressed the need for known and accepted rules, form in literature and authority in politics.

Yeats, Lewis, Pound and Eliot were really interested in society only in so far as it would allow the arts to flourish. Their interest in social problems stemmed . . . from their interest in the arts, and their plans were worked out on the basis of providing good literature, and not necessarily a "good" society; that is, one in which the majority of its members live full, free and satisfying lives. The desire to influence society in order to create a suitable background for his own writing is characteristic of each of these writers. Moreover, they based their political and social criticism on the same principles as their imaginative writing and literary criticism. They transferred their value-judgements from aesthetics to politics. It worked out differently in Lawrence's case, as his literary principles were very different from those of the other four. But he, like them, advocated a rigidly hierarchised, anti-democratic society, and the transfer of value-judgements from literature to society is the same. David Daiches, in *Critical Approaches to Literature,* says that it is wrong to transfer value-judgements of society to literature. He means that it is wrong to say that in a good society the literature will be good, or if society is bad, the literature must be bad. It is often though a Marxist position to hold that nothing good can come out of a corrupt society. But it is also wrong, and more dangerous, to transfer value-judgements the other way, from literature to society. The desire for "classical" order, discipline, strict rules and hardness in literature led Yeats, Pound, Lewis and Eliot to demand the same in society. They were within their rights, and it need not have worked out badly; but the process was not likely to produce good political judgement. . . . They were attracted to fascism because it promised to provide a clearly defined ruling elite, whereas in a democracy the responsibility lies with no one or with everyone. . . . Like many

others they were impressed not only by Hitler and Mussolini as hero-types, but by the promise of a more active, decisive role which fascist leaders said writers and artists should play in political affairs. One of the main causes of frustration of men like Lewis and Pound was that while the improvement in the artist's social status, and more important, the sense of his moral superiority which culminated in the aesthetic movement, made them see themselves as leaders of society, the increasingly esoteric nature of the arts tended to alienate society as a whole. Their own attitude to the public could only mean that the public in a democratic society could not seriously consider them as political leaders, while fascism, which at first seemed to be the antithesis of a mass movement, appeared to promise political responsibility for creative artists who supported the regime.

The desire for authority, together with the belief in the superiority of the creative man, led them to advocate the rule of the artist-hero in politics. They wanted responsibility for affairs; they wanted political power for themselves because they genuinely thought that they were the men most suited to wield it. Like Ruskin, they believed that the arts should be an active guide to society, and therefore to political action. Political economy, Ruskin said, is "a system of conduct and legislature, founded on the sciences, directed by the arts, and impossible, except under certain conditions of moral culture." The idea that the writer should be the leader of society was stated most directly by Lawrence. He thought that it was not only the "artist" or the writer who should be the leader of society, but Lawrence himself. To quote again from *Fantasia of the Unconscious,* "I would like him to give me back the responsibility for general affairs, a responsibility which he can't acquit, and which saps his life. I would like him to give me back the responsibility for thought, for direction. I wish we could take hope and belief together.... I would like him to give me back books and newspapers and theories. And I would like to give him back in return his old insouciance, and rich, original spontaneity and fullness of life."[7] Lawrence here at least professed to want power himself for the benefit of the majority. The others did so for the benefit of the arts. The danger is to become preoccupied with power itself, rather than the ends to which it can be put, and they all, to a certain extent, were imaginatively guilty of this.

Because these five writers thought they saw a society developing in which there could be no good art, they attacked the democratic, humanitarian ideal. They criticised the humanist principles of their time, the belief, for example, that man is the measure of all things, or that one should act for the greatest good of the greatest number. The main effect was something that none of them wanted except Eliot; that is, a Christian revival, if not among society in general, at least among many intellectuals. Joyce, although he was associated with the "neo-classicists," supported the ideals of humanistic liberalism while he attacked its vulgarities. He had experienced a "paternal" society in his childhood in Ireland, with the authority provided by the Catholic Church, and he had no enthusiasm for a fascist one. Orwell thought that people like Yeats who hated democracy, science, machinery, the ideas of human equality and progress, in fact the modern world in general, were necessarily gathered under the wing of fascism because this was the one movement that consciously attempted to formalise these phobias.

Writers like Lewis and Pound, however, were completely mistaken in equating fascism in politics with "classicism" in literature. They failed to realise early enough the irrational stress of fascist ideology, which was the antithesis of the

[7]D. H. Lawrence, *Fantasia of the Unconscious* (London: Martin Secker, 1923), p. 104.

intellectualism and rationalism of the art and literature they called "classical." It is possible that these writers did not realise that a totalitarian regime will repress writers and artists who do not uphold the government in power. It is more probable that they did see this, but were so intent on propagating the literary and political beliefs they themselves held, that they were quite willing to see different opinions suppressed. Pound and Lewis, in particular, were totalitarians in that they would have suppressed anything to which they were opposed, not only in the practical sphere—Pound suppressing Jewish financiers—but in the intellectual sphere—Lewis suppressing behaviourism and Bergson's philosophy. They developed and refined their prejudices into a political philosophy....

Men like Lewis and Pound, whose pessimism was based on a sense of man's feebleness rather than a belief in original sin, were forced to look to a political system for that absolute certainty that politics can never provide. The result was their addiction to authority, organisation, hierarchies, which alone, outside the arts, could give meaning and significance to man's life. In Germany it has been thought that man exists for the state, not the state for man, and social and political ideals have been regarded as ends in themselves. The separation of ideal from individual has been accompanied by a confusion of means with ends. The same is true of writers like Yeats, Lewis, Pound and Eliot, who in spite of their concern with social and political problems adopted an essentially aesthetic position. Oscar Wilde in gaol can be compared with Pound in the prison camp—"I have been hard as youth sixty years." Neither of them had seen any need for human sympathy or understood the nature of human suffering. Literature becomes an end in itself; man creates something more important than man, that is great "art." The individual is insignificant in the face of the magnificence of the impersonal ideal. Art does not exist for man, man exists for art, therefore society must be organised so that the arts will flourish. The individual is sacrificed to the cultural ideal.

Each of these writers attacked the democratic system because it lacked the kind of stability he wanted. With the possible exception of Lawrence, they believed that great art is impossible without social stability. For Lewis, social stability depends on minority rule. For Yeats, the stable society is synonymous with aristocratic rule; and this would help great art because patronage would free the artist to work and let him meet people with good manners. The image of the stable society is constantly recurring in the *Cantos,* as Pound describes what he considers to be good forms of society in the past. It was largely an economic stability that Pound wanted, but he believed that other kinds of stability depend on that. Eliot thought that small, closely knit, mainly agricultural units would provide the necessary stability. Lawrence also regretted the destruction of the agricultural basis of society, and the increasing industrialisation and mechanisation, not only of society but of individual human life. Occasionally they idealised the Middle Ages as a time when a static society produced great works of art, culminating in the poetry of Chaucer. Nothing, however, could be further from the truth. The Middle Ages as a whole were not stable, and the late Middle Ages were a time of bewildering change: "It [the thirteenth century] was followed by a period of exhausting wars, economic difficulties, and the gradual, bewildering break-up of its code of values. Late medieval England experienced disillusionment, and a desire for new aims and new verities."[8] Had Yeats and Eliot lived in the late Middle Ages, they would probably have attacked their society as fiercely as they did twentieth-century

[8]A. R. Myers, *England in the Late Middle Ages* (London: Penguin, 1952), p. xi.

society, since "the rise of the yeomen and gentry broke up the old village community and made the hierarchical conception of society more and more unreal."[9]

The Italian Renaissance shows most clearly that social stability is not a prerequisite of great art. Bertrand Russell has said that "the moral and political anarchy of fifteenth century Italy was appalling, and gave rise to the doctrines of Machiavelli. At the same time, the freedom from mental shackles led to an astonishing display of genius in art and literature. But such a society is unstable."[10] It is difficult to see why so many writers have thought that stability, whether social, political, moral or philosophical, is a prerequisite of artistic creation. Twentieth-century writers such as Lewis, Pound and Yeats realised that there was no hope of a return to an earlier form of civilisation, so they hoped for a stability provided by totalitarian regimes. Totalitarianism, however, depends on mental shackles which make continuous artistic excellence impossible. It produces the rigid attitude to the arts illustrated by recent controversies in Russia; and this is what will destroy the arts, if anything will.

An Open Secret

Philip Rahv

Philip Rahv (1908–) is best known as founding editor of the Partisan Review. *Currently, he is professor of English at Brandeis University. He became known in the Thirties as a left-wing theorist and vigorous polemicist. The* Review *became a forum for Marxist and pro-Soviet views, but the Moscow Trials of 1936 brought disillusionment. Publication was suspended but resumed in 1937 with an anti-Stalinist, independently Marxist line. The* Review *has since built a reputation for stimulating articles of literary and political interest. Rahv sparked the Henry James revival and edited* The Great Short Novels of Henry James. *His critical essays, including articles on James, Tolstoy, Kafka, and Dostoievsky, are included in two early volumes,* Images and Idea *(1949) and* The Myth and the Powerhouse *(1965) and, more recently, in* Literature and the Sixth Sense *(1969). He comments here on Harrison's book and the issues it raises.*

This is an important book, but it is scarcely likely to win favor in the Literary Establishment. It rattles too many skeletons in the closet. The importance of the book does not lie in the incidental literary criticism it contains but in its undertaking a necessary job of systematic research into the "beliefs" present in the work of some of the major writers of our age. Why, then, do I anticipate this negative reaction of defensive maneuvers and clever alibis? Because four of the five writers (Wyndham Lewis is the least famous among them) examined by Mr. Harrison—and he finds the ideas about history and society of all five to be lamentably reactionary—belong to the exalted company of the "sacred untouchables," as they have rightly been called, of the modern creative line. Read and praised everywhere, they have been speedily converted into classics of the college

[9]*Ibid.,* p. xiv.

[10]B. Russell, *History of Western Philosophy,* (London: Allen and Unwin, 1946), p. 100.

From *Literature and the Sixth Sense* by Philip Rahv, pp. 437–445. Copyright © 1969 by Philip Rahv. Reprinted by permission of the publisher, Houghton Mifflin Co. and Faber and Faber Ltd.

classroom, where they are almost invariably presented in a heroic light. Thus they have come to represent a vested interest not so readily affronted.

I suppose there is a natural propensity among critics, scholars, and teachers of literature to equate superior works of the imagination with creedal wisdom and beneficence. Few can resist the temptation to swallow a doctrine implicit in a body of poetry that gratifies the aesthetic sense; most cannot bear to admit to themselves that the relation between literature and truth or moral insight is sometimes very erratic, if not altogether deceptive. This is a weakness that fits in neatly with the megalomaniacal disposition of modern art, a disposition easily diverted in our latter days from the close appreciation of the work to the apotheosis of the artist's person. People in the aging twentieth century, prostrate amid their material affluence and spiritual bankruptcy, surveying the wreckage of all the earlier schemes of salvation, whether secular or religious, are impelled to seek in art the highly consolatory, if not absolute, values they crave. As a consequence we have the culture explosion so called, the promoters of which, all too ubiquitous at present, are sometimes touching in their naivete but more often frenetic and offensive in the impostures and dissimulations they subject us to. How much closer to the truth is Jean Dutourd, who observes in his latest novel that "loving beautiful things doesn't mean that one has a beautiful soul but that one has a taste for luxury. The supreme luxury, which is the prerogative of artists of genius, doesn't presuppose that one possesses the supreme virtue, which is charity." Though this is by no means the whole story, Dutourd's way of putting it is certainly worth keeping in mind, if only as a corrective to the cultism of art nowadays rampant among us. The tacit assumption of this cult is that art by itself is capable of conferring ultimate value and meaning upon life. In the long run such vain expectations are bound to lead to total disillusionment with culture.

The virtue of charity is the last one can look for in the "sacred untouchables" whose programmatic ideas Mr. Harrison (somewhat ingenuously, to be sure) has undertaken to investigate. But he is on to an open secret, which is simply, as he puts it in an early chapter, that

> *what Yeats, Pound, Lewis and Eliot wanted in literature...was a hard intellectual approach ruled by the authority of strict literary principles. They rejected the humanist tradition in literature, and in society the democratic humanitarian tradition. The same principles governed their social criticism as their literary criticism, and led them to support the fascist cause, either directly as Pound and Lewis did, or indirectly, as Yeats and Eliot did.*

As for Lawrence, though emphatically not a believer in any kind of intellectual approach, he was quite as reactionary, as in his preaching a return to primitive life forms and his idealizing of blood sacrifice, his hostility to the democratic process and rant against the "mob-spirit" and "democratic mongrelism," his acclaim of power, of mastery and lordship, as a marvelous life-giving "mystery," and his urging us to surrender to "the natural power of the superior individual, the hero." Mr. Harrison hastens to note that "Lawrence's views on social leadership are inherently close to the fascist conception of society." I see no real gain in such a formulation. Admittedly Lawrence's views and attitudes are as false as they are dangerous, but what they represent is a private dream rather than a political plan or design; it is far more profitable to approach them through individual psychology and the precise analysis of the moment in Western culture that encouraged their emergence. Bald

political terms, with their inevitable crudity of labeling, cannot provide illumination in this particular context. For all the coincidence of certain moods and preconceptions, neither Mussolini's Italy nor Hitler's Germany could find any real use for Lawrence in their cultural propaganda.

Hence I am inclined to object to Mr. Harrison's rather gummy use of the label "fascist" in his indictment of all five writers under consideration, just as I object to Empson speaking, in his Introduction to the book, of "the political scandal of their weakness for Fascism." Not that I deny that for a time Pound and Lewis supported the fascist cause—though Lewis reversed himself in later years, perhaps for the wrong reasons. Surely the "scandal" invoked by Empson can easily be made out to be real, but only if the entire theme of reaction in modern literature is transposed into strictly political terms. This transposition does not get us very far because it tends to stop discussion. In their social and political thinking all these writers were sheer amateurs, wonderfully alert in their own verbal medium but unable to grasp that politics too is a specific medium—of action in history and society—and that it is preposterous to introduce into this medium notions of "personal supremacy" (Yeats) or of "the natural power of superior individuals" (Lawrence) as serious recommendations for the organization of society. They were drawn ideologically to authoritarian positions but were not in any definite way committed (not even Pound, who is by far the most vulnerable) to the shifting demands and intolerable dogmas of any given political party. Not one of them was in any meaningful sense a political man or even capable of consistent political thought. I doubt whether they understood how capitalism actually functions or exactly what socialists have in mind in proposing a different system. Their social-political unworldliness shows through all their denunciations of liberal ideas. There is in all five of them a radical want of modesty, and I am using the word as Chekhov used it in deploring Dostoevsky's "spiritual immodesty." What they can be truly accused of is presumption in undertaking to speak portentously about matters they knew little about. This presumption by quite a few men of letters is a cultural phenomenon—a symptom of certain antinomian qualities intrinsic to the literature of the modern age—which deserves more attention than Mr. Harrison, bemused by the political terminology he has adopted, has given it.

Yeats, for example, looked forward to a new aristocratic society, the rise of which he deduced from his theory of "cycles," with concentration of power in a small ruling class, "every detail of life hierarchical, every great door crowded at dawn by petitioners, great wealth in a few men's hands ... an inequality made law." Despising democracy as a standardizing process, he idealized previous modes of social life. But these earlier periods, the model of which he saw in the custom of patronage supposedly beneficial to artists and in the "great houses" (Coole Park) of the eighteenth-century patricians, actually knew no such equality of aristocrat and artist as he had in mind. (Even in his own lifetime he imagined the "great houses" to be centers of civilized discourse and behavior, but according to the testimony of Louis MacNeice, a far less subjective observer than Yeats, those old houses contained no culture worth speaking of—"nothing but obsolete bravado, insidious bonhomie and a way with horses.") In Yeats a strain of social snobbery and resentment of certain features of the modern era (such as the prestige of science) combined to produce a kind of historical snobbery scarcely at all concerned with historical truth. Vision was all; the facts didn't matter. An exacerbated imagination, over-stimulated by certain poems and graceful phrases he found in old books, conjoined with a coldness and aloofness of temper, "a lack of sympathy with

ordinary humanity," as Mr. Harrison notes, generated in him a dream of the unity of art and life established in an order powerfully conducive to the creation of works of art.

This type of historical snobbery, though not necessarily always mixed with social snobbery, is also to be found in Eliot, Pound, Lewis, and Lawrence. Thus Pound, in the *Cantos* locates his ideal society in the China of the eighteenth century and the time of Malatesta in the Italian Renaissance; he casts Jefferson and John Adams in the role of precursors of Mussolini, whose execution he laments in sincere poetic words: "han'g dead by the heels before his thought in proposito/came into action efficiently." It is not difficult to recognize in all five the vagaries of those who at once abuse the present and undercut the Utopias of the future by placing theirs in the past....

In the sections dealing with the cultural and historical background of these archaistic Utopias Mr. Harrison is both perceptive and thorough: he is one of the very few critics who do not skirt the question of the enormous influence exerted on Eliot by Charles Maurras and the *Action Franaise* movement. The anti-Semitic feelings divulged in the early poems, up to and including *The Waste Land,* as well as the emphasis on *the* tradition (with the obligatory definite article enforcing exclusion), by means of which he set out to instruct his recusant British hosts—so prone to fall away from allegiance to "Outside Authority" and ecclesiastical monarchical domination—are derived not from native sources but primarily from Maurras. In his Introduction Empson remarks that Joyce was one of the few men of the 1880s to escape this pervasive archaism and reaction: he quotes a letter of 1934 in which Joyce says he is "afraid that poor Mr. Hitler will soon have few friends in Europe apart from my nephews, Masters W. Lewis and E. Pound." Perhaps Joyce resisted the lure because "he had actually escaped from a theocracy such as many of the authors examined in this book recommended."

There is one exaggerated claim, which Mr. Harrison advances on his own behalf, that one would want to challenge. He defines his aim as that of showing "the relationship between the 'tendency' of these five writers and their literary style, also their literary principles." As for establishing any kind of direct relationship, particularly in style, Mr. Harrison has not, in my opinion, succeeded. Between their "tendency" and their literary principles the connections drawn are much clearer. Principles, however, are one thing and practice another. Some of the best qualities of these writers crystallize around the contradiction between stated principle and actual practice. Eliot, for instance, boosted for a long time the virtues of classicism, whereas as a practitioner he developed in his poetry what is unmistakably a new version of romanticism. In his nostalgia for the past he is openly romantic, and in his patrician-puritan scrupulosity and feelings of sexual disgust he is the romantic turned inside out. (He was writing before the onset of the present period of "positive" sex, so grossly romantic in its hankering to discover in pornography yet another and quite acceptable literary form.)...

Mr. Harrison would have been well advised, I think, to be persuaded by George Orwell's judgment, quoted in the book, that "no one has succeeded in tracing the connection between 'tendency' and literary style. Texture can not seemingly be explained sociologically." Texture or style is the product of the workings, at once extremely minute and extremely complex, of individual sensibility: and though the entire process is no doubt in some way affected by the writer's "belief," it cannot be altered fundamentally. This question of "belief" in poetry caused Eliot no end of worry (cf. especially his 1929 essay on Dante) and he wrestled with it vigorously and with exemplary truthfulness in essay after essay. He never came to any

definitive conclusion and finally let the matter rest. The case of Bertolt Brecht will serve as a good example in this respect. However orthodox he may have been in his communist principles, his unquenchable and highly original sensibility got him into trouble with the Soviet commissars of culture. What goes for radical writers, goes equally for the reactionary ones.

Let me approach this question from another angle. One can show, I believe, that virtually all of Lawrence's novels after *Sons and Lovers* are considerably damaged as works of art by his undue insistence on his own "belief"; but what shall we say about the numerous works which despite the salient element of "belief" in them easily transcend the level of idea-mongering and doctrinal bluster? *The Possessed* is admittedly a counter-revolutionary novel politically and in the writer's explicit intention, but that does not deter those of us who spurn its propagandistic "message" from fully enjoying it. Nor do the antipathetic social-political views of W. B. Yeats deter me from appreciating his poetry.... I think that posterity will no doubt forgive the ideological aberrations of at least three of the writers discussed in this book—certainly Yeats and Eliot and in part Lawrence—as it has already forgiven Dostoevsky and many other great artists of word and image.

But I agree with Mr. Harrison when he takes to task such critics as L. C. Knights and F. R. Leavis for glossing over the real meaning of some of the ideas of these writers. "It is one thing to see and accept his [Yeats's] prejudices, and another to conjure them away, to pretend that they were something different." This false stance is one of which most literary critics who have dealt with Yeats and the others are notoriously guilty. Thus Mr. Harrison justly attacks Dr. Leavis's position on Lawrence as a social critic. The conclusions of this criticism, writes Dr. Leavis, "were Lawrence's and Lawrence was an artist of genius: that is why they are to be considered." Mr. Harrison has no trouble demonstrating that such an approach is irresponsible even from a literary point of view. "One has not only to understand Lawrence's ideas but to make some attempt to sympathize with them before one can begin to appreciate a novel such as *The Rainbow.*" After all, Lawrence did not primarily conceive of himself as an artist but as a leader and prophet. And he himself, I have no doubt, would have protested against such cavalier treatment of his ideas as he gets from Dr. Leavis; for he went so far as to assert that "even art is utterly dependent on philosophy: or, if you prefer, on a metaphysic." It is precisely this metaphysic, so important to Lawrence, that Dr. Leavis, in his book *D. H. Lawrence: Novelist,* willfully ignores in his anxiety to promote Lawrence as an artist of narrative prose in the "great tradition" (of whose existence I am not at all persuaded). Lawrence is admirable, to be sure, in the immediacy and spontaneity of his language, but there is more to the fictional medium than language and he is not nearly so good a novelist as Dr. Leavis makes him out to be.

To my mind, what these five writers have in common is a conviction, not always conscious, of the sovereignty of the word, not only in literature but also in life. This is their real "heresy," to use an expression much favored by Eliot and his disciples....

Writers and Politics

Stephen Spender

One of Britain's most distinguished poets and critics, Stephen Spender (1909–) was another of the many intellectuals who were captivated in the thirties by Communism only to become disenchanted. Along with others, he expressed his disillusionment in the widely read The God That Failed *(1949). He was a founder of* Horizon *and co-editor until 1941 and became co-editor with Irving Kristol of* Encounter *in 1953. He has written* The Burning Cactus *(1936),* Forward from Liberalism *(1937),* Life and the Poet *(1942),* European Witness *(1946),* The Creative Element *(1954), and an autobiography,* World Within World *(1951). Spender has taught and lectured at numerous English and American universities. Like Philip Rahv in the preceding selection, he comments on some of the basic issues raised by John Harrison's book,* The Reactionaries.

Mr. John Harrison's reactionaries are W. B. Yeats, Wyndham Lewis, Ezra Pound and D. H. Lawrence.[1] Mr. Harrison knows that to prove that they are really reactionary, it is not enough to show that they occasionally labeled themselves so. However he does not altogether avoid the dangers implicit in compiling lists of their reactionary pronouncements without asking how far these really correspond to ideas in their best creative work. His problem is to relate their expressed opinions to convictions of which they themselves may not have been wholly aware, but which do have political implications, in their best writing.

The extent to which we should take a writer's expressed opinions seriously is difficult to ascertain. What I [suggest] ... here is that in France it is not so difficult to do this, because there is a tradition of intellectually respect-worthy opinion about politics to which the writer can relate his own views. But in England and America there is no such tradition of the writer in politics. Therefore his interventions tend to be sporadic and occasional and perhaps not consistent with his truest, that is his most imaginative, insights.

This is even more true of the Right than of the Left. For the Left, after all, even in England and America, can merge into the traditions of the French and American Revolutions, the internationalism of nineteenth-century liberals, Marxism, mingling, for the time being, with a world river of continuous thought and energy. During the decade of the Popular Front the English anti-Fascist writers became, as it were, honorary French intellectuals. And this was not altogether absurd because of the international character of the Left. But Fascism, and indeed the European right, so diverse in its manifestations in different countries, although potentially an international threat, was nationalist and local in ideas and performance. Therefore there was something much more esoteric and perverse about the intermittent support which Mr. Harrison's reactionaries gave to right-wing and Fascist movements than about the corresponding political involvements of the anti-Fascists.

From *Partisan Review* (Summer 1967), pp. 359–379. Copyright © 1967 by *Partisan Review.* Reprinted by permission of the publisher and the author.

[1]Editors' note: also, T. S. Eliot.

"The Reactionaries" Reviewed

The traditionalism which appealed so much to Yeats, Pound, Eliot, Wyndham Lewis and others doubtless had political implications, and given the crucial nature of the period, it was not dishonorable of traditionalists to want to realize these by supporting rightist parties. But a big leap into the near dark had to be made in order to convert the poetic traditionalism of Yeats, Pound or Eliot into support of General O'Duffy, Mussolini or the *Action Francaise*.[2]

The political attitudes of Yeats, Eliot, Pound, Lewis, Lawrence, consist largely of gestures toward some movement, idea, leadership which *seems* to correspond to the writer's deeply held traditionalism. Such gestures and attitudes are largely rhetorical. For the politics of these writers are secondary effects of their thoughts about the tragedy of culture in modern industrial societies. They are sometimes conscientious, sometimes irresponsible attempts to translate their traditionalist standpoint into programs of action.

Whereas the leftist anti-Fascist writers—believing that the overthrow of Fascism was the most important task of their generation—tended to think that their writing should perhaps be the instrument of the overriding public cause, the reactionaries thought that politics should be the servant of their vision of the high tradition. Wyndham Lewis, for example, never supposed that he should become the mouthpiece of Hitler. What he thought was that as the living representative in the contemporary world of renaissance "genius" perhaps a few renaissance thugs would be helpful to the cause of his art: if this was the role that Hitler and Mussolini had unknowingly cast for themselves, maybe they should be encouraged. Yeats had a not very different attitude toward the soldiers of the Right who could perhaps be given orders by Art, and who also were useful in providing sound effects for the end of a civilization.

The most important thing common to the reactionaries was that they had a kind of shared vision of the greatness of the European past which implied hatred and contempt for the present. It might be said that all their most important work was an attempt to relate their experiences to this central vision. On the secondary level of their attempts to carry forward the vision into action and propaganda there is a good deal of peripheral mess, resulting from their search for political approximations to their love of past intellect, art, discipline and order. Often their politics only shows that they care less for politics than for literature.

Mr. John Harrison takes some remarks of Orwell as his text which he sets out to illustrate with examples drawn from his authors. This text is worth examining:

The relationship between fascism and the literary intelligentsia badly needs investigating, and Yeats might well be the starting point. He is best studied by someone like Mr. Menon who knows that a writer's politics and religious beliefs are not excrescences to be laughed away, but something that will leave their mark even on the smallest detail of his work.

This sounds sensible enough though it is perhaps too offhand to bear the weight of Mr. Harrison's thesis. Certain objections occur to one. For example, if it were true that a writer's politics and religious beliefs extend from a center outward into every smallest detail of his work, then the converse would also be true that one could deduce his party or creed from an analysis of any smallest detail, whether or not the writer thought that he supported such a party or a creed.

[2]Editors' note: A fiercely reactionary organization with royalist and totalitarian sympathies, noted for its rabid anti-Semitism.

This leads back into the objectivist fallacy of the writer holding certain views whether he thinks he does or not.

What is wrong is Orwell's loose bracketing of religious and political beliefs, and his assumption that it is a comparatively simple matter to know what a writer believes. But it is not simple, since he is writing out of his imagination, his vision of life, and not according to labels which he or others may stick on to him. Orwell appears to think that Yeats's symbolism, mythology, imagery—his poetry in a word— are projections onto the plane of the imagination of his declared political and religious beliefs. It is really the other way round. Yeats's religion and politics are the results of numerous inconsistent attempts to rationalize his central poetic vision, as dogma, politics, action. Whether or not they should be "laughed off," Yeats's Fascism was an excrescence. It grew rather approximately and grossly from the center of his poetic imagination which was neither approximate nor gross. To anyone who reads *A Vision* or his journals and prose, it must be quite clear that his opinions are attempts to systematize the intuitions of his imagination.

Add to this that even when they are stated as prose, one cannot discuss Yeats's beliefs without making many qualifications. Outside of believing in art and in some universe of the spirit in which the visions of art are realistic truth, Yeats himself was extremely approximate about what he believed. He was candid in admitting that he cultivated beliefs and attitudes in himself for the purpose of propping up the symbolism of his poetry. He also had a sharp picture of a materialist world which undermined his world of the poetic imagination: this was Bernard Shaw's Fabian philosophy and belief in material progress. That which to Shaw was superstition and reaction recommended itself as dogma and practice to Yeats.

Dr. O'Brien has drawn up a formidable list of Yeats's pro-Fascist statements, including one or two sympathetic to Hitler. But to the reader who thinks that Yeats's poems and not his opinions matter, it will seem, I think, that he used the political stage properties of the thirties in the same way as he used the assertions of his esoteric system set out in *A Vision*—as a scenario stocked with symbols and metaphors which he could draw on for his poetry. To Yeats writing the tragic-gay poetry of his old age, Hitler had the seductive charm of an apocalyptic cat.

What is distressing about the reactionaries is not that they were occasionally betrayed by intoxication with their own ideas and fantasies into supporting dictators who would, given the opportunity, certainly have disposed very quickly of them, but that in the excess of their hatred of the present and their love of the past, they developed a certain cult of inhumanity. One has to ask though—was not their renaissance vision enormously valuable to us, and could it have been stated without dramatizing the statuesque figures of a visionary past against the twittering ghosts of the disintegrated present?

Eliot's political views, like those of Yeats, are a defense system hastily thrown out with the intention of defending a spiritual world deriving strength from the past, against modern materialism. One suspects that Eliot was convinced intellectually, as a critic, and not with his imagination, as a poet, of the necessity of rationalizing poetic values as politics. Without the example of T. E. Hulme and without some cheer-leading from Ezra Pound and some satiric pushing from Wyndham Lewis, Eliot would scarcely have made those remarks about liberalism and progress, which seem casual asides, and which yet set him up as an authority, defender of the monarchy and the faith. In his role of political commentator in *The Criterion* he must have baffled readers who did not realize that his mind was moving along lines laid down by Charles Maurras.[3] There is also something

[3]Editors' note: cf. above, pp. 58–59, 87.

cloak-and-dagger about the anti-Semitic passages in the Sweeney poems which Mr. Harrison inevitably relies on to demonstrate his thesis:

> *The smoky candle end of time*
> *Declines. On the Rialto once.*
> *The rats are underneath the piles.*
> *The jew is underneath the lot.*
> *Money in furs.*

Of course this was distasteful caricature even when it was written. In the light of later developments it seems almost criminal. Nevertheless what seems wrong about the Sweeney poems is not that they are reactionary-political but that they use a tawdry view of a conspiratorial capitalism to construct a rather cardboard background to the poetry.

That Eliot, Yeats, Pound and Lawrence were all exiles (and Wyndham Lewis a self-declared outsider—"the Enemy") has a bearing on their politics. The exile is particularly apt to dramatize himself as a metaphor moving through a world of metaphors. Pound and Eliot left what they regarded as barbarous America to come to civilized Europe, where they found, in the First World War:

> *There died a myriad,*
> *And of the best among them,*
> *For an old bitch gone in the teeth,*
> *For a botched civilization.*

Their poetry exalted the past which they had sought among the Georgian poets and found only embalmed in museums, and it derided the present, the decay of standards. They were, politically, Don Quixotes of the new world armed to rescue the Dulcinea of the old—an old hag. The aim of their polemical criticism was to reinvent the past, shining and modern, and use it as a modern weapon against the arsenals of the dead men stuffed with straw.

Their politics were secondary to the creative and critical attempt. In them, they were drawn to whatever points of view presented social and economic problems as metaphors for their idea of the state of civilization. The appeal of politics in the guise of metaphor is curiously shown in the great attraction—which can only be compared with that of Donne's ideas about time—of Social Credit theories for a number of writers, including not only Eliot and Pound but also Edwin Muir—during the late twenties and thirties. Social Credit is easy to visualize. One sees objects of value being produced on one side of a chart and on the other side money—credit—being printed equal to the value of the object. Since Schacht and Mussolini actually made adjustment to the German and Italian economies along similar lines, Social Credit seemed to be an idea which could be abstracted from the rest of Fascism and applied to other systems. For reactionaries who could not swallow violence, it was a kind of Fascism without tears.

Students of Ezra Pound's *Cantos* will observe how metaphors of this kind drawn from a reading of economics imagized and then applied to describe the state of the civilization are used by Pound, sometimes to justify inhuman attitudes. A famous example is the passage about usury in which Pound explains that the introduction of usury into the economic system falsifies the line drawn by the painter, causes his hand to err. This justifies a massacre of Jews.

The Left also of course had their metaphors, which by making history appear a poetic act tended to regard human beings as words to be acted upon, deleted if necessary, so that the poem might come right.

In fact, on a level of false rhetoric, so far from there being a separation of politics from poetry, there is a dangerous convergence. Marxism, because it regards history as malleable material to be manipulated by the creative will of the Marxist, is rich in this kind of raw material poetic thinking.

The temptation for the poet is to take over the rhetoric of political will and action and translate it into the rhetoric of poetry without confronting the public rhetoric of politics with the private values of poetry. If there is a sin common to poetry such as Auden's *Spain*, the anti-Semitic passages in Eliot's Sweeney poems, the political passages in Pound's cantos, Wyndham Lewis' adulation of what he calls "the party of genius" (meaning Michelangelo and Wyndham Lewis), Lawrence's worship of the dynamic will of nature's aristocrats (in *The Plumed Serpent*), certain of my own lines, it is that the poet has—if only for a few moments—allowed his scrupulous poet's rhetoric of the study of "minute particulars" to be overwhelmed by his secret yearning for a heroic public rhetoric. Sensibility has surrendered to will, the Keatsian concept of poetic personality to the dominating mode of character....

The reactionaries cared passionately for past values. Their nostalgia misled them into sympathizing with whatever jack-booted corporal or demagogue set himself up in defense of order. As the history of Ezra Pound shows, the results of this could be tragic. But they did put literature before politics, and their first concern was to preserve the civilization without which, as they thought, neither past nor future literature could survive. They did not, as the anti-Fascist writers did, abandon or postpone their literary tasks. For the anti-Fascists allowed themselves, rightly or wrongly, to be persuaded that civilization could only be saved by action: the logical consequence of this attitude was to put writing at the service of necessity as dictated by political leaders....

Pound, Wyndham Lewis and Roy Campbell were the only reactionaries whose public attitudes we sometimes attacked: with the mental reservation that we thought them zanies anyway. As for Eliot, Yeats and Lawrence, if one minimized their statements about politics, there was much in their deepest political insights with which we agreed.

> *Things fall apart: the centre cannot hold;*
> *Mere anarchy is loosed upon the world.*

This described our situation. By comparison the fact that Yeats went out and supported General O'Duffy seemed singularly irrelevant. No poem could show better than *The Second Coming* how wrong Orwell was to approach Yeats' poetry as a function of his Fascism. To us, his Fascism seemed a misconception arising from his deep political (and here the word seems quite inadequate) insight.

It is a pity that Mr. Harrison, instead of accepting at their face value labels like "left" and "reactionary," did not compare at a deeper level than that of political parties the social vision of the poets of the thirties and the older generation. He might have found then that the two generations often agreed in their diagnoses: they came to opposite conclusions with regard to remedies. He might also have found that the younger generation, in coming to their revolutionary conclusions, owed their view that we were living in a revolutionary situation to the insights of the reactionaries.

His biographers point out that John Cornford,[4] while he was still a schoolboy, was led to Communism by reading *The Waste Land*. "He believed it to be a great poem, read it not as a religious allegory . . . but as an anatomy of capitalist society in decay; it shaped his style, but more important, it was a preface to his politics."

...What was common to modern poets between 1910 and 1930 was their condemnation of a society which they saw as the disintegration of civilization. Given this agreed on line, it was possible to be on the reactionary or the socialist side of it. The reactionaries, on their side asked: "What of the past can be saved?" The socialists, on their side, asked: "How can there be new life?" The awesome achievement of the earlier generation was to have created for their contemporaries a vision of the whole past tradition which had a poignant immediacy: giving shattered contemporary civilization consciousness of its own past greatness, like the legendary glimpse of every act of his life in the eyes of a man drowning. Without the awareness of drowning, of the end of the long game, the apprehended moment could not have been so vivid. Thus the gloomy prophecies of the future, and the consequent weakness for reactionary politics, were the dark side of an intensely burning vision....

[4]Editors' note: A talented young English poet who died fighting on the side of the Loyalists in the Spanish Civil War.

The Strange Case
of Ezra Pound

The Partisan
Review Symposium

William Barrett, W. H. Auden,
R. G. Davis,
Clement Greenberg,
Irving Howe, George Orwell,
Karl Shapiro, and
Allen Tate

William Barrett's editorial in The Partisan Review *and the responses to it constitute an exciting symposium on the Pound award. Three of the respondents, Auden, Shapiro, and Tate, were Bollingen jurors.*

W. H. Auden is one of the leading poets of our time. His Collected Poetry *(1945) capped an established reputation, and* The Age of Anxiety *won the Pulitzer Prize in 1948. An Englishman who became an American citizen, he returned to England to become Oxford Professor of Poetry.*

Robert Gorham Davis is a well-known literary critic and is now Professor of English at Columbia University. In addition to his many articles of criticism he is known for his John Dos Passos *(1962) and his edition of* Ten Modern Masters *(1958).*

Clement Greenberg is, internationally, America's best known art critic and publicist for American vanguard painting and sculpture. Some of his best critical essays have been collected under the title Art and Culture *(1961).*

Irving Howe, author and critic, is Professor of English at Hunter College and has written ably and extensively on radical politics.[1]

George Orwell (1903–1950), English satirist, is widely known for his devastating attacks on totalitarianism, of which the best known is Animal Farm *(1946). His most famous work is* 1984, *a chilling warning of what could be in store for us. Orwell lived his convictions, risking his life fighting for the Loyalists in the Spanish Civil War.*

[1]Cf. below, pp. 276–287.

Karl Shapiro, American poet and critic, won the Pulitzer Prize for poetry in 1945. His Essay on Rime, *published in that year, caused a stir in literary circles. He is Professor of English at the Circle Campus of the University of Illinois.*

Allen Tate is one of the elder statesmen of American letters. One of the founders of the New Criticism stressing the exact and exhaustive analysis of literary texts, he is well known for his critical works as well as for his poetry.

William Barrett, whose editorial provided the text for the discussion which follows, is Professor of Philosophy at New York University and is well known for his Irrational Man *(1958) and* What is Existentialism? *(1964). He wrote a book-reviewing column for the* Atlantic Monthly *and was an editor of the* Partisan Review *from 1945 to 1953.*

William Barrett: A Prize for Ezra Pound

The awarding of a prize is a public act usually surrounded with many difficulties. When the prize is literary, there are not only all the difficulties that attend literary judgment, but the further complications from the fact that the judges, because of the public nature of the award, act both as citizens and literary critics.

The Bollingen Foundation has recently announced that the Bollingen Prize for Poetry, the first of an annual series, has been awarded to Ezra Pound for *The Pisan Cantos* as the best book of poetry published during 1948. The judges were the Fellows in American Letters of the Library of Congress, among whom are T. S. Eliot, W. H. Auden, Allen Tate, Robert Penn Warren, Katherine Anne Porter, and Robert Lowell. In the public statement accompanying the award the judges tell us that they were aware that the choice of Pound was likely to provoke objections, and their brief statement implies that they have given these objections careful consideration, ending with something like an affirmation of a general principle:

To permit other considerations than that of poetic achievement to sway the decision would destroy the significance of the award and would in principle deny the validity of that objective perception of value on which any civilized society must rest.

The sentiments behind this declaration seem to us admirable. Our only interest here is to insist on the application of this principle. Civilization is a difficult task for all of us, requiring that we live in many different domains of human life at once, in each of which we are called on to affirm the principle of the "objective perception of value." It would be a pity if in the enthusiasm of affirming an "objective perception of value" in one direction we ceased to affirm it in another; if in the aesthetic recognition of Pound's poetry as valuable we chose to forget all about the humanly ugly attitudes of which he has been a spokesman both in his writing and in his brief and lamentable career as a broadcaster.

In this number of *Partisan Review* we print a long essay on Pound's poetry by John Berryman. Our printing of this essay is an affirmation of our belief that independent aesthetic judgment must be the continuing task of criticism, and in this belief we are clearly in agreement with the attitude enunciated by the Bollingen judges. It is not likely that Mr. Berryman has said the last word in the criticism of Pound (in these matters there is never a last word), but it is likely that he has made

From *Partisan Review* (April 1949), pp. 344–347. Copyright © 1949 by *Partisan Review*. Reprinted by permission of the publisher and the author.

out the strongest possible case for Pound's having a subject matter as a poet. Mr. Berryman deals chiefly with the earlier and middle phases of Pound's career, and does not touch upon what Pound's subject matter became in recent years. This is perhaps incomplete, since our understanding of the whole career of a writer must surely take into view what his subject matter was capable of degenerating into under the pressures of personal and social disintegration. But whatever the critical truth here may be, it seems to us that Mr. Berryman's essay is in a different boat from the statement by the Bollingen judges, who were making a public award and were therefore more directly involved in public responsibilities.

Two things have to be, and are here distinguished: the case of Pound the man, and the value of the particular book, *The Pisan Cantos.* Pound the man has passed beyond the court of literary criticism into the jurisdiction of psychiatry and public justice, and it would be gratuitously vindictive for anyone to heap new tribulation on his wretched figure. Therefore our concern is, like that of the Bollingen judges, directly with the single book.

The statement by the judges shows an admirable frankness, but it is a pity that having gone so far in being frank, they did not go all the way, and actually name and face the specific objections they foresaw. The possible statement, which they might have made and the details of which each judge may have traced mentally, might then run something like this (considerations of style omitted):

"We are aware of the objections that may be raised concerning Pound's career as a fascist and anti-semite. However, under the terms of this award, we have confined our judgment to his poetry, and specifically the poetry found in the particular book under consideration, *The Pisan Cantos.* Of course, we have not missed the fact that this book itself expresses some of those unfortunate attitudes that led to Pound's downfall:

> *Petain defended Verdun while Blum*
> *was defending a bidet.*

These lines express a vicious anti-semitic lie that was a part of the official Vichy propaganda during the War. Nevertheless, under the terms of the award, our judgment is of the poetry as poetry, and therefore we cannot reject it because of political considerations.

"To be sure, we know that the matter of these lines is not a political belief (with which we might disagree), but a deep human attitude, an emotion of hatred that is hideous, ugly and vicious and is expressed even more painfully in other lines in the book:

> *the yidd is a stimulant, and the goyim are cattle*
> *in gt/proportion and go to saleable slaughter*
> *with the maximum of docility*

and again:

> *and the goyim are undoubtedly in great numbers cattle*
> *whereas a jew will receive information.*

But if the reader considers these verses carefully for their rhythm and diction, their effective use of a living colloquial language, he will be led to overlook, we think, the vicious and ugly emotion expressed.

"Our problem would be much easier if this were a dramatic poem, in which this odious human attitude was expressed by one of the characters with whom the author need not be in agreement. But *The Pisan Cantos* is a lyrical poem, or group of lyrical poems, in which Pound is expressing Pound, and this ugly human attitude expressed in the lines above is one that the poet seeks to convey as his own to the reader. This has been another difficulty we have had to surmount in making our award.

"Nor do we feel that the difficulty is overcome by saying, in excuse of Pound, that this hideous attitude is the expression of a pathological mind. We know that, however privately pathological this mind may be, the attitudes it expresses are historically connected with certain objective facts like six million Jews dead in Europe, in crematory ovens or battles of extermination; and historical facts like these make it immensely more difficult to perform that necessary aesthetic judgment that separates matter from form in a poem.

"All these difficulties might have been shirked if we had chosen not to make the award at all for the year 1948. Nobody compelled us to grant this prize. Under the terms of the award, the prize need not be given in a year when no book is deemed to meet critical standards. But it seemed to us more important that all the foregoing difficulties be met, and that in the interests of civilization the aesthetic principle be affirmed that a poet's technical accomplishments can transform material that is ugly and vicious into beautiful poetry."

Naturally, it would be foolish to expect any jury of selection ever to make a statement like this. Nobody is compelled to wear his complete honesty in public; it would be tedious to assemble such a costume, and tedious to have to observe it. The brief statement accompanying the award seems to show that the judges may have traversed these details involved in their choice. We hope that they did. We hope even more that all those persons interested in literature and "civilized society" who have read the news of the award and its accompanying statement will be moved to follow through the details of the judges' difficulties outlined above.

Every particular literary judgment brings us in the end to some question of principle, and we should not like to leave the Pound case without bringing out this general question to which it has led us. During the 'thirties literature was subjected uncritically to all kinds of aesthetically distorting or irrelevant political attitudes. These political attitudes have by this time collapsed, leaving behind them a deposit of vague sentimentalities which, while obstructing any current of new political thought, still makes it impossible for many people to separate aesthetic from other considerations. When a historical movement collapses, it seems, it does not leave even the virtues of its vices. The statement by the Bollingen judges shows a laudable intention to reaffirm the validity of aesthetic principles. Our history, however, would be incomplete if we did not notice that within American literary criticism over the past decade or more there has developed another attitude which is so obsessed with formal and technical questions that it has time for only a hasty glimpse at content. Given these two conflicting tendencies, the perennial question of form and matter in a literary work seems to be still with us and is perhaps not altogether solved by the brief statement of the Bollingen judges. The Pound case enables us to put it to aestheticians in this definite way:

How far is it possible, in a lyric poem, for technical embellishments to transform vicious and ugly matter into beautiful poetry?

Responses to the Question of the Pound Award

W. H. Auden: I fully share Mr. Barrett's concern over the excessive preoccupation of contemporary criticism with Form and its neglect of Content. I am not sure however that this is the precise problem which his comment raises. In stating my own views, I should like to emphasize that I am speaking purely for myself and am not to be construed as representing any other colleague with whom at any time I may have been associated.

1) According to one theory, art, both in intention and effect, is a means by which emotions are aroused in the spectator or reader, either in order that, by re-living them imaginatively, he may get rid of them, or because he needs to be roused to feel in a certain way. If this theory is adopted, then it seems to me that Plato and Tolstoy are irrefutable. No works of art may be permitted which do not purge men of their bad feelings and stimulate good ones. The criterion of value may vary—Plato thought the supreme value was love of justice and loyalty to the Good State, Tolstoy thought it was love of one's neighbor—but the principle is the same. Applied to the present issue, the conclusion would be obvious—no prize; suppression.

2) One may, on the other hand, hold another theory of art, that, in intention, at least, it is a mirror in which the spectator sees reflected himself and the world, and becomes conscious of his feelings good and bad, and of what their relations to each other are in fact. This theory presupposes, I believe, certain other beliefs into which there is no time to go now, beyond baldly stating them:

 a) All created existence is a good.
 b) Evil is a negative perversion of created good.
 c) Man has free will to choose between good and evil.
 d) But all men are sinners with a perverted will.

An art which did not accurately reflect evil would not be good art.

3) This does not dispose, however, of the question of censorship. Whatever its intention, a work of art cannot compel the reader to look at it with detachment, and prevent him from using it as a stimulus to and excuse for feelings which he should condemn. Everyone, I am sure, has had the experience of reading a book which he was aware, at the time or later, was bad for him personally, whatever its artistic merit, or however harmless it might be for others, because, in this case, he was not capable of exercising free will, and was therefore not reading it as a work of art. For instance, Baudelaire's poem *La Charogne* would not be healthy reading for a necrophilist. Antisemitism is, unfortunately, not only a feeling which all gentiles at times feel, but also, and this is what matters, a feeling of which the majority of them are not ashamed. Until they are, they must be regarded as children who have not yet reached the age of consent in this matter and from whom, therefore, all books, whether works of art or not, which reflect feeling about Jews—and it doesn't make the slightest difference whether they are pro or anti, the *New York Post* can be as dangerous as *Der Sturmer*—must be withheld.

If it were to seem likely that the *Pisan Cantos* would be read by people of this kind, I would be in favor of censoring it (as in the case of the movie, *Oliver Twist*).

From *Partisan Review* (May 1949), pp. 512–522. Copyright © 1949 by *Partisan Review*. Reprinted by permission of the publisher and the authors.

That would not however prevent me awarding the *Pisan Cantos* a prize before withholding it from the public. But I do not believe that the likelihood exists in this case.

Robert Gorham Davis: The Pound award, it seems to me, is not most profitably taken as a problem in aesthetics. When form and content or free will and determinism or nominalism and realism are allowed to fall into this kind of abstract polarity, they can be argued about fruitlessly until doomsday. What confronts us in the Pound case is a complex of ideas dominant in American criticism during the forties, and made so largely by the talents and critical activities of some of the judges, of Eliot, Auden, Tate and Warren. The judges were judging themselves along with Pound, their master. But nearly everyone in America who is serious about literature is involved in one way or another.

The complex of ideas I speak of has been promoted with tactical skill, group movements, concerted attacks and extremes of mutual laudation. Snobbery and prestige have counted heavily. But it is not a conspiracy. There are truths in it, and much immediate support from the particular history of our time. It asserts that living language, literary sensibility and poetic values are supported by the traditional, the Catholic, the regional, the mythic, the aristocratic, and by a sense of the tragic, of transcendental absolutes, of sin and grace. Language and sensibility and values are destroyed by rationalism, liberalism, positivism, progressivism, equalitarianism, Shelleyanism, sociology, and the ideology of the Enlightenment. This has been made explicit by Eliot in *After Strange Gods* and *The Idea of a Christian Society;* by the Southern Regionalists, including Tate and Warren in much that they have written since their first manifesto *I'll Take My Stand,* and by Auden in the Herod-as-liberal speech in *A Christmas Oratorio* and in the various reviews urging liberals and reformers to go jump in the lake.

In this complex of ideas the antisemitism with which William Barrett is principally concerned has a vital part. For these ideas did not originate with Eliot or Pound or Hulme, but with the French reactionary critics at the end of the nineteenth century, and were made into a program of action by Charles Maurras of whom Eliot used to speak with favor in *Criterion* days. Under the influence of Maurras, the virulently antisemitic students of the *Action Francaise* stormed the Sorbonne, beat up liberal professors, and howled down plays by Jewish writers, as untroubled as their Fascist and Nazi successors by problems of form and content. This mob antisemitism was the antisemitism of Pound's broadcasts when he, like Maurras, became a traitor both to his country and humane culture. (John Berryman's extenuating all this in *Partisan Review* by comparing Pound to Roger Casement is one of the more fantastic examples of the way we are all involved.)

Eliot's antisemitism is different in kind but just as essential in his poetry and social ideas. Awed by his great achievements, fearful of showing insensibility, of introducing irrelevant "liberalism," most critics have accepted this in Eliot's terms. As homeless cosmopolitans and usurers, the Bleisteins and Sir Ferdinand Kleins represent the debasements of modern commercialism. As intellectuals, the Jews are the foremost carriers of disintegrative rationalism, earthly messianism. For the Southern Regionalists, Negroes are less interesting ideologically, but equally outside the tradition, and not to be made part of it by any liberal rhetoric.

Here we have not a question of form and content, of purity in art, but of the requirement of certain social attitudes, particularly ethical and communal ones, for literature, and rejection of certain others. These are programmatic demands, which are quite separable from the real achievements and values which they rationalize or

exploit. Such demands can be refuted even by the example of many of the masters these critics claim as their own, and they are inapplicable to whole areas of literary experience which these critics under-value or ignore. If Ezra Pound's *Cantos* are read with a wider literary and historical sense than the "new criticism" permits, they gain in meaning. As poetry they fail, despite Pound's sensibility. Their incoherence is real incoherence; it is not "achieved form." But against the author's intention they are highly revealing. They are a test case for a whole set of values, and stand self-condemned. They are important documents; they should be available, they should be read. But they deserve no prize.

Clement Greenberg: I agree with Mr. Barrett. The Fellows in American Letters should have said more—that is, if they had more to say, and they should have had. As a Jew, I myself cannot help being offended by the matter of Pound's latest poetry; and since 1943 things like that make me feel *physically* afraid too.

I do not quarrel here with the Fellows' aesthetic verdict, but I question its primacy in the affair at hand, a primacy that hints at an absolute acceptance of the autonomy not only of art but of every separate field of human activity. Does no hierarchy of value obtain among them? Would Mr. Eliot, for instance, approve of this for his "Christian society?"

Life includes and is more important than art, and it judges things by their consequences. I am not against the publication of *The Pisan Cantos,* even though they offend me; my perhaps irrational sensitivity as a Jew cedes to my fear of censorship in general, and to the anticipation of the pleasure to be gotten from reading poetry, and I have to swallow that consequence. But I wish the Fellows had been, or shown themselves, more aware of the additional consequence when they awarded their Bollingen Prize. They could have taken greater trouble to explain their decision and thereby spared me, and a good many Jews like me, additional offense. (This does not mean, necessarily, that I am against the award itself.)

In any case, I am sick of the art-adoration that prevails among cultured people, more in our time than in any other: that art silliness which condones almost any moral or intellectual failing on the artist's part as long as he is or seems a successful artist. It is still justifiable to demand that he be a successful human being before anything else, even if at the cost of his art. As it is, psychopathy has become endemic among artists and writers, in whose company the moral idiot is tolerated as perhaps nowhere else in society.

Although it is irrelevant to the discussion, I must not let fall the opportunity to say at this point that, long before I heard of Pound's fascist sympathies, I was struck by his chronic failure to apprehend the substance, the concrete reality, of the things he talked about or did. I feel this failure in his poetry just as much as in what he wrote about painting and music. As a poet he seems to me to have always been more virtuoso than artist and to have seldom grasped the reality of the poem as a whole, as something with a beginning, middle, and ending. Thus, usually, any line or group of lines of a poem by Pound impresses me as superior to the whole of which it is part. (I would, however, except the "Mauberley" poems and several others of the same period from this stricture.)

Irving Howe: That "a poet's technical accomplishments can transform material that is ugly and vicious into beautiful poetry" is at least possible; but *how far* (as Mr. Barrett asks) he can do so I hardly know. One things seems certain: Pound hasn't done it. There is nothing very beautiful in "the yidd is a stimulant," though there is in "pull down thy vanity." Pound the crank is only rarely Pound the poet.

Doesn't this split in Pound make possible a justification of the Bollingen award? I think not. I would move beyond Mr. Barrett's question and assume that the *Pisan Cantos did* contain the best poetry of 1948. That does not yet settle the question of whether Pound should have been given the award. For while believing in the autonomy of aesthetic judgment, I believe in it so deeply that I also think there are some situations when it must be disregarded.

I am against any attempt to curtail Pound's rights to publish, and I don't want to see him prosecuted. (I don't like police measures; and cops aren't qualified to handle poets, not even mad or fascist poets.) I am, however, also against any campaign to condemn the Bollingen judges. What is involved in the Pound case is not a matter for public action but for a dialogue of conscience. But while defending Pound's rights, I could not in good conscience acquiesce to *honor* him with a literary award—which, if you please, must also mean to honor him as a man.

To give Pound a literary prize is, willy-nilly, a moral act within the frame of our social world. To honor him is to regard him as a man with whom one can have decent, normal, even affectionately respectful human and intellectual relations; it means to extend a hand of public fraternity to Ezra Pound. Now a hand to help him when he is down, yes. A hand to defend him from censors, fools and blood-seekers, yes. But a hand of honor and congratulations, no. For Pound, by virtue of his public record and utterances, is beyond the bounds of our intellectual life. If the judges felt that he had written the best poetry of 1948, I think they should have publicly said so—but not awarded any prize for the year. That might, by the way, have been an appropriate symbol of our cultural situation.

My position has, I know, grave difficulties and can easily lead to abuse. Once you consider extra-literary matters in a literary judgment, where do you stop? You stop at the point where intelligence and sensibility tell you to—that is what they are for. But it would be absurd to deny that there are occasions when aesthetic standards and our central human values clash, and when the latter must seem more important. On such painful occasions one can only say: not that I love literature less, but that I love life more. Is there any other way of taking literature seriously?

George Orwell: I think the Bollingen Foundation were quite right to award Pound the prize, if they believed his poems to be the best of the year, but I think also that one ought to keep Pound's career in memory and not feel that his ideas are made respectable by the mere fact of winning a literary prize.

Because of the general revulsion against Allied war propaganda, there has been—indeed, there was, even before the war was over—a tendency to claim that Pound was "not really" a fascist and an anti-semite, that he opposed the war on pacifist grounds and that in any case his political activities only belonged to the war years. Some time ago I saw it stated in an American periodical that Pound only broadcast on the Rome radio when "the balance of his mind was upset," and later (I think in the same periodical) that the Italian government had blackmailed him into broadcasting by threats to relatives. All this is plain falsehood. Pound was an ardent follower of Mussolini as far back as the nineteen-twenties, and never concealed it. He was a contributor to Mosley's review, the *British Union Quarterly,* and accepted a professorship from the Rome government before the war started. I should say that his enthusiasm was essentially for the Italian form of fascism. He did not seem to be very strongly pro-Nazi or anti-Russian, his real underlying motive being hatred of Britain, America and "the Jews." His broadcasts were disgusting. I remember at least one in which he approved the massacre of the East European Jews and "warned" the American Jews that their turn was coming

presently. These broadcasts—I did not hear them, but only read them in the BBC monitoring report—did not give me the impression of being the work of a lunatic. Incidentally I am told that in delivering them Pound used to put on a pronounced American accent which he did not normally have, no doubt with the idea of appealing to the isolationists and playing on anti-British sentiment.

None of this is a reason for [not?] giving Pound the Bollingen Prize. There are times when such a thing might be undesirable—it would have been undesirable when the Jews were actually being killed in the gas vans, for instance—but I do not think this is one of them. But since the judges have taken what amounts to the "art for art's sake" position, that is, the position that aesthetic integrity and common decency are two separate things, then at least let us keep them separate and not excuse Pound's political career on the ground that he is a good writer. He *may* be a good writer (I must admit that I personally have always regarded him as an entirely spurious writer), but the opinions that he has tried to disseminate by means of his works are evil ones, and I think that the judges should have said so more firmly when awarding him the prize.

Karl Shapiro: Mr. Barrett's analysis of the Pound award seems to be on the safe side, but his extension of the official statement of the Fellows makes it clear that we are dealing with the *pons asinorum* of modern criticism.

I voted against Pound in the balloting for the Bollingen Prize. My first and more crucial reason was that I am a Jew and cannot honor antisemites. My second reason I stated in a report which was circulated among the Fellows: "I voted against Pound in the belief that the poet's political and moral philosophy ultimately vitiates his poetry and lowers its standards as literary work." This statement of principle I would place against the official statement of the Fellows, which seems to me evasive, historically untrue, and illogical. That it was a successful device in placating opinion you know. The newspaper editorials I saw all rejoiced in "the objective perception of value on which any civilized society must rest" and I heard one radio commentator remark benignly that "this could never happen in Russia."

What appeased the journalists must have been their belief that Pound, despite his unintelligibility to them, is on the side of beauty or "technical excellence." The Fellows and the newsmen meet at the point where an unspecified technical excellence is accepted by the lay reader as successful (i.e., "beautiful") poetry. What the journalists think would not matter very much, but Mr. Barrett follows the same line of reasoning. "How far is it possible, in a lyric poem," he asks, "for technical embellishments to transform vicious and ugly matter into beautiful poetry?" Shouldn't the question rather be: Through his experience with vicious and ugly ideas, what poetic insights into our world has this poet given us? Pound's worth as a poet rests upon some answer to such a question.

Another question is well worth asking, namely, how objective could the Fellows be in a decision of this kind? If we consider a work for literary merit alone (whatever that may mean) we imply a personal decision to disregard the mythopoeic and moral function of the artist. If Pound had sufficient intellectual honesty, he would be the first to oppose such a criterion of selection.

The jury that elected Pound was made up partly of Pound's contemporaries, those who had come under his influence as impresario and teacher, those who had at some time made declarations of political reaction, and those who had engaged in the literary struggle to dissociate art from social injunction. The presence of Mr. Eliot at the meetings gave these facts a reality which perhaps inhibited open discussion. For reasons of personal loyalty, which one must respect, and for reasons

of sectarian literary loyalty, which one may or may not respect, few poets anywhere are in a position to say what they really think of Pound's work. But eventually what the serious well-intentioned critic admires in Pound is his aesthetic integrity. It is curious to see the flower of this integrity grafted onto criminality, but this should not lead us to the conclusion that artists can be criminals without incriminating their art.

The technical charge of treason against Pound is not our concern, but all artists should stand against this poet for his greater crime against civilization. Let the same charge be laid against Stalinist artists. But even if we claim to be objective perceptionists about it, let us at least ask ourselves whether fascism is or is not one of the "myths" of *The Cantos*. Who will deny that it is?

Allen Tate: I do not propose to express any extensive views on Mr. Barrett's article, but rather to set down a brief statement of my own position on the only serious question that it raises.

A few weeks before the Bollingen Prize was awarded some persons of antisemitic feelings expressed to me their alarm lest it be given to Mr. Pound.

Mr. Barrett, it seems to me, goes a long way round, through a good deal of cant and vulgarity (to say nothing of the effrontery with which he invents the "difficulties" of the Fellows in coming to their decision), in order to arrive at the following insinuation: The decision of the Fellows in American Letters of the Library of Congress was dominated by antisemitic prejudice.

I consider any special attitude toward Jews, in so far as they may be identified as individuals or as a group, a historical calamity; and it is not less calamitous when the attitude is their own. I consider antisemitism to be both cowardly and dishonorable; I consider it cowardly and dishonorable to insinuate, as Mr. Barrett does, without candor, a charge of antisemitism against the group of writers of which I am a member.

I hope that persons who wish to accuse me of cowardice and dishonor will do so henceforth personally, in my presence, so that I may dispose of the charge at some other level than that of public discussion. Courage and honor are not subjects of literary controversy, but occasions of action.

Rejoinder by William Barrett: I am not a Jew, but surely it must be clear to everyone by this time that antisemitism is a problem for gentiles as much as for Jews. When Jews whom I know and respect feel uneasy, as Mr. Clement Greenberg does, about a public award to Pound, I am bound to feel uneasy myself and to question the judgment of the Bollingen jury. Some of these questions I tried to raise in my brief comment. Mr. Tate's explosion in reply seems to us astonishing, to say the least. Neither Mr. Auden nor Mr. Shapiro, who were his colleagues on the Bollingen jury, have responded in his fashion; and the fact that among all the foregoing comments Mr. Tate's alone sticks out like a very sore and angry thumb is sufficient evidence that his reply was a complete and unwarranted misconstruction of my editorial, which contained absolutely no allegation whatever of antisemitism on the part of the judges. The question was, and is, the public wisdom of an award to Pound, and not the private psychology of the judges. It is Mr. Tate who has injected the personal issues. Surely Mr. Tate must recognize that he has a public responsibility to answer, not me personally, but all those people who have not forgotten what happened in Germany during this last War and who, like Mr. Greenberg, feel threatened by an award to Pound. Mr. Tate still has the opportunity open to him to offer a reasoned justification of the award, and we hope that he will

do so. In the meantime, his challenge to a personal duel is strictly extra-curricular sport—having nothing to do with the public issue.

The comments explain themselves sufficiently so that it is unnecessary for me to linger in detailed examination of all of them. I should like to confine the rest of my remarks to the statements by Mr. Davis and Mr. Auden.

I agree with Mr. Davis that the context in which this question is raised has to be extended to include the historical circumstances that now condition literary judgment in the United States. What the present controversy demonstrates is that the category of the aesthetic is not the primary one for human life, and that the attitude which holds aesthetic considerations to be primary is far from primary itself, but produced by very many historical, social, and moral conditions. It would be hard to define just what the reigning climate of opinion has become in literary America since the collapse of the 'thirties; but perhaps it is high time we sought to establish a new climate, beginning with a re-examination of some of these "non-aesthetic" bases of literary judgment.

Mr. Auden's letter is the kind of rational, impersonal, and calm justification of the prize that we had hoped to have from Mr. Tate. I respect Mr. Auden's position, but I am not altogether convinced by his arguments. I would agree with everything that he says if the question had been one of censorship. But the question I raised was not one of suppressing Pound's book but of publicly honoring it with a prize. Mr. Auden's jump—"no prize; suppression"—is his own inference and not mine.

This point must be stressed since, as Mr. Shapiro remarks in his comment, some people are glad to celebrate the awards for Pound just *because* it seems a triumph of liberalism. Such is the line taken by Mr. Dwight Macdonald, who in an editorial in his magazine *Politics* finds the award "the brightest political act in a dark period." One can be in favor of the prize for Pound and still find Mr. Macdonald's enthusiasm here just a little extreme. I am against censorship in principle even though in particular cases it might be publicly beneficial, because censorship, once invoked, is difficult to control and therefore dangerous. I think this is as far as liberalism need go. To push it further is to indulge in a bohemian attitude of liberalism for liberalism's sake, which can become as unbalanced as the traditional attitude of art-for-art's sake, or of any part of life for that part's sake as abstracted from the whole. Liberalism is urged here to countenance things that deny its own right to exist—and for no other purpose but to show off. There is a kind of childishly competitive bravado in this need to show that one can outliberal all other liberals. One step further, and Mr. Macdonald will be seeking out for a prize a *bad* poet who expresses antisemitism just in order to show how liberal he (Macdonald) can be.

Mr. Auden makes his most significant point, I think, when he argues that because evil is a part of life we have often to place great value upon works of art that do express evil attitudes. I agree with him in this, and I also agree that in his example of Baudelaire's *La Charogne* much of the power of this poem does derive from the fact that the poet participates, up to a point, in the emotions of necrophilia. For the aesthetic exploration of his subject matter the poet identifies himself with the emotions he expresses. But I doubt very much that one can call Baudelaire a necrophilist in the same public sense in which one can call Pound an antisemite. Moreover, it seems to me to make a difference that necrophilia (so far as I know) has not been connected in our time with any large political movements, necrophiliac speeches have not been broadcast over the radio, and there are not large numbers of decent people who feel that their lives are threatened by necrophilists. Thus Mr. Orwell's remarks about Pound's broadcasts do not seem irrelevant to the present

problem: the antisemitic lines I quoted from *The Pisan Cantos* simply versify statements made by Pound in his broadcasts to the effect that the War was brought about by the Jews, for whose interests American soldiers were being killed like cattle. In comparison, necrophilia still remains a private evil.

Since the discussion has unfortunately brought out some acrimony, I am glad to resign my part in it on at least one note of unqualified admiration—and that is for Mr. Karl Shapiro's comment, which is the kind of courageous and outspoken statement that has become a rare thing on our literary scene. I would agree with Mr. Shapiro that he has made a much better statement of the question of form and content in a literary work than I did in my Comment. I also think with him that fascism is part of the "myth" of the *Cantos* generally—and that it can be found in *The Pisan Cantos* too.

Pure Poetry and Impure Politics

Peter Viereck

Peter Viereck (1916–), historian and poet, has published widely and made an early reputation, especially as a poet. A professor at Mount Holyoke College, interested in history, politics, and letters, he has been in demand as a lecturer and as an exponent of conservative politics. Viereck became an important spokesman for the "New Conservatism" and wrote several books on the subject, of which The Shame and Glory of the Intellectuals *(1953) and* Conservatism and the New Conservatives: What Went Wrong *(1962) attracted much attention. For all his sympathy with the New Conservatives, Viereck is well disposed to liberal ideas and liberals and is willing to criticize whatever offends him, whether on the left or the right. The issues raised by the Pound case prompt him to question here whether ethics and aesthetics are completely separable. The answer to that question has implications which extend far beyond the merits of the Pound award.*

I

The awarding of the Bollingen prize for American poetry to Ezra Pound in 1949 aroused a controversy that is still very much alive. At the outset, the question at issue was whether a poet who in his work expressed fascist and anti-Semitic views, and who during the war had broadcast over the Rome radio applauding the Nazi extermination of Jews, was a suitable recipient for a prize. However, the controversy broadened out wildly on both sides: the opponents of the award in some cases used the occasion for a general unfair attack on the whole body of modern poetry, while the supporters of Pound responded with an uncompromising aestheticism that in fact has often ceased to be aesthetic and bordered on the political.

From *Dream and Responsibility* by Peter Viereck (Washington, D.C.: The University Press of Washington, D.C., 1953), pp. 3–22. Copyright 1953 by Peter Viereck. This essay appeared in magazine version in *Commentary* (April 1951); copyright retained by author. Reprinted by permission of the author.

Pound himself opposes *l'art pour l'art.* But some defenders of the Bollingen Award to his pro-fascist *Pisan Cantos* seem to believe that beauty is 100 per cent separate from life, that great art is 100 per cent separate from the greatness of its artists, that greatness is not a moral term, or that aesthetics is 100 per cent separate from ethics. The issue raised by these separations is no mean one. Not necessarily 100 per cent (I concede) is involved but a matter of degree. Because the issue is so important, it is wrong to dismiss the Pound controversy as a tempest in a teapot. The tempest is real. It is important. It must not be "tactfully" allowed to die down before its implications have been thought through. In contrast with the above separations, I believe that beauty is life-enhancing and not life-indifferent. I believe that aesthetics partly overlaps with ethics. I believe that greatness is more often found inside this area of overlapping than outside it. I believe that the *realness of values* underlies art as it underlies politics, though more often semi-consciously than consciously and far more effectively when implied than when stated.

Toward Pound *personally,* my own chief reaction is one of compassion for his present situation, a compassion that has no room for political recriminations and that is intensified by my grateful admiration for the delicate lyricism of his middle period (post-Imagist and pre-canto). But primarily these pages do not deal with Pound personally, nor with political implications. They deal with the *impersonal ethical and aesthetic implications* raised for poetry as a whole by the Pound controversy. And these impersonal implications should be debated on a relatively objective level, where all concerned try to set aside their subjective reactions toward Pound, whether pro or con. The position which I took in the public Pound controversy of 1949–51, and which is here elaborated and broadened, is to subordinate so-called "pure" art to ethics—or, more precisely, to subordinate "pure" art to an admittedly unpure art in which the two realms of ethics and aesthetics overlap to each other's mutual benefit.

The violent reaction of the quarterlies against my above position has only underlined the fact that my choice was on the unpopular and almost completely isolated side of a dispute in which the "pure" *l'art-pour-l'art* side was supported belligerently and sincerely (though mistakenly, I do believe) by almost all of our finest poets and critics. These excellent writers, by an overwhelming and articulate majority, were *justifiably* indignant (via ably-organised protests and resolutions) against the unjust, demagogic slanders of their motives and of all modern poetry which the wrong (or philistine) kind of anti-Poundians interjected into what should have remained a seriously philosophical dispute. To these perfectly valid considerations and indignations of the pro-Poundian majority, I have always attached every bit as much weight as they do.

However, I attach even more weight to the following considerations: all human beings, including poets, who enjoy the privileges of a free society, ought to make their freedom-enjoying privileges be equaled by their freedom-defending duties (provided, always, that these duties are undertaken individually and voluntarily, not under state coercion or blind conformism). Art withers under any kind of conformist totalitarianism, whether the communist version, celebrated by fellow-traveller literati, or the fascist-racist version, celebrated by Pound's *Pisan Cantos.* The free artist, like any other free individualist, has a moral responsibility against the evil of either version; not mere politics but the nature of evil is an issue raised for thoughtful debate by these prize-winning Cantos.

The important parenthetical proviso in the above paragraph ought not to get lost in the shuffle. Namely: "provided, always, that these duties are undertaken individually and voluntarily, not under state coercion or blind conformism." This

proviso rules out the coercive statists of "proletarian verse," who were influential in the "sing me a song of social significance" era, the now half-forgotten 1930's. Although the economics-oriented position of this school would condemn the Bollingen award and Pound's message as much as would my own ethics-oriented position, yet their position is based on political and economic dogma exclusively and not on a primary concern with poetry, whereas I am assuming that the primary concern of poetry criticism is poetry. (By "poetry" I mean not the "pure" poetry of those who narrowly contemplate formalistic technical tricks but the full vital poetic experience in which ethics, aesthetics, and sheer humanness overlap.) Therefore, the "proletarian verse" Marxists of the 1930's were right about Pound for the wrong reasons (too narrow political reasons, indifferent to the dignity of lyricism as a self-justified genre), while the New Critic formalists are wrong about Pound for the right reasons (at least they are concerned with the dignity of poetry, not with degrading it to soap-box propaganda).

And even if we argue not on the level of poetry but on their own political-economic level, these coercive statists of the far left are unimpressive as friends of liberty, insofar as they would condemn Pound and fascism not for the sake of the free individual but merely for the sake of an equally conformist left-wing totalitarianism. The free, ethical, nonstatist position condemns tyranny simply because it is tyranny, regardless of whether the tyrant is so-called left or so-called right. This much, however, can be said in favour of the Marxist critics and the formalist critics: each group points out unerringly the fatal onesidedness of the other....

II

Not even Ezra Pound's most intolerant belittlers have ever been able to deny his trail-blazing function, whether or not they like his trails. Therefore one wonders what his feelings must be at watching his pious, humorless disciples—for example, in the recent symposium *An Examination of Ezra Pound*—turn his rebellious originality into a frozen image as stereotyped as that of the Georgians and late-Victorians whom he overthrew. The contrast between his vitality in the 1920's and the stuffiness of his present praetorian guard is brought out by reading his vivid collected *Letters,* also recently published, side by side with *An Examination.* The former book is alive. Much of the latter book is dead with precisely that kind of pompous, pretentious, deadly deadness that Pound was overthrowing in 1913.

...Both friends and foes of his Bollingen prize award will find effective new ammunition in the symposium. You can prove Pound's disciples to be pure aesthetes or anti-Semitic fascist sympathizers, depending on which particular essays you pick from the book. If you pick Edith Sitwell's chapter, for example, you will find a brilliant appreciation of Pound's artistic techniques, the kind of appreciation that—basing itself on the noble if unreal assumption that art is radically distinct from life—motivated the original Bollingen award. However, not all the contributions are of the same order as Edith Sitwell's. If you turn to certain of the others (perhaps closest to Pound's own intention), you find Pound's fascism and anti-Semitism accepted as inseparable from his poetry. Reading these disciples, one is forced to wonder to what extent his chichi "anti-usury" gospels are catching on among the more "advanced" English students and the *avant-garde.* As Robert Gorham Davis has noted ironically, in a review of the book: "After the long religio-critical hiatus of the forties, it is now proper, as in the thirties, to tie up literature with political reform. But what reform it is! ... Pound is made the master

again, and Eliot the shrewd and talented disciple. Money Reform and Fascism become more fashionably topical than Original Sin and Anglicanism."

From the *Examination* symposium, let us cite a few examples of this new topicality. John Drummond finds "cogent reasons for Pound's admiration of Fascism" and coyly suggests that Italy's lack of new ideas "almost forces one to maintain that Fascism's greatest crime was not that it was too hard on the Italians but that it was not hard enough." Max Wykes-Joyce sees Pound's message on fascism and usury as an essential part and purpose of his *Cantos,* and declares: "Fascism carried the implication of something positive....It was based on the progressive prosperity of the whole people; it typified for the many honest Fascists what Pound calls 'the increment of association,' that economic element possible only in a group of people working towards a common end: thus 'the increment of building.'...His detestation of universal usury accounts for his anti-Semitism. That he is not racially anti-Jewish can be abundantly proved....Among the usurers, however, there are so many Jews; and against that sort of Jew Pound is justly merciless."

"Merciless" is a strong word. Does the "just" kind of mercilessness include the torture and gassing and burning alive of millions? Pound himself evidently thought so when on the Rome radio he approved of the Nazi extermination of Jews.

In the same symposium, Henry Swabey is another who puts first stress on Pound's supposed political wisdom. Swabey denies that Pound was "an advocate of despotism" and then quotes without demur a panegyric of Mussolini's movement by the Fascist propagandist Signora Agresti. Both Wykes-Joyce and Swabey gloss over Pound's racism by asserting that—some of his best friends were Jews! Swabey adds such *non sequiturs* as that Pound "is far less consciously 'racial' in outlook" than was the Jewish statesman Disraeli. With great enthusiasm he cites the isolationist attacks of the Roosevelt-haters on Roosevelt's "aggressive" foreign policy, and on the "distasteful facts about Pearl Harbor," in order to prove a fact that is unfortunately all too true: "Pound is not the solitary crotchet that the mesmeric press would have us believe and was certainly not alone among Americans in deploring Roosevelt's policies." With a prim contempt for this decadent democracy of alleged rackets and racketeers, Swabey concludes that ideologically "Pound is a genial, if exacting, guide and, although vilification of him and his work is the latest 'racket' in America, one who has studied his work cannot quit the subject without a word of gratitude."

There is also Peter Russell, earnest and sincere editor of *An Examination,* founder of the Ezra Pound Society of London, who has arranged for publication in England of some of Pound's pro-Axis and allegedly treasonable broadcasts from Radio Rome. Russell says gleefully of the *Cantos* what the anti-Poundians dolefully have been maintaining all along: "To try to separate the poetic essence from the didactic substance of the poem would be valueless pedantry or, at best, adolescent romantic aestheticism." Exactly!

It is not intended to suggest by these quotations that a purely literary appreciation of Pound is impossible. It goes without saying that the valuable firm of New Directions—which published the *Examination*—and its able editor, James Laughlin, have no use whatever for fascism or racism. Moreover, in this same *Examination,* Hugh Porteus, Hugh Kenner, G. S. Fraser, and others offer mainly literary insights. Only a witch-hunt mentality could accuse them of sharing the views of Russell, Swabey, Wykes-Joyce, etc., merely because they all appear in the same book. Examples of both types of Poundians can be multiplied *ad infinitum* if we begin citing the Little Magazines. The fairest thing is to recall that the world

contains both Gentle Poundians (the pure aesthetes) and Tough Poundians (those who find in his "just mercilessness" to Jews and usurers a "genial guide"). And both can validly quote scripture (the Book of Ezra?) to their purpose.

Similarly, to draw a strikingly relevant parallel, there were Gentle Wagnerians (those who loved Wagner as a pure musician) and those Tough Wagnerians who preached his proto-Nazism and anti-Semitism and who included Houston Stewart Chamberlain and Adolf Hitler. In Wagner's day those who, like Nietzsche, prophetically feared Wagner's political influence were ridiculed: how could a "crank artist" ever be a political "danger"? Yet in the century that followed, Wagner's metapolitical credo became the main fountainhead of Hitler's ideology. The prior example of Wagner is perhaps an answer and warning to the Gentle Poundians, who sincerely detest Pound's fascism but deem it no future menace in America.

On the other hand, much of the moralizing hue and cry against Pound's fascism and Jew-baiting comes not from sincere anti-fascists but from the envy with which the dwarfs of mediocrity forever regard originality and experimentalism in art. Without telepathy and an impossibly subtle lie-detector machine, we cannot estimate exactly how much of the anti-Pound hue and cry can thus be explained, but certainly a high percentage is involved.

Such is the company one inevitably gets oneself into. Philistia, for example, would exploit my own objections to Pound's receiving the Bollingen prize in a fashion never intended by me: namely, as a demagogic weapon against everything original and novel in poetry, everything that challenges the reader to effort. Yet this playing into wrong hands, though admittedly a danger, is not an ineluctable danger. It all depends on how the matter is handled....

III

The position of really serious, non-philistine opponents of the Bollingen prize gets so misrepresented in most periodicals that the following must be stressed (though it ought not to be necessary to stress it): most of us were never impugning the committee's motives or indicting all modern poetry. For us the issue is whether, as some of the school of "New Critics" believe, form and technique can be considered apart from content and meaning. The sympathies of the committee were not with Pound's politics. Judging by their much debated press release, their sympathies were with the widely held belief—a belief I consider unhistorical and psychologically false but not at all "fascist"—that artistic form can be considered apart from its content and moral meaning.

But it should have been clear that the *Pisan Cantos* were far from being a non-political ivory tower of pure aesthetic formalism. On the contrary, fascism and anti-Semitism compose one of the essential "myths" of these and the earlier *Cantos*. Both earlier and later *Cantos*—and no question of insanity arises with the earlier ones—proclaim that same fascism and racism which Pound preached over Mussolini's radio....

Obviously, Pound has a right to publish anything whatever, with any opinions whatever. But should he also get a prize for it? Perhaps yes, if it were for his distinguished literary career as a whole. Unfortunately, the Bollingen prize was solely for one book: *The Pisan Cantos;* and while poems of aesthetic intention must be judged aesthetically, regardless of their author's politics, Pound's prize-winning poem was not intended as purely aesthetic. Its message politically was that Mussolini was martyred and World War II caused by Jews: "the goyim go to

saleable slaughter" for "the yidd," known as "David rex the prime s.o.b." This is politics, not serious poetry, hence not exempt from ethical, as well as aesthetic, condemnation.

Whether from a famous coterie-protected poet, or from a mere "low-brow" Gerald L. K. Smith, such racist propaganda must be protested by those to whom a simple human compassion for Hitler's millions of tortured victims is the deepest emotional and moral experience of our era. What, indeed, is our urgently necessary zeal against Communism but this same heart-breaking distress over inhumanity? To fellow authors who indiscriminately blacken the motives of all critics of the *Pisan Cantos,* we ask in good will one simple question:—is it anti-poetic and philistine to feel rather violently about the *Pisan Cantos* and other influential neo-fascist revivals when one hears of an ex-Nazi official boasting this year in Frankfort that, when Jewish mothers asked him where their missing two-year-old babies went, he replied: "Up the chimney!"

IV

Message aside, there is much downright bad writing in the *Pisan Cantos.* William Barrett has asked, "How far is it possible, in a lyric poem, for technical embellishments to transform vicious and ugly matter into beautiful poetry?" But really, now, would even the proverbially objective observer from Mars, utterly free from anti-fascist "prejudices," be able to find any "technical embellishments" or "beautiful poetry" in the following lines from the *Pisan Cantos:* "Petain defended Verdun while Blum was defending a bidet"; "Geneva the usurers' dunghill/Frogs, brits, with a few dutch pimps."

Nevertheless, the bad writing of most of this book is a point I raise only in passing and one I am unwilling, though not unable, to stress. Stressing it would reduce the argument over Pound to too easy a plane. If the book (as I believe) is badly written, then even the advocates of art for art's sake would oppose its award. The problem is made more difficult for those who opposed the award—more difficult but also more important and basic—if we temporarily pretend "for the sake of the argument" that it *is* well written and then add: *even in that case* we would oppose the award. Not on political grounds. *Poetry must never be judged by politics.* But on grounds that *our entire civilization,* including poetry, depends almost completely on our constantly maintaining a moral heritage which Nazi anti-Semitism would destroy.

Anti-fascist admirers of Pound, writing in honest bewilderment, have asked me personally why Pound's fascism, though admittedly evil, should spoil his poetry for me when the anti-democratic views and alleged "bad politics" of Dante or Shakespeare obviously do not spoil their poetry for me in the slightest. The answer is that genocidal anti-Semitism is not, except ephemerally and superficially, politics at all but a uniquely obscene anti-ethics, a metaphysics of satanism. There is no such metaphysics, no such ethical obscenity basic to Dante or Shakespeare; one may disagree with their monarchism, but this disagreement does not affect the value of their poetry; no basic challenge to civilization is involved in it.

V

A seemingly more telling argument on the part of the defenders of the Bollingen prize is to recite the familiar list of the great and admittedly moral authors of the past who happened to dislike Jews. But is it really fair, in defense of Pound and of

his award, to cite the anti-Semitism and anti-usury of Shakespeare's *Merchant of Venice*? One contributor to *An Examination of Ezra Pound* does so almost gloatingly, and indeed the Nazis during the war performed the *Merchant of Venice* with glee. Does this analogy undermine Shakespeare in our regard or bolster Pound? Or is it false and misleading?

Probably false and misleading. Though racial prejudice is never a good thing, the extent to which it is a bad thing varies tremendously according to the age and the moral and social context. Though abstractly just as wrong in Shakespeare's day as now, anti-Semitism was then not in such blunt defiance of the limited information available to that age; nor was it the spearhead of a sinister assault on liberty itself; nor was there a background of sadistic mass murder even remotely approaching Belsen and Ravensbrueck. Today we "know better" (or at least ought to, from the psychological and historical information generally available). It was infinitely more difficult for an Elizabethan to "know better" about anti-Semitism than for Pound. Anti-Semitism in Shakespeare's day was to some extent a norm, even for men of good intentions, while today it represents the very worst and most ill-intentioned forces of our age.

Moreover, Shakespeare gives dignity to, and arouses his readers' sympathy for, the predicament of Shylock. There is a world of difference artistically and also ethically between Shakespeare's letting Shylock express the common humanity of: "I am a Jew. If you prick us, do we not bleed?" and Pound's joking reference to mass murder as "fresh meat on the Russian steppes," the most callous single reference ever written by an American artist.

Pre-Belsen and post-Belsen anti-Semitism, though both unjustified, are qualitatively different; and the former (Shakespeare or Voltaire) cannot be logically compared to the latter (Pound or Celine).[1] The burning or gassing of five or six million Jews gave, from that point on, an entirely new dimension to anti-Semitism. Anti-Semitism after Belsen becomes a uniquely loathsome insult to all *Christian* ideals, to all human aspirations, to the very core of the dignity of man. This was not the case with the pre-Nazi anti-Semitism of a Shakespeare, a Voltaire, or a Henry Adams. Wrong? Yes. Beyond the pale? Hardly.

Even if, for the sake of the broader issue, we concede the fantastic hypothesis that the *Pisan Cantos* are great poetry, in that case—while respecting such greatness and defending its right of free speech—we must still raise the issue of whether this in addition requires the public honor of an award. Either fascist anti-Semitism is "beyond the bounds of our intellectual life"...or it isn't...

VI

How is it that no truly elegant *avant-garde* critic, when praising Pound, designs to express qualms about: (1) the immoral political message or (2) the unintelligibility of the non-political parts of the poem? This irresponsible qualmlessness about immorality and about unclarity would seem to be the result of two prevalent attitudes, originally liberating but now exerting a despotism of their own. The two attitudes are: first, the triumph of detailed textual criticism for its own sake, scorning the "heresy of paraphrasing" a poem's meaning and ethical content;

[1]Admittedly there were also pogroms during the Crusades, the Inquisition, and in Czarist Russia. But they did not involve, morally and politically, a Shakespeare or a Voltaire as intimately as Belsen does the Axis broadcaster, Pound; and there are further obvious distinctions (such as religious persecution versus racial persecution) making Nazi genocide *sui generis*.

second, the pushing of T. S. Eliot's plausible statement that modern poetry must be complex into an anxiety neurosis where critics are *scared of ever objecting to obscurity* lest they sound like middle-brows instead of like Sensitive Plants.

The famous New Criticism's method of analysis tends to treat a poem by itself, like a self-created airtight-sealed object, outside cause and effect. By discarding a poem's *irrelevant* historical, psychological, and "moralizing" encrustations, the "new critics" have splendidly taught us to read the text itself. But by also discarding the *relevant* historical, psychological, and ethical aspects, they are often misreading the text itself.

A reader's response to a poem is a total response, a *Gestalt* in which aesthetic as well as ethical, psychological, and historical factors are inseparably fused together. It is a self-deception to try to separate them and to discover some alchemistical quintessence of isolated "pure" aesthetics, to be judged only by certified "pure" mandarins of criticism. It may be argued that this inextricability of form and content is undesirable; in any case, that it exists is undeniable, with the *Pisan Cantos* only one example among many. This inextricability prompted Paul Valery's wise warning: "To construct a poem that contains only poetry is impossible. If a piece contains only poetry, it is not constructed; it is not a poem."

So independent an observer as Harry Levin has summarized some of the pros and cons as follows: "Spingarn had called for 'the new criticism' in 1910, without receiving very much response. John Crowe Ransom called again in 1941—and this time spirits came from the vasty deep. It is salutary that criticism, which is bound to admit a good deal of extraneous matter, should thus renew itself for each generation by returning to the direct contemplation of the artistic object. The danger is that the critic who limits his purview too narrowly is apt to misinterpret the text upon which he dwells. Critics of the new critics, however, have adduced enough specific reminders that interpretation of the present requires acquaintance with the past.... We may well be faced, when the situation crystallizes, with a new academicism. The issue will then be whether it is more enlightening, less occult than the old."[2]

VII

To Archibald MacLeish's splendid statement about poetry ("a poem should not mean but be") must be added the belief that a poem should both mean and be. Only to be, leads to hermetic "new critic" formalism. Only to mean, leads to demagogy, the wrong kind of popularity, and ultimately to the fatal exploitation of literature by Agitprop, which is not really "democratic," as claimed, but either commercial (in America) or totalitarian (in Soviet and fellow-traveler circles).

The current battle of "obscurity" versus "clarity" (or of "to be" versus "to mean") tends to divide poets into two extremes equally deadly to poetry. The first extreme, in the name of anti-philistinism, is for cross-word-puzzle poetry which, whatever its fascination, would kill poetry by scaring away its audience. The second extreme, in the name of communication, would demagogically popularize poetry, in betrayal of all integrity of standards, until it reaches the widest but also lowest common denominator and is no longer poetry at all, but verse. The first group would sterilize the muse. The second group would prostitute her.

Is there no third possibility for the serious craftsman? Must he become either *precieux* or "corny," either Babbitt Junior or Babbitt Senior?

[2]Preface to *Perspectives of Criticism.*

The answer is: an act of creative faith in a new and third force in poetry, already emerging, equally remote from the muse's mincing sterilizers and back-slapping salesmen. Such a third force must prefer a difficult simplicity to an easy obscurity. It must return to the function of ethical responsibility and of communication of ideas and emotions. Any fool can lucidly communicate an easy greeting-card level of ideas and emotions. Any fool can obscurely "impress" a would-be modernist reader by incoherent and pretentious approximations of difficult ideas and emotions. Great art communicates lucidly and with classic simplicity the most difficult level of ideas and emotions.

VIII

It is not easy to say how the new young poets of the mid-century can ever achieve the vitality and originality of the Eliot and Pound movement of three decades ago. But it is easy to say how they can never achieve it; namely, by continuing to imitate Eliot and Pound, whose great virtue—which atones for great harm—is that they were not imitators. "Woe to you," said Goethe, "if you are a grandson!" Pound's and Eliot's ubiquitous "grandsons" have turned the anti-philistinism of their masters into a snobbish new philistinism.... These devout grandsons have played Pound a worse trick than anything intended by those of us who cannot enjoy his latest *Cantos*. They have frozen his dynamic experimental zest, which three decades ago was still doing more good than harm, into a static Alexandrian school. Disarmingly, really endearingly humorless, their school would do no harm even today, were it not for the well-meaning tyranny of its literary Party Line (now beginning to crumble) over college English departments and Little Magazines.

Pound is the keystone of this school of criticism. If he goes out of fashion, then the whole structure becomes shaky. Hence, the violence of the attacks on the "philistinism" of critics of the Bollingen prize. These attacks (in some instances, it should be repeated, quite justified) are for the most part motivated not by sympathy with the Master's politics but either by an honorable appreciation of Pound's genius or else by the strategy of sectarian literary patronage systems. Can we distinguish which is which? "For reasons of personal loyalty, which one must respect, and for reasons of sectarian literary loyalty, which one may or may not respect," wrote Karl Shapiro of the Bollingen prize, "few poets anywhere are in a position to say what they really think of Pound's work." In either case, whether as lofty above-the-battle exquisites or as unlofty ward-heelers of a belletristic Tammany Hall, these funny little Sacred Calves (the *nouveaux* New Critics, *Hudson Review* and such) have Alexandrianized and Babbittized their Sacred Cow, *not* into a "fascist" conspiracy, as some *Saturday Review of Literature* writers absurdly implied, but into a supreme bore. They have turned the vital and original revolt of 1913 and the 1920's into a New Academy, today's most baneful block to vitality and originality.

In overcoming this road block, the growing revolt may be rejuvenating poetry as once the Eliot-Pound revolt did in its first exciting dawn. The American poetry of the future, like the classicism of the ancient past, will again see art as a groping search for the good, the true, the beautiful; all three as potentially harmonizing rather than conflicting. What if you seek only the beautiful? Suppose, like so much "new" criticism, you passively ignore the good and the true? Or suppose, like the fascist diabolism of some of Pound's *Cantos*, you actively attack the good and the true? In such cases, you usually find yourself losing the beautiful also.

You will find the beautiful only when you seek more than the beautiful.

Part IIB Socialist Realism: Aesthetic of the Left

Marx, Marxists, and Socialist Realism

Since the 1830s, the subordination of art to the service of social, political, or, more inclusively, "moral" ends occurs in one of its most extreme versions among Marxists and self-styled Marxists.

Marx and Engels held that art, like law, philosophy, religion, and morality, is a reflection of the economic forces at work in a society as represented by its level of technology and the system of class relationships that prevail at any given time. The classes referred to are *economic* classes, defined in every case by reference to the means of production, one class owning those means and a second class working for the owners. The interests of such classes, whether of masters and slaves, lords and serfs, employers and wage-earners, are opposed, and, until private ownership of the means of production is abolished and a classless society emerges, their relationship is one of irreconcilable conflict. Such conflict reaches a revolutionary climax when, as technology improves, the prevailing system of class relationships no longer releases but retards productive energies and must therefore by the verdict of history be "superseded" by a more efficient system. This recurrent conflict or contradiction between technology and the prevailing system of property relationships, or what Marx and Engels called the "forces of production" and the "relations of production," is the dynamic factor in social evolution. In the famous words of the *Communist Manifesto* (1848), "The history of all existing society is the history of class struggles. Free man and slave, patrician and plebeian, lord and serf, guild master and journeyman, in a word, oppressor and oppressed, stood in constant opposition to one another, carried on an uninterrupted, now hidden, now open fight, a fight that ended either in a revolutionary reconstitution of society at large or in the common ruin of the contending classes." In our epoch, these class antagonisms are simplified, and "Society is more and more splitting up into two great hostile camps, into two great classes directly facing each other: bourgeoisie and proletariat," a confrontation in which "the fall of the bourgeoisie and the victory of the proletariat are equally inevitable."

There is no reference in these words of Marx and Engels to the arts and the moral issues which man in his role as artist or art lover may or must face. But a familiarity with them is essential today because in the Marxist ideology all social institutions—political, religious, familial, educational, recreational—are shaped and all values are

determined by this class conflict and the changing economic forces that bring it about; and because one third of the peoples of the earth live under regimes which take economic determinism or historical materialism, as this doctrine is called, seriously, as do many in non-Communist countries. Even though economic determinism is not, as T. S. Eliot observed in the thirties, "a god before whom we fall down and worship with all kinds of music," it still deserves our careful attention.

Those of the following selections written by Marxists take for granted the ideas just outlined. However, readers who look for a consistent and uniform application of these ideas will be disappointed. For example, Engels wrote in 1894:

Political, judicial, philosophical, religious, literary, artistic, etc. development is based on economic development. But all these react upon one another and also upon the economic basis. It is not that the economic condition is the cause *and alone active, while everything else only is a passive effect. There is, rather, interaction on the basis of economic necessity, which* ultimately *always asserts itself.*[1]

Elsewhere, he noted that "if someone twists this into saying that the economic element is the *only* determining one, he transforms that proposition into a meaningless, abstract, senseless phrase."[2]

Marx's love of Homer and Aeschylus betrayed him into conceding in the unpublished Introduction (1857) to his *Critique of Political Economy*—only the Foreword (1859) was published—"the unequal relation between the development of material production and art" and affirming, with Greece in mind, that "In the case of art...certain periods of highest development stand in no direct connection with the general development of society, nor with the material basis..."[3] Peter Demetz reminds us that "In Marx's and Engels' written remarks upon Shakespeare one will look in vain for the slightest trace of economic determinism, ...all their lives they spoke of him with the same unchanging, ardent, completely non-political admiration."[4]

Again, the term "socialist realism," now in such favor among Communists, does not appear in Marx's writings and hardly at all in Engels'. They would probably have deplored the crude version of "socialist realism" inflicted by Stalin and Zhdanov on the artists and writers of the Soviet Union and dutifully elaborated at the First All Union Congress of Soviet Writers (1934). That Congress, it may be recalled, interpreted realism as requiring the "truthful, historically concrete representation of reality in its revolutionary development" which, as such, "must be linked with the task of ideological transformation and education of workers in the spirit of socialism." Moreover, the socialist realism which produced the wedding-cake architecture, the calendar painting, the sometime denigration of Shostakovich, and the morality plays of the Stalin era (and to a slightly lesser extent the post-Stalin era) is at considerable remove from the more sophisticated version of realism expounded by Georg Lukacs and Gaylord LeRoy in the selections reprinted below, even though Lukacs defended the banalities of Stalinism and LeRoy is conspicuously silent about them.

[1]Letter to H. Starkenburg, January 25, 1894. His emphasis. *Selected Works,* Vol. II (Moscow: Foreign Languages Publishing House, 1962), pp. 503–505.

[2]Letter to J. Bloch, September 21-22, 1890, *Ibid.,* Vol. 2, p. 488.

[3]Appendix, *Critique of Political Economy* (Chicago: H. Kerr and Co., 1918), p. 311.

[4]Peter Demetz, *Marx, Engels and the Poets* (Chicago: University of Chicago Press, 1967), p. 153.

However, common to all Marxists is a tension between what might be called their aesthetic common sense, i.e., their loyalty to generally accepted aesthetic values, and an ideologically required emphasis on the cognitive role of art as disclosing "truth," which to them means recognizing and falling in step with the dialectical progression of history (as interpreted by Marxist epigones) and hence a *moral* dedication to the values which it brings to fruition.

Marxists also have in common a boundless optimism, whether it be Marx and Engels concluding the *Manifesto* with the words "Its [the bourgeoisie's] fall and the victory of the proletariat are equally inevitable"; or Trotsky proclaiming that in the new society "The average human type will rise to the heights of an Aristotle, a Goethe, or a Marx";[5] or an American socialist professor writing of "the conscious activity of men who have taken control of the course of history."[6] For Marxists, man is never, as with the ancient writers of tragedy or a Kafka of our time, the victim of malignant and inscrutable powers. The dialectical movement of history makes man's ultimate triumph inevitable.

Studies in European Realism

Georg Lukacs

Georg Lukacs (1885–) is one of the patriarchs of the Communist world and one of the few Communists who enjoy great prestige among intellectuals in Western Europe as literary critics and aestheticians. Born into a family of prosperous Budapest bankers, he achieved considerable repute in German literary circles as a young man. He returned to Hungary during World War I, became a convert to Marxism, and joined the Communist Party, in which he enjoyed varying fortunes as a theoretician and functionary. As Professor of Aesthetics at the University of Budapest he achieved great eminence throughout the Soviet world for his literary and philosophical studies.

With the promulgation of socialist realism as the official party line in 1932–1934, he became one of its important spokesmen, representing what has been called the "Engelsian"[1] tendency in Marxist literary criticism. Moved by Khrushchev's denunciation of the Stalin personality cult, his Realism in Our Time *(1958), written just before the Hungarian uprising, represents an attempt to find a middle way between the new alienated generation of Russian writers[2] and the old regime. George Steiner has written that Lukacs "stands as a lone and splendid tower amidst the gray landscape of eastern European and Communist intellectual life," ranking as one of the "master-critics of our age."[3]*

[5]Leon Trotsky, *Literature and Revolution,* translated by R. Strunsky (New York: International Publishers, 1925), p. 256.

[6]Gaylord LeRoy, *"Marxism and Modern Literature,"* Cf. below pp. 115–131.

From *Studies in European Realism* by Georg Lukacs (New York: Grosset & Dunlap, 1964), pp. 1–19. Copyright © 1964 by Grosset & Dunlap, Inc. Reprinted by permission of Grosset & Dunlap, Inc. and Hillway Press.

[1]Were a lesser mortal to qualify the doctrine of economic determinism as Engels did, he would no doubt be denounced as a deviationist. See, for example, his letters to J. Bloch (September 21- 22, 1890), C. Schmidt (October 27, 1890), F. Mehring (July 14, 1893), and H. Starkenburg (January 25, 1894).

[2]Cf. below, p. 142.

[3]"Marxism and Literature," in *Language and Silence* (New York, Athenaeum, 1967), p. 367.

Studies in European Realism consists of articles written during the purges of the 1930s. When they appeared under this title in the following decade, Lukacs wrote the remarks reprinted below as a preface. The first American edition appeared in 1964. Other important works are Goethe and His Time (1947), German Realists of the Nineteenth Century (1951), Contributions to a History of Aesthetics (1954), The Historical Novel (1955), and The Meaning of Contemporary Realism (1962). Ironically, Lukacs' reputation in western Europe is based primarily on his History and Class Consciousness (1923), which he repudiated shortly after its publication. It continues to be regarded as the classic text of western Marxism in contrast to the orthodox Soviet line.

Preface

...Let us begin with the general atmosphere: the clouds of mysticism which once surrounded the phenomena of literature with a poetic colour and warmth and created an intimate and "interesting" atmosphere around them, have been dispersed. Things now face us in a clear, sharp light which to many may seem cold and hard; a light shed on them by the teachings of Marx. Marxism searches for the material roots of each phenomenon, regards them in their historical connections and movement, ascertains the laws of such movement and demonstrates their development from root to flower, and in so doing lifts every phenomenon out of a merely emotional, irrational, mystic fog and brings it to the bright light of understanding.

Such a transition is at first a disillusionment to many people and it is necessary that this should be so. For it is no easy matter to look stark reality in the face and no one succeeds in achieving this at the first attempt. What is required for this is not merely a great deal of hard work, but also a serious moral effort. In the first phase of such a change of heart most people will look back regretfully to the false but "poetic" dreams of reality which they are about to relinquish. Only later does it grow clear how much more genuine humanity—and hence genuine poetry—attaches to the acceptance of truth with all its inexorable reality and to acting in accordance with it.

But there is far more than this involved in such a change of heart. I am thinking here of that philosophical pessimism which was so deeply rooted in the social conditions of the period between the two world wars. It was not by accident that everywhere there arose thinkers who deepened this pessimism and who built up their *Weltanschauung* on some philosophical generalization of despair. The Germans, Spengler and Heidegger, and a considerable number of other influential thinkers of the last few decades embraced such views.

There is, of course, plenty of darkness around us now, just as there was between the two wars. Those who wish to despair can find cause enough and more in our everyday life. Marxism does not console anyone by playing down difficulties, or minimizing the material and moral darkness which surrounds us human beings today. The difference is only—but in this "only" lies a whole world—that Marxism has a grasp of the main lines of human development and recognizes its laws. Those who have arrived at such knowledge know, in spite of all temporary darkness, both whence we have come and where we are going. And those who know this find the world changed in their eyes: they see purposeful development where formerly only a blind, senseless confusion surrounded them. Where the philosophy of despair weeps for the collapse of a world and the destruction of culture, there Marxists watch the birth-pangs of a new world and assist in mitigating the pains of labour.

One might answer to all this—I have met with such objections myself often enough—that all this is only philosophy and sociology. What has all this to do with the theory and history of the novel? We believe that it has to do quite a lot. If we were to formulate the question in terms of literary history, it would read thus: which of the two, Balzac or Flaubert, was the greatest novelist, the typical classic of the 19th century? Such a judgment is not merely a matter of taste—it involves all the central problems of the aesthetics of the novel as an art form. The question arises whether it is the unity of the external and internal worlds or the separation between them which is the social basis of the greatness of a novel; whether the modern novel reached its culminating point in Gide, Proust and Joyce or had already reached its peak much earlier, in the works of Balzac and Tolstoy; so that today only individual great artists struggling against the current—as for instance Thomas Mann—can reach the heights already long attained.

These two aesthetic conceptions conceal the application of two opposite philosophies of history to the nature and historical development of the novel. And because the novel is the predominant art form of modern *bourgeois* culture, this contrast between the two aesthetic conceptions of the novel refers us back to the development of literature as a whole, or perhaps even culture as a whole. The question asked by the philosophy of history would be: does the road of our present-day culture lead upwards or downwards? There is no denying that our culture has passed and is passing through dark periods. It is for the philosophy of history to decide whether that darkening of the horizon which was adequately expressed for the first time in Flaubert's *Education Sentimentale* is a final, fatal eclipse or only a tunnel from which, however long it may be, there is a way out to the light once more.

Bourgeois aestheticists and critics, the author of the present book among them, saw no way out of this darkness. They regarded poetry merely as a revelation of the inner life, a clear-sighted recognition of social hopelessness or at best a consolation, an outward-reflected miracle. It followed with logical necessity from this historico-philosophical conception that Flaubert's *oeuvre*, notably his *Education Sentimentale,* was regarded as the greatest achievement of the modern novel. This conception naturally extends to every sphere of literature. I quote only one instance: the real great philosophical and psychological content of the epilogue to *War and Peace* is the process which after the Napoleonic wars led the most advanced minority of the Russian aristocratic *intelligentsia*—a very small minority, of course—to the Decembrist rising[1] that tragically heroic prelude to the secular struggle of the Russian people for its liberation. Of all this my own old philosophy of history and aesthetics saw nothing. For me the epilogue held only the subdued colours of Flaubertian hopelessness, the frustration of the purposeless searchings and impulses of youth, their silting-up in the grey prose of *bourgeois* family life. The same applies to almost every detailed analysis of *bourgeois* aesthetics. The opposition of Marxism to the historical views of the last 50 years (the essence of which was the denial that history is a branch of learning that deals with the unbroken upward evolution of mankind) implied at the same time a sharp objective disagreement in all problems of *Weltanschauung* or aesthetics. No one can expect me to give even a skeleton outline of the Marxist philosophy of history within [these] limits... But we must nevertheless eliminate certain commonplace prejudices in order that author and reader may understand one another... The Marxist philosophy of history is a comprehensive doctrine dealing with the necessary

[1]Editors' note: The reference is to a revolt of liberal members of the Russian nobility in December 1825 which was brutally crushed by Nicholaus I.

progress made by humanity from primitive communism to our own time and the perspectives of our further advance along the same road; as such it also gives us indications for the historical future. But such indications—born of the recognition of certain laws governing historical development—are not a cookery book providing recipes for each phenomenon or period; Marxism is not a Baedeker of history, but a signpost pointing the direction in which history moves forward. The final certainty it affords consists in the assurance that the development of mankind does not and cannot finally lead to nothing and nowhere.

Of course, such generalizations do not do full justice to the guidance given by Marxism, a guidance extending to every topical problem of life. Marxism combines a consistent following of an unchanging direction with incessant theoretical and practical allowances for the deviousness of the path of evolution. Its well-defined philosophy of history is based on a flexible and adaptable acceptance and analysis of historical development. This apparent duality—which is in reality the dialectic unity of the materialist world-view—is also the guiding principle of Marxist aesthetics and literary theory.

Those who do not know Marxism at all or know it only superficially or at second-hand, may be surprised by the respect for the classical heritage of mankind which one finds in the really great representatives of this doctrine and by their incessant references to that classical heritage.... It is not by chance that the great Marxists were jealous guardians of our classical heritage in their aesthetics as well as in other spheres. But they do not regard this classical heritage as a reversion to the past; it is a necessary outcome of their philosophy of history that they should regard the past as irretrievably gone and not susceptible of renewal. Respect for the classical heritage of humanity in aesthetics means that the great Marxists look for the true highroad of history, the true direction of its development, the true course of the historical curve, the formula of which they know; and because they know the formula they do not fly off at a tangent at every hump in the graph, as modern thinkers often do because of their theoretical rejection of the idea that there is any such thing as an unchanged general line of development.

For the sphere of aesthetics this classical heritage consists in the great arts which depict man as a whole in the whole of society. Again it is the general philosophy, (here: proletarian humanism) which determines the central problems posed in aesthetics. The Marxist philosophy of history analyses man as a whole, and contemplates the history of human evolution as a whole, together with the partial achievement, or non-achievement of completeness in its various periods of development. It strives to unearth the hidden laws governing all human relationships. Thus the object of proletarian humanism is to reconstruct the complete human personality and free it from the distortion and dismemberment to which it has been subjected in class society. These theoretical and practical perspectives determine the criteria by means of which Marxist aesthetics establish a bridge back to the classics and at the same time discover new classics in the thick of the literary struggles of our own time. The ancient Greeks, Dante, Shakespeare, Goethe, Balzac, Tolstoy all give adequate pictures of great periods of human development and at the same time serve as signposts in the ideological battle fought for the restoration of the unbroken human personality.

Such viewpoints enable us to see the cultural and literary evolution of the nineteenth century in its proper light. They show us that the true heirs of the French novel, so gloriously begun early in the last century, were not Flaubert and especially Zola, but the Russian and Scandinavian writers of the second half of the century....

If we translate into the language of pure aesthetics the conflict (conceived in the sense of the philosophy of history) between Balzac and the later French novel, we arrive at the conflict between realism and naturalism. Talking of a conflict here may sound [like] a paradox to...most writers and readers of our day. For most present-day writers and readers are used to literary fashions swinging to and fro between the pseudo-objectivism of the naturalist school and the mirage-subjectivism of the psychologist or abstract-formalist school. And inasmuch as they see any worth in realism at all, they regard their own false extreme as a new kind of near-realism or realism. Realism, however, is not some sort of middle way between false objectivity and false subjectivity, but on the contrary the true, solution-bringing third way, opposed to all the pseudo-dilemmas engendered by the wrongly-posed questions of those who wander without a chart in the labyrinth of our time. Realism is the recognition of the fact that a work of literature can rest neither on a lifeless average, as the naturalists suppose, nor on an individual principle which dissolves its own self into nothingness. The central category and criterion of realist literature is the type, a peculiar synthesis which organically binds together the general and the particular both in characters and situations. What makes a type a type is not its average quality, not its mere individual being, however profoundly conceived; what makes it a type is that in it all the humanly and socially essential determinants are present on their highest level of develop-ment, in the ultimate unfolding of the possibilities latent in them, in extreme presentation of their extremes, rendering concrete the peaks and limits of men and epochs.

True great realism thus depicts man and society as complete entities, instead of showing merely one or the other of their aspects. Measured by this criterion, artistic trends determined by either exclusive introspection or exclusive extraversion equally impoverish and distort reality. Thus realism means a three-dimensionality, an all-roundness, that endows with independent life characters and human relationships. It by no means involves a rejection of the emotional and intellectual dynamism which necessarily develops together with the modern world. All it opposes is the destruction of the completeness of the human personality and of the objective typicality of men and situations through an excessive cult of the momentary mood. The struggle against such tendencies acquired a decisive importance in the realist literature of the nineteenth century. Long before such tendencies appeared in the practice of literature, Balzac had already prophetically foreseen and outlined the entire problem in his tragi-comic story *Le Chef d'Oeuvre Inconnu*. Here experiment on the part of a painter to create a new classic three-dimensionality by means of an ecstasy of emotion and colour quite in the spirit of modern impressionism, leads to complete chaos. Fraunhofer, the tragic hero, paints a picture which is a tangled chaos of colours out of which a perfectly modelled female leg and foot protrude as an almost fortuitous fragment. Today a considerable section of modern artists has given up the Fraunhofer-like struggle and is content with finding, by means of new aesthetic theories, a justification for the emotional chaos of their works.

The central aesthetic problem of realism is the adequate presentation of the complete human personality. But as in every profound philosophy of art, here, too, the consistent following-up to the end of the aesthetic viewpoint leads us beyond pure aesthetics: for art, precisely if taken in its most perfect purity, is saturated with social and moral humanistic problems. The demand for a realistic creation of types is in opposition both to the trends in which the biological being of man, the physiological aspect of self-preservation and procreation are dominant (Zola and his disciples) and to the trends which sublimate man into purely mental psychological

processes. But such an attitude, if it remained within the sphere of formal aesthetic judgments, would doubtless be quite arbitrary, for there is no reason why, regarded merely from the point of view of good writing, erotic conflict with its attendant moral and social conflicts should be rated higher than the elemental spontaneity of pure sex. Only if we accept the concept of the complete human personality as the social and historical task humanity has to solve; only if we regard it as the vocation of art to depict the most important turning-points of this process with all the wealth of the factors affecting it; only if aesthetics assign to art the role of explorer and guide, can the content of life be systematically divided up into spheres of greater and lesser importance; into spheres that throw light on types and paths and spheres that remain in darkness. Only then does it become evident that any description of mere biological processes—be these the sexual act or pain and sufferings, however detailed and from the literary point of view perfect it may be—results in a levelling-down of the social, historical and moral being of men and is not a means but an obstacle to such essential artistic expression as illuminating human conflicts in all their complexity and completeness. It is for this reason that the new contents and new media of expression contributed by naturalism have led not to an enrichment but to an impoverishment and narrowing-down of literature.

Apparently similar trains of thought were already put forward in early polemics directed against Zola and his school. But the psychologists, although they were more than once right in their concrete condemnation of Zola and the Zola school, opposed another no less false extreme to the false extreme of naturalism. For the inner life of man, its essential traits and essential conflicts, can be truly portrayed only in organic connection with social and historical factors. Separated from the latter and developing merely its own immanent dialectic, the psychologist trend is no less abstract, and distorts and impoverishes the portrayal of the complete human personality no less than does the naturalist biologism which it opposes.

It is true that, especially regarded from the viewpoint of modern literary fashions, the position in respect of the psychologist school is at the first glance less obvious than in the case of naturalism. Everyone will immediately see that a description in the Zola manner of, say, an act of copulation between Dido and Aenas or Romeo and Juliet would resemble each other very much more closely than the erotic conflicts depicted by Virgil and Shakespeare, which acquaint us with an inexhaustible wealth of cultural and human facts and types. Pure introspection is apparently the diametrical opposite of naturalist levelling-down, for what it describes are quite individual, non-recurring traits. But such extremely individual traits are also extremely abstract, for this very reason of non-recurrence. Here, too, Chesterton's witty paradox holds good, that the inner light is the worst kind of lighting. It is obvious to everyone that the coarse biologism of the natural-ists and the rough outlines drawn by propagandist writers deform the true picture of the complete human personality. Much fewer are those who realize that the psychologists' punctilious probing into the human soul and their transformation of human beings into a chaotic flow of ideas destroy no less surely every possibility of a literary presentation of the complete human personality. A Joyce-like shoreless torrent of associations can create living human beings just as little as Upton Sinclair's coldly calculated all-good and all-bad stereotypes.

Owing to lack of space this problem cannot be developed here in all its breadth. Only one important and, at present, often neglected point is to be stressed here because it demonstrates that the live portrayal of the complete human personality is possible only if the writer attempts to create types. The point in question is the organic, indissoluble connection between man as a private individual and man as a social being, as a member of a community. We know that this is the most difficult

question of modern literature today and has been so ever since modern *bourgeois* society came into being. On the surface the two seem to be sharply divided and the appearance of the autonomous, independent existence of the individual is all the more pronounced, the more completely modern *bourgeois* society is developed. It seems as if the inner ... genuine "private" life, were proceeding according to its own autonomous laws and as if its fulfilments and tragedies were growing ever more independent of the surrounding social environment. And correspondingly, on the other side, it seems as if the connection with the community could manifest itself only in high-sounding abstractions, the adequate expression for which would be either rhetoric or satire.

An unbiassed investigation of life and the setting aside of these false traditions of modern literature leads easily enough to the uncovering of the true circumstances ... the discovery [of] which had long been made by the great realists of the beginning and middle of the nineteenth century and which Gottfried Keller expressed thus: "Everything is politics." The great Swiss writer did not intend this to mean that everything was immediately tied up with politics; on the contrary, in his view—as in Balzac's and Tolstoy's—every action, thought and emotion of human beings is inseparably bound up with the life and struggles of the community, i.e., with politics; whether the humans themselves are conscious of this, unconscious of it or even trying to escape from it, objectively their actions, thoughts and emotions nevertheless spring from and run into politics.

The true great realists not only realized and depicted this situation—they did more than that, they set it up as a demand to be made on men. They knew that this distortion of objective reality (although, of course, due to social causes), this division of the complete human personality into a public and a private sector was a mutilation of the essence of man. Hence they protested not only as painters of reality, but also as humanists, against this fiction of capitalist society however unavoidable this spontaneously formed superficial appearance. If as writers, they delved deeper in order to uncover the true types of man, they had inevitably to unearth and expose to the eyes of modern society the great tragedy of the complete human personality.

In the works of such great realists as Balzac we can again find a third solution opposed to both false extremes of modern literature, exposing as an abstraction, as a vitiation of the true poesy of life, both the feeble commonplaces of the well-intentioned and honest propagandist novels and the spurious richness of a preoccupation with the details of private life.

This brings us face to face with the question of the topicality today of the great realist writers. Every great historical period is a period of transition, a contradictory unity of crisis and renewal of destruction and rebirth; a new social order and a new type of man always comes into being in the course of a unified though contradictory process. In such critical, transitional periods the tasks and responsibility of literature are exceptionally great. But only truly great realism can cope with such responsibilities; the accustomed, the fashionable media of expression, tend more and more to hamper literature in fulfilling the tasks imposed by history. It should surprise no one if from this point of view we turn against the individualistic, psychologist trends in literature. It might more legitimately surprise many that [we are in] sharp opposition to Zola and Zolaism.

Such surprise may be due in the main to the fact that Zola was a writer of the left and his literary methods were dominant chiefly, though by no means exclusively, in left-wing literature. It might appear, therefore, that we are involving ourselves in a serious contradiction, demanding on the one hand the politization of

literature and on the other hand attacking insidiously the most vigorous and militant section of left-wing literature. But this contradiction is merely apparent. It is, however, well suited to throw light on the true connection between literature and *Weltanschauung*.

The problem was first raised (apart from the Russian democratic literary critics) by Engels, when he drew a comparison between Balzac and Zola. Engels showed that Balzac, although his political creed was legitimist royalism, nevertheless inexorably exposed the vices and weakness of royalist feudal France and described its death agony with magnificent poetic vigour. This phenomenon ... may at first glance again—and mistakenly—appear contradictory. It might appear that the *Weltanschauung* and political attitude of serious great realists are a matter of no consequence. To a certain extent this is true. For from the point of view of the self-recognition of the present and from the point of view of history and posterity, what matters is the picture conveyed by the work; the question to what extent this picture conforms to the views of the authors is a secondary consideration.

This, of course, brings us to a serious question of aesthetics. Engels, in writing about Balzac, called it "the triumph of realism"; it is a problem that goes down to the very roots of realist artistic creation. It touches the essence of true realism: the great writer's thirst for truth, his fanatic striving for reality—or expressed in terms of ethics: the writer's sincerity and probity. A great realist such as Balzac, if the intrinsic artistic development of situations and characters he has created comes into conflict with his most cherished prejudices or even his most sacred convictions, will, without an instant's hesitation, set aside these his own prejudices and convictions and describe what he really sees, not what [he] would prefer to see. This ruthlessness towards their own subjective world-picture is the hall-mark of all great realists, in sharp contrast to the second-raters, who nearly always succeed in bringing their own *Weltanschauung* into "harmony" with reality, that is, forcing a falsified or distorted picture of reality into the shape of their own world-view. This difference in the ethical attitude of the greater and lesser writers is closely linked with the difference between genuine and spurious creation. The characters created by the great realists, once conceived in the vision of their creator, live an independent life of their own; their comings and goings, their development, their destiny is dictated by the inner dialectic of their social and individual existence. No writer is a true realist—or even a truly good writer, if he can direct the evolution of his own characters at will.

All this is however merely a description of the phenomenon. It answers the question as to the ethics of the writer: what will he do if he sees reality in such and such a light? But this does not enlighten us at all regarding the other question: what does the writer see and how does he see it? And yet it is here that the most important problems of the social determinants of artistic creation arise.... [There are] basic differences which arise in the creative methods of writers according to the degree to which they are bound up with the life of the community, take part in the struggles going on around them or are merely passive observers of events. Such differences determine creative processes which may be diametrical opposites; even the experience which gives rise to the work will be structurally different, and in accordance with this the process of shaping the work will be different. The question whether a writer lives within the community or is a mere observer of it, is determined not by psychological, not even by typological factors; it is the evolution of society that determines (not automatically, not fatalistically, of course), the line the evolution of an author will take. Many a writer of a basically contemplative type has been driven to an intense participation in the life of the community by the

social conditions of his time; Zola, on the contrary, was by nature a man of action, but his epoch turned him into a mere observer and when at last he answered the call of life, it came too late to influence his development as a writer.

But even this is as yet only the formal aspect of this problem, although no longer the abstractly formal. The question grows essential and decisive only when we examine concretely the position taken up by a writer. What does he love and what does he hate? It is thus that we arrive at a deeper interpretation of the writer's true *Weltanschauung,* at the problem of the artistic value and fertility of the writer's world-view. The conflict which previously stood before us as the conflict between the writer's world-view and the faithful portrayal of the world he sees, is now clarified as a problem within the *Weltanschauung* itself, as a conflict between a deeper and a more superficial level of the writer's own *Weltanschauung.*

Realists such as Balzac or Tolstoy in their final posing of questions always take the most important, burning problems of the community for their starting point; their pathos as writers is always stimulated by those sufferings of the people which are the most acute at the time; it is these sufferings that determine the objects and direction of their love and hate and through these emotions determine also what they see in their poetic visions and how they see it. If, therefore, in the process of creation their conscious world-view comes into conflict with the world seen in their vision, what really emerges is that their true conception of the world is only superficially formulated in the consciously held world-view and the real depth of their *Weltanschauung,* their deep ties with the great issues of their time, their sympathy with the sufferings of the people can find adequate expression only in the being and fate of their characters.

No one experienced more deeply than Balzac the torments which the transition to the capitalist system of production inflicted on every section of the people, the profound moral and spiritual degradation which necessarily accompanied this transformation on every level of society. At the same time Balzac was also deeply aware of the fact that this transformation was not only socially inevitable, but at the same time progressive. This contradiction in his experience Balzac attempted to force into a system based on a Catholic legitimism and tricked out with utopian conceptions of English Toryism. But this system was contradicted all the time by the social realities of his day and the Balzacian vision which mirrored them. This contradiction itself clearly expressed, however, the real truth: Balzac's profound comprehension of the contradictorily progressive character of capitalist development.

It is thus that great realism and popular humanism are merged into an organic unity. For if we regard the classics of the social development that determined the essence of our age, from Goethe and Walter Scott to Gorki and Thomas Mann, we find *mutatis mutandis* the same structure of the basic problem. Of course every great realist found a different solution for the basic problem in accordance with his time and his own artistic personality. But they all have in common that they penetrate deeply into the great universal problems of their time and inexorably depict the true essence of reality as they see it. From the French revolution onwards the development of society moved in a direction which rendered inevitable a conflict between such aspirations of men of letters and the literature and public of their time. In this whole age a writer could achieve greatness only in the struggle against the current of everyday life. And since Balzac the resistance of daily life to the deeper tendencies of literature, culture and art has grown ceaselessly stronger. Nevertheless there were always writers who in their life-work, despite all the resistance of the day, fulfilled the demand formulated by Hamlet: 'to hold the

mirror up to nature,' and by means of such a reflected image aided the development of mankind and the triumph of humanist principles in a society so contradictory in its nature that it on the one hand gave birth to the ideal of the complete human personality and on the other hand destroyed it in practice.

The great realists of France found worthy heirs only in Russia. All the problems mentioned here in connection with Balzac apply in an even greater measure to Russian literary development and notably to its central figure Leo Tolstoy. It is not by chance that Lenin (without having read Engels' remarks about Balzac) formulated the Marxist view of the principles of true realism in connection with Tolstoy.... The great Russian realist Tolstoy was claimed by reactionary ideologies for their own and the attempt was made to turn him into a mystic gazing into the past; into an "aristocrat of the spirit" far removed from the struggles of the present. This falsification of the image of Tolstoy served a second purpose as well; it helped to give a false impression of the tendencies predominant in the life of the Russian people. The result was the myth of a "holy Russia" and Russian mysticism. Later, when the Russian people in 1917 fought and won the battle for liberation, a considerable section of the *intelligentsia* saw a contradiction between the new, free Russia and the older Russian literature. One of the weapons of counter-revolutionary propaganda was the untrue allegation that the new Russian had effected a complete volte-face in every sphere of culture and had rejected, in fact was persecuting, older Russian literature.

These counter-revolutionary allegations have long been refuted by the facts. The literature of the White Russian emigres, which claimed to be the continuation of the allegedly mystical Russian literature, quickly showed its own sterility and futility, once it was cut off from the Russian soil and the real Russian problems. On the other hand, it was impossible to conceal from the intelligent reading public that in the Soviet Union the vigorous treatment of the fresh issues thrown up by the rejuvenated life of the nation was developing a rich and interesting new literature and the discerning readers of this literature could see for themselves how deeply rooted were the connections between it and Russian classical realism. (It will suffice to refer here to Sholokhov, the heir to Tolstoy's realism.)... In the past, western critics and readers in their approach to Tolstoy and others took for their guide the views on society, philosophy, religion, art, and so on, which these great men had themselves expressed in articles, letters, diaries and the like. They thought to find a key to the understanding of the often unfamiliar great works of literature in these conscious opinions. In other words reactionary criticism interpreted the works of Tolstoy and Dostoyevski by deriving the alleged spiritual and artistic content of these works from certain reactionary views of the authors.

The [proper] method ... is the exact opposite of this. It is a very simple method: it consists in first of all examining carefully the real social foundations on which, say, Tolstoy's existence rested and the real social forces under the influence of which the human and the literary personality of this author developed. Secondly, in close connection with the first approach, the question [must be] asked: what do Tolstoy's works represent, what is their real spiritual and intellectual content and how does the writer build up his aesthetic forms in the struggle for the adequate expression of such contents. Only if, after an unbiassed examination, we have uncovered and understood these objective relationships, are we in a position to provide a correct interpretation of the conscious views expressed by the author and correctly evaluate his influence on literature.

...In applying this method a quite new picture of Tolstoy will emerge. The revaluation will be new only to the non-Russian reading public. In Russian literature

itself the method of appreciation outlined in the preceding has an old tradition behind it: Bielinski and Herzen were the precursors of the method, the culminating points of which are markedly by the names of Lenin and Stalin....

In the remarks about method ... social tendencies ... have been strongly stressed and their significance could scarcely be exaggerated. Nevertheless the main emphasis ... [must be] on the aesthetic, not the social, analysis; investigation of the social foundations is only a means to the complete grasp of the aesthetic character of Russian classical realism. This point of view is not an invention of the author. Russian literature owed its influence not only to its new social and human content but chiefly to the fact of being a really great literature. For this reason it is not enough to eradicate the old firmly-rooted false notions regarding its historical and social foundations; it is also necessary to draw the literary and aesthetic conclusions from the correct evaluation of these social and historical foundations. Only then can it be understood why great Russian realism has played a leading part in world literature for three quarters of a century and has been a beacon of progress and an effective weapon in the struggle against open and covert literary reaction and against the decadence masquerading as innovation.

Only if we have a correct aesthetic conception of the essence of Russian classical realism can we see clearly the social and even political importance of its past and future fructifying influence on literature. With the collapse and eradication of Fascism a new life has begun for every liberated people. Literature has a great part to play in solving the new tasks imposed by the new life in every country. If literature is really to fulfil this role, a role dictated by history, there must be as a natural prerequisite, a philosophical and political rebirth of the writers who produce it. But although this is an indispensible prerequisite, it is not enough. It is not only the opinions that must change, but the whole emotional world of men; and the most effective propagandists of the new, liberating, democratic feeling are the men of letters. The great lesson to be learnt from the Russian development is precisely the extent to which a great realist literature can fructifyingly educate the people and transform public opinion. But such results can be achieved only by a truly great, profound and all-embracing realism. Hence, if literature is to be a potent factor of national rebirth, it must itself be reborn in its purely literary, formal, aesthetic aspects as well. It must break with reactionary, conservative traditions which hamper it and resist the seeping-in of decadent influences which lead into a blind alley.

In these respects the Russian writers' attitude to life and literature is exemplary, and for this, if for no other reason, it is most important to destroy the generally accepted reactionary evaluation of Tolstoy, and, together with the elimination of such false ideas, to understand the human roots of his literary greatness. And what is most important of all; to show how such greatness comes from the human and artistic identification of the writer with some broad popular movement. It matters little in this connection what popular movement it is in which the writer finds this link between himself and the masses; that Tolstoy sinks his roots into the mass of the Russian peasantry, and Gorki of the industrial workers and landless peasants. For both of them were to the bottom of their souls bound up with the movements seeking the liberation of the people and struggling for it. The result of such a close link in the cultural and literary sphere was then and is to-day that the writer can overcome his isolation, his relegation to the role of a mere observer, to which he would otherwise be driven by the present state of capitalist society. He thus becomes able to take up a free, unbiassed, critical attitude towards those tendencies of present-day culture which are unfavourable to art and literature. To fight against

such tendencies by purely artistic methods, by the mere formal use of new forms, is a hopeless undertaking, as the tragic fate of the great writers of the West in the course of the last century clearly shows. A close link with a mass movement struggling for the emancipation of the common people does, on the other hand, provide the writer with the broader viewpoint, with the fructifying subject-matter from which a true artist can develop the effective artistic forms which are commensurate with the requirements of the age, even if they go against the superficial artistic fashions of the day....

Marxism and Modern Literature

Gaylord C. LeRoy

Gaylord C. LeRoy (1910–), Marxist literary critic, has specialized in English prose and poetry and twentieth century literary criticism, as well as Marxist aesthetics. He is a professor at Temple University, where he has taught since 1960. He has published Perplexed Prophets: Six 19th Century British Authors *(1953) and* Marxism and Modern Literature *(1967). In the following selection LeRoy contends that literature and the arts can and should make possible a fuller apprehension of the world. However, this can happen only if the artist participates in the conflicts of his time and is able to perceive the meaning and value of life in the perspective provided by socialist realism.*

William Van O'Connor had Marxist criticism at least partly in mind when he stated what the job of the critic is and what it is not:

The job of the critic is to help us perceive the nature and worth of the literary work. It is not his function to offer us coherent systems of philosophy, coherent theories of the nature of language, or even ideological systems that include accounts of poetry as a substitute for religion and the relation of the poet to the economic order. He can use all the information he can get, but he can employ his knowledge, as a critic, only insofar as it is relevant to the particular work or works he is discussing and attempting to make more available to the reader. Occasionally someone offers to subsume the study of literature under sociology—which would mean the end of the study of literature as an art.[1]

Yet today the Marxist critic could agree with most of O'Connor's points. Certainly the job of the critic is "to help us perceive the nature and worth of the literary work" and not "to offer us coherent systems of philosophy." Certainly the study of literature is not to be subsumed under sociology. O'Connor's comments apply to a stereotype of Marxist criticism that has been superseded—at any rate in the socialist countries. But now we have the problem that much of the recent work

[1]William Van O'Connor, *An Age of Criticism: 1900–1950*, Chicago, 1956, p. 174.

From *Marxism and Modern Literature* by Gaylord C. LeRoy (New York: American Institute of Marxist Studies, Occasional Paper No. 5, 1967), pp. 5–10, 12, 15–18, 21–24, 28–37. Copyright 1967 by Gaylord C. LeRoy. Reprinted by permission of the publisher and the author.

is unavailable in English. In what follows I attempt to give an impression of some of the important features of Marxist criticism today, in so far as it bears upon modern literature....

But if Marxist criticism is far from the stereotype O'Connor has in mind, it also differs from the criticism he advocates. The chief difference rests on opposing conceptions concerning the role of the interpretation of reality on the part of author and critic alike. While the Marxist would agree that the critic's job is to see the nature and worth of literary work and not to offer coherent systems of philosophy, he would also insist that we can do this only if we bring the best available understanding of reality to bear upon the critical task, and he would add that for this understanding Marxism is indispensable. The great strength of Marxist criticism, he would say, lies in the validity of the world view with which the critic operates. While we agree with O'Connor that it is not the purpose of the critic to set forth a coherent system of philosophy, therefore, we would insist that the critic cannot do his work without this, and in our view the most coherent system of philosophy, and the most plausible, is supplied by Marxism....

On the Function of Literature

The almost universal appeal of literature and the arts is to be explained in part by the fact that they have many functions. They serve as an instrument of a special kind of cognition, they give aesthetic pleasure, they are morally formative, they provide a stimulus to action, they furnish entertainment. For the student of the Marxist approach to literature, the most important of these functions, and the hardest one to account for in a satisfactory way, is the function of cognition. We can best begin by relating the conception of literature as cognition to four traditional theories concerning the function of poetry as they are set forth by Murray Krieger.[2] Krieger talks specifically about poetry but in this context we can regard poetry and literature as interchangeable.

According to the first of the conceptions Krieger reviews, the poet is a liar and literature has no significant claim upon us. It is either a waste of time or dangerous. Plato advanced this view in the interest of the security of the state, and some Elizabethan Puritans supported it as part of the morality of early capitalism, which expressed itself of course in the guise of a strenuous religious ethic....

A second notion is that poetry is important primarily as a source of propositional truth. A main effort in American literary pedagogy in recent decades has sought to demonstrate the insufficiency of this approach to literature. Brooks and Warren argued the point in *Understanding Poetry,* and I. A. Richards has shown that many statements in literature are in reality pseudo-statements, making no claim either explicit or implicit upon the reader's system of beliefs. Perhaps this valid point has now been over-demonstrated, and it is time for a reminder that not only maxims and apothegms like those of La Rochefoucauld but a vast array of poetry, fiction and drama offers propositional truth that has rightly been treasured. Nevertheless, to approach literature only or even mainly in search of this species of knowledge is of course mistaken.

The third concept dissociates poetry and knowledge altogether. Those who subscribe to this view would say that it is not important whether poetry yields propositional truth or any other kind of truth, it is not important therefore whether the poet is a liar in Plato's sense. The arts are justified because they give

[2]Murray Krieger, *The New Apologists for Poetry,* Bloomington, Ind., 1963.

pleasure, perhaps a "higher pleasure." This is a version of aesthetic hedonism. It represents an outlook widely held today, and often by people of cultivated sensibility. Many who are professionally concerned with literature declare that they look upon the arts this way, not as a form of cognition but simply as something to enjoy. The Marxist view here will be that while it is right to emphasize the pleasure to be derived from literature, it is a mistake to assume that the principal function of literature is to afford this pleasure and accordingly to deny or minimize the connection between literature and truth. In the one-sided stress on the pleasure function of literature at the expense of its cognitive features, we have a manifestation of the tendency in a certain kind of society to erect a barricade against truths having to do with the state of man and the meaning of history—against truths, that is, with which the humanities are specially concerned.

The fourth concept is that poetry has something to do with truth but not propositional truth; it is truth of another kind. Coleridge advanced this view when he described the imagination, as opposed to the fancy, as the truly original or creative power of the mind. The imagination enables the poet to see into the life of things, whereas the fancy, a more passive instrument, merely selects and combines images. Those who defend this theory of Coleridge's commonly insist that the truth poetry yields cannot be verified since it is separate from or even contrary to truth arrived at through the intellect. This view of the matter is attractive, as Krieger observes, because it appears to do justice to the creative role of the poet, showing him to be more than "an amasser and combiner of the experience he has discovered in the world." The theory accounts for "the utter newness of the true work of art." It is far preferable, therefore, to any theory "that would limit the poet to mechanical reshuffling, no matter how thorough that reshuffling may be."[3]

The Marxist would take the position that Coleridge was surely right when he asserted that the poetic imagination has a unique contribution to make to the discovery of truth. But he would reject the idealist assumption in the notion that the poetic imagination is a power to be accounted for in terms of a transcendental philosophy, and he would reject the irrationalist implications of a theory which, as Krieger says, generally rests on "the postulation of a faculty of imagination superior to the faculty of reason."[4] The more acceptable view would be that the artistic imagination provides materials for a certain kind of apprehension of the world and the scientific reason for another. Each of the two modes of knowledge is important; neither is superior to the other; neither is sufficient in itself.

To recapitulate the relationship between Marxism and the four concepts concerning the function of art, we can say that no one of these concepts can be subscribed to in an unqualified way, but that there are important elements of truth in each of the last three. What is needed is a view that will have room in it for these insights and will make them serve as part of a larger and unified whole.

Literature and Cognition

Among the many functions of literature, one of the most important is that it constitutes an indispensable way of discovering what reality is. In this function it parallels the other disciplines of learning—philosophy, history, the sciences. All have a similar goal, to give knowledge of reality—of the past, of changes taking place in our own time, of perspectives and possibilities for the future. Each of the

[3]*Ibid.*, pp. 65-66.
[4]*Ibid.*, p. 175.

them has as a main function merely illustration of knowledge that properly belongs within the domain of another.

Literature operates not in isolation from other forms of cognition but rather as a part of the totality of our effort to understand the world. We need the poem as an instrument of discovery, and we need all the rest of our knowledge of reality as a way of validating and verifying the insights the poem furnishes....

The experience gained through literature and the arts may be regarded then as a supplement to the knowledge acquired by exclusively intellectual means. It enters into and enlarges the awareness that is derived from that source and thus makes possible a fuller and more complex apprehension of the world. Knowledge of man and society that is gained through the intellect alone will be one-sided without this enlargement and enrichment, whereas the experience gained through literature will be impressionistic and untrustworthy without the discipline that the intellect alone can supply.

For an example of how literature functions as an instrument of discovery and how at the same time we need to put this discovery into the context of all we know, consider the image at the end of "Dover Beach" in which Arnold conveys his sense of the disorder of his time:

> *. . . for the world, which seems*
> *To lie before us a land of dreams,*
> *So various, so beautiful, so new,*
> *Hath really neither joy, nor love, nor light,*
> *Nor certitude, nor peace, nor help for pain;*
> *And we are here as on a darkling plain*
> *Swept with confused alarms of struggle and*
> *flight,*
> *Where ignorant armies clash by night.*

Here Arnold evokes primarily a sense of the precariousness and vulnerability of life—this in the context of the breakdown of the traditional religious props. One will not respond with a high degree of consciousness to certain aspects of the experience of modern man without knowledge of poetic passages like this; here we see how poetry functions as an instrument of cognition. Yet one cannot take the Arnold passage as a *revelation* concerning the human condition. The experience belonged to a certain period of transition, as Arnold himself avowed when he wrote about "standing between two worlds." If you are going to use a passage of this kind to widen and deepen consciousness of reality, you must make it part of an examined philosophy. We need the poetic statement and we also need historical and scientific knowledge. Without the complement of understanding that comes from these sources, the arts will hardly function reliably as an instrument of cognition, but at the same time cognition that comes from the other disciplines of learning without the particularity and immediacy of the arts will be impoverished.

In Yeats' "The Second Coming" we see again how the poem as discovery and a context of verification must supplement each other. Yeats evokes a sense of disintegration that has become part of the chronic burden of men whose outlook reflects the darkening perspectives of the West. "Things fall apart;/Mere anarchy is loosed upon the world . . ." Yeats pictures the emergence of murderous forces: "The blood-dimmed tide is loosed, and everywhere/The ceremony of innocence is drowned . . ."; he points to the unassertiveness of good men and the appalling

disciplines has an element of uniqueness in its way of pursuing this goal. No one of energy of fanatics: "The best lack all conviction, while the worst/Are full of passionate intensity." Then he goes on to describe the cycle of civilization that may follow our own, the incarnation of which he presents as a creature that appears to symbolize mindlessness and brutality—

> *somewhere in sands of the desert*
> *A shape with lion body and the head of a man,*
> *A gaze blank and pitiless as the sun,*
> *Is moving its slow thighs, while all about it*
> *Reel shadows of the indignant desert birds.*

We can say of "The Second Coming" what was said of "Dover Beach," first, that cognition of modern reality that has not been sharpened by poetic passages of this kind will be impoverished, and second, that the cognitive features of such a poem cannot function in isolation from the totality of our philosophical comprehension of reality. Like "Dover Beach," "The Second Coming" embodies a subjective vision. It is a vision that needs perhaps even more correction than Arnold's and the correction must be the outcome of a struggle with all one's powers to use every available discipline to find out what reality is....

Literature, then, is one of the indispensable ways of understanding the world and ourselves. Some such notion about literature has been part of the great central tradition of aesthetics; we see it in German classical philosophy, in Coleridge, in Arnold.

In this tradition, literature has always been regarded as one of the supreme concerns of man, chiefly because of the importance of its function in enabling us to know who we are and what we are, "of what scenes the actors and spectators." This view of literature is now in jeopardy. A society in which the dominant class has no program to offer for the general welfare, especially when a revolutionary class is in possession of such a program, will be compelled in a thousand ways to turn against its own life-affirming past. Part of what is being jettisoned is the traditional conception of the supreme importance of art. At least since Walter Pater a main trend has been to reject the whole concept of the cognition function of the arts. This is why one so frequently encounters the notion that the only proper concern of the student of literature is felicities of expression—a view that might parallel the mistake of supposing that the only concern of the construction engineer is the photogenic features of the buildings he erects.

On the question of the role and importance of the arts Marxism is at one with the great tradition; as an ideology of struggle it fights to maintain this tradition. Marxism may be regarded as a revolutionary philosophy designed among other things to conserve, transform and recreate the intellectual and cultural heritage. It proposes to rebuild social institutions in order to salvage and eventually to enrich the tradition by taking it as the starting point of a new humanist culture that will transcend the old because of new sources of strength provided by the socialist organization of society. One of the most important components of the tradition Marxism seeks to maintain and then augment has to do with the ideas we have been discussing concerning the function and importance of the arts.

In fighting for the cognitive role of the arts, the Marxists will make common cause with other humanists who are devoted to maintaining this tradition. We will differ from them in many ways—some of the differences will be alluded to in the

pages that follow—but we share an important function with them, namely, the effort in the face of adverse circumstances to salvage a long-standing humanist tradition in regard to the arts.

On What Reality Is

Marxists as individuals will differ from one another as does everyone else, but at the same time they will agree upon some fundamentals. Marxists are in agreement...as to what the 20th century is *about*; it is the age of transition from capitalism to socialism. The effects on behavior of one's understanding or not understanding this are prodigious. The effects go beyond behavior, as a matter of fact; they determine in the end the fundamental complexion of the art of our time. Those who think of this as the century of transition to socialism will display confidence, in themselves and in history. They look forward to a society in which economic relationships will be brought under social control so that man can take collective responsibility for directing the course of historical change in the interest of a programmatic humanism. Such collective responsibility is regarded as a pre-requisite for advance toward realization of the conception of human possibility that reached its high points in the Renaissance, the Enlightenment and Romanticism....

No writer in this country today will have much success in moving toward an increased realism unless he involves himself in the conflicts of the age. This will require that he ally himself in one way or another with some of the forces that have the capacity to create a socialist future, the working class, minority groups in their campaign for equal rights, the colonial people in their fight for independence, and the socialist countries themselves. Participation in the struggles of one's time is necessary in order to preserve confidence in man's capacity to create a society that will serve human ends....

Participation is needed also simply for an *understanding* of the conflicts of the age. Humboldt University in Berlin has at its main entrance the inscription from Marx stating that heretofore the philosophers have merely interpreted the world, the point however is to change it. At first one might think that this is an odd inscription for a university, which surely is devoted more to the interpretation of the world than to changing it. Yet the inscription is right, if only because you cannot understand the world without taking part in the struggle to change it.

...social involvement is needed for the *art*. If the artist's job is to illuminate the new reality of his time, and if what is genuinely new is emerging in the great areas of conflict like the civil rights movement and the peace movement, then it follows that the artist will not be able to throw significant light on this without being part of it. Furthermore, in the inter-relationship between emerging form and emerging content, it is probably more the new content (the reflection of a new social reality) that creates new artistic form than the other way around, as the matter is generally understood. The artist interested in developing new forms should therefore become a part of the new reality. That is where the new forms will come from....

Participation in the sense in which we have been using the term does not exclude detachment, another quality needed by the writer who wants to create an art that does not falsify. There is no reason why a man cannot enter fully into partisan activity and yet withdraw from time to time to see things in a detached way. In practice some will lean toward the extreme of involvement without participation, others to the extreme of participation without involvement, but the ideal is to combine the maximum of both....

Formalism

Exclusive preoccupation with form always carries us away from the essentials of art. One can test this with his own writing. No matter what kind of writing you do, you have to think of how to hold the material together, how to keep the reader involved, how to point forward to what is going to come later, how to make clear the interrelationships of the parts, and such matters. These are structural, or formal, considerations. But while engaged with this part of the writer's work, do you want the reader to observe what you are doing? On the contrary, you hope he will concentrate on what you are *saying*. If you manage the structural parts successfully, he will give no thought to your formal devices at all. A reader who observed the structural devices, who took note of transitions and the effort to anticipate questions and so on, would almost certainly be missing the point. You can test the proposition even with music, the most "formal" of the arts. Is it desirable that the listener should attend merely to the question of form that occupied Mozart or Schubert in the composition of a string quartet or for that matter with the questions of technique that are of concern to the musicians who perform the music? Is it not true rather that music offers an organization of auditory experience that will best accomplish its work for the listener when he relegates these questions of technique to a level of secondary importance?

An account of the reasons for the one-sided emphasis on form would be a long story. One reason is that frequently the critic regards life itself as uniform and unchanging and therefore ultimately without artistic interest, this in contrast to the Marxist view that we are perpetually confronted with the emergence of novelty in the evolution of man's nature and society. If one thinks of life as mere repetition, then in the search for the new, the changing, the different, one may well turn to questions of technique. Then of course it is a good deal easier to address yourself to questions of technique than to try to do justice to the totality of meaning in an artistic work. People who would feel incapable of dealing with the question of how an artistic work functions in the context of an examined philosophy will feel themselves able to speak with confidence about technique. A more important consideration, however, is that reality is often too hot to handle. A vital literature in our time must, like life itself, directly or indirectly pose the question of the need for fundamental change. In socialist realism it is part of the conscious aim of the author to pose this question. In critical realism the author may not have these perspectives in mind, but the reader is likely to. In modernism the author fails to grasp the causes of the plight of man today but even here if he does his work well, intelligent readers will get the point. So what can a corporation-sponsored college professor do except shift his attention to an area where academic rituals can be performed without hazard? Professor Peter Demetz has observed that German professors in 1945 found that "the poem itself" was "a convenient escape from political responsibility." One need hardly mention that the critic in question will not himself be consciously aware of such motives as these. We should have in mind also that in an age like ours, avoidance of political questions commonly means subservience to the reigning deities. In many of the New Critics, form served as a cover for the politics of the Right.

A sound criticism, while avoiding the current tendency to make an absolute of form, will at the same time attempt to do justice to the formal side of art. Yet Marxism will have its most important contribution to make at this moment in clarifying the cognition function of literature. This is what has been neglected in American criticism. It is only when we examine literature in this way that we begin to get the dimensions of a tragedy in art that exists side by side with the tragedy of

society in the epoch of deepening capitalist disorder. We move here into an area of persistent misunderstandings. Those who try to make essential points will be accused of being interested only in the politics of literature, not in art, of wanting to put the artist into an ideological straightjacket, and so on.

Realism

It is probably best to think of the term realism not as designating stylistic devices employed in realistic literature and not as a literary trend parallel to symbolism or expressionism or dadaism, but rather as signifying a certain way in which literature appropriates and interprets reality. Marxist critics use the term "method" of realism in some such way as this. The notion of method in this sense has both subjective and objective implications. The method of realism is subjective in that it requires a certain world view; it is objective in that a realist work will concern itself with certain features of outer reality more than with others. For example, if it is true that realistic literature gives better understanding of the relationship between the individual and society than other forms of art, it will necessarily concern itself with different spheres of human behavior and of social movement. Realism is an aesthetic term, since it has to do with the way the artist represents reality, but of course it has implications in regard to philosophy and *Weltanschauung* generally...

Socialist realism makes a significant advance beyond other forms of realism in a new grasp of the relationship between individual and society, with understanding of the power of the individual (expressed generally through the collective) to dominate circumstance. Where other forms of realism may show the protagonist as crushed by society, the socialist realist grasps man's power to alter the direction of social movement and make society serve human ends. The socialist realist will be aware of past, present and future in the events he describes. He will see how contradictions lead to resolutions, which in turn generate new contradictions. The socialist realist will be more consistent in his analysis of human motivations and will go further toward grasping the complexity of man. He will have a better understanding of estrangement, both of its sources and of how it is to be overcome.

Again realism should not be thought of as confining itself to the externals of man's behavior. It is concerned with the inner content of the psyche, with dream and fantasy, as well as with behavior associated with economic or social realities and the collision of classes.

Truthful reflection of life is always important in realism (this is the key concept) but reflection is not to be thought of in mechanistic sense. The creation of a world of possibility is also part of what one means by artistic reflection—a term generally to be interpreted in a broad sense.

An important feature of realism is a kind of partisanship which enables the artist to see meanings in experience that the non-partisan writer would push into the background. The realist writer will know the difference between essential and non-essential, though this does not mean that realist writing is concerned *only* with essentials. The realist writer will take account of the connection between the behavior of man and the dynamic movement of the society in which he lives. He will see things from all sides and be aware of their general contours, their relationships, their movements, their development.

Realist literature goes far toward a truthful representation of the condition of man, and in our own time this means that it must present or imply something like the actual state of affairs in a period marked by monopoly capitalism, disintegration of the colonial system, and the transition to socialism. Since realist art approaches a grasp of the actual contradictions of the segment of society and the

moment of time under examination, and since it portrays society in the process of change and manifests something of the possibilities in change, it cannot exclude the dominant historic transformations taking place in our century, though of course these do not need to be there in an *explicit* way....

Realist literature will explore the typical;[5] but by the typical we should understand not the average but rather the significant, the essential. To stress the typical in this sense does not mean to sacrifice the particular. In actual life the particular and the general go together, as do the accidental and the necessary, appearance and essence. The same is true of representation of the typical in art. The sacrifice of the particular to the general will lead to the one-sidedness of classical art. On the other hand the sacrifice of the general to the particular will lead to a diminished realism or to an art that approaches naturalism.

We cannot make effective use of the concept of realism without some notion as to what it excludes. The need to be clear about this was dramatized in a paper by Lee Baxandall at the Socialist Scholars' Conference in September, 1966. Baxandall in effect proposed to widen the bounds of realism to include what he described as "fantastic" or subjectivist or "modernist" realism. His main motive seemed to be to sanction innovation and experiment in modern art of a kind that in his opinion Marxists have not dealt with satisfactorily. His effort, he said, was "to arrive at a perspective whereby such major works of modernism as the writings of Kafka, Genet, Robbe-Grillet, Burroughs and the Surrealists, the painting of Impressionism, Cubism and after, the Happenings and related phenomena may be analyzed 'from within' and historically understood 'from without' using the viewpoint of realism."[6] Later he added Rilke, Picasso, Proust, Joyce, Natalie Sarraute, Pop Art, abstract expressionism and Brecht. The objection to Baxandall's proposal is that it seems logically to lead to a blanket endorsement of almost all art with the exception of the slender pickings that he described toward the end of his paper as non-cognitive art.

Baxandall sought support for his argument concerning fantastic realism in Marx. He called attention to the fact that Marx, expecially in his youth, showed a preference for the subjectivity, fancy, invention and whimsy in romantic art. Even among the novels of Balzac, Marx did not give preference to those dealing with political and economic questions. Baxandall believes that this feature of Marx has been obscured by his later hostility to romanticism. In the *Rheinische Zeitung* Marx campaigned against romanticism that associated itself with feudal hierarchy, with fantastic and perverted emotions, mysticism and pietism; he denounced the "medley of lies" in romantic art.

But this approach of Baxandall's leads to the anomalous view that in an age of capitalist decay, when signs of disintegration are all about us, in behavior, newspapers, conduct of foreign affairs and Vietnam, art is to be thought of as marching bravely forward from one success to another. But surely the fact is that in art you have the same contradictions as everywhere else, vital and progressive movements and also signs of disintegration, aridity, sickness, delirium. Baxandall encourages us to forget that the situation is as contradictory as this. Instead, he wants to award the honorific badge of realism to almost any and every artistic development of the 20th century.

What Baxandall's proposal amounts to is liquidation of some of the essentials of Marxist theory in regard to the arts. For while we can accept a high degree of subjectivity in art, Marxism should offer us criteria for determining what the role of

[5]Editors' note: Cf. above, pp. 108, 109.
[6]Lee Baxandall, *"Fantastic Realism"* (manuscript), pp. 1–2.

the subjectivity is, whether it leads to valid perceptions or innocuous ones or to what Marx termed "a medley of lies."

So when at the end Baxandall says that "fantastic realism can provide some of the most profound artistic experiences of the world needing change, and as well some foretaste of the freedom toward which man must be liberated,"[7] we can applaud, and yet we must add that *it may* not do this at all, it may lead to a profound artistic experience of being bogged down in the present, to a foretaste of illusory kinds of freedom; it may lead to surrender to a sense of anguish and absurdity.

Thus modernist art will depict man as hopelessly and irredeemably isolated or it will represent the human situation as being incomprehensible; it will concentrate on feelings of helplessness and anguish; it will debase the image of man by portraying him as essentially victimized and brutalized. It will do all this without perspective—that is, it will show these characteristics not as consequences and stigmata of capitalist decay but instead will exhibit them as if they represented the condition of man as such. Modernism may also include a tendency on the part of the artist to give up the struggle to grasp the truth about life and to escape into a preoccupation with form.

If you consider modernism as a method, the most important characteristic would be the failure to grasp the relationship between individual experience and the phenomena of capitalist disorder and the transition to socialism.

Modernism

Modernism differs from realism primarily in a different quality of perspective. Realist literature will embody a perspective that makes the human situation at least relatively intelligible and establishes a kind of coherence or meaning in it. Failures, frustrations, and defeat are not felt in realism to be the whole story but instead are placed within a context which establishes for them a different range of significance. Lukacs asserts[8] that perspective in some such sense as this is to be found in all the great literature of the world, whose protagonists—he mentions Achilles, Werther, Oedipus, Tom Jones, Antigone and Anna Karenina—are all seen as part of a "social and historical environment."[9] When the realist deals with characters who may be regarded as aberrations, they are understood *as* aberrations. Even if we are not shown what brought about this condition, we are kept aware of the norms from which they deviate.

A defining characteristic of modernism is loss of perspective in this sense. The modernist "identifies what is necessarily a subjective experience with reality as such,"[10] and so makes an absolute out of conditions that the realist is able to see in historical context. He portrays the torment and confusion of modern man, his victimization and anguish, as if this were somehow the whole story:

Modernist literature is incapable of depicting distortion in human nature or in the individual's relation to his environment—incapable, that is, of seeing distortion as distortion.

Once again we observe the profoundly anti-artistic character of modernism. The historical legitimation of modernism derives from the fact that the distortion of

[7]*Ibid.*, p. 81.
[8]Cf. above, pp. 105–115.
[9]Georg Lukacs, *Realism in Our Time*, New York, 1964, p. 19.
[10]*Ibid.*, p. 51.

human nature, the anti-artistic character of human relationships, is an inevitable product of capitalist society. Yet since modernism portrays this distortion without critical detachment, indeed devises stylistic techniques which emphasize the necessity of distortion in any kind of society, it may be said to distort distortion further.[11]

The loss of perspective in modernism involves a breakdown of the selective principle. The importance of this can hardly be exaggerated, Lukacs observes, since it is the selective principle that

determines the course and content; it draws together the threads of the narration; it enables the artist to choose between the important and the superficial, the crucial and the episodic. The direction in which characters develop is determined by perspective, only those features being described which are material to their development. The more lucid the perspective—as in Moliere or the Greeks—the more economical and striking the selection.[12]

When the selective principle ceases to operate, the writer will give prominence to insignificant detail and fail to penetrate to "the essence of man."[13] Man is thus reduced "to a sequence of unrelated experiential fragments."[14] He becomes "as inexplicable to others as to himself...."

Both realist and modernist literature will deal with the phenomenon of fragmentation, but the realist writer will bring enough perspective to show that we are dealing with specific kinds of sickness of a transient stage of society. The modernist, as always, will treat this condition as if it were part of the human essence. *Ulysses* will serve well to illustrate this as well as some other features of modernism. Joyce may be thought of as an infinitely talented genius who at the same time remained prisoner of the dead-end anguished condition of a late phase of capitalist disorder. The book in its general character is modernist partly in its lack of the kind of perspective discussed above. What makes long stretches of the book so unrewarding is perhaps precisely the fact that the experience is not set forth as part of a comprehended whole. The characters are not felt to be meaningfully related to a society understood either in terms of structure or of process. The book has many passages illustrative of the modernist failure to distinguish between significant and irrelevant detail. The book also lacks perspective in *time*. To be sure, something does happen—the son finds the father and the father the son. But apart from this event—the significance of which is hardly explored—we do not feel that the characters are comprehended in terms of development. The same goes for the social life of Ireland as it is pictured in this novel.

Because of the lack of perspective the satire in *Ulysses* has a modernist significance; it functions chiefly to belittle man and re-enforce the sense of meaninglessness in human experience. The satire in realist literature requires standards in terms of which deviations can be apprehended and ridiculed. But without perspective in the sense in which we have been using the term, such standards are unavailable....

One of the ironies of recent American cultural history is that *Ulysses* was for a long time banned because it was supposed to be obscene. The true objection to the

[11]*Ibid.*, pp. 75-76.
[12]*Ibid.*, p. 33.
[13]*Ibid.*, pp. 74–75.
[14]*Ibid.*, p. 26.

book has nothing to do with sexual morality, and indeed it is not a moral objection at all—except in so far as aesthetics and morals are dialectically inter-related. The objection is that the book does not give a discerning interpretation of human behavior in our time. The reason it fails to do this is that it embodies the constricted and ultimately falsifying perspectives of modernism.

Modernist literature will differ from realist in its depiction of another endemic phenomenon of our time, the sense of victimization. Ihab Hassan describes the typical protagonist of current American novels as a "rebel victim." The experience of victimization finds expression in all the arts, including the kind of music that has been described as giving voice to what people feel "in the air raid shelters."[15] Closely related to victimization is the "revolt in the void"—that is, revolt directed against the totality of the existing order, but characterized not so much by a program for change as by frustration and impotence....

The revolt in the void has the attraction of being politically innocuous. Ernst Fischer points out that "the ruling class only occasionally has any objection to this kind of 'radicalism'":

> More than that: in times of revolutionary upheaval, nihilism such as this becomes virtually indispensable to the ruling class, more useful, indeed, than direct eulogies of the bourgeois world. Direct eulogies provoke suspicion. But the radical tone of the nihilist's accusation strikes 'revolutionary' echoes and so can channel revolt into purposelessness and create a passive despair. Only when the ruling class thinks itself unusually secure, and particularly when it is preparing a war, does its satisfaction with anti-capitalist nihilism evaporate: at such times it requires direct apologetics and references to 'eternal values.' Nihilistic radicalism then runs the risk of being branded as 'degenerate art.'

The revolt in the void offers the most tempting kind of self-delusion. It makes no demand for the fierce integrity and courage required by a genuine revolutionary program:

> The nihilist artist is generally not aware that he is, in effect, surrendering into the hands of the capitalist bourgeois world, that in condemning and denying everything he condones that world as a fit setting for universal wretchedness. For many of these artists, who are subjectively sincere, it is by no means easy to grasp things that have not yet come fully into being and to translate these things into art. There are two good reasons why it is not easy: first, the working class itself has not remained entirely uncorrupted by imperialistic influences in the capitalist world; secondly, the overcoming of capitalism, not only as an economic and social system but also as a spiritual attitude, is a long and painful process, and the new world does not come forth gloriously perfect but scarred and disfigured by the past. A high degree of social consciousness is needed in order to distinguish between the death-throes of the old world and the birth-pangs of the new, between the ruin and the as yet unfinished edifice. Equally a high degree of social consciousness is needed in order to portray the new in its totality without ignoring, or worse still idealizing, its ugly features. It is far easier to notice only the horrible and inhuman, only the ravaged foreground of the age, and to condemn it, than to penetrate into the very essence of what is about to be—the more so as decay is more colorful, more striking, more

15Ihab Hassan, *Radical Innocence: Studies in the Contemporary American Novel*, Princeton, N.J., 1961.

immediately fascinating than the laborious construction of a new world. And one last word: nihilism carries no obligation.[16]

In its treatment of victimization, modernism differs from realism in that it portrays the attitudes in question as part of the nature of things rather than the product of a phase of historical development. So the anguish associated with the experience of powerlessness comes to be one of the defining characteristics of modernism. "Ought *Angst* to be taken as an absolute, or ought it to be overcome?" Lukacs asks. "Should it be considered one reaction among others, or should it become the determinant of the *condition humaine?* These are not primarily, of course, literary questions; they relate to a man's behavior and experience of life. The crucial question is whether a man escapes from the life of his time into a realm of abstraction—it is then that *Angst* is engendered in human consciousness—or confronts modern life determined to fight its evils and support what is good in it. The first decision leads then to another: is man the helpless victim of transcendental and inexplicable forces, or is he a member of a human community in which he can play a part, however small, towards its modification or reform?"[17]

The Kafka controversy hinges in part on the question of whether Kafka's treatment of victimization is realist or modernist. An examination of Kafka's work ... has led certain scholars to the conclusion that the final effect is to convey a sense of incomprehension and of victimization. Kafka provides Lukacs with the best possible illustration of the impulse to take flight from present reality combined with inability to picture an alternative:

As the ideology of most modernist writers asserts the unalterability of outward reality (even if this is reduced to a mere state of consciousness) human activity is, a priori, *rendered impotent and robbed of meaning.*

The apprehension of reality to which this leads is most consistently and convincingly realized in the work of Kafka. Kafka remarks of Joseph K., as he is being led to execution: 'He thought of flies, their tiny limbs breaking as they struggle away from the fly-paper.' This mood of total impotence, of paralysis in the face of the unintelligible power of circumstances, informs all his work. Though the action of The Castle *takes a different, even an opposite, direction to that of* The Trial, *this view of the world, from the perspective of a trapped and struggling fly, is all-pervasive. This experience, this vision of a world dominated by* angst *and of man at the mercy of incomprehensible terrors, makes Kafka's work the very type of modernist art. Techniques, elsewhere of merely formal significance, are used here to evoke a primitive awe in the presence of an utterly strange and hostile reality. Kafka's angst is the experience* par excellence *of modernism.*[18]

Kafka's world is "an allegory of transcendent nothingness," Lukacs says.[19] The writer did not understand the causes of the condition of alienation he portrayed and therefore could not put it in a satisfactory perspective. In Kafka, as in all modernist literature, "an intensively subjective vision is identified with reality itself."[20]

[16]*The Necessity of Art: A Marxist Approach*, Baltimore, 1963, pp. 88–89.
[17]Lukacs, *Realism in Our Time*, pp. 80–81.
[18]*Ibid.*, p. 36.
[19]*Ibid.*, p. 53.
[20]*Ibid.*, p. 52.

Modernism differs from realism also in its treatment of the theme of isolation. When in "Metamorphosis" Kafka turns Gregor into a cockroach with the size and weight of a man, he creates a symbol of isolation carried to the ultimate degree. No doubt Kafka was using the story to convey his own experience of paranoid alienation, yet we observe that he keeps us from thinking of Gregor's isolation as representative of the human condition by reminding us repeatedly of the norms of an affectionate family life. When the sister notices that Gregor doesn't care for the milk she has put out for him, he wonders how she will react. "Yet what she actually did next, in the goodness of her heart, he could never have guessed. To find out what he liked, she brought him a whole selection of food, all set out on an old newspaper. There were old half-decayed vegetables, bones from last night's supper covered with a white sauce that had thickened," etc. He is touched by her thoughtfulness. When she finds that Gregor has been struggling to move the armchair so he can look out of the window, she is careful to place the chair in the right position after tidying the room. Even after the sister begins to reject Gregor because of the smell, he thinks of her lovingly and wants to make her understand that he has intended to send her to the conservatory and would have announced this plan to the family at Christmas time if it hadn't been for his mishap....

The withering of personal relationship is a main theme in Albee's "The Zoo Story" and "The American Dream." For Peter in the first of these plays all human contacts have worn thin, his home life having become a thing of cats and parakeets (compare Orwell's aspidistra), and it is despair about human contact that drives Jerry to suicide....

Joyce's treatment of isolation is modernist, as one would expect. Consider the scene in the last chapter of *The Portrait of the Artist* in which Stephen rejects most of the "causes" that intrude their claims upon him:

—My ancestors threw off their language and took another, Stephen said. They allowed a handful of foreigners to subject them. Do you fancy I am going to pay in my own life and person debts they made? What for?

—For our freedom, said Davin.

—No honorable and sincere man, said Stephen, has given up to you his life and his youth and his affections from the days of Tone to those of Parnell but you sold him to the enemy or failed him in need or reviled him and left him for another. And you invite me to be one of you. I'd see you damned first.

Such passages reach their climax in the celebrated "I will not serve" speech:

—Look here, Cranly, he said. You have asked me what I would do and what I would not do. I will tell you what I will do and what I will not do. I will not serve that in which I no longer believe whether it call itself my home, my father-land or my church: and I will try to express myself in some mode of life or art as freely as I can and as wholly as I can, using for my defence the only arms I allow myself to use—silence, exile, and cunning.

Clearly Joyce means us to feel that these rejections are necessary if Stephen is to do the work he sets for himself, "to forge in the smithy of my soul the uncreated conscience of my race."

The roots of Joyce's distrust of social bonds lie in his own personal experience, needless to say. Joyce puts into *The Portrait of the Artist* his own disgust with

politics and shows the degree to which he shared an embittered dissatisfaction that went back to the time of the fall of Parnell. Since then Dublin had remained a "center of paralysis." Where others found a new cause in the Irish literary Renaissance, Joyce felt that the new effort to revive interest in the heroes of the distant past was factitious. These are the conditions that help to explain his need to refuse the claims of his city and country.[21] During the war, when he lived for the most part in Zurich, he appears to have had no political interests whatsoever. He was in the habit of talking disparagingly about "ideas" and "political terminologies." He described these as "things one has passed beyond." When asked whether Irish self-government would not be a good thing, he replied, "I don't think anything about it." When asked what he thought about the national movement in Ireland, his reply was, "I'm fed up with it."[22]

What got in the way of the formation of new ties was probably contempt for people that Joyce seems to have inherited from the aesthetic movement. "No man," he wrote in an early pamphlet, *The Day of Rabblement* (1901), "can be a lover of the true or the good unless he abhors the multitude; and the artist, though he may employ the crowd, is very careful to isolate himself...."[23]

But the fact is that in the modern world the gesture of severing bonds has two opposite kinds of significance. It may first of all be an act of often desperately needed self-liberation. Who can find himself in modern society without some such initial rejections as these? But the second point is that the gesture of defiance should at the proper time give way to new identifications and commitments. When this does not happen, the severing of bonds will create the conditions for a new bondage.

Socialist Realism

A difficulty in establishing an attitude toward socialist realism—or even in describing it—is that little of the significant work is closely studied in this country....

While socialist realism developed in capitalist society half a century ago, it may be expected to realize its potential only with the advance toward socialism. In what follows, I will indicate some of the features of socialist realism considered as the art of the future.

Like critical realism, it will put stress on truthfulness in the representation of reality (and ... this does not mean mere fidelity to external fact and does not imply simplification of the complex relationship between literature and reality). Like critical realism also, social realism will give special attention to the exploration of the relationship between the individual and society; it will examine the experience of the private person as it affects and is affected by the movement of society as a whole. Like critical realism, it will presumably be marked by the kind of historic concreteness that gets lost in an art that deals primarily with general and archetypal truths.

But it will differ from critical realism in being especially concerned with the day-to-day experience of the struggle for socialism. In some of its forms it will examine the "non-antagonistic" contradictions that begin to replace the antagonistic contradictions of capitalism. It will give particular attention also to the

[21]James D. Farrell in Seon (Givena) Manley, *James Joyce: Two Decades of Criticism*, N.Y., 1948, pp. 175–197.

[22]Cf. Richard Ellman, *James Joyce*, N.Y., 1959, p. 394.

[23]Quoted by Haskell M. Block in Thomas E. Connelly, ed., *Joyce's Portrait: Criticism and Critiques*, N.Y., 1962, pp. 235–236.

emergence of new modes of sensibility and behavior and to the conflict between these and the inheritance from the past. Of course a socialist realist art could exhibit the new while employing materials from the past, as in Shakespeare and much of the medievalism in romantic literature, yet on the whole it is to be expected that this literature will derive its materials from contemporary experience.

Socialist realism may be expected to differ from critical realism and even more from modernism in its assumptions concerning man's powers. Here it will show some affinities with the tradition of bourgeois humanism. But the belief in man's potential in the bourgeois tradition has largely been extinguished in the past century. The private person, in so far as he lacks comprehension of the conflicts that beset our society, or is unable to identify with an organized effort to work toward an ultimate change, has in fact become powerless; novels that reflect this powerlessness are showing things as they really are. In critical realism the humanism of the bourgeois tradition has come to express itself mainly in the indictment of existing society. Much of this literature has explored the defeat of the individual in his struggle against adverse social conditions, or it has examined the conflict between individual aspiration and a repressive society, between the yearning for a full life and frustration of this yearning. This literature, in other words, has been concerned with the quality of human experience in the context of the great contradictions of capitalism. A chief value in it has been the documenting of man's inability to cope with his environment. These generalizations apply even to the critical realism produced by writers who have seen the need for an advance toward socialism, such as Anatole France, Romain Rolland and Theodore Dreiser, and to the work of writers who have been to some extent influenced by Marxism, Jack London, H. G. Wells, G. B. Shaw, Martin du Gard, Thomas Mann, and Ernest Hemingway.

In modernism the earlier belief in human capacities is almost entirely extinguished, the protest being confined largely to a desperate defense of the anarchic freedom of the individual. With modernism art becomes increasingly private, and writers give up the effort to comprehend social reality or to convey in their works a comprehensive world view. In modernism, as also to a great extent in naturalism, the individual is passive and victimized. Literature continues to express dissatisfaction with the world of late monopoly capitalism, but this world is understood to be "the condition of man" and the dissatisfaction is passive. Such has been the fate of bourgeois humanism in the literature of recent times.

In contrast to all this, socialist realism will explore the increasing confidence and power of socialist man. The source of this augmentation in power lies primarily in the scientific world view of the first society in history whose foundations were elaborated before the new order came into existence. In this society man will have the power to go further than in previous times toward conscious control of social change. The power of the individual will be magnified through participation in collectives. In these new features of socialism, great problems are of course still to be faced and overcome, since conscious direction of history can also mean manipulation, and the collective has power to submerge as well as liberate the individual. But the problems of manipulation and of individual participation in state power exist everywhere in the modern world. In the Marxist view, the conditions of socialist construction will provide the only framework within which they can eventually be solved. The literature of socialist realism will in consequence be able to depict the conscious activity of men who have taken control of the course of history....

Of course socialist literature may have a "critical" element in the sense that faults will be found with existing socialist conditions, but this criticism would not in most cases be made in such a way as to raise doubts as to the capacity of collective man to solve the problems that confront him.

The new literature may be expected to employ a wide variety of technical or formal devices. We have no reason to think that in its formal aspect the literature of socialist realism will closely resemble what now exists.... There is an important element of truth in T. S. Eliot's observation that if it is not new, it is not art. On the other hand, one would not want to adopt the common bourgeois notion that formal experiments always represent a gain. Novelty can be sterile too....

Although the accomplishments of socialist realism are largely remote from this country, we have achieved something here. Whatever is to be said about the proletarian literature of the 30s, one thing is certain—that its literary importance was far greater than the critics of the 50s and 60s have been willing to allow. Steinbeck's *The Grapes of Wrath* and Hemingway's *For Whom the Bell Tolls* are probably the most important literary products of this movement. What are the chances of a revival of socialist realism in this country today? In so far as the struggle for socialism is going on here, we do have a basis for literature of this kind. The more the struggle broadens and intensifies, the greater the number of people who involve themselves in it, the better will be the conditions for such a development.

Political Control of Literature

Harold Swayze

Harold Swayze (1930–) is a political scientist who attended Harvard, Oxford, and the University of Moscow, receiving his Ph.D. from Harvard in 1955. The volume from which the following selection was taken is the first major study since World War II of the control of belles lettres in the U.S.S.R. during the postwar period. Swayze's account of "partiinost," "Ideinost," and "narodnost"—key concepts of the Soviet art and literary world—helps us understand the rebellion of Abram Tertz recorded in the next selection.

Marx and Engels devoted little attention to questions of aesthetics as such. Most of their writings on art and belles-lettres are actually concerned with social and ethical problems treated in particular works rather than with broader problems of art. But some key concepts of their science of history claim attention because they have become fundamentals in a theory of art. Central to the Soviet rationalization of controls over the arts is the view that history is, among other things, a process whereby men, as members of social classes, gradually shed their illusions and adopt ideas which ever more closely approximate an ultimate truth that can be known. The view embraces the postulates that a material reality exists apart from mind,

From *Political Control of Literature in the USSR, 1946–1959* by Harold Swayze (Cambridge, Mass.: Harvard University Press, 1962), pp. 2–25. Copyright 1962 by the President and Fellows of Harvard College. Reprinted by permission of the publisher.

that mind is dependent upon it, and that truth is essentially a reproduction of that reality. In conjunction with the thesis that history is the history of class conflicts, this view provides the basis for a doctrine of "ideologies." Just as changes in productive relationships determine the supersession of one class by another, so do they condition the mutation of the sets of ideas which arise from the economic substructure. These sets of ideas—political, philosophical, religious ideologies—reflect and serve the interests of the social classes which adhere to them; they are at worst gross distortions and at best defective approximations of the truth about various aspects of reality. But as successively more "advanced" classes achieve domination, truth is apprehended more adequately. Dialectical materialism, the scientific theory which makes it possible for man to view the world objectively, is associated with the proletarian consciousness and appears in history with the rise of the proletariat, "the class which no longer counts as a class,"[1] the class which has been relieved of false world views and can see existing ideological superstructures for what they are—"just so many bourgeois prejudices, behind which lurk in ambush just as many bourgeois interests."[2]

It is evident that there is a strong pragmatic strain in Marxist thought despite its absolutist stand on the question of the status of truth. Ideas not only reflect but serve the interests of their adherents, and Marxism itself is more than an explanation of the past and present and a scientific prediction of the advent of socialism: it is an instrument for guiding the forces of history toward the realization of the inevitable, a first step in the process of reshaping history and human society. Indeed, this is precisely why it is "scientific" and true, for control over events is, for Marx and Engels, the proof of true thinking. Engels once wrote in a particularly revealing passage that "the most telling refutation" of skepticism about the possibility of knowledge of the real world and other such philosophical fancies

is practice, viz., experiment and industry. If we are able to prove the correctness of our conception of a natural process by making it ourselves, bringing it into being out of its conditions and using it for our own purposes in the bargain, then there is an end of the Kantian incomprehensible "thing-in-itself."[3]

These are among the ideas that lie behind the doctrine of the unity of theory and practice, and they account in part for the Soviet preoccupation with the intimacy of the relationship between thought and action.

Marxian scientific historicism is permeated by a crusading spirit which implies a set of ethical values. Some indication of the character of these values is to be found in Marx's prophetic utterances about the role of art in the ideal society, utterances which Lenin sometimes echoed when expounding his own visions. When man has grasped the working of economic laws and is no longer their slave, thought Marx, when the detested capitalist order has disintegrated and freedom is actualized, man will be able to develop his capacities fully, to become a complete human being. This "objectivization of human existence," Marx once wrote emphatically, means "making man's *senses human* as well as creating *senses* corresponding to the vast

[1]Karl Marx and Frederick Engels, *The German Ideology,* Parts I and III, ed. R. Pascal (New York, 1947), p. 69.

[2]*The Communist Manifesto.*

[3]*Ludwig Feuerbach and the Outcome of Classical German Philosophy* (New York, 1935), pp. 32–33.

Socialist Realism: Aesthetic of the Left

richness of human and natural life"; it will bring "the complete *emancipation* of all human senses and aptitudes."[4] And in *The German Ideology* Marx and Engels looked forward to the reintegration of art in the life of the individual and the community. In a society based on communism, they asserted, "the exclusive concentration of artistic talent in a few individuals and its consequent suppression in the large masses" disappears with the elimination of the division of labor: "there are no painters; at most there are people who, among other things, also paint."[5]

... G. V. Plekhanov's views on art were widely influential in Russia through the twenties, and their repudiation in the early thirties was an event of considerable significance.... Plekhanov demonstrates that there has never been an "art for art's sake" and that those who professed such theories really served the cause of the bourgeoisie, though at first unconsciously. He now asserts explicitly that "the merit of a work of art is, in the final analysis, determined by the 'specific gravity' of its content."[6] It is apparent that truth, which means essentially the truth of social relations, becomes for Plekhanov the principal criterion of aesthetic evaluation. Plekhanov approves the view that the value of a work of art is determined by the loftiness of its idea, that art "is one of the means of spiritual intercourse among men, and the loftier the sentiment expressed by a given work of art, the better will the work fulfill its role as a means of intercourse, other conditions being equal."[7] To foresee the conclusions to which this leads, it is only necessary to place it against the Marxist view that history is the gradual advance toward truth through class conflict and that the ultimate good is the victory of the proletariat. Because Plekhanov regards art as an aspect of the economically determined superstructure, he is able to claim: "The ideologies of the ruling class lose their intrinsic value in the same measure as that class ripens for destruction; the art created in the spirit of that class declines with it."[8] The implication is that a vigorous art, one whose ideals are "lofty," can only be an art which is associated with the proletarian cause and that truthfulness in depicting society can best be attained by those who adopt the Marxist viewpoint. It is noteworthy that, in an earlier manuscript which provided the basis for this essay, Plekhanov said explicitly that some bourgeois writers during the decline of their class will go over to the side of the proletariat and that both their world view and their creative work will gain considerably from this.[9] Thus, Plekhanov linked the possibility of high artistic achievement to a definite world view and a particular cause, and he tended to regard the liberation of the proletariat as the value of values, the ultimate criterion for evaluating everything. Nonetheless, there remain in his writings, somewhat inconsistently, a demand for objectivity and a defense of relativism in aesthetics and art criticism. Plekhanov's emphasis on the distinctive character of aesthetic experience, on the nonrational and nondiscursive character of artistic expression, and his insistence on aesthetic as well as sociological evaluation of art were incompatible with the crude intellectualist reductions of theories which regard art solely as an instrument of political action. The apotheosis of "Leninist aesthetics" in the thirties marked a more emphatic effort to resolve the tensions apparent in Plekhanov's thinking on problems of art and belles-lettres....

Lenin, in fact, added nothing to aesthetic theory as such. His remarks on various writers and even his articles on Tolstoy are concerned with social questions rather

[4]Marx and Engels, *Literature and Art: Selections from Their Writings* (New York, 1947), pp. 17, 61.
[5]*Ibid.*, p. 76.
[6]"Iskusstvo i obschestvennaya zhizn," *Soch.*, XIV, 120–182.
[7]*Ibid.*, p. 138.
[8]*Ibid.*, p. 150.
[9]*Literaturnoye naslediye G. V. Plekhanova*, P. F. Yudin ed. and others (Moscow, 1934–1939), III, p. 201.

than with problems of art. But the importance of his article of 1905, *Party Organization and Party Literature,* can hardly be exaggerated, if only because of the use made of it in later years. Lenin declared in the article that literature "must become party literature" and said that *partiinost* in literature means that literary affairs "must become a *part* of the general proletarian cause ... a part of organized, systematic, united Social Democratic party work."[10] And he seemed to outline a general program for party supervision of literary activities, asserting that writers "must without fail enter party organizations," that newspapers must become attached to such organizations and that publishing houses, libraries, and such, must be accountable to the party.[11] On the other hand, Lenin was mainly concerned with the question of party discipline at a time when socialist parties and their press had been legalized; and he emphasized that he was speaking only of party literature and the party's right to expel writers who would not subject themselves to control. Furthermore, Lenin observed that in the realm of literature "it is absolutely necessary to provide a broad scope for individual initiative, individual inclinations, scope for thought and imagination, form and content," and he warned that literary affairs "must not be mechanically identified with the other parts of the party affairs of the proletariat."[12] If there is an apparent inconsistency between the advocacy of freedom for the writer and the principle of party control, it is resolved by Lenin's view that the freedom of the bourgeois writer is really "only disguised dependence on the moneybag" and by his assertion that a truly free and diverse literature can only be one that is *"openly* bound to the proletariat."[13] It is this identification of freedom with party control that makes Lenin's writings such a fertile source for citations justifying divergent viewpoints and that permits such breathtaking transitions as the following one, recorded by Klara Zetkin:

> *Every artist ... has the right to create freely, according to his ideal and independently of anything else.*
> *But we are Communists, of course. We must not stand with folded arms and let chaos develop as it will. We must guide this process according to a systematic plan and mold its results.*[14]

If Lenin's writings leave any doubt about his views on the question of subjecting literature to party control, the policies he pursued after the revolution go far to dispel them.... Thus, the principles were established that cultural organizations could not be independent of government, and ultimately party, supervision and that there could be no place in such organizations for artists whose views differed from those of the party or, it would seem, whose practices in art suggested divergent views....

Lenin's writings also furnish authoritative support for requiring a popular art, for insisting on the principle of *narodnost* in the arts. Lenin was, of course, acutely aware of Russia's cultural backwardness, and many of his remarks on cultural matters focus on the need to increase literacy and to make the achievements of the past widely accessible in order to provide a basis for cultural advance. And he was certainly alert to the emotional impact of art and its inherent educative

[10]*Lenin o kulture i iskusstve,* ed. M. Lifshits (Moscow, 1938), p. 112.
[11]*Ibid.,* p. 113.
[12]*Ibid.*
[13]*Ibid.,* pp. 114- 115.
[14]*Ibid.,* p. 298.

potentialities. Such concerns are apparent in utterances of his which have been used to justify practices of which he might not have approved:

Art belongs to the people. It must penetrate with its deepest roots into the very midst of the laboring masses. It must be intelligible to these masses and be loved by them. It must unite the feeling, thought, and will of these masses; it must elevate them....[15]

The foregoing sketch may help to elucidate the specific significance for belles-lettres of the triad of concepts—*partiinost, ideinost, narodnost*—which Soviet ideologists regard as the basis of literary policies. It must be observed at the outset, however, that the partiinost of Soviet literature "is identified with ideinost and narodnost,"[16] as one critic said in a typical statement indicating that the latter two terms tend to dissolve in an all-embracing partiinost; for the party is, after all, the guardian of the ideology and the embodiment of the people's will. Obviously the principles overlap and, though each may represent a unique idea or set of ideas, the task here is not to analyze each to its irreducible core of meaning, but rather to determine how together they form a theoretical framework and justification for controls.

It has been pointed out that Marxist theory posits an evolutionary scheme which, combined with a sociology of knowledge, leads to the conclusion that an absolute truth is more closely approached as successively more advanced classes achieve a dominant position in society. This truth is the truth of Marxism, which demonstrates that history is a gradual advance toward a classless society. The proletariat is at once the objective embodiment of this truth and the class that is best able to perceive the meaning of history and to hasten the realization of history's purposes. Or, more precisely, these are the attributes of the most advanced segment of this class, the Communist Party. Thus the program of the party is both a projection of historical laws and an instrument for achieving the inevitable and ethically desirable outcome of the processes of history. What is true, as well as what is ethically good, must be what corresponds to party policy and, on the basis of the pragmatic principle inherent in Marxism, to what serves the party's aims. The circular argument thus justifies authoritarian truth determination and at the same time leaves great scope for variations of program, since the party is the single source of truth. If representing the truth is conceived to be literature's main function and truth to be the ultimate aesthetic standard, it is evident that the more tenaciously a writer cleaves to the party line and the more scrupulously he reproduces the party viewpoint in his work, the greater will be the aesthetic merit of what he creates....

Soviet thinking on art and belles-lettres does not on its surface appear so crude as this, of course. Although scientific knowledge and aesthetic knowledge are considered to have essentially the same content, and although sometimes the distinction between aesthetic and scientific cognition has been explicitly rejected, a difference between art and science is more often recognized and even stressed; for art is frequently characterized not merely as the representation of reality in images but as imagistic cognition of reality—as "thinking in images." Thus it is of central

[15]Editors' note: A famous exhortation of Alexander Herzen, "father" of Russian liberalism, was "V Narod," ("To the People!"). In the 1860s and 70s, the Narodniki, as they were called, most of them students and many from Russia's best families, dedicated themselves to living with and serving the peasants in what is known as the Narodnichestvo Movement. Often betrayed by suspicious peasants, most of these idealists wound up in exile.

[16]B. Yakovlev, "Veliky printsip," *Novy Mir*, no. 2, 1947, p. 26.

importance to determine the character and profundity of the distinction.... The crucial question is whether art as aesthetic cognition is considered to be an autonomous mode of cognition, independent of intellectual cognition and conceptual knowledge, or whether it is considered to be inadequate and incomplete in itself, in need of guidance and verification from some other source. If aesthetic cognition is understood to be dependent upon or derivative from conceptual knowledge, it tends to become indistinguishable from the latter, or at most to be treated as an accessory to it. If the primary function of belles-lettres is the cognition and truthful representation of reality—which can only be reality as it is defined by the party ideology—the content of belles-lettres must be the content of that ideology in disguise; it must be the knowledge of conceptual cognition and not that of independent aesthetic cognition. Pious declarations that art is a "special means of cognizing reality" are by themselves insufficient to maintain the distinctions necessary for accounting for the peculiarities of aesthetic experience. Proclaiming the need to ascertain the "defining characteristics" of art, Soviet ideologists are unable, if not unwilling, to preserve the requisite distinctions because their formulations must be fit into the Procrustean bed of Leninist-Stalinist aesthetics, whose form is determined by partiinost. And within this framework of ideas, the theoretical basis for the existence of art is at best uncertain. The force of the doctrine is to reduce art to a subsidiary mode of describing a reality that may be more truly and adequately described by the use of the conceptual tools at the disposal of the party; it is to treat art as a means of illustrating truths attained in some way other than through aesthetic cognition. Eloquent testimony to this is provided by Soviet ideologists' obsession with the question of "typicalness," which often seems to imply a metaphysics of essences and their insistence that belles-lettres should be concerned with "types," which are concepts produced by analysis and abstraction; thus literature is presented with the task of clothing intellectual constructs in sensible forms. The problems created by this viewpoint have been discussed in the Soviet Union for the past twenty-five years or more.[17]

Although the exaltation of partiinost appears in principle to close the gap between political and aesthetic criteria, it cannot remove the need for taking account of aesthetic values in actual practice; nor can it eliminate the tensions that arise between a theory which in its essence denies aesthetic values as such and a program which places considerable reliance on art as an instrument of political action. For even if works of art are regarded only as instruments of indoctrination, they must possess a modicum of artistic merit if they are to be effective as such; and to admit this is already to point to distinctions which apparently have been rendered meaningless. The interplay between these incompatibilities and the concern about it displayed by writers and party officials are among the forces which mold the course of Soviet literary politics. It is the existence of such tensions that is acknowledged by halfhearted, ill-defined references to the differences between art and science, between "thinking in images" and "thinking in concepts," and the like. The existence of two orders of values is symbolized by the fact that socialist realism rather than dialectical materialism has been canonized as the basic method of Soviet literature. But it is not easy to say exactly what socialist realism means beyond "fulfilling the party's program for belles-lettres," or "partiinost."[18]

[17]Editors' note: Cf. above, pp. 108, 109, 123.
[18]Even Soviet writers whose works are held up as outstanding examples of socialist realism have not found it easy to explain what the doctrine means. When Mikhail Sholokhov was asked,

A sampling of writings on socialist realism indicates that the vast quantity of material devoted to this subject consists largely of terminological hairsplitting, efforts to manipulate previous formulations into conformity with a shifting party line, and consciously or unconsciously misleading and confused attempts to reconcile the irreconcilable. Penetrating analysis of aesthetic problems and methodologically significant discussion of literary criticism have long since vanished from the pages of philosophical and literary publications, and if debates arise whose significance extends beyond some immediate political development or policy trend, their deeper implications are obscured by the garb of conformity....

The Soviet approach to aesthetics results in what is not only an intellectualist but also a pedagogic and moralistic theory of art: art is not merely a subsidiary to the intellectual cognition of reality. As with all intellectual endeavor, from a Marxist point of view, art serves some specifiable end external to art itself. Art is instrumental to the realization of the inevitable and desirable outcome of the historical process, which is the victory of the proletarian cause. Thus, a justification is already provided for requiring art to disseminate certain kinds of knowledge and to inculcate ideas and modes of behavior that are adapted to proletarian purposes. The recognition that art conveys information and has a moral impact is transformed into the theory that these are virtually the only purposes of art, and even in principle the possibilities for discussing aesthetic problems as such, or investigating something that may be called aesthetic enjoyment, are narrowly circumscribed.

A series of corollaries is drawn from the basic formulations of Soviet art theory to make unmistakably explicit what the theory entails with respect to the tasks of depicting reality and inculcating moral and political values. Correct representation of reality is dependent upon adherence to a specific world view: "Knowledge of Marxism-Leninism," goes a typical statement of the point, "makes it possible for the artist to see the true social essence of the profound processes of reality in development... The truth of life and Communist ideinost are inseparable from one another."[19] To affirm the need to adopt a definite ideological position is, of course, to affirm the principle of partiinost, since that is regarded as the highest form of ideinost, just as it is said to be the highest expression of narodnost. And the meaning of partiinost has become even broader than that which Lenin seemed to intend in his famous essay, for it now applies to party and nonparty writers alike. As Fadeyev generously declared at the Second Writers' Congress:

The partiinost of Soviet literature is not an exclusive thing, the peculiar property of writers who are party members and in general of the few. It is the historical property of our Soviet literature....when we speak of the partiinost of Soviet literature, we have in mind the historical fact that Soviet writers, both party and nonparty, recognize the correctness of the Communist Party's ideas and defend them in their work, and therefore naturally acknowledge the guiding role of the party in literary affairs.[20]

during his trip abroad in 1958, to define socialist realism, he at first replied by citing a remark that his friend and colleague, the late Alexander Fadeyev, made shortly before his suicide in 1956: "If any one should ask me what Socialist realism is, I should have to answer that the devil alone knows." Sholokhov went on to say that his own answer would be that "Socialist realism is that which is written for the Soviet Government in simple, comprehensive [sic], artistic language." *New York Times*, May 11, 1958.

[19]L. Plotkin, "Vazhneishy vklad V. I. Lenina v nauky o literature," *Oktyabr*, no. 11, 1955, p. 162.

[20]*Vtoroi vsesoyuzny syezd sovetskikh pisatelei, Stenograficheskky otchyot* (Moscow, 1956), p. 506.

The rationale for this was provided, historically, by the determination that, classes having been eliminated, Soviet society had become homogeneous in composition and uniform in viewpoint. Furthermore, the doctrine of the unity of theory and practice leads logically to the conclusion, "any deviation from the principle of partiinost produces an unwitting distortion of reality,"[21] or "whoever is not armed with Marxist-Leninist ideas loses perspective in his daily work and inevitably makes mistakes."[22] But more than distortion and error is involved, for ideas, according to the theory of ideologies, reflect and serve class interests, and ideas that diverge from proletarian ideology represent hostile class interests. As Karl Radek stated the point at the First Writers' Congress: "When it seems to a person that he is defending only some individual shade of opinion against it [the party], it will always become apparent on the basis of a political test that he is defending interests alien to the proletariat."[23] ... The argument was stated quite bluntly in 1922 by the Marxist critic P. S. Kogan: "Behind the struggle between styles, forms, and artistic schools," said Kogan, "lies hidden the struggle between ideologies, and still further back, the struggle between classes."[24] Like all elements of the superstructure, art inevitably participates in the class struggle, and even ostensibly neutral, escapist, "pure" art actually serves bourgeois interests, as Plekhanov demonstrated so forcefully. Such arguments buttress the claim that only a single method is possible in Soviet art:

> Socialist realism is the only method of our art.... Any other method, any other "direction," is a concession to bourgeois ideology.... In our country, where socialism has been victorious, where there has arisen a moral and political unity of the people unprecedented in the history of mankind, there is no social basis for different directions in art.[25]

Against the elaborate rationale underlying such statements, the metaphor that normally accompanies them—that within the limits of a single "direction" there can exist diverse "tendencies"—is not very reassuring.

From the basic formulations that give rise to a moralistic-pedagogic theory of art are derived certain propositions that justify specific didactic claims. The "socialist" of socialist realism in a sense points to this facet of the system of exactions. For if "realism" means artistic cognition of an external reality, "socialist" connotes the "dialectics" of dialectical materialism and signifies the artistic representation of reality in its "revolutionary development"—or discerning the rose of the future in the cross of the present. This view finds expression in the conviction that a principal task of literature is showing "advanced" types of Soviet man, or Soviet man as he ought to be, or creating "valid examples for emulation," as Konstantin Simonov once put it.[26] Indeed, the phrase which Stalin is supposed to have uttered in conversation with Maxim Gorky and which has been quoted relentlessly ever

[21]A. Tarasenkov, "Zametki kritika," *Znamya*, no. 10, 1949, p. 176.

[22]"Vyshe znamya ideinosti v literature," *Znamya*, no. 10, 1946, p. 30.

[23]*Pervy vsesoyuzny syezd sovetskikh pisatelei. Stemograficheshy otchyot* (Moscow, 1934), p. 312.

[24]Quoted in William Edgerton, "The Serapion Brothers: An Early Controversy," *American Slavic and East European Review*, VIII (February 1949), 57.

[25]"Za dalneishy podyom sovetskoi literatury," *Kommunist*, no. 9, 1954, p. 24.

[26]*Literaturnaya a gazeta* (hereafter cited as *Lit. gaz.*), May 5, 1955, p. 3.

since—that writers are "engineers of human souls"—only casts into terms presumably more suitable to the spirit of this century an old thesis about the function of literature, one which Aristophanes characterized in the line: "As the teacher instructs little children, so do the poets speak to those of maturer age."[27] The moralistic-pedagogic viewpoint gives rise to the theory of "the necessary unity of aesthetic and ethical evaluations in Soviet art,"[28] and it manifests itself in the widespread belief that "it is necessary to judge the value of a book by the educative effect it has on the human soul."[29]

If literature is to be socially effective as a device for instruction and edification, it must create an impact that is not only intensive but extensive. For this reason, the principle of narodnost is invoked and another criterion applied—the one designated by Simonov's rhetorical question:

When a book addresses itself to our whole society and in principle, ideally can be read by the whole society, is not the very popular character [obshchedostupnost] of this book one of its artistic criteria? Is not the creation of literary works...which will in equal measure stir a citizen with a higher education, a university professor, and one who has only completed a seven-year school, a machinist in a factory— is not...the ability to create such a book not only a political and an ideological achievement, but an aesthetic achievement as well?[30]

The same interest is among the factors that lie behind the Soviet opposition to experimentalism in literature and the bias in favor of exploiting traditional forms of folk literature and familiar devices of nineteenth-century realism. "In the province of form," goes the usual rationalization of this, "socialist narodnost signifies high perfection of artistic expression combined with simplicity and intelligibility, with accessibility to the masses. Lenin said that art must be intelligible to the masses."[31]

Thus, there are fundamentally three standards for estimating the merit of a literary work: the truthfulness, or party-minded spirit, of the work's portrayal of reality, the work's pedagogic potentiality, and its intelligibility to the broad masses—all prerequisites for transforming literature into a serviceable social tool. In terms of Soviet doctrine, belles-lettres become an adjunct to politics and pedagogy, a sugar coating on the pill of knowledge and morality. Insistent demands that Soviet literature meet high artistic standards suggest that significant aesthetic criteria are officially acknowledged; but public discussion reveals little about the special properties of these criteria and even less about the theoretical grounds for recognizing the claims of such criteria.... Writers are caught in a vicious circle whereby works which express their own feelings and special insights may be branded "subjectivistic," "pessimistic," "retreats from reality," and works produced as an effort to meet official requirements may be declared "abstract" or "schematic." But the assumption made at least formally is that the writer's

[27] *The Frogs,* line 1055.

[28] P. Trofimov, "Yedinstvo eticheskikh i esteticheskikh printsipov v iskusstve," *Bolshevik,* no. 18, 1950, p. 36.

[29] G. Lenobl, "Sovetsky chitatel i khudozhestvennaya literatura," *Novy mir,* no. 6, 1950, p. 215.

[30] "Zametki pisatelya," *Novy mir,* no. 1, 1947, p. 172.

[31] M. Rozental, "Voprosy sovetskoi esteticheskoi nauki," *Bolshevik,* no. 13, 1948, p. 56.

approach to the world about him does not diverge from that necessitated by the party ideology.... That the subordination of the claims of self-expression to those of orthodoxy has impaired the quality of Soviet literature is abundantly demonstrated by Soviet literary criticism itself. The conflict between these claims is a main current in Soviet literary politics.

Another fundamental contradiction in the official theory of art lies in the claim that reality must be portrayed truthfully but also in its "revolutionary development," that is, in a didactically purposeful manner. How to reconcile these demands is a question that continually plagues Soviet writers. The problem is revealed clearly enough in one of Fadeyev's efforts to demonstrate that its solution lies within the realm of possibility:

> *One may ask: Is it possible to portray truthfully a living human character "as he is" and at the same time "as he ought to be"? Of course. This not only does not diminish the strength of realism, but it is what genuine realism is. Life must be shown in its revolutionary development. I shall take an example from the realm of nature. An apple as it is in nature is a rather bitter wild fruit. An apple grown in a garden (particularly in such a garden as Michurin's) is an apple "as it is" and at the same time "as it ought to be." This apple reveals more truly the essence of an apple than does the wild fruit.* [32]

This may be realism, but it suggests realism of a Platonic variety rather than what is usually meant when the term is applied to literature and art. Soviet theorists have never pretended to subscribe to a naturalistic literary theory of the sort represented by Stendhal's definition of the novel as a "mirror walking down a roadway," which as an ideal of objectivity toward which literature should strive is undoubtedly unattainable, if not undesirable. But in Soviet usage, "realism" and "truthfulness" are mainly honorific terms meaning representation of that aspect of reality in which the party happens to be interested and representation of it in a manner approved by the party. And writers must steer a difficult course between a "crude naturalism" that portrays reality in undesirably somber tones and an "embellishment of reality" that portrays it in unbelievably bright ones. The real question is not so much whether Soviet theory prevents literature from approaching photographic objectivity as it is one of whether the political and moral didacticism required by the theory is compatible with depicting the myriad facts of human life and expressing complex imaginative intuitions in literary works. Soviet writers are continually reminded that, while they must reveal life in all its diversity, their principal aim must be "to expose relics of the past, to aid the development and victory of the new, to affirm that victory, to create an image of the positive hero." [33] If "positive" characters are to be created that they may be imitated, "negative" characters must be portrayed to be condemned. The enemy, Alexei Surkov once said, "must not only be shown but also exposed with the whole power of the work of art. He must be morally vanquished, as actually happens in our life, and the persons who triumph over this enemy must not be left in the shade." [34] Soviet literary pundits sometimes sound remarkably like Dr. Johnson who, similarly unable to differentiate between the functions of belles-lettres and those of a moral tract, could not "discover why there should not be exhibited the most perfect idea of virtue; of virtue not angelical, nor above probability, for what we cannot credit,

[32] A. Fadeyev, "Zadachi literaturnoi kritiki," *Oktyabr*, no. 7, 1947, p. 150.

[33] "Nasushchnye zadachi sovetskoi literatury," *Kommunist*, no. 21, 1952, pp. 15–16.

[34] "V dolgu pered narodom," *Lit. gaz.*, April 8, 1952.

we shall never imitate, but the highest and purest humanity can reach.... Vice, for vice is necessary to be shewn, should always disgust."[35] A striking example of the extent to which such attitudes have entered into Soviet thinking is to be found in an article by Ilya Ehrenburg which is notable for its generous views on various problems of creative writing. In support of his position, however, Ehrenburg suggests at one point that showing "angelical virtue" may be incompatible with literature's pedagogic purposes:

The critics claim that only irreproachable heroes can set the reader an example. Is this so?... Some readers genuinely try to imitate the ideal hero. To others these heroes seem remote and unattainable; they learn from the example of people who are not lacking in weaknesses, they learn from such characters' mistakes and successes. They want to learn not how to be born a hero but how to become one.[36]

That they may fulfill their pedagogic tasks, Soviet writers are expected to develop clearly defined attitudes and to display their views without perplexing ambiguities in their treatment of fictional characters and situations. This viewpoint was affirmed with customary forthrightness at a writers' conference early in 1957, where the main speaker said, after approving the representation of man "in all his manysidedness, complexity, and fullness": "But socialist realism, like all realism, all truthful and progressive art, demands precision in evaluating people, in revealing their main, defining features."[37] Yet such views themselves ultimately lead to that "vulgar simplification, schematism, and 'poster-painting' " in literature which the same speaker disparaged, and they serve as rationalizations for limiting the writer's choice of colors to black and white....

They do so necessarily through conflicts over particular problems in various literary genres—problems that center on such issues as the distinction between "positive satire" and "slander" or, in lyric poetry, between self-analysis and decadent subjectivism; in comedy, problems created by the bias against "laughter for laughter's sake" and "unprincipled entertainment"; in tragedy, by the doctrine of the inevitable victory of the "advanced" and the theory of "optimistic tragedy." These and related problems, which illustrate the impact of the larger theory on particular aspects of literary practice, are beyond the scope of this study....

True creativeness implicitly threatens a doctrine which, in spite of its dynamic appearance, is deeply conservative and inflexible in its hostility toward the undetermined, the uncertain, the inexplicable, toward whatever fails to fit into existing categories of thought and analysis, in short, toward whatever is profoundly original. Moreover, the Soviet regime has displayed an acute awareness of the vast influence that works of art may exert precisely because of their appeal to the imagination, their power of suggestion, their claim on the emotions. And the regime has far outdone other authoritarian systems in striving to guide these potentialities into desired channels, to foster a literature of a certain kind and a certain content, one that will play an active role in indoctrinating the masses and integrating the individual into the social whole.... But this activates forces which tend to weaken the affective powers of literature and to reduce its usefulness as an instrument of

[35]*The Rambler*, no. 4, in *The Works of Samuel Johnson,* ed. Arthur Murphey (London, 1820), IV, 26.

[36]Ilya Ehrenburg, "O rabote pisatelya," *Anamya,* no. 10, 1953, as trans. in *The Current Digest of the Soviet Press* (hereafter cited as *CDSP*), V, no. 52 (February 10, 1954), 12.

[37]*Lit. gaz.,* January 15, 1957, p. 3.

social control. Maintaining a balance between these contrary tendencies is a central problem of Soviet literary politics.

On Socialist Realism

Andrei Sinyavsky
(Abram Tertz)

Abram Tertz (1925–) is the pseudonym for Andrei Sinyavsky, sentenced with Yuli M. Daniel[1] in February 1966 by a Soviet court, in his case to five years of hard labor, for having published works abroad of an "anti-Soviet" character. The harshness of the penalty was without precedent even in Czarist Russia and thus aroused intellectuals throughout the Communist world. Some four of Sinyavsky's works had indeed been smuggled abroad as part of an expanding underground literature which reminds Russia and the world that the spirit of Pushkin and Lermontov still lives.

Sinyavsky is one of the new generation of Russian poets, aching under the constraints of "socialist realism" and bitterly critical of Stalinism. A talented writer, he has become since his conviction a symbol of the awakening forces of protest in the Soviet Union. His and Daniel's trial and their courageous refusal to retract or recant have stirred Russians as nothing else since the denigration of Stalin. A transcript of the trial has been secretly circulated in the U.S.S.R. and smuggled abroad.[2]

Sinyavsky, prior to his arrest a senior staff member of Moscow's Gorky Institute of World Literature, had achieved a reputation as an interpreter and admirer of Pasternak as well as considerable repute as a poet and critic. On Socialist Realism, a large part of which is reprinted below, represents his evaluation of the official Communist literary credo as it has revealed itself in practice.

I

What is socialist realism? What is the meaning of this strange and jarring phrase? Can there be a socialist, capitalist, Christian, or Mohammedan realism? Does this irrational concept have a natural existence? Perhaps it does not exist at all; perhaps it is only the nightmare of a terrified intellectual during the dark and magical night of Stalin's dictatorship? Perhaps a crude propaganda trick of Zhdanov's or a senile fancy of Gorki's? Is it fiction, myth, or propaganda?

Such questions, we are told, are often asked in the West. They are hotly debated in Poland. They are also current among us, where they arouse eager minds, tempting them into the heresies of doubt and criticism.

Excerpts from *On Socialist Realism* by Abram Tertz, pp. 23–33, 39–51, 89–95. Translated by George Dennis. Copyright © 1960 by Pantheon Books, Inc. Reprinted by permission of Random House, Inc.

[1]Daniel was permitted to leave Vladimir Prison in September 1970 and is now living in exile not far from Moscow.

[2]Max Hayward, *On Trial*, (New York: Harper & Row, 1966).

Meanwhile, the productions of socialist realism are measured in billions of printed sheets, kilometers of canvas and film, centuries of hours. A thousand critics, theoreticians, art experts, pedagogues are beating their heads and straining their voices to justify, explain, and interpret its material existence and dialectical character. The head of the state himself, the First Secretary of the Central Committee, tears himself away from pressing economic tasks to pronounce some weighty words on the country's aesthetic problems.[1]

The most exact definition of socialist realism is given in a statute of the Union of Soviet Writers: "Socialist realism is the basic method of Soviet literature and literary criticism. It demands of the artist the truthful, historically concrete representation of reality in its revolutionary development. Moreover, the truthfulness and historical concreteness of the artistic representation of reality must be linked with the task of ideological transformation and education of workers in the spirit of socialism." (First All-Union Congress of Soviet Writers, 1934, p. 716.)

This innocent formula is the foundation on which the entire edifice of socialist realism was erected. It includes the link between socialist realism and the realism of the past, as well as its new and distinguishing quality. The link lies in the *truthfulness* of the representation; the difference, in the ability to seize the *revolutionary development* and to educate readers in accordance with that development, *in the spirit of socialism.* The old realists, or, as they are sometimes called, critical realists (because they criticized bourgeois society), men like Balzac, Tolstoi, and Chekhov, truthfully represented life as it is. But not having been instructed in the genius and teachings of Marx, they could not foresee the future victories of socialism, and they certainly did not know the real and concrete roads to these victories.

The socialist realist, armed with the doctrine of Marx and enriched by the experience of struggles and victories, is inspired by the vigilant attention of his friend and teacher, the Communist Party. While representing the present, he listens to the march of history and looks toward the future. He sees the "visible traits of Communism," invisible to the ordinary eye. His creative work is a step forward from the art of the past, the highest peak of the artistic development of mankind and the most realistic of realisms.

Such, in a few words, is the general scheme of our art. It is amazingly simple, yet sufficiently elastic to comprehend Gorki, Mayakovski, Fadeev, Aragon, Ehrenburg, and hundreds of others. But we cannot understand this concept at all as long as we skim the surface of the dry formula and do not penetrate into its deep and hidden meaning.

The gist of this formula—"the truthful, historically concrete representation of reality in its revolutionary development"—is founded on the concept of Purpose with a capital P. The Purpose is an all-embracing ideal, toward which truthfully represented reality ascends in an undeviating revolutionary movement. To direct this movement toward its end and to help the reader approach it more closely by transforming his consciousness—this is the Purpose of socialist realism, the most purposeful art of our time.

The Purpose is Communism, known in its early stage as socialism. A poet not only writes poems but helps, in his own way, to build Communism; so, too, do sculptors, musicians, agronomists, engineers, laborers, policemen, and lawyers, as well as theaters, machines, newspapers, and guns.

[1]This refers to Khrushchev's speeches to Soviet intellectuals, collected and published in 1957 under the title *For a Close Link Between Literature and Art and the Life of the People.*

Our art, like our culture and our society, is teleological through and through. It is subject to a higher destiny, from which it gains its title of nobility. In the final reckoning we live only to speed the coming of Communism.... "A world that we can imagine, more material and better suited to human needs than Christian paradise"—thus was Communism defined by the Soviet writer Leonid Leonov.

Words fail us when we try to talk about it. We choke with enthusiasm and we use mostly negative comparisons to describe the splendor that is waiting for us. Then, under Communism, there will be no rich and no poor, no money, wars, jails, frontiers, diseases—and maybe no death. Everybody will eat and work as much as he likes, and labor will bring joy instead of sorrow. As Lenin promised, we will make toilets of pure gold...But what am I talking about?

> *What words and what colors are needed*
> *To describe these grandiose heights*
> *Where whores are as modest as virgins*
> *And hangmen as tender as mothers?*

The modern mind cannot imagine anything more beautiful and splendid than the Communist ideal. The best that it can do is to restore to circulation old ideals of Christian love and the liberty of the individual. But it has been unable so far to set up a new Purpose.

Where socialism is concerned, the Western liberal individualist or Russian skeptical intellectual is about in the same position as the cultured and intelligent Roman with regard to victorious Christianity. He called the new faith of the crucified God barbarous and naive, laughed over the lunatics who worshipped the cross—that Roman guillotine—and believed that the doctrines of the Trinity, the Immaculate Conception, the Resurrection, etc., made no sense whatsoever. But it was quite above his powers to advance any serious arguments against the *ideal* of Christ as such. True, he could say that the best parts of the moral code of Christianity were borrowed from Plato, just as contemporary Christians assert here and there that Communism took its noble aims from the Gospel. But could he say that God conceived as Love or Goodness was evil or monstrous? And can we say that the universal happiness, promised for the Communist future, is evil?

> *For don't I know that blindfold thrusts*
> *Will not make darkness yield to light?*
> *Am I a monster? Is not the happiness of millions*
> *Closer to me than empty luck for a few?*

<div align="right">Pasternak</div>

We are helpless before the enchanting beauty of Communism. We have not lived long enough to invent a new Purpose and to go beyond ourselves—into the distance that is beyond Communism.

It was the genius of Marx that he proved the earthly paradise, of which others had dreamed before him, was actually the Purpose which Fate destined for man. With the aid of Marx, Communism passed from moral efforts of isolated individuals—"Oh, where are you, golden age?"—into the sphere of universal history, which became purposeful as never before and turned into mankind's march toward Communism.

At once, everything fell into place. An iron necessity and a strict hierarchical order harnessed the flow of centuries. The ape stood up on its hind legs and began its triumphant procession toward Communism. The system of primitive Communism arose because it was fated to grow into slavery; slavery, to give birth to feudalism; feudalism, to capitalism; and finally capitalism, so that it could give way to Communism. That is all! The magnificent aim is achieved, the pyramid is crowned, history at an end.

A truly religious person relates all the splendid variety of life to his divinity.... A consistent Christian views the entire history previous to the birth of Christ as the prehistory of Christ.... It can therefore hardly surprise us that, in another religious system, ancient Rome has become an indispensable stage on the road to Communism. Or that the Crusades are explained not by their internal dynamics, by the ardent efforts of Christians, but by the action of the omnipresent forces of production that are now ensuring the collapse of capitalism and the triumph of socialism. True faith is not compatible with tolerance. Neither is it compatible with historicism, i.e., with tolerance applied to the past. And though the Marxists call themselves historical materialists, their historicism is actually reduced to a desire to regard life as a march toward Communism. Other movements are of little interest to them. Whether they are right or wrong is a matter of dispute. What is beyond dispute is that they are consistent.

If we ask a Westerner why the French Revolution was necessary, we will receive a great many different answers. One will reply that it happened to save France; another, that it took place to lead the nation into an abyss of moral experiments; a third, that it came to give to the world the great principles of Liberty, Equality, and Fraternity; a fourth, that the French Revolution was not necessary at all. But if you ask any Soviet schoolboy—to say nothing of the beneficiaries of our higher education—you will invariably receive the correct and exhaustive reply: the French Revolution was needed to clear the way to Communism.

The man who received a Marxist education knows the meaning of both past and future. He knows why this or that idea, event, emperor, or military leader was needed. It is a long time since men had such an exact knowledge of the meaning of the world's destiny—not since the Middle Ages, most likely. It is our great privilege to possess this knowledge once more....

Achievements are never identical with the original aim. The means used to reach the aim change its original appearance into something unrecognizable. The stakes of the Inquisition helped to establish the Gospel; but what is left of the Gospel after the stakes have done their work? Yet all of them—the stakes of the Inquisition and the Gospel, the Massacre of St. Bartholomew and St. Bartholomew himself—add up to one great Christian culture.

Yes, we live in Communism. It resembles our aspirations about as much as the Middle Ages resembled Christ, modern Western man resembles the free superman, and man resembles God. But all the same, there is *some resemblance*, isn't there?

This resemblance lies in the subordination of all our actions, thoughts, and longings to that sole Purpose which may have long ago become a meaningless word but still has a hypnotic effect on us and pushes us onward and onward—we don't know where. And, obviously, art and literature could not but get caught in the meshes of that system and become, as Lenin predicted, "a small wheel and a small screw" of the gigantic state machine. "Our magazines, both scientific and artistic, cannot be apolitical... The strength of Soviet literature, the most advanced in the world, is that it is a literature for which there can be no other interests than those of the people and of the state." (Decree of the Central Committee of the CPSU [b], August 14, 1946.)

It must be remembered, when reading this decree of the Central Committee, that the interests of the people and of the state—which, incidentally, are exactly the same from the point of view of the state—have but a single aim: the all-pervading and all-absorbing Communism. "Literature and art are part of the whole people's struggle for Communism.... The highest social destiny of art and literature is to mobilize the people to the struggle for new advances in the building of Communism." (N. S. Khrushchev, "For a Close Link Between Literature and Art and the Life of the People," *Kommunist* magazine, number 12, 1957.)

When Western writers deplore our lack of freedom of speech, their starting point is their belief in the freedom of the individual. This is the foundation of their culture, but it is organically alien to Communism. A true Soviet writer, a true Marxist, will not accept these reproaches, and will not even know what they are all about. What freedom—if the comparison be permitted—does the religious person require from God? The freedom to praise God still more ardently? ...For the man who believes in Communism, as Khrushchev correctly noted in one of his latest cultural pronouncements, "for the artist who truly wants to serve his people, the question does not arise of whether he is free or not in his creative work. For him, the question of which approach to the phenomena of reality to choose is clear. He need not conform or force himself; the true representation of life from the point of view of Communist *partiinost*[2] is a necessity of his soul. He holds firmly to these positions, and affirms and defends them in his work."

It is with the same joyous facility that this artist accepts the directives of the Party and the government, from the Central Committee and its First Secretary. For who, if not the Party and its leader, knows best what kind of art we need? It is, after all, the Party that leads us to the Purpose in accordance with all the rules of Marxism-Leninism, the Party that lives and works in constant contact with God. And so we have in it and in its leader the wisest and most experienced guide, who is competent in all questions of industry, linguistics, music, philosophy, painting, biology, etc. He is our Commander, our Ruler, our High Priest. To doubt his word is as sinful as to doubt the will of God.

These are the aesthetic and psychological concepts the knowledge of which is indispensable to anyone who would penetrate the secret of socialist realism.

II

Works produced by socialist realists vary in style and content. But in all of them the Purpose is present, whether directly or indirectly, open or veiled. They are panegyrics on Communism, satires on some of its many enemies, or descriptions of life "in its revolutionary development," i.e., life moving toward Communism....

Each work of socialist realism, even before it appears, is thus assured of a happy ending. The ending may be sad for the hero, who runs every possible risk in his fight for Communism; but it is happy from the point of view of the superior Purpose; and the author never neglects to proclaim his firm belief in our final victory, either directly or through a speech of his dying hero. Lost illusions, broken hopes, unfulfilled dreams, so characteristic of literature of other eras and systems, are contrary to socialist realism. Even when it produces a tragedy, it is an *Optimistic Tragedy*, the title of Vishnevski's play in which the heroine dies at the end but Communism triumphs.

[2]*Partiinost* is the point of view that considers everything in terms of the correct Party line. Cf. above, pp. 135-138.

A comparison between some representative titles of Soviet and Western literature is revealing. *Journey to the End of the Night* (Celine); *Death in the Afternoon* and *For Whom the Bell Tolls* (Hemingway); *Everyone Dies Alone* (Fallada); *A Time to Live and a Time to Die* (Remarque); *Death of a Hero* (Aldington) are all in minor key. *Happiness* (Pavlenko); *First Joys* (Fedin); *It is Well!* (Mayakovski); *Fulfilled Wishes* (Kaverin); *Light over the Earth* (Babaevski); *The Victors* (Bagritski); *The Victor* (Simonov); *The Victor* (Chirikov); *Spring in the Victory Collective Farm* (Gribachev), and so on, are all in a major key....

For example, many of our novels and stories deal with the work of a factory, the building of a power plant, the application of an agricultural decree, and so on. An economic task is carried out in the course of the action (e.g., the start of building introduces the plot; the end of building, the denouement). But the task is presented as an indispensable stage on the way toward a higher purpose. In such a purposeful view, even technical processes acquire dramatic tension and can be followed with great interest. The reader finds out step by step how, against all kinds of obstacles, the plant was put to work, the "Victory" collective farm gathered a good crop of corn, and so on. He closes the book with a sigh of relief and realizes that we have made yet another step toward Communism....

This purposefulness of the historic processes is linked with the great interest our writers show in history, both recent and remote. Recent historical events like the Civil War and collectivization are landmarks on the road we chose. In more remote eras it is, alas, harder to find the movement toward Communism. But if the writer concentrates hard enough he will uncover, even in the most remote of times, some phenomenon that might be called progressive because, in the final account, it aided in some way our victories of today. The writers merely anticipate somewhat and give these events the Purpose that they did not yet have. And so the leaders of the past like Ivan the Terrible, Peter the Great, or the peasant rebel Stenka Razin, though they did not know the word "Communism," still know quite well that our future will be brilliant. They never cease to celebrate this future from the pages of our historical novels, and they constantly gladden the heart of their readers by their astounding perspicacity.

Another subject is offered to our literature by the internal world of man's psychological life. This internal world moves toward the Purpose by dynamics of its own, fights against "the traces of the bourgeois past in its conscience," and re-educates itself under the influence of the Party and of surrounding life. A large part of Soviet literature is an "educational novel" which shows the Communist metamorphosis of individuals and entire communities. Many of our books turn around the representation of these moral and psychological processes, which aim at producing the ideal man of the future. One such is Gorki's *Mother*, where an ignorant woman, defeated by life, is transformed into a conscious revolutionary. Written in 1906, this book is generally considered the first example of socialist realism. Or there is Makarenko's *Pedagogical Poem* about the young criminals who take the road to honest work, or Ostrovski's novel *How the Steel Was Tempered*, i.e., how the steel of our youth was tempered in the fire of the Civil War and the cold of early Communist construction.

As soon as the literary character becomes fully purposeful and conscious of his purposefulness, he can enter that privileged caste which is universally respected and called "positive heroes." This is the Holy of Holies of socialist realism, its cornerstone and main achievement.

The positive hero is not simply a good man. He is a hero illuminated by the light of the most ideal of all ideals. Leonid Leonov called his positive hero "a peak of

humanity from whose height the future can be seen." He has either no faults at all or else but a few of them—for example, he sometimes loses his temper a little. These faults have a two-fold function. They help the hero to preserve a certain likeness to real men, and they provide something to overcome as he raises himself ever higher and higher on the ladder of political morality. However, these faults must be slight or else they would run counter to his basic qualities. It is not easy to enumerate these basic qualities of the positive hero: ideological conviction, courage, intelligence, will power, patriotism, respect for women, self-sacrifice, etc., etc. The most important, of course, are the clarity and directness with which he sees the Purpose and strives toward it. Hence the amazing precision of all his actions, thoughts, tastes, feelings, and judgments. He firmly knows what is right and what is wrong; he says plainly "yes" or "no" and does not confuse black with white. For him there are no inner doubts and hesitations, no unanswerable questions, and no impenetrable secrets. Faced with the most complex of tasks, he easily finds the solution—by taking the shortest and most direct route to the Purpose.

The positive hero first appeared in some books of Gorki's written in the first decade of the twentieth century. He started by proclaiming to the world: "One must say firmly yes or no!" Many were shocked by the self-assurance and straightforwardness of his formulations, by his tendency to preach at everyone around him, and by his pompous monologues celebrating his own virtues. Chekhov, when he managed to read through *The Petty Bourgeois*, frowned with embarrassment and advised Gorki to soften the loud proclamations of his hero. Chekhov feared pretentiousness worse than fire: he viewed such purple passages as a boastfulness foreign to the Russian character.

But Gorki was deaf to such advice. He did not fear the reproaches and sneers of the shocked intelligentsia and its repeated assertions that the new hero was dull-witted and narrow-minded. He knew that his hero was the man of the future and that "only men who are as pitiless, straight, and hard as swords will cut their way through." (*The Petty Bourgeois*, 1901.)

Since then the positive hero has gone through many changes and presented himself in many guises. He unrolled his positive qualities in many ways, grew big and sturdy, and finally drew himself up to his full stature. This happened as early as the 1930s, when the Soviet writers dropped their little cliques and their literary tendencies, and accepted, almost unanimously, the best and most advanced trend of all: socialist realism.

To read the books of the last twenty or thirty years is to feel the great power of the positive hero. First he spread in every direction, until he filled all our literature. There are books in which *all* the heroes are positive. This is but natural, since we are coming ever closer to the Purpose. So that if a book about the present deals not with the fight against the enemies but with, say, a model collective farm, then all its characters can and must be positive. To put negative characters in such a situation would, to say the least, be strange. And so we get dramas and novels where all moves smoothly and peacefully. If there is a conflict between the heroes, it is a conflict between good and better, model and supermodel. When these books appeared, their authors—men like Babaevski, Surkov, Sofronov, Virta, Gribachev, etc.—were highly praised and set up as examples for others. True, since the Twentieth Congress—one hardly knows why—our attitude toward them has changed somewhat and we apply to them the contemptuous adjective "conflictless." Once Khrushchev came out in defense of these writers, such reproaches were stilled somewhat, but they are still voiced here and there by intellectuals. They are unjust.

Since we don't want to lose face before the West, we occasionally cease to be consistent and declare that our society is rich in individualities and embraces many

interests; and that it has differences of opinion, conflicts, and contradictions, and that literature is supposed to reflect all that.

True, we differ from each other in age, sex, nationality, and even intelligence. But whoever follows the Party line knows that these are heterogeneities within a homogeneity, differences of opinion within a single opinion, conflicts within a basic absence of conflict. We have one aim—Communism; one philosophy—Marxism; one art—socialist realism.

Art is not afraid of dictatorship, severity, repressions, or even conservatism and cliches. When necessary, art can be narrowly religious, dumbly governmental, devoid of individuality—and yet good. We go into aesthetic raptures over the stereotypes of Egyptian art, Russian icons and folklore. Art is elastic enough to fit into any bed of Procrustes that history presents to it. But there is one thing it cannot stand: eclecticism.

Our misfortune is that we are convinced socialist realists but not convinced enough. Submitting to its cruel rules, we are yet afraid to follow to the end the road that we ourselves have chosen. No doubt, if we were less educated, it would be easier for us to attain the integrity that is indispensable to a writer. But we went to school, read all kinds of books, and learned only too well that there were great writers before us—Balzac, Maupassant, Tolstoi, and, yes, what's his name?— Chekhov. This is what has undone us. We wanted to become famous and to write like Chekhov. This unnatural liaison produced monsters.

It is impossible, without falling into parody, to produce a positive hero in the style of full socialist realism and yet make him into a psychological portrait. In this way, we will get neither psychology nor hero. Mayakovski knew this and, hating psychological analysis and details, wrote in proportions that were larger than life. He wrote coarsely, poster-style, Homerically. He avoided like a plague descriptions of common life and rural nature. He broke with "the great traditions of great Russian literature" and, though he loved Pushkin and Chekhov, he did not try to imitate them. All this helped Mayakovski to lift himself to the level of his epoch and to express its spirit fully and clearly, without alien admixtures.

But the writing of so many other writers is in a critical state right now precisely because, in spite of the classicist nature of our art, they still consider it realism. They do it because they base their judgments on the literary criticism of the nineteenth century, which is furthest away from us and most foreign to us. Instead of following the road of conventional forms, pure fantasy, and imagination which the great religious cultures always took, they try to compromise. They lie, they maneuver, and they try to combine the uncombinable: the positive hero (who logically tends toward the pattern, the allegory) and the psychological analysis of character; elevated style and declamation with and prosaic descriptions of ordinary life; a high ideal with truthful representation of life.

The result is a loathsome literary salad. The characters torment themselves though not quite as Dostoevski's do, are mournful but not quite like Chekhov's, found their happy families which are not quite like Tolstoi's, and, suddenly becoming aware of the time they are living in, scream at the reader the copybook slogans which they read in Soviet newspapers, like "Long live world peace!" or "Down with the warmongers!" This is neither classicism nor realism. It is a half-classicist half-art, which is none too socialist and not at all realist.

It seems that the very term "socialist realism" contains an insoluble contradiction. A socialist, i.e., a purposeful, a religious, art cannot be produced with the literary method of the nineteenth century called "realism." And a really faithful representation of life cannot be achieved in a language based on teleological concepts. If socialist realism really wants to rise to the level of the great world

cultures and produce its *Communiad* there is only one way to do it. It must give up the "realism," renounce the sorry and fruitless attempts to write a socialist *Anna Karenina* or a socialist *Cherry Orchard*. When it abandons its effort to achieve verisimilitude, it will be able to express the grand and implausible sense of our era.

Unfortunately, this is not likely to happen. The events of the last few years have dragged our art on a road of half-measures and half-truths. The death of Stalin inflicted an irreparable loss upon our religiously aesthetic system; it cannot be resuscitated through the now revived cult of Lenin. Lenin is too much like an ordinary man and his image is too realistic: small, bald, dressed in civilian clothes. Stalin seemed to be specially made for the hyperbole that awaited him: mysterious, omniscient, all-powerful, he was the living monument of our era and needed only one quality to become God—immortality.

Ah, if only we had been intelligent enough to surround his death with miracles! We could have announced on the radio that he did not die but had risen to Heaven, from which he continued to watch us, in silence, no words emerging from beneath the mystic mustache. His relics would have cured men struck by paralysis or possessed by demons. And children, before going to bed, would have kneeled by the window and addressed their prayers to the cold and shining stars of the Celestial Kremlin.

But we did not listen to the voice of our conscience. Instead of intoning devout prayers, we set about dethroning the "cult of personality" that we ourselves had created. We thus blew up the foundations of that classicist colossus which, if we had waited but a little, would have joined the Pyramid of Cheops and the Apollo Belvedere in the treasury of world art.

The strength of a theological system resides in its constancy, harmony, and order. Once we admit that God carelessly sinned with Eve and, becoming jealous of Adam, sent him off to labor at land reclamation, the whole concept of the Creation falls apart, and it is impossible to restore the faith.

After the death of Stalin we entered upon a period of destruction and re-evalution. It is a slow and inconsistent process, it lacks perspective, and the inertia of both past and future lie heavy on it. Today's children will scarcely be able to produce a new God, capable of inspiring humanity into the next historical cycle. Maybe He will have to be supplemented by other stakes of the Inquisition, by further "personality cults," and by new terrestrial labors, so that after many centuries a new Purpose will rise above the world. But today no one yet knows its name.

And meanwhile our art is marking time between an insufficient realism and an insufficient classicism. Since the loss it suffered, it is no longer able to fly toward the ideal and to sing the praises of our life in a sincere and elevated style, presenting what should be as what is. In our works of glorification resound ever more openly the notes of baseness and hypocrisy. The most successful writers are those who can present our achievements as truthfully as possible and our failings as tactfully, delicately, and untruthfully as possible. Any works that lean too far toward an "excessive verisimilitude"—meaning realism—fail. This is what happened with Dudintsev's novel *Not by Bread Alone*, which stirred up a lot of noise and was publicly anathematized for blackening our bright socialist reality.

But is the dream of the old, good, and honest "realism" the only heresy to which Russian literature is susceptible? Is it possible that all the lessons that we received were taught in vain and that, in the best of cases, all we wish is to return to the naturalist school and the critical tendency? Let us hope that this is not so and that our need for truth will not interfere with the work of thought and imagination.

Socialist Realism: Aesthetic of the Left

Right now I put my hope in a phantasmagoric art, with hypotheses instead of a Purpose, an art in which the grotesque will replace realistic descriptions of ordinary life. Such an art would correspond best to the spirit of our time. May the fantastic imagery of Hoffmann and Dostoevski, of Goya, Chagall, and Mayakovski (the most socialist realist of all), and of many other realists and nonrealists teach us how to be truthful with the aid of the absurd and the fantastic.

Having lost our faith, we have not lost our enthusiasm about the metamorphoses of God that take place before our very eyes, the miraculous transformations of His entrails and His cerebral convolutions. We don't know where to go; but, realizing that there is nothing to be done about it, we start to think, to set riddles, to make assumptions. May we thus invent something marvelous? Perhaps; but it will no longer be socialist realism.

The Artist and His Conscience

Jean-Paul Sartre

Jean-Paul Sartre (1905–　　) is probably the best known publicist of existentialism. The more technical existentialist philosophical doctrines were worked out by the German philosophers Heidegger and Jaspers, but Sartre, himself a trained philosopher, also contributed a massive work, Being and Nothingness *(1943; English version 1956). In addition, Sartre has written plays, novels, criticism, an autobiography, and essays on a great variety of subjects, including politics.*

Sartre's novels have not, properly, been as popular as his plays, two of which, No Exit *and* The Flies, *have held the stage in many countries. His fundamental existentialist beliefs, that we have freedom of choice, that existence should be our central concern, that we should be actively engaged in affairs and committed to values and beliefs, that the fact of death should be central to the choices of life, and that we are responsible for our acts, have been argued by him with great brilliance and insight.*

Like Picasso, Sartre became a Communist, although, again like Picasso, he is a non-conformist Communist, subscribing to a number of doctrines that do not easily square with the official party line. Even so, as indicated in the statement which follows, his commitment to Communism involves him in awkward predicaments.

This selection is important not only because it related the issues under discussion to a non-literary art form, music, but because Sartre wrestles here with one of the two great problems troubling the aesthetic conscience of the socialist artist: his art requires a sophisticated public; his ideology requires him to address himself to the masses who are unable to understand him. (The other problem concerns his loss of freedom.) Art, says Sartre, is a "permanent revolution," and "for forty years now, the fundamental situation of our societies (European?) has been revolutionary." But—and this is the great paradox—"the social revolution calls for a conservative aesthetic whereas the aesthetic revolution demands, in spite of the artist himself, a

From *Situations* by Jean-Paul Sartre, translated from the French by Benita Eisler (New York: Braziller, 1965), pp. 205–224. English translation copyright ©1965 by George Braziller, Inc. French edition © Editions Gallimard 1947. Reprinted by permission of George Braziller, Inc., Editions Gallimard

social conservatism." The supreme example of this contradiction is, of course, Picasso, the sincere Communist, whose later work is canonized by rich bourgeois collectors and incomprehensible to the masses.

Rene Leibowitz, to whose book the following remarks are a preface, is a well-known French composer, conductor, and musicologist of the modernist school.

My dear Leibowitz,

You have asked me to add a few words to your book, since, some time ago I had occasion to write on the subject of literary commitment, and you now hope, through the association of our names, to emphasize the solidarity which unites artists and writers in their common concerns in a given age. Had friendship alone not sufficed, the desire to declare this solidarity would have decided me. But now that I must write, I admit to feeling very awkward.

I have no specialized knowledge of music and no desire to make myself ridiculous by paraphrasing poorly and with the wrong terms what you have so well stated in the appropriate language: nor do I foolishly presume to introduce you to readers who already know you well, following you avidly in your triple activity of composer, conductor and music critic.... All things considered, I think the best is to suppose that we are talking just as we have often done and that I unburden myself of the questions and anxieties raised by your book. You have convinced me, yet I still feel certain areas of resistance and uneasiness. I must share them with you. To be sure, I am one of the profane who dares to question an initiate, a pupil who argues with the teacher after class. But the same is true of many of your readers and I can imagine that my feelings reflect theirs....

I cannot laugh at the nausea of the Communist boa constrictor, unable either to keep down or vomit up the enormous Picasso. In the C.P.'s indigestion, I see the symptoms of an infection which contaminates our entire era.

When the privileged classes are comfortably settled in their principles, when their consciences are clear, and when the oppressed, duly convinced of being inferior creatures, take pride in their servile state, the artist is at his ease. Since the Renaissance, you say, the musician has consistently addressed himself to a public of specialists. But who is this public, if not the ruling aristocracy who, not content with merely exercising military, judicial, political and administrative powers over the whole territory, made itself also a tribunal of taste? Just as that elite determined, by divine right, the human shape, so the cantor or choirmaster produced his symphonies or cantatas for the whole man. Art could call itself humanist because society remained inhuman.

Is the same still true today? This is the question which haunts me, and which, in turn, I put to you. For by now, the ruling classes of our western societies can no longer believe that they themselves provide the measure of man. The oppressed classes are conscious of their power, and possess their own rituals, techniques and ideology. Rosenberg, speaking of the proletariat, has put it admirably:

On one side, the present social order is permanently threatened by the extraordinary virtual power of the workers; on the other, the fact that his power is in the hands of an anonymous category, a historical "zero," is a temptation to all the modern myth-makers to seize upon the working class as the raw material of new collectivities, by means of which the society can be subjugated. May not this proletariat without a history be as easily converted into anything other than itself?

The pathos of the proletariat, holding in the balance the drama between revolution by the working class on its own behalf, and revolution as an instrument for others, dominates modern history.

Now, it is precisely music—to speak only of this one area—which has been metamorphosed. This art took its laws and limitations from what it conceived to be its essence. You have demonstrated brilliantly how, in the course of a free yet rigorous evolution, music wrenched itself from its alienation and set about creating its essence while freely providing its own laws. In its modest way, couldn't music thus influence the course of history by providing the working class with the image of a "total man," who also has wrenched himself from his alienation, from the myth of a human "nature" and who, through daily struggle, forges his own essence and values according to which he judges himself? As soon as it recognizes *a priori* limitations, music reinforces alienation in spite of itself, glorifies the *given* and, while proclaiming freedom in its own fashion, declares that this freedom receives its limitations from nature. It is not uncommon that these "myth-makers" use music to fool the listener by inspiring him with holy emotions, as witnessed by the use of martial music or choirs. But, if I understand you correctly, something akin to a show of the naked power of creation must be seen in the most recent forms of this art. I think I have grasped precisely what you would oppose to these Communist musicians who signed the Prague Manifesto.[1] They want the artist to reduce himself to a society-object, they want him to sing the praises of the Soviet world as Haydn sang those of divine Creation. They ask him to copy what *is*, to imitate without transcending, and to set an example to his public of submission to an established order: if music is defined as a permanent revolution, doesn't it threaten, in its turn, to arouse in the listener the desire to carry this revolution into other areas? You, on the contrary, want to show man that he is not manufactured and never will be, that he will everywhere and always retain the freedom to make and to remake himself beyond everything which is ready-made.

But here is what disturbs me: haven't you established the fact that an internal dialectic has carried music from monody to polyphony and from the most simple to the most complex polyphonic forms? This means that it can go forward but not backward: it would be as naive to hope for its return to previous figurations as to want industrial societies to return to pastoral simplicity. Very good. But by the same token, its increasing complexity reserves it—as you yourself recognized—for a handful of specialists, found, by necessity, among the privileged classes. Schoenberg is farther removed from the workers than Mozart was from the peasants. You will tell me that the majority of bourgeois understand nothing of music, and this is true. But it is equally true that those who can appreciate it belong to the bourgeoisie, profit from bourgeois culture, bourgeois leisure, and in general, practice a bourgeois profession. I know: amateurs are not rich; they are most often found in the middle classes, and it is rare to find a big industrialist who is a fanatic music lover. This does happen, however: but I don't ever recall seeing a worker at one of your concerts. It is certain that modern music is shattering forms, breaking away from conventions, carving its own road. But exactly to whom does it speak of liberation, freedom, will, of the creation of man by man—to a stale and genteel listener whose ears are blocked by an idealist aesthetic. Music says "permanent revolution" and

[1]Editors' note: The reference is to a statement issued at the Second International Congress of Composers and Music Critics held under Communist auspices in Prague in May 1948.

the bourgeoisie hear "Evolution, progress." And even if, among the young intellectuals, a few understand it, won't their present impotence make them see this liberation as a beautiful myth, instead of their own reality?

Let us understand each other. This is neither the fault of the artist nor of art. Art has not changed internally: its movement, negativity and creative power remain what they have always been.... But in the heavens above our modern societies, the appearance of those enormous planets, the masses, upsets everything. Transforming artistic activity from a distance, they rob it of its meaning without even touching it and spoil the artist's tranquil conscience. Because the masses are *also* fighting for man, but blindfolded, since they are in constant danger of going astray, of forgetting who they are, of being seduced by the voice of the myth-maker, and because the artist has no language which permits them to hear him. He is speaking of *their* freedom—since there is only one freedom—but speaking of it in a foreign tongue.

The difficulties of the cultural policy of the USSR suffice to prove that this is a question of historical contradiction inherent to our time and not one of bourgeois disgrace, due in part to the subjectivism of the artist. Of course, if we believe that the Soviet Union is the Devil, then it follows that its leaders find perverse pleasure in carrying out purges which overthrow and decimate the artistic ranks. Or if we believe that God is a Soviet, then things are just as easy: God does what is just. That is all. But if, for a moment we dare to uphold this new and paradoxical thesis, that the Soviet leaders are men, men in a difficult, indeed, untenable position, who are nevertheless trying to bring about what they believe is right, who are often outstripped by events, and who are sometimes carried farther than they might like, in short, men like all of us, then everything changes. Then we can imagine that they are not overjoyed by these sudden jerks of the gear which threaten to derail the locomotive. By destroying classes, the Russian revolution set out to destroy the elite, that is, those refined and parasitic organisms which are found in all societies of oppression and which produce values and works of art like papal bulls. Wherever an elite functions, an aristocracy of the aristocracy outlining for aristocrats the shape of the whole man, new values and works of art, far from enriching the oppressed man, increase his absolute impoverishment. The productions of the elite are, for the majority of men, rejection, want and boundaries. The taste of our "art lovers" forcibly defines the bad taste or lack of taste of the working classes, and as soon as refined minds consecrate a work, there is one more "treasure" in the world which the worker will never possess, one more thing of beauty that he is unable to appreciate or understand. Values cannot be a positive determination for each man until they are the common product of all. Any one of society's new acquisitions, whether a new industrial technique or a new form of expression, being created for everyone, must be for each an enriching of the world and a way which opens before him, in short, his innermost potential. But instead, the whole man as defined by the aristocracy is the sum of opportunities taken away from everyone; it is he who knows what others do not know, who appreciates what they cannot appreciate, who does what they cannot do, who is, in short, the most irreplaceable of beings.

By contrast, the individual in a socialist society is defined at birth by the totality of possibilities which all give to each one, and at his death, by still new possibilities—small as they may be—which he has given to all. Thus *all* is the road of each man towards himself and *each one* the way of all towards all. But the necessities of administration, industrialization and war forced the Soviet Union into first forming a policy of a trained elite. It needed engineers, bureaucrats and military leaders at the same time that it undertook to realize a socialist aesthetic. And from this follows the danger that this trained elite whose culture, profession

and standard of living sharply affect those of the mass, produces in its turn values and myths, that "amateurs" bred in its midst create a special *demand* for artists. The Chinese text which you quote ... sums up quite well the threat hanging over a society in the process of construction: if horse lovers suffice to produce beautiful race horses, an elite which becomes a specialized public would suffice to give rise to an art for the elite. A new segregation threatens to take effect: a culture of *cadres* will rise with its whole procession of abstract values and esoteric works of art, while the mass of workers will again fall into a new barbarism which will be measured exactly by its incomprehension of the products destined for this new elite.

This, I think, is the explanation of the infamous purges which revolt us. To the degree that the body of trained specialists is reinforced, in the measure that the bureaucracy threatens to become a class, if not an oppressive elite, to that degree will the artist develop a tendency towards aestheticism. And at the same time that they are obliged to depend upon this elite, the rulers must force themselves to maintain, at least in terms of an ideal, the principle of values produced by the community as a whole. Certainly, this drove them into contradictory action, since they created a general policy of *cadres* and a cultural policy of the masses; with one hand they create an elite and with the other they are obliged to destroy its ideology which is incessantly reborn and which will always rise again.

But there is, conversely, as much confusion in the minds of the enemies of the Soviet Union when they reproach its leaders, at the same time, for creating a class of oppressors and for wanting to destroy the class aesthetic. The truth is that the Soviet leaders and the artist in the bourgeois society are colliding against the same impossibility: music has developed according to its dialectic, becoming an art which depends upon a complex technique. This is a regrettable fact, but *it is a fact*, nevertheless, that it demands a specialized public. To sum up, modern music requires an elite and the working masses require music. How can this conflict be resolved? By "giving a form to the profound sensibility of the people"? But *what* form? Vincent d'Indy wrote serious music "On a French Mountain Air." Do you think the mountain dwellers would recognize their song? Besides, the popular sensibility creates its own forms. Folk songs, jazz and African chants don't need revision and correction by professional musicians. On the contrary, the application of a complex technique to the spontaneous products of this sensibility has the necessary consequence of distorting the products. This is the tragedy of Haitian artists who are unable to weld their formal training to the folk material they want to use.

The Prague Manifesto states, more or less, that the level of music must be lowered, while the cultural level of the masses is being raised. Either this is totally meaningless, or it confesses that art and its public will meet in absolute mediocrity. You are right to observe that the conflict of art and society is eternal, stemming from the essence of the one and the other. But it has taken a new and sharper form in our time: art is a permanent revolution, and for forty years now, the fundamental situation of our societies has been revolutionary; but the social revolution calls for a conservative aesthetic whereas the aesthetic revolution demands, in spite of the artist himself, a social conservatism. Picasso, a sincere Communist, condemned by the Soviet leaders, purveyor by appointment to rich American collectors, is the image of this contradiction. As for Fougeron, his paintings have ceased to please the elite, without arousing the slightest interest on the part of the proletariat.

Further, the contradiction widens and deepens as soon as we begin to consider the sources of musical inspiration. The problem, states the Prague Manifesto, is "to express the feelings and loftiest progressive ideas of the people." So much for

feelings. But as for "lofty progressive ideas," how on earth do you set them to music? For music is a *non-signifying* art. Slovenly minds have taken delight in speaking of a "musical language." But we are perfectly aware that the "musical phrase" has no designated object: it is in itself an object. How then can this mute evoke for man his destiny? The Prague Manifesto suggests a solution which for sheer naivete is a joy: we shall cultivate "musical forms which allow these goals to be attained, above all, vocal music—operas, oratorios, cantatas, chorals, etc." Good God, these hybrids are nothing but babblers, making small talk to music. What they are really saying is that music should be only a pretext, a means of enhancing the glory of the word. *It is the word* of which Stalin will sing, the Five Year Plan, the electrification of the Soviet Union. Set to other words, the same music could glorify Petain, Churchill, Truman, the TVA. By changing the words, a hymn to the Russian dead of Stalingrad will become a funeral oration for Germans fallen before the same city. What do the sounds contribute? A great blast of sonorous heroism; it is the word which will speak. There can be no musical engagement unless the work of art is such that it can receive only one verbal commentary. In a word, the sonorous structure must *repel* certain words and *attract* others. Is this even possible? Perhaps, in certain special cases, and you give as an example, *The Survivor of Warsaw*. But even there, Schoenberg could not avoid recourse to words. In that "gallop of wild horses," how would we recognize the enumeration of the dead without the words? We would only hear a gallop.

Poetic comparison doesn't reside in the music, but in the rapport of the music with the words. But here, at least, you will say, the words are a part of the work, they are not in themselves a musical element. True, but must we now reject the sonata, quartet and symphony? Must we devote ourselves to "operas, cantatas and oratorios," as urged by the Prague Manifesto? I know that you do not believe this. And I am completely in agreement with you when you write that "the chosen subject should remain a *neutral* element, something akin to raw material which is then subjected to a purely artistic treatment. In the final analysis, it is only the quality of this treatment which will prove or deny the adherence of extra-artistic feelings and concerns to a purely artistic design."

Only now I no longer know wherein lies musical engagement and I fear it has already escaped from the work of art to take refuge in the behavior of the artist, that is, in his attitude towards art. The life of the musician may be exemplary; exemplary of the chosen poverty, the refusal of easy success, the constant state of dissatisfaction and that permanent revolution which he wages against others and against himself. But I'm still afraid that his austere personal morality remains an external commentary to his work. The musical work of art is not, *by itself,* negativity, rejection of traditions, a liberating movement: it is the positive consequence of this rejection and this negativity. A *sonorous object,* it no more reveals the composer's doubts and fits of despair than the patent of an invention reveals the torments and anxieties of the inventor; it does not show us the dissolution of old rules, but makes us see others which are the *positive* laws of its development. Moreover, the artist *should not be* a commentator of his own work for the benefit of the public. If his music is committed, this commitment will be found in its intuitive reality, in the sonorous object as it will appear immediately to the ear, without reference to the artist or to previous traditions. Is this even possible? It seems to me that we simply stumble again upon the same dilemma which we found at first: by forcing music, a nonsignifying art, to express predetermined meanings, it becomes alienated. But again, by rejecting the meaning which you call "extra-artistic" musical liberation runs the risk of leading to

abstraction and of offering the composer in question that purely formal and negative freedom which Hegel characterizes as Terror. Slavery or Terror. Conceivably our era offers the artist no other alternative.[2] If a choice must be made, I confess that I prefer Terror: not for its own sake, but because, in this era of flux, it upholds the exigencies proper to the aesthetics of art, allowing it to await, without too much detriment, a more favorable time.

... I shall now give you the feelings of a rather uncultured listener; whenever I heard a musical composition performed, I found no significance of any sort in the sequence of sounds, and it was a matter of complete indifference to me whether Beethoven composed one of his funeral marches on "the death of a hero" or that Chopin might have wanted to suggest Wallenrod's satanic laugh at the end of his first *Ballade*. Conversely, it did seem to me that this sequence had a *meaning* and it was this meaning which I liked. I have always really distinguished meaning from significance. It seems to me, an object signifies when an allusion to another object is made through it. In this case, the mind ignores the sign itself; it reaches beyond to the thing signified; often it so happens that this last remains present when we have long since forgotten the words which caused us to conceive of it. The meaning, on the contrary, is not distinct from the object itself and is all the more manifest inasmuch as we are more attentive to the thing which it inhabits. I would say that an object has a meaning when it incarnates a reality which transcends it but which cannot be apprehended outside of it and which its infiniteness does not allow to be expressed adequately by any system of signs: it is always a matter of a totality, totality of a person, milieu, time or human condition. I would say that the Mona Lisa's smile does not "mean" anything, but that it has a meaning. Through it, that strange fusion of mysticism and naturalism, evidence and mystery which characterize the Renaissance is materialized. And I have only to look at it to distinguish it from that other smile, equally mysterious but more troubling, more rigid, ironic, naive and holy, which hovers vaguely about the lips of the Etruscan Apollo, or from the "hideous," secular, rationalist and witty suspicion of a smile on Houdon's Voltaire. Certainly, Voltaire's smile was *significant*. It appeared at specific times, it *meant,* "I'm no fool" or "Just listen to that fanatic!" But at the same time, the smile is Voltaire himself, Voltaire as an ineffable totality. You can talk about Voltaire forever—his existential reality is incommensurate with speech. But let him smile and you *have* him completely and with no effort. Thus does music seem to me, a beautiful mute with eyes full of meaning. When I listen to a Brandenburg Concerto, I never *think* of the seventeenth century, of the austerity of Leipzig, of the puritan stolidity of the German princes, of that moment of the spirit where reason, in full possession of its techniques, nevertheless remained subject to faith and where logic of concept was transformed into logic of judgment. But it is all there, present in the sounds, just as the Renaissance smiles on the lips of the Mona Lisa.

Further, I have always believed that the "average" public who, like me, lacks precise knowledge of the history of musical composition could date to the minute a work of Scarlatti, Schumann or Ravel, even if mistaken in the name of the composer, because of this silent presence, inherent in all sonorous objects, of an entire era and its concept of the world. Isn't it conceivable that musical commitment might reside at this level? I know what you will reply to this: if the artist paints himself entirely into his work—and his century with him—he did so

[2]To be precise: The artist, for me, differs from the man of letters in that he deals with non-signifying arts. I have elsewhere shown that the problems of literature are entirely different.

unintentionally: his only concern was to sing. It is today's public who, at a hundred years' remove, finds intentions in the object which were never placed there. The listener of the last century only perceived the melody. He found natural and absolute rules in what we, in retrospect, consider to be postulates reflecting the era. All this is true, but can't one conceive of a more conscious artist today who, by reflecting on his art, would try to endow it with his condition as a man? I only put the question to you: you are the one who is qualified to answer it. But even if, like you, I condemn the absurd Prague Manifesto, I also cannot help being disturbed by certain passages in Jdanov's heralded speech[3] which inspired the Soviet Union's whole cultural policy. You know it as well as I do: the Communists are guilty because they are wrong in their means of being right and they make us guilty because they are right in their means of being wrong.

The Prague Manifesto is the stupid and extreme consequence of a perfectly defensible theory of art and one which does not necessarily imply an aesthetic authoritarianism. Jdanov states: "we must know life in order to represent it truthfully through works of art, not just to represent it in a dead scholastic way, not only as objective reality, but to represent reality in its revolutionary development." What does he mean if not that reality is never inert, but always in the process of changing, and that those who understand or portray it are themselves in the process of changing. The profound unity of all these changes which come at will is the future meaning of the entire system. It is the artist who must break the already crystallized habits which make us see in the *present* tense those institutions and customs which are *already out of date.* To provide a true image of our time, he must consider it from the pinnacle of the future which it is creating, since it is tomorrow which will decide today's truth. In one sense, this concept rejoins yours—you have shown that the committed artist is *in advance* of his times and that he looks on the present traditions of his art with the eyes of the future. In you as in Jdanov, there is certainly an allusion to negativity and transcendence. But he is not satisfied with the moment of negation. For him, the work has value, above all, for its positive content: it is a block of the future fallen into the present, anticipating by several years the judgment we shall bring to bear upon ourselves. It releases our future possibilities, and in one move it follows, accompanies and precedes the dialectical progression of history....

Thus is it true that a work of art is at the same time an individual achievement and a social fact. It is not the religious and monarchical orders alone that we find in *The Well-Tempered Clavier:* to these prelates and barons, both victims and beneficiaries of oppressive traditions, Bach held up the image of a freedom which, at the same time as it appeared to be contained within a traditional framework, transcended tradition towards new creations. Against the closed traditions of little despotic courts, he opposed an open tradition: he taught how to find originality within an established discipline; actually—how to live. He demonstrated the play of moral freedom within the confines of a religious and monarchical absolutism and depicted the proud dignity of the subject who obeys his king and the devout who worships his God. Entirely at one with his era, whose prejudices he accepts and reflects, he is, at the same time, outside it, and judges it wordlessly according to the still-implicit laws of a pietistic morality which will give birth, half a century later, to the ethics of Kant. The infinite variations which he performs, the postulates which he constrains himself to respect, place his successors on the verge of changing the postulates themselves. His own life, certainly, was a model of conformism and I

[3]Delivered on August 17, 1934, to the First Soviet Writers' Congress.
Editors' note: More recognizable here as Zhdanov.

cannot imagine that he ever advocated any very revolutionary views. But from the point of view of a still-unborn individualistic rationalism, isn't his art simultaneously the exaltation of obedience and the transcendence of this same obedience which he *judges* at the same instant that he claims to demonstrate?

Later on, without losing his noble audience, the artist will acquire another. By the reflection which he exercises upon the formulas of his art, by his continuous reworking of worn-out customs, the artist reflects, *in anticipation of* the bourgeoisie, that progression without obstacles or revolution which they hope to bring about.... Rhetorical, moving, sometimes verbose, the art of Beethoven gives us, with some delay, the musical image of the Assemblies of the French Revolution. It is Barnave, Mirabeau, sometimes, alas, Lally-Tollendal. And I am not thinking here of the meanings he himself occasionally liked to give his works, but of their meaning which ultimately expressed his way of hurling himself into a chaotic and eloquent world. For in the final analysis, these torrential discourses and floods of tears seem suspended in the freedom of an almost mortuary calm. Without shattering the rules of his own art, without crossing its boundaries, we could say that he went beyond the triumphs of the Revolution, beyond even his own failure. If so many people find consolation in music, it seems to me that it is because it speaks to them of their sorrows in the same voice which they will use to speak of them when they are comforted, and because it makes them see these sorrows with the eyes of a future day.

Is it so impossible that an artist will emerge in the world today, and without any *literary* intention, or interest in *signifying,* still have enough passion, to love and hate it, to live its contradictions with enough sincerity, and to plan to change it with enough perseverance, that he will transform even this world, with its savage violence, its barbarism, its refined techniques, its slaves, its tyrants, its mortal threats and our horrible and grandiose freedom into music? And if the musician has shared the rage and hopes of the oppressed, is it impossible that he might be transported beyond himself by so much hope and so much rage that he could sing today of this world with the voice of the future? And if that were so, could one still speak of "extra-aesthetic" concerns? Of "neutral" subject matter? Of "significance"? Would the raw material of music be distinct from its treatment?

I put these questions to you, my dear Leibowitz, to you and not to Jdanov. His answer I know. For at the moment when I believed he would show me the way, I realized that he was lost. Scarcely had he mentioned this transcendence of objective reality, when he added: "Truth must unite with the historical and concrete character of the representation in the task of ideological transformation and education of the workers in the spirit of Socialism." I had thought he was asking the artist to live the problems of his times freely and intensely, *in their totality,* so that the work of art could reflect them to us in his way. But I see now that it was a question only of ordering didactic works of art from bureaucrats which they should execute under the supervision of the party. Since the artist is to have his concept of the future imposed upon him, instead of being allowed to find it himself, it makes little difference, politically, that this future is still to be created: for the musician, it is ready-made. The entire system founders in the past; Soviet artists, to borrow the expression so dear to them, are *passeistes.*[4] They sing the future of Soviet Russia the way our romantics sang the past of the monarchy. Under the Restoration, it was a problem of balancing the immense glory of our revolutionaries by an equal glory which they pretended to discover in the first years of the Old Order. Today,

[4]*passeiste:* one who lives in the past, who is incapable of adjusting to the present. (*Trans.*)

the Golden Age has been displaced by projecting it ahead of us. But, in any case, this shifting Golden Age remains what it is: a reactionary myth.

Reaction or Terror? An art that is free but abstract, or an art that is concrete but indentured? A mass public that is ignorant or a learned listener who is bourgeois? It is for you, my dear Leibowitz, who live in full conscience, without compromise or mediation, to tell us whether this conflict is eternal, or whether it is a moment in history, and in the latter instance, whether the artist has today the means within himself to resolve it, or whether, before we see the outcome, we must wait for a profound change of social life and human relations.

Part III Sexuality in Art: Implicit, Explicit, and Illicit

Those who reached college age in the late twenties will recall that they thought the sexual revolution was waged and won in that decade. Havelock Ellis was on the bookshelves, pirated copies of *Lady Chatterley's Lover* were easily available (at a premium), flappers had exposed their knees, girls had substituted white shorts for black bloomers in gym classes, mobile couches parked on decently dark lover's lanes provided unprecedented opportunities for familiarity. There were pockets of resistance—The Legion of Decency, Boston's police, deans who warned that familiarity breeds attempt—but Comstockism had been routed, and psychologists everywhere announced that prudery was as bad as prurience; all that remained was a mopping-up operation. For the next three decades sex, though never a peripheral concern, caused no cataclysms: the revolution of the thirties concentrated on social change, the decade of the forties was occupied with war, and the fifties with recovery from exhaustion.

No one would have predicted, despite the intervening labors of Kinsey, Masters, and Johnson, and the decisions of the U. S. Supreme Court, that the ground was being prepared for a second sexual revolution in the 1960s, in the course of which sex was to become a new spectator sport. This defies all psychological rules, for voyeurism is said to be a recourse of the sexually repressed, and ours has been an age of increasing sexual permissiveness. (Contrary to some, the Warren Court did not invent sex.) Sexual permissiveness may take the form of freer sexual conduct or more explicit comment about and representation of sex. Since the two are in a reciprocal causal relationship one can hardly be discussed without reference to the other. Clearly, also, sexual permissiveness involves a more elastic interpretation of obscenity and sexual pathology and with this a more ambiguous line between what is and is not thought of as obscene and pathological, the tendency being in the direction of (a) reducing the scope of obscenity and pathology and (b) reducing obscenity—a moral category—to pathology.

Obscenity is offensive sexual language or conduct. Brutality and violence are loosely called obscene by some, but this is confusing unless, as is often the case, sado-masochistic behavior has a sexual focus or sexual overtones. Pornography is simply—or, as will be seen, not so simply—the representation of obscenity, either by means of words which call up the appropriate images or by simulation, for the purpose of "entertainment," usually with a view to arousing a sexual response. Reference to intent or purpose is clearly essential. A sober, sociological account of prostitution is hardly pornographic (although the Oxford English Dictionary magisterially declares that pornography is "a description of prostitutes or of prostitution").

Novels have been written which even arouse sympathy for prostitutes, suggesting that prostitution is a social evil, without therefore being stigmatized as pornographic fiction—one such is a Russian novel called *Yama (The Pit)*.

It is also important to see that sexual conduct or sex objects, in themselves not the least offensive or obscene, become so in many cultures by virtue of being depicted, that is, made *public*. In nearly all cultures sexual intercourse is a private matter (although Ford and Beach in *Patterns of Sexual Behavior* report customs requiring little or no concealment, especially on ceremonial occasions). While anthropologists reject the theory that clothing originates in some modesty instinct and stress the variability of modesty patterns (including taboos against general nudity) among different social groups, our culture calls for concealment of the genitals (and even secondary sex organs) in most public contexts. Pornography thus includes departures from prevailing standards of privacy and modesty when, in the language of the U. S. Supreme Court, such departures have no "redeeming" social value.

Although what is found pornographic varies from age to age, culture to culture, and subculture to subculture, an overwhelming majority are agreed that there *is* such a category. Even D. H. Lawrence reckoned with smut and condemned it: "You can recognize it," he said, "by the insult it offers, invariably, to sex, and to the human spirit." He found it an affront "to a vital human relationship."

In these times, when it is fashionable to dismiss pornography as innocuous, Lawrence's comment will be rejected by some as dealing in imponderables. But deeply-hidden feelings surface at the portrayal of sex, even in simple words and gestures, and frighten those who would prefer to keep such feelings repressed. That may be most of us. And, even if we have no great sexual repressions or jealousies, or if we can cope with them, we may still raise important social questions: are there types of sexual portrayal that stimulate desires in people who have no ordinary sexual "outlets"—to use a term from the Kinsey Report on the human male—and who may then be driven to crimes like rape and sexual murder? Are there types of sexual portrayal combined with violence that may increase the incidence of genuine sadism and lead to horrors of the kind represented by the Moors murders? Will overmuch sexual portrayal create a cultural atmosphere in which other human activities seem less valuable, by comparison, than they should?

Another set of problems concerns the question of privacy. If sexual activity becomes less private, is the culture injured? Are we deprived of something of great value? A distinguished author, Katherine Anne Porter, says so in her comments, reprinted below, on D. H. Lawrence's *Lady Chatterley*. What about the trust and confidence married partners and lovers may have in each other? Will more public sexuality bring greater promiscuity, and with it a breach of loyalty and of the normal and happy acceptance of fidelity?

Perhaps the most important questions about pornography and obscenity hinge on the intimacy and beauty of sex when people love each other. Are these subtly eroded by sexual display and gradually replaced by sexual athleticism, including a new evaluation of sex in terms of thrill and excitement? Does the feeling that there is something of the sacramental about sexual love, as there is about marriage, vanish or diminish? That would be a high price to pay for a growth in freedom of sexual expression. Even if people become bored by "hard-core pornography," for which there is some evidence, are its effects eradicated by that boredom, or does sexuality itself seem boring, however necessary? One remembers lines of Swinburne's:

*"A month or twain to dwell on honeycomb is pleasant,
But one tires of scented time,
Cold sweet recurrence of accepted rhyme."*

And Swinburne was writing of sexual passion, not sexual promiscuity.

We may even ask if ordinary sexual behavior would seem boring in the light of all the possibilities pornography displays, so that people might need recourse to more and more extreme conduct to get stimulation. Would this require more and different partners, as in the Don Juan complex, destroying monogamy in the process and even driving people to partners of their own sex as interest in the opposite sex dwindles? The interpretation of Don Juan as a homosexual who cannot be satisfied by a partner of the opposite sex is a standard Freudian diagnosis. Can a life of sexual variety and excess create the conditions for homosexuality? And is such a life more likely when pornography is widespread?

Most of these questions are scorned by those who regard our culture as puritanical and repressive of sexual interest and expression. Sex, they argue, is life-enhancing, and its repression deadens man even in non-sexual ways. George Orwell's *1984*, which is not an argument for sexual promiscuity, contains the implicit thesis that men can be enslaved only when sex is suppressed. And many have argued that sexual repression is an aid, perhaps even necessary, to fanaticism and to the sadistic horrors of Nazi concentration camps, which replace ordinary sexuality when it is repressed. People who take this stand will not grant that faithful partners, or the marriage bed, provide enough sexuality for psychological freedom, for they think that sexual repression casts its pall over marriage too. Some of those who maintain these things find pornography liberating and obscenity salutary.

Those who are offended by pornography or fear its adverse consequences have called for legal restraints which, until recently, have been abundantly available. And, if the majority in a democratic society believe pornography to be dangerous as well as offensive, they have the right to ban it by law. If others think such laws foolish or harmful, they have the right to try to convince enough people of their case to amend or repeal the laws. The point is that censorship laws are not all inherently undemocratic. Some, indeed, may not be. Unlike free speech, religious toleration, and the right to refuse self-incrimination, pornography and obscenity have no special constitutional protection. We may censor pornography and obscenity if we want to. Of course, we then have the great problem of knowing what is pornographic and what is obscene, of drawing a line between what we allow and what we ban.

A man named Bowdler expurgated Shakespeare.[1] Thus, he gave his name, in the verb, "to bowdlerize," to all similar activity in the course of which "whores" in Shakespeare's works became "harlots." Lady Macbeth's famous line became "Out, crimson spot," and one inscrutable editor, troubled by "grunt" in Hamlet's most famous soliloquy, had him "groan and sweat under a weary life." Other Bowdlers might be tempted to perform the same office for the Bible, which is strong meat, like Shakespeare. They might even be tempted to cut out reference to the "publicans and sinners" with whom Jesus associated, on the ground that Christ should not be said to have kept low company.

[1]According to Noel Perrin, author of a recent history of expurgated books (*Dr. Bowdler's Legacy*), it was not Thomas Bowdler but his sister who performed the surgery on Shakespeare. Her name is not on the title page of the "Family Shakespeare" because this would have implied that she knew and understood enough of Shakespeare's bawdry to excise it, a confession no proper spinster would wish to make.

Shakespeare is bawdy; there is no question about it. So were many other great writers, among them Aristophanes, Rabelais, Swift, Plautus, most Elizabethan poets, and most Restoration dramatists. Is their bawdiness part of their art, so that expurgation cuts out pieces of living flesh? Very likely; in some instances certainly. Doesn't that mean pornography can be art, and when it is—so great is the power of art—it can mold men's minds and alter their characters? Should society permit that, if the molding and alteration are anti-social?

Before coming to a conclusion and perhaps deciding to bowdlerize all art, a number of problems should be stated and faced. As a start, is the bawdiness of the great writers just mentioned actually pornographic or obscene? One can quote lines from any of them that would seem shocking and offensive to many people. But the lines would be out of context. In context, they reveal character, add to the plot, enter the complex relations found in all great art, and provide the tone and feeling of the work. That makes a great difference. Othello's heated imagings of sexual detail between his wife and her presumed lover makes plausible a jealousy great enough to bring him to kill. In "hard-core" pornography, however, everything except the shocking scenes or lines is a cardboard scaffolding, a cheap, jerry-built, contrived base for the pornographic and obscene, which is the real point of the work. In great art the work as a whole is great art, including the moments that, out of context, might shock us.

Next, there is a complex and fascinating question about artists, their work, and the particular culture they live in. Renaissance Italy was not Victorian England in its standards, and what shocked the latter may have been counsels of prudence to the former. Neither Aristophanes nor Shakespeare was particularly bawdy in his own day, so far as we can tell. And the great transforming quality of art puts us, when we see their plays, in their own day. Even more significant, a homosexual in Periclean Athens, where it was common to be homosexual, or in Renaissance Italy, where even the overwhelmingly powerful Michelangelo was homosexual, was accepted by society and so could live, if he chose, a life of moral rectitude, crowned with honors and even adulation.[2] But Oscar Wilde, for all his genuine brilliance, went to jail and was ruined in Victorian England. Wilde had genius and a strong and organized personality; other homosexuals of his time, unlike Wilde, more easily met society's disapprobation and outright contempt by slipping into an underworld of unpleasant, anti-social, even criminal activity.

By analogy, it is more than possible that art is at one time bawdy, healthy, obscene, and wonderful, and at another time is no longer art at all because its bawdiness or obscenity cannot fit into the entire work in a natural and easy way, but becomes contrived, loses relation to the whole work, and is sniggering or unpleasant. The difference would in part be made by the values of the society in which the art is produced. If the artist works in an age where bawdry is acceptable, even commonplace, his work as a whole is untainted by its bawdy parts, but if bawdry is offensive to his public, and his work is partly bawdy, the rest of his work may be corrupted by the self-consciousness and defiance necessary to the construction of the bawdy parts.

The foregoing position is often described as cultural relativism. However, what is and is not pornographic may depend on more than cultural differences. It may involve the integrity of the artist's motives: did he, for example, introduce sex irrelevantly in order to increase the market for his work or because the subject

[2]It should be noted, however, that one could be arrested for homosexuality in Renaissance Florence and that ancient Athens had laws protecting boys from homosexual men.

matter called for it?[3] *It may involve certain aesthetic imperatives that transcend cultural differences.* Such imperatives are nowhere better exemplified than in the distinctions discussed (and illustrated) in these pages by Sir Kenneth Clark and E. H. Gombrich between the naked and the nude. What they bring out is that explicitness, which makes effort and participation by the viewer redundant and hence dispenses with *his essential contribution* to the final impact or effect of an art work, is the death of art. The novelist, says George Steiner in his discussion of "high pornography" reprinted below, "does not tell all." The application of this criterion to such theater productions as "Hair" (which appears to have initiated a current craze for nakedness on the stage), "Oh! Calcutta!," and "Che" or such moving pictures as "I am Curious (Yellow)" may require a verdict concerning their aesthetic merit which has nothing to do with changing times and different cultures. In his poem, *Christabel*, Coleridge wrote of the strange lady, Geraldine, who undresses before Christabel:

> *Behold! her bosom and half her side—*
> *A sight to dream of, not to tell!*

Would he have done better had he told?

In most of what has been said thus far it has been assumed that pornography is a real category, even though there is disagreement concerning its boundaries and consequences. It has also been assumed that pornography and authentic art are imcompatible. We must now ask whether a work can be essentially or totally pornographic and still be art. Is the pornographic thin, repetitive, and unimportant compared with the other, and greater, issues of life? Is pornography rich enough and significant enough to carry the weight of art? The United States now permits John Cleland's *Memoirs of Fanny Hill*, a book describing the behavior of prostitutes in lurid detail, to be published and distributed openly. The book does reveal some social values and attitudes of its time, but it is cliche-ridden (the prostitute with the heart of gold, for instance), it rings as many changes as it can on the sexual act, boringly, and has no genuine literary merit. Can such a theme be the subject of a whole book which has literary merit? There are very few defenses, as art, of such books written in the past. Some people think, though, that today, especially with our anti-novels and our anti-heroes, pornography can be the basic theme of a work of art. A brilliant critic and commentator, Susan Sontag, defends this thesis in a highly controversial article reprinted here. It represents what some would regard as the most extreme position yet taken on the aesthetics of pornography. Ably challenged by George Steiner in a succeeding article, it nevertheless leaves us uneasily brooding over a predicament that forces us to find answers to questions never faced by our ancestors.

[3]The relevance of consulting an artist's motives or intentions is discussed below, pp. 234–247.

The Pornographic Imagination

Susan Sontag

A brilliant young avant gardist, Susan Sontag (1933–) may be described as an unconventional literary critic in more senses than one: she rarely writes about fiction (as such) or poetry; her preoccupation with pornography, camp, and the extravagant in general has elicited comment disproportionate to the volume of her work. Her article "Camp" established that word in the small talk of would-be worldlings. Her first novel, The Benefactor, *was published in 1963. Since then two collections of her essays,* Against Interpretation *(1966) and* Styles of Radical Will *(1969), have been published. Most recently Miss Sontag has turned her talents to the writing and directing of movies. The essay reprinted here, defending the thesis that pornography can be an authentic literary genre, has been described by Richard Gilman, literary editor of the* New Republic *as a "dazzlingly learned, risky piece of advocacy and interrogation."*

I

No one should undertake a discussion of pornography before acknowledging the pornograph*ies*, of which there are at least three; and before pledging to take them on one at a time. A good deal is gained by treating pornography as an item in social history quite separately from pornography as a psychological phenomenon (according to the usual view, symptomatic of sexual deficiency or deformity in both the producers and the consumers). And everything is to be gained by distinguishing from both of these another pornography—a minor but highly interesting modality or convention within the arts.

It's the last of the three pornographies that I want to focus upon. More narrowly, upon the literary genre for which, lacking a better name, I'm willing to accept (in the privacy of serious intellectual debate, not in the courts) the dubious label of pornography. By literary genre I mean a body of work belonging to literature considered as an art, and to which inherent standards of artistic excellence pertain.

From the standpoint of social and psychological phenomena, all pornographic texts have the same status; they are documents. But from the standpoint of art, some of these texts may well become something else. I for one am convinced that not only do Pierre Louys's *Trois Filles et leur Mere,* Georges Bataille's *Histoire de l'Oeil* and *Madame Edwarda*, the pseudonymous *Story of O* and *The Image* belong to literature, but that it can be made clear why these books, all five of them, occupy a much higher rank as literature than Oscar Wilde's *Teleny* of the Earl of Rochester's *Sodom* or Apollinaire's *The Debauched Hospodar* or Cleland's *Fanny Hill* or *Candy*. The avalanche of pornographic potboilers marketed for two centuries under and now, increasingly, over the counter no more impugns the status as literature of at least a dozen pornographic books I have read than the proliferation of books of the caliber of *The Carpetbaggers* and *Valley of the Dolls* throws into question the credentials of *Anna Karenina* and *The Great Gatsby* and *The Man Who Loved Children.* The ratio of authentic literature to trash in pornography may be somewhat lower than the ratio of novels of genuine literary merit to the entire volume of subliterary fiction produced for mass taste. But I doubt that it's any lower than, for instance, that of another somewhat shady subgenre with a few first-rate books to its credit, science fiction. (As literary forms, pornography and science fiction resemble each other in several interesting ways.) Anyway, the quantitative measure supplies a trivial standard. Relatively uncommon as they may be, there are writings which it seems reasonable to call pornographic—assuming that the stale label has any use at all—which, at the same time, cannot be refused accreditation as serious literature.

The point would seem to be obvious. Yet, apparently, that's far from being the case. At least in England and America, the reasoned scrutiny and assessment of pornography is held firmly within the limits of the discourse employed by psychologists, sociologists, historians, jurists, professional moralists and social critics. Pornography is a malady to be diagnosed and an occasion for judgment. It's something one is for or against. And taking sides about pornography is hardly like being for or against aleatoric music or Pop Art, but quite a bit like being for or against legalized abortion or federal aid to parochial schools. In fact, the same fundamental approach to the subject is shared by recent eloquent defenders of society's right and obligation to censor dirty books, like George P. Eliot and George Steiner, and writers, like Paul Goodman, who warn of pernicious consequences of a policy of censorship far worse than any harm done by the books themselves. Both the libertarians and the would-be censors agree in reducing pornography to pathological symptom and problematic social commodity. A near unanimous consensus exists as to what pornography is—this being identified with notions about the *sources* of the impulse to produce and consume these curious goods. As a theme for psychological analysis, pornography is rarely seen as anything more interesting than texts which illustrate a deplorable arrest in normal adult sexual development. On this view, all pornography amounts to is the representation of the fantasies of infantile sexual life, these fantasies having been edited by the more skilled, less innocent consciousness of the masturbatory adolescent, for purchase by so-called adults. As a social phenomenon—for instance, the boom in the production of pornography in the societies of Western Europe and America since the eighteenth century—the approach is no less unequivocally clinical. Pornography becomes a group pathology, the disease of a whole culture, about whose cause everyone is pretty well agreed. The mounting output of dirty books is attributed to a festering legacy of Christianity-sponsored sexual repression and to sheer physiological ignorance, these ancient disabilities being now compounded by

more proximate historical events, the impact of drastic dislocations in traditional modes of family and political order and unsettling change in the roles of the sexes. (The problem of pornography is one of "the dilemmas of a society in transition," Goodman said in an essay several years ago.) Thus, there is a fairly complete consensus about the *diagnosis* of pornography itself. The disagreements arise only in the estimate of the psychological and social *consequences* of its dissemination, and therefore in the formulating of tactics and policy.

The more enlightened architects of moral policy are undoubtedly prepared to admit that there is something like a "pornographic imagination"; although only in the sense that pornographic works are tokens of a radical failure or deformation of the imagination. And they may grant, as Goodman, Wayland Young and others have suggested, that there also exists a "pornographic society": that, indeed, ours is a flourishing example of one, a society so hypocritically and repressively constructed that it must inevitably produce an effusion of pornography as both its logical expression and its subversive, demotic antidote. But nowhere in the Anglo-American community of letters have I seen it argued that some pornographic books are interesting and important works of art. So long as pornography is treated as only a social and psychological phenomenon and a focus for moral concern, how could such an argument ever be made?

II

There's another reason, apart from this presumption about what pornography is as a topic of analysis, why the question of whether or not works of pornography can be literature has never been genuinely debated. I mean the view of literature itself maintained by most English and American critics—a view which in excluding pornographic writings *by definition* from the precincts of literature excludes much else besides.

Of course, no one denies that pornography constitutes a branch of literature in the sense that it can take the form of printed books of fiction. But beyond that trivial correspondence, no more is allowed. The way most critics construe the "nature" of prose literature, no less than their view of the "nature" of pornography, must put pornography in an adverse relation to literature. A pornographic book is defined as one not belonging to literature (and vice versa), which suggests there's no need to examine the books.

One common charge is that the utterly singleminded way in which works of pornography address the reader, proposing to arouse him sexually, is antithetical to the complex function of literature. It may then be argued that pornography's aim, that of inducing sexual excitement, is at odds with the tranquil, detached involvement evoked by genuine art. But this seems particularly unconvincing, in view of the much admired appeal to the reader's moral feelings that "realistic" writing generally intends. It's more plausible to emphasize just the very singleness of pornography's aim, while acknowledging that some certified masterpieces (from Chaucer to Lawrence) do properly excite readers sexually in certain passages or sections. Nevertheless, the argument goes, pornography still possesses only one "intention," while any genuinely valuable work of literature has many.

Another common argument, offered by Adorno among others, is that works of pornography lack the beginning-middle-and-end form characteristic of literature. A piece of pornographic fiction concocts no better than a crude excuse for a beginning; and once having begun, it goes on and on and ends nowhere.

Another argument is that pornographic writing can't evidence any care for its means of expression as such (the concern of literature), since the aim of

pornography is to inspire a set of nonverbal fantasies in which language plays a debased, merely instrumental role.

Last and most weighty is the following argument. The subject of literature is something called "the human," that is, the relation of human beings to each other, their complex feelings and emotions; pornography, in contrast, disdains fully formed persons (psychology and social portrayal), is oblivious to the question of motives and their credibility and reports only the motiveless tireless transactions of depersonalized organs. Simply extrapolating from the conception of what a work of literature is maintained by most English and American critics writing today, it would follow that the literary value of pornography has to be nil.

But this argument by paradigm simply won't do. Even taking the prevailing concept of literature and applying it to, say, *Story of O*, there's scarcely a single respect in which it fits. Though the novel is thoroughly obscene by the usual standards, and more effective than many in arousing a reader sexually, it can't be said that sexual arousal is the sole function of the situations portrayed. The narrative does have a definite beginning, middle and end. Far from giving the impression that its author considered language a bothersome necessity, the book is written in an elegant, accomplished French (whose quality the translation doesn't put over too well into English). Further, the characters do possess emotions of a very intense kind, although obsessional and indeed wholly asocial ones; characters do have motives, though they are not psychiatrically or socially "normal" motives. The characters in *Story of O* are endowed with a "psychology" of a sort, one derived from the psychology of lust. And while what is learned of the characters within the situations in which they are placed is severely restricted—to modes of sexual concentration and explicitly rendered sexual behavior—O and her partners are, in form, no more reduced or foreshortened than the characters in many nonpornographic works of contemporary fiction.

The fact is, if English and American critics had a more sophisticated view of literature, an interesting debate could get underway. (In the end, this debate would be not only about pornography, but about the whole body of contemporary literature insistently focused on extreme situations and behavior.) The difficulty is that so many critics continue to identify with prose literature itself the particular literary conventions of "realism" (what might be crudely associated with the major tradition of the nineteenth-century novel). For examples of alternative literary modes, one is not confined to appealing only to much of the greatest twentieth-century writing—to *Ulysses,* which is a book not about characters but about media of transpersonal exchange, about all that's outside individual psychology and personal need, to French Surrealism and its most recent offspring, the New Novel, to German "expressionist" fiction, to the Russian post-novel represented by Biely's *St. Petersburg* and by Nabokov, or to the nonlinear tenseless narratives of Stein and Burroughs. A definition of literature that faults a work for being rooted in "fantasy" rather than in the realistic rendering of how lifelike persons in familiar situations live with each other couldn't even handle such venerable conventions as the pastoral, which depicts relations between people that could scarcely be more reductive, vapid or unconvincing.

An uprooting of some of these tenacious cliches is long overdue: it will promote a sounder reading of the literature of the past as well as put critics and ordinary readers better in touch with contemporary literature, which includes zones of writing that structurally resemble pornography. It's too easy, virtually meaningless, to demand that literature stick with the "human." For what is at stake is not "human" versus "inhuman" (in which choosing the "human" guarantees instant moral self-congratulation for both author and reader) but an infinitely varied

register of forms and tonalities for transposing *the human voice* into prose narrative. From the point of view of criticism, the proper question is not the relationship between the book and "the world" or "reality" (in which each book of fiction is judged as if it were a unique item, and in which the world is taken as a far less complex place than it is) but the complexities of consciousness itself, as the medium through which "a world" exists at all and is constituted, and an approach to single books which doesn't slight the way they exist in dialogue with each other. From this point of view, the decision of the old novelists to depict the unfolding of the destinies of sharply individualized "characters" in familiar, socially dense situations within the conventional notation of chronological sequence is only one of many possible decisions, with no inherently superior claim to the allegiance of serious readers. There is nothing innately more "human" about these procedures of the old novelists. The presence of realistic "characters" isn't, in itself, something wholesome. Nor is it more nourishing for the moral sensibility.

The only sure thing that can be said about characters in prose fiction is that they are, to use the phrase of Henry James, "a compositional resource." The presence of human figures in literary art can serve many purposes. Dramatic tension or three-dimensionality in the rendering of personal and social relations is often *not* what is being aimed at, in which case it doesn't help to insist on that as a generic standard. The presentation of lifelike persons is far from being a necessary staple of literature. The exploration of ideas is as authentic an aim of prose fiction, although the adoption of this aim severely limits the representation of persons by the standards of novelistic realism. The constructing or imaging of something inanimate, or of part of the world of nature, is also a valid enterprise, and entails an appropriate rescaling of the human figure. (The form of the pastoral involves a mixture of both these aims: the depiction of ideas and of nature. Persons are used only to the extent that they create a certain kind of landscape, which is partly a stylization of "real" nature and partly a neo-Platonic landscape of ideas.) And equally valid as a subject for prose narrative are the extreme states of human feeling and consciousness, those so peremptory that they exclude the mundane flux of feelings and are only contingently linked with concrete persons—which is the case with pornography.

One would never know, from the confident generalizations on the "nature" of literature set forth by most American and English critics, that a stirring debate on the issue had been going on now for several generations. As Jacques Riviere wrote in the *NRF* in 1924, "It seems to me that we are witnessing a very serious crisis in the concept of what literature is." One of several responses to "the problem of the possibility and the limits of literature," Riviere notes, is the marked tendency for "art (if even the word can still be kept) to become a completely nonhuman activity, a supersensory function, if I may use that term, a sort of creative astronomy." I have cited Riviere not because his essay, "Questioning the Concept of Literature," is particularly original or definitive or subtly argued, but merely to recall to mind that group of radical notions about literature, which were almost critical commonplaces forty years ago in European magazines comparable to *PR*.

To this day, though, that ferment remains something alien, unassimilated and persistently misunderstood in the English and American world of letters: suspected as issuing from a collective cultural failure of nerve, frequently dismissed as outright perversity or obscurantism or creative sterility. The better English-speaking critics could, however, hardly fail to notice how much great twentieth-century literature subverts those ideas received from certain of the great nineteenth-century novelists on the "nature" of literature which they continue to echo in 1967. But the critics' awareness of genuinely new literature was usually tendered in a spirit much like

Obscenity as an Aesthetic Category

that of the rabbis a century before the beginning of the Christian era who, humbly acknowledging the spiritual inferiority of their own age to the age of the great prophets, nevertheless firmly closed the canon of prophetic books and declared—with more relief, one suspects, than regret—the era of prophecy ended. So was the age of what in Anglo-American criticism is still called, astonishingly enough, "experimental" or "avant-garde" writing repeatedly declared to be closed. The ritual celebration of each contemporary genius' undermining of the older notions of literature was often accompanied by the nervous insistence that the writing brought forth was, alas, the last of its noble, sterile line. Now, the results of this intricate one-eyed way of looking at modern literature have been several decades of unparalleled interest and brilliance in English and American—particularly American—criticism. But it is an interest and brilliance that's reared on bankruptcy of taste and something approaching a fundamental dishonesty of method. The critics' retrograde awareness of the impressive new claims staked out by modern literature, linked with their chagrin over what was usually designated as "the rejection of reality" and "the failure of the self" endemic in that literature, indicates the precise point at which most talented Anglo-American literary criticism leaves off considering structures of literature and transposes itself into criticism of culture.

I don't wish to repeat here the arguments that I have advanced elsewhere on behalf of a different critical approach. Still, some allusion to that approach needs to be made. To discuss even a single work of the radical nature of *Histoire de l'Oeil* raises the question of literature itself, of prose narrative considered as an art form. Books like those of Bataille could not have been written except for that intellectual upheaval over the nature of literature which has been taking place in Europe for more than half a century; but lacking that context, they must be almost unassimilable for English and American readers—except as "mere" pornography, mysteriously fancy trash. If it is even necessary to take up the issue of whether or not pornography and literature are antithetical, if it is at all necessary to assert that works of pornography *can* belong to literature, then the assertion has to imply an overall view of what art is.

To put the matter most generally: art (and art-making) is a form of consciousness; the materials of art are the variety of forms of consciousness. And no *esthetic* principle exists by which this notion of the materials of art can be construed as excluding even the most extreme forms of consciousness that transcend social personality or psychological individuality.

In daily life, to be sure, we may acknowledge a moral obligation to inhibit such states of consciousness in ourselves. The obligation seems pragmatically sound. Such inhibition on the part of most seems necessary for social order in the widest sense, and seems necessary on the part of each in order to establish and maintain a humane contact with other persons (though that contact can be renounced, for shorter or longer periods). It's well known that when people venture into the extremities of consciousness, they do so at the peril of their sanity, that is to say, of their humanity. But the "human-scale" or humanistic standard proper to ordinary life and conduct seems misplaced when applied to art. It oversimplifies. If within the last century art conceived as an autonomous activity has come to be invested with an unprecedented stature—the nearest thing to a sacramental human activity acknowledged by a secular society—it is because one of the things art has elected to do is to make forays into and take up positions on the frontiers of consciousness (often very dangerous to the artist as a person) and to report back what's there. Being a free-lance explorer of spiritual dangers, the artist is given a certain license to behave differently from other people; matching the singularity of his vocation, he may or may not be decked out with a suitably eccentric life style. But his main job

is to invent trophies of his experiences—objects and gestures that fascinate and enthrall, not merely (as older notions of the artist would have it) edify or entertain. His principal means of fascinating is to advance one step further in the dialectic of outrage. To make his work repulsive, obscure, inaccessible; in short, to give what is, or seems to be, *not* wanted. But however fierce may be the outrages he perpetrates upon his audience, the artist's credentials and spiritual authority ultimately depend on the audience's sense (whether something known or inferred) of the outrages he commits upon himself. The exemplary modern artist is a broker in madness.

The notion of art as the dearly-purchased fruits of an immense spiritual risk, one whose cost goes up with the entry and participation of each new player in the game, invites a new set of critical standards. Certainly, the art produced under the aegis of this conception is not, cannot be, "realistic." But words that merely invert the guide-lines of realism—like "fantasy" or "surrealism"—don't clarify much. Fantasy all too easily declines into "mere" fantasy; the clincher is the adjective "infantile." Where does fantasy, condemned by psychiatric rather than artistic standards, end and imagination begin?

Since it's hardly likely that most contemporary critics seriously mean to bar prose narratives that are unrealistic from the domain of literature, one suspects that a special standard is being applied to sexual themes. Transfer to another kind of book, another kind of "fantasy," and the matter becomes clear. The ahistorical dreamlike landscape in which action is situated, the peculiarly congealed time in which acts are performed—these occur almost as often in science fiction as they do in pornography. There is nothing very remarkable in the fact that most men and women fall short of the sexual prowess people in pornography are represented as enjoying; that size of organs, number and duration of orgasms, variety and feasibility of sexual postures and amount of sexual energy available all seem grossly exaggerated. Yes, and the spaceships and the teeming planets depicted in science-fiction novels don't exist either. That the site of narrative is an ideal *topos* doesn't disqualify either pornography or science fiction from being literature. Such negations of real, concrete, three-dimensional social time, space and personality— and such "fantastic" enlargements of human energy—are rather the ingredients of another kind of literature, founded on another mode of consciousness.

The materials that go into the pornographic books which count as a branch of literature are, precisely, one of the extreme forms of human consciousness. Of course, many people would agree that the sexually-obsessed consciousness can, in principle, enter into literature considered as an art form. Literature about lust? Why not? But then they usually add a rider to the agreement which effectually nullifies it. What's asked is that the author of such a work have the proper "distance" from his obsessions for their rendering to count as literature. This is a hypocritical standard, revealing once again that the values most people employ to deal with pornography are, in the end, those belonging to psychiatry and social affairs rather than to art. (Since Christianity upped the ante and concentrated on sexual behavior as the core of virtue, everything pertaining to sex has been a "special case" in our culture, evoking peculiarly inconsistent attitudes.) Van Gogh's paintings are not considered less admirable nor does their status as art become dubious because there is reason to think that his manner of painting had less to do with a conscious choice of representational means, according to esthetic or art-history standards, than with the fact that he was deranged and actually saw reality the way he painted. Similarly, *Histoire de l'Oeil* does not become case history rather than art because the extraordinary autobiographical essay appended to the narrative reveals that these obscene obsessions are indeed Bataille's own.

What makes a work of pornography part of the history of art rather than of trash is not distance, the superimposition of a consciousness more conformable to that of ordinary reality upon the "deranged consciousness" of the erotically obsessed. It is rather the originality, thoroughness, authenticity and power of that "deranged consciousness" itself, as it is incarnated in a work. From the point of view of art, the exclusivity of the consciousness embodied in pornographic books is, in itself, neither anomalous nor antiliterary.

Nor is its purported aim or effect (whether it is intentional or not)—to excite the reader sexually—a defect. Only by following a degraded and mechanistic idea of sex could one be misled into thinking that to be sexually stirred by a book like *Madame Edwarda* is a simple matter. That singleness of intention often condemned by critics is, when the work of pornography merits treatment as art, compounded of many resonances. The physical sensations involuntarily produced in the reader carry with them something that touches upon the reader's whole experience of his humanity—and his limits as a personality and as a body. Actually, the singleness of pornography's intention is spurious. But the aggressiveness of the intention is not. What seems in pornography like an end is as much a means, startlingly and oppressively concrete. The end, though, is less concrete. Pornography is one of the branches of literature—science fiction is another—aiming at disorientation, at psychic dislocation.

In some respects, the use of sexual obsessions as a subject for literature resembles that of a subject whose validity far fewer people would contest: religious obsessions. So compared, the familiar fact of pornography's definite, aggressive impact upon its readers looks somewhat different. Its celebrated intention of sexually stimulating readers is really a species of proselytizing. Pornography that is serious literature aims to "excite" in the same way that books which render an extreme form of religious experience aim to "convert."

III

Two French books recently translated into English, *Story of O* and *The Image*, conveniently illustrate some issues involved in the topic, barely explored in Anglo-American criticism, of pornography as a branch of serious literature.

Story of O by "Pauline Reage" was published in Paris in 1954, and immediately became famous, partly due to the patronage of Jean Paulhan, who wrote the preface. It was widely believed that Paulhan had written the book, too—perhaps because of the precedent set by Bataille, who had contributed an essay (signed with his own name) to his *Madame Edwarda* when it was first published in 1941 under the pseudonym "Pierra Angelique," and also because Pauline suggested Paulhan. But Paulhan has always denied that he wrote *Story of O*, insisting that it was indeed by a woman, someone living in another part of France who didn't wish her name known. Though Paulhan's story about the unambitious provincial author was not generally believed, the conviction that it was he who wrote the book eventually faded. In the years since, a number of more ingenious hypotheses, attributing the book's authorship to other figures on the Paris literary scene, gained credence; and then were dropped. The real identity of "Pauline Reage" remains one of the few well-kept secrets in contemporary letters.

The Image came out two years later, in 1956, also under a pseudonym, "Jean de Berg," and, to compound the mystery, dedicated to and with a preface by "Pauline Reage," who has not been heard from since. (The preface by "Reage" is terse and forgettable; the one by Paulhan is long and very interesting.) Speculation at Paris literary parties about the identity of "Jean de Berg" is at least more restful than the

gossip about "Pauline Reage." One rumor only, which names the wife of an influential younger novelist, has swept the field.

It's not unreasonable that those curious enough to speculate about the real people behind the two pseudonyms should regularly come up with some name from the established community of letters in France. That either of these two books should be an amateur's stroke of genius is almost inconceivable. Both, but particularly *Story of O* are highly "literary" books. By this I mean that, different as one is from the other, both *Story of O* and *The Image* evince a quality in the writing that can't be ascribed simply to an abundance of the usual writerly endowments of sensibility, energy and intelligence. Such gifts were surely present, but one is also aware of the extent to which these gifts have themselves been processed through a dialogue of artifices. The degree of somber self-consciousness with which the narratives are executed could hardly be farther from the lack of control and craft usually considered as accompanying the expression of obsessive lust. The fact is that, intoxicating as is their subject (if the reader doesn't cut off and find it just funny or sinister), both narratives have more to do with the "use" of erotic material than with the "expression" of it. And this use is pre-eminently—there is no other word for it—literary. The imagination pursuing its outrageous pleasures in *Story of O* and *The Image* is firmly anchored to certain notions of the *formal* consummation of intense feeling, of procedures for exhausting an experience, that connect as much with literature and recent literary history as with the ahistorical domain of eros. And why not? Experiences aren't pornographic; only expressions and representations—structures of the imagination—are. This is why what a pornographic book can make the reader think of, mainly, is other pornographic books, rather than sex unmediated—and this not necessarily to the detriment of his erotic excitement.

To take only one of many connections with the idea of literature as such projected by *Story of O:* what resonates throughout the book is a voluminous body of pornographic or "libertine" literature, mostly trash, in both French and English, going back to the eighteenth century. The most obvious reference is to Sade. But here one must not think only of the writings of Sade himself, but of the reinterpretation of Sade by French literary intellectuals after World War II, a critical gesture perhaps comparable in its importance and influence upon educated literary taste and upon the actual direction of serious fiction in France to the reappraisal of James launched just before World War II in the United States, except that the French reappraisal has lasted longer and seems to have struck deeper roots. (Sade, of course, had never been forgotten. He was read enthusiastically by Flaubert, Baudelaire and most of the other radical geniuses of French literature of the second half of the nineteenth century. He was one of the patron saints of the Surrealist movement, and figures importantly in the thought of Breton. But it was the writings after 1945 that really consolidated Sade's position as an inexhaustible point of departure for radical thinking about the possibilities of the human condition. The well-known essay of Beauvoir, the indefatigable scholarly biography undertaken by Gilbert Lely and writings as yet untranslated by Blanchot, Paulhan, Bataille, Klossowski and Leiris constitute the most eminent documents of the postwar reevaluation which secured this astonishingly hardy modification of French literary sensibility. The quality and theoretical density of the French interest in Sade remains virtually incomprehensible to English and American literary intellectuals, for whom Sade is perhaps an exemplary figure in the history of psychopathology, both individual and social, but inconceivable as someone to be taken seriously, in an ahistorical context, as a "thinker.")

But it's not only Sade, and both the problems he raised and the ones raised in his name, that stands behind *Story of O.* There are also the conventions of the "libertine" potboilers written in nineteenth-century France, such as those which take place in a fantasy England populated by brutal aristocrats with enormous sexual equipment and violent tastes, along the axis of sadomasochism, to match. The name of O's second lover-proprietor, Sir Stephen, is clearly a reference, a kind of homage, to this highly period fantasy, as is the Sir Edmond of *Histoire de l'Oeil.* What's important to note is that the allusion to a stock type of pornographic trash stands, as a literary reference, on exactly the same footing as the anachronistic setting of most of the action, which is lifted straight from Sade's books. The narrative opens in Paris with O joining her lover Rene in a car and driving around, but most of the subsequent action is removed to more familiar if less plausible territory: that conveniently isolated chateau, luxuriously furnished and lavishly staffed with servants, where a group of rich men congregate and to which women are brought as virtual slaves in order to be the objects, shared in common, of the men's brutal and inventive lust. There are whips and chains, masks worn by the men when the women are admitted to their presence, great fires burning in the hearth, unspeakable sexual indignities, floggings and more ingenious kinds of physical mutilation, several lesbian scenes when the excitement of the orgies in the great drawing room seem to flag. In short, the novel comes equipped with some of the creakiest items in the repertoire of pornography.

How seriously are we to take this? A bare inventory of the plot might give the impression that *Story of O* is not so much pornography as metapornography, a brilliant parody. Something similar was urged in defense of *Candy* when it was published here several years ago, after some years of more modest existence in Paris as a more or less official dirty book. *Candy* wasn't pornography, it was argued, but a spoof, a witty burlesque of the conventions of cheap pornographic narrative. A good try, but it isn't so. *Candy* may be funny, but it's still pornography. For pornography isn't a form which can parody itself. It is the nature of the pornographic imagination to prefer readymade conventions of character, setting and action. Pornography is a theater of types, never of individuals. A parody of pornography always remains pornography (so far as it's at all competent). Indeed, parody is one common form of pornographic writing. Sade himself often used it, inverting the moralistic fictions of Richardson in which female virtue always triumphs over male lewdness, either by saying no or by dying afterwards. With *Story of O,* it would be more accurate to speak of a "use" rather than of a parody of Sade.

The tone alone of *Story of O* indicates that whatever in the book might be read as parody or antiquarianism—a mandarin pornography?—is only one of several elements forming the narrative. (Although sexual situations encompassing all the expectable variations of lust are graphically described, the prose style is rather formal, the level of language dignified and almost chaste.) Features of the Sadean staging are used to shape the action, but the narrative's basic line differs fundamentally from anything Sade wrote. Consider his *120 Days of Sodom,* probably the most ambitious pornographic book ever conceived (in terms of scale), a kind of summa of the pornographic imagination; stunningly impressive and upsetting, even in the truncated form, part narrative and part scenario, in which it has survived. (The manuscript was accidentally rescued from the Bastille after Sade had been forced to leave it behind when he was transferred in 1789 to Charenton, but Sade believed until his death that his masterpiece had been destroyed when the prison was razed.) Sade's express train of outrages tears along an interminable but

level track. His descriptions are too schematic to be sensuous. The actions of the book are illustrations, rather, of his relentlessly repeated ideas. Yet these polemical ideas themselves seem, eventually, more like principles of a dramaturgy than a serious theory. Sade's ideas—of the person as a "thing" or an "object," of the body as a machine and of the orgy as an inventory of the hopefully indefinite possibilities of several machines in collaboration with each other—seems mainly designed to make possible an endless, nonculminating kind of ultimately affectless activity. In contrast, there is a definite movement in *Story of O,* a logic of events, as opposed to Sade's static principle of the catalogue or encyclopedia. This plot movement is certainly abetted by the fact that, for most of the narrative, the author tolerates at least a vestige of the unit of "the couple" (O and Rene, O and Sir Stephen)—a unit generally repudiated in pornographic literature.

And, of course, the figure of O herself is different. Her feelings, however insistently they adhere to one theme, have some modulation and are carefully described. If O is passive, she is scarcely like those ninnies in Sade's tales who are detained in remote castles to be tormented by cliques of pitiless noblemen and satanic priests. And O is represented as active, too; literally active, as in the seduction of Jacqueline, and more important, profoundly active in her own passivity. Only superficially does O resemble her predecessors in Sade's writings. There is never any personal consciousness, except that of the author, in Sade's books. But O does possess a consciousness, from which vantage point her story is told. (Although written in the third person, the narrative never departs from O's point of view or understands more than she understands.) Sade's effort is to neutralize sexuality of all its personal associations, to represent a kind of impersonal—or pure—sexual encounter. But the narrative of "Pauline Reage" does show O reacting in quite different ways (including love) to different people, notably Rene, to Sir Stephen, to Jacqueline and to Anne-Marie.

Sade, of course, is more representative of the major conventions of pornographic writing. So far as the pornographic imagination tends to make one person interchangeable with another and all people interchangeable with things, it's not functional to describe a person as O is described—in terms of a certain state of her will (which she's trying to discard) and of her understanding. Pornography is mainly populated by creatures like Sade's Justine, endowed with neither will, intelligence nor even, apparently, memory. Justine lives in a perpetual state of astonishment, never learning anything from the strikingly repetitive violations of her innocence. After each fresh betrayal she gets in place for another round, as uninstructed by her experience as ever, ready to trust the next masterful libertine and be rewarded for it by a renewed loss of liberty, the same indignities and the same blasphemous sermons in praise of vice.

For the most part, the figures who play the role of sexual objects in pornography are made of the same stuff as a principal "humour" of comedy. Justine is like Candide, who is also a cipher, a blank, an eternal naif who can learn nothing from his atrocious ordeals. The familiar structure of comedy which features a character who is a kind of still center in the midst of outrage (Buster Keaton is a classic image) crops up repeatedly in pornography. The personages in pornography, like those of comedy, are seen only from the outside, behavioristically. By definition, they can't be seen in depth, so as truly to engage the audience's feelings. In much of comedy, the joke resides precisely in the *disparity* between the understated or anesthetized feeling and a large outrageous event. Pornography works in a similar fashion. What's gained by a deadpan tone, by what seems to the reader in an ordinary state of consciousness to be the incredible *under*reacting of most of the

characters to the situations in which they're placed, isn't the release of laughter. It's the release of a sexual reaction, originally voyeuristic but probably needing to be secured by an underlying direct identification with one of the participants in the sexual act. The emotional flatness of pornography is thus neither a failure of artistry nor an index of principled inhumanity. The arousal of a sexual response in the reader *requires* it. Only in the absence of directly stated emotions is the reader of pornography likely to have room for his own responses. When the event narrated comes already festooned with the author's explicitly avowed sentiments, the reader may be stirred by those sentiments. But it's harder to be stirred by the event itself.[1]

Silent film comedy offers many illustrations of how the formal principle of continual agitation or perpetual motion (slapstick) and that of the deadpan really amount to the same thing—a deadening or neutralization or distancing of the audience's emotions, its ability to identify in a "humane" way and to bring moral judgments (etc.) about situations of violence. The same principle is at work in all pornography. It's not that the characters in pornography cannot conceivably possess any emotions. They can. Still, the principles of underreacting and frenetic agitation make the emotional climate self-canceling, so that the basic tone of pornography is affectless, emotionless.

However, degrees of this affectlessness can be distinguished. Justine is the stereotype sex-object figure (invariably female, since most pornography is written by men or from the stereotyped male point of view): a bewildered victim, whose consciousness, as I have said, is never changed in the slightest by her experiences. But O is an adept; grateful, whatever the cost in pain and fear, for the opportunity to be initiated into a mystery. That mystery is the loss of the self. O learns, she suffers, she changes. Step by step she becomes more what she is, a process identical with the emptying out of herself. In the vision of the world presented by *Story of O,* the highest good is the transcendence of personality. The plot's movement is not horizontal, but a kind of ascent through degradation. O does not simply become identical with her sexual availability, but wants to reach the perfection of becoming an "object." Her condition, if it can be characterized as one of "dehumanization," is not to be understood as a by-product of her situation of enslavement to Rene, Sir Stephen and the other men at Roissy. It's exactly the point of her situation, something she seeks and eventually attains. Her achievement is represented in the last scene of the book when she's led to a party, mutilated, in chains, unrecognizable, costumed (as an owl)—so convincingly no longer human that none of the guests even thinks of speaking to her directly.

O's quest is neatly summed up in the expressive letter which serves her for a name. "O" suggests a cartoon of her sex, not her individual sex but simply woman; it also stands for the void, a vacuity, a nothing. But what *Story of O* unfolds is a spiritual paradox, that of the full void and of the vacuity that is also a plenum. The power of the book lies exactly in the anguish stirred up by the continuing presence of this paradox. "Pauline Reage" raises, in a far more organic and sophisticated manner than Sade does with his clumsy expositions and discourses, the question of the status of human personality itself. But whereas Sade is interested in the

[1]This is very clear in the case of Genet's books which, despite the explicitness of the sexual experiences related, are not sexually arousing for most readers. What the reader knows (and Genet has stated it many times) is that Genet himself was sexually excited while writing *The Miracle of the Rose, Our Lady of the Flowers,* etc. The reader makes an intense and unsettling contact with Genet's erotic excitement, which is the energy that propels these metaphor-studded narratives; but, at the same time, the author's excitement precludes the reader's own. Genet was perfectly correct when he said that his books were not pornographic.

obliteration of personality from the viewpoint of power and liberty, the author of *Story of O* is interested in the obliteration of personality from the viewpoint of happiness. (The closest thing to a statement of this theme we possess in English literature are certain passages in Lawrence's *The Lost Girl*.)

For the paradox to gain real significance, however, depends on at least glimpsing a view of sex different from that held by most enlightened members of the community. The prevailing view—an amalgam of Rousseauist, Freudian and liberal social thought—estimates the phenomenon of sex as a perfectly intelligible although uniquely precious source of emotional and physical pleasure. What difficulties there are come from the long deformation of the sexual impulses administered by Western Christianity, whose ugly wounds scarcely anyone in this culture escapes. First, guilt and anxiety. Then, the reduction of sexual capacities leading if not to virtual impotence or frigidity, at least to the depletion of erotic energy and the repression of many natural elements of sexual appetite (the "perversions"). Then the spill-over into public dishonesties in which people tend to respond to news of the sexual pleasures of others with envy, fascination, revulsion and spiteful indignation. It's from this pollution of the sexual health of the culture that a phenomenon like pornography is derived.

Now, what's decisive in the complex of views held by most educated members of the community is the assumption that human sexual appetite is, if untampered with, a natural pleasant function; and that "the obscene" is a convention, the fiction imposed upon nature by a society convinced that there is something vile about the sexual functions, and by extension, about sexual pleasure. It's just these assumptions that are challenged by the French tradition represented by Sade, Lautreamont, Bataille and the authors of *Story of O* and *The Image*. Their assumption seems to be that "the obscene" is a primal notion of human consciousness, something much more profound than the backwash of a sick society's aversion to the body. Human sexuality is, quite apart from Christian repressions, etc., a highly questionable phenomenon, and belongs, at least potentially, among the extreme rather than the ordinary experiences of humanity. Tamed as it may be, sexuality remains one of the demonic forces in human consciousness—pushing us at intervals close to taboo and dangerous desires, which range from the impulse to commit sudden arbitrary violence upon another person to the voluptuous yearning for the extinction of one's consciousness, for death itself. Even on the level of simple physical sensation and mood, making love surely resembles having an epileptic fit at least as much, if not more, than it does eating a meal or conversing with someone. Everyone has felt (at least in fantasy) the erotic glamor of physical cruelty and an erotic lure in things which are vile and repulsive. These phenomena are part of the genuine spectrum of sexuality, and if they are not to be written off as mere neurotic aberrations, the picture may look different from the one promoted by enlightened public opinion, and less simple.

It almost seems as if it's for good reason that most people's whole capacity for sexual ecstasy is inaccessible to them, given that each person's sexuality is something, like nuclear energy, that may prove amenable to domestication through scruple, but then again, it may not. That most people do not regularly, or perhaps ever, experience their sexual capacities at this unsettling pitch doesn't mean that the extreme isn't authentic, or that the possibility of it doesn't haunt them anyway. (Religion is probably, after sex, the second oldest resource which human beings have available to them for blowing their minds. Yet among the multitudes of the pious, the number who have ventured very far with that state of consciousness must be fairly small, too.) There is, demonstrably, something incorrectly designed and

potentially disorienting in the human sexual capacity—at least in the capacities of man-in-civilization. Man, the sick animal, bears within him an appetite which can drive him mad. And it's that understanding of sexuality as something beyond good and evil, beyond love, beyond sanity, sexuality as a resource for ordeal and for breaking through limits of consciousness, that informs the French books which I've been talking about.

The *Story of O*, with its project for completely transcending the idea of personality, rests on this dark and complex vision of sexuality—so far removed from the hopeful view sponsored by American Freudianism and liberal culture. The woman who is given no other name than "O" progresses simultaneously toward her own extinction as a human being and her fulfillment as a sexual being. It's hard to know how anyone would ascertain whether there is truly anything in "nature" or human consciousness that supports such a split. But, surely, the possibility has always haunted man, as accustomed as he is to decrying such a split.

O's project enacts, on another scale, no more than what's performed by the existence of pornographic literature itself. What pornographic literature does is precisely to drive a wedge between one's existence as a full human being and one's existence as a sexual being—while in ordinary life one hopes to prevent such a wedge from being driven. Normally we don't experience, at least don't want to experience, our sexual fulfillment as distinct from or opposed to our personal fulfillment. But perhaps in part they are distinct, whether we like it or not. Insofar as strong sexual feeling does involve an obsessive degree of attention, it surely does contain experiences in which one can feel one is losing one's "self." The literature that goes from Sade through Surrealism to these more recent books precisely capitalizes on that mystery, isolates that and makes the reader aware of it, invites him to participate in it.

This literature is both an invocation of the erotic in its darkest sense and, in certain cases, an exorcism. The devout, solemn mood of *Story of O* is fairly unrelieved; an example of a work of mixed moods on the same theme of a journey toward the estrangement of the self from the self is Bunuel's film *L'Age d'Or*. Perhaps it would be worth positing that pornography as a literary form works with both a pattern equivalent to tragedy (as in *Story of O*) in which the erotic subject-victim heads inexorably toward death and an equivalent to comedy (as in *The Image*) in which the obsessional pursuit of sexual exercise is rewarded by a terminal gratification, union with the uniquely desired sexual partner.

IV

Bataille is the writer who works with a darker sense of the erotic, its perils of fascination and humiliation, than probably anyone. His *Histoire de l'Oeil* (first published in 1921) and *Madame Edwarda* (1941),[2] qualify as pornographic books so far as their theme is sexual quest, an all-engrossing quest which annihilates every consideration of persons extraneous to their roles in the sexual dramaturgy, and the fulfillment of this quest is depicted graphically. But this conveys nothing of their extraordinary quality. For sheer explicitness about sexual organs and acts is in no sense necessarily obscene; it only becomes so when delivered in a particular tone, when it has acquired a certain moral resonance. As it happens, the sparse number of

[2]It's unfortunate that the only translation available in this country of what purports to be *Madame Edwarda*, that included in *The Olympia Reader*, pp. 662-673, published by Grove Press two years ago, gives just half the work. Only the *recit* is translated. But *Madame Edwarda* isn't a *recit* padded out with a preface also by Bataille. It is a two-part invention—essay and *recit*—and one part is almost unintelligible without the other.

sexual acts and quasi-sexual defilements related in Bataille's novellas can hardly compete, either in number of variety, with the interminable mechanistic inventiveness of the *120 Days of Sodom.* Yet what he describes seems somehow more potent and outrageous than the most lurid orgies that Sade could stage, because Bataille possessed a much finer and more profound sense of transgression.

One reason that *Histoire de l'Oeil* and *Madame Edwarda* make such an extreme and upsetting impression is that Bataille understood more clearly than anyone else that what pornography is really about, ultimately, isn't sex, but death. This is not to suggest that every pornographic work speaks, either overtly or covertly, of death. Only those works which deal with that specific and strongest inflection of the themes of lust, "the obscene," do. It's toward the gratifications of death, succeeding and surpassing those of eros, that every truly obscene quest tends. (An example of a pornographic work that isn't about the "obscene" is Louys's jolly saga of sexual insatiability, *Trois Filles et leur Mere. The Image* presents a less clear-cut case. While the enigmatic transactions between the three characters are charged with a sense of the obscene—more like a premonition, since the obscene is reduced to being only a constituent of voyeurism—the upshot is an unequivocally happy ending, with the narrator finally united with Claire. In *Story of O* there is another sort of problem. The book ends ambiguously, with several lines to the effect that two versions of a final suppressed chapter exist, in one of which O received Sir Stephen's permission to die when he was about to discard her. Although this double ending satisfyingly echoes the book's opening, in which two versions "of the same beginning" are given, it shouldn't, I think, shake the reader's sense that O is death-bound, whatever doubts the author expresses about her fate.)

Bataille's books, the chamber music of pornographic literature, are usually in *recit* form (sometimes accompanied by an essay). Their unifying theme is Bataille's own consciousness, a consciousness in an acute, unrelenting state of agony; but as an equally extraordinary mind in an earlier age might have written a theology of agony, Bataille has written an erotics of agony. Willing to tell something of the autobiographical sources of his narratives, he appended to *Histoire de l'Oeil* some memories of his own outrageously terrible childhood. (One memory: his blind, syphilitic, insane father trying unsuccessfully to urinate.) Time has neutralized these memories, he explains; after many years, they have largely lost their power over him and "can only come to life again, deformed, hardly recognizable, having in the course of this deformation, taken on an obscene meaning." Thus, for Bataille, "the obscene" simultaneously revives what is most painful and scores a victory over that pain. And of necessity, he must deal with the extremity of the erotic experience. Human beings, he says in the essay part of *Madame Edwarda,* live only through "excess." And pleasure depends on "perspective," or giving oneself to a state of "open being," open to death as well as to joy. Most people, Bataille notes, try to outwit their own feelings; they want to be receptive to pleasure but keep "horror" at a distance. That's foolish, he argues, since horror reinforces "attraction" and excites desire.

What the extremity of the erotic experience means for Bataille is its subterranean connection with death. It's not that Bataille litters his narratives with corpses. (For instance, only one person dies in the terrifying *Histoire de l'Oeil;* and the book ends with the three central characters, having debauched their way through France and Spain, acquiring a yacht at Gibraltar to pursue their infamies elsewhere.) What Bataille does is more effective. He invests each action with a weight, a disturbing gravity, that feels authentically "mortal."

Yet despite the obvious differences of scale and finesse of execution, there are some resemblances between the conceptions of Sade and Bataille. For instance, Sade, like Bataille, was not so much a sensualist as someone with an intellectual project: to explore the scope of transgression. And he shares with Bataille the same ultimate identification of sex and death. But Sade could never have written what Bataille did: "The truth of eroticism is tragic." People often die in Sade's books. But these deaths never seem real. They're no more convincing than those mutilations inflicted during the evening's orgies from which the victims recover completely the next morning following the use of a wondrous salve. One is continually caught up short by Sade's bad faith about death. (Of course, many pornographic books which are much less interesting and accomplished than those of Sade share this bad faith.)

Indeed, one might speculate that the fatiguing repetitiveness of Sade's books is the consequence of his imaginative failure to confront the inevitable goal or haven of a truly systematic venture of the pornographic imagination. Death is the only end to the odyssey of the pornographic imagination when it becomes systematic; that is, when it comes to be focused on the pleasures of transgression rather than mere pleasure itself. Since he could not or would not arrive at his ending, Sade stalled. He multiplied and thickened his narrative; tediously reduplicated orgiastic permutations and combinations. And he regularly interrupted a bout of rape or buggery to deliver to his victims his latest reworkings of lengthy sermons on what real "Enlightenment" means—the nasty truth about God, society, nature, the individual, virtue. Bataille manages to eschew anything resembling the counter-idealisms which are Sade's blasphemies (and thereby perpetuate the banished idealism lying behind those fantasies); his blasphemies are autonomous.

Sade's books, the Wagnerian music-dramas of pornographic literature, are neither subtle nor compact. Bataille achieves his effects with far more economical means: a chamber ensemble of noninterchangeable personages instead of Sade's operatic multiplication of sexual virtuosi and professional victims. Extreme compression is the artistic means which Bataille chooses to render his radical negatives. And it works. This is why Bataille's lean work and gnomic thought go farther than Sade's. Even in pornography, less can be more.

Bataille also has offered distinctly original and effective solutions to one of the perennial formal problems of pornographic narration: the ending. The most common procedure has been an end which lay no claim to any internal necessity. Hence, Adorno remarked that pornography has neither beginning, middle nor end. But it does. That the end is abrupt and, by conventional novel standards, unmotivated, is not necessarily objectionable. (The discovery, midway in a science-fiction novel, of an alien planet may be no less abrupt or unmotivated.) Abruptness, an endemic facticity of encounters and chronically renewing encounters, is not some unfortunate defect of the pornographic narration which one might wish removed in order for the books to qualify as literature. These features are constitutive of the very imagination or vision of the world which goes into pornography. They supply, in many cases, exactly the ending that's needed.

But this doesn't preclude other types of endings. One notable feature of *Histoire de l'Oeil* and, to a lesser extent, *The Image,* considered as works of art, is their attempt to find more systematic or rigorous kinds of endings. And to do this, still within the terms of the pornographic imagination; not seduced by the solutions of a more realistic or less abstract fiction.

What seems to be entailed is the construction of a narrative which is, from the beginning, more rigorously controlled; less spontaneous and lavishly descriptive.

In *The Image* the narrative is controlled by a single metaphor, "the image" (though the reader doesn't understand the full meaning of the title until he has reached the end of the novel). At first, the metaphor appears to have a clear single application. "Image" seems to be used in the sense of "flat" object or "two-dimensional surface" or "passive reflection"—all referring to the girl Anne whom Claire instructs the narrator to use freely for his own sexual purposes, making the girl into "a perfect slave." But exactly in the middle of the book ("Section V" in a short book of ten sections), an enigmatic scene is interposed which introduces another sense of "image." Claire, alone with the narrator, wants to show him a set of strangely unintelligible photographs of Anne in obscene situations; and these are described in such a way as to insinuate a mystery in what has been a brutally straightforward, if seemingly unmotivated, situation. From this caesura forward to the end of the book, the reader will have to carry simultaneously the awareness of the fictionally actual "obscene" situation being described and of some kind of oblique mirroring or reduplication of that situation. That burden (the two perspectives) will then be relieved in the final pages of the book, when, as the title of the last section has it, "Everything Resolves Itself." Anne is discovered to be not the erotic plaything of Claire donated gratuitously to the narrator, but Claire's "image" or "projection," sent out ahead to teach the narrator how to love *her*.

The structure of *Histoire de l'Oeil* is no less rigorous, and more ambitious in scope. It's interesting that both novels are in the first person; in both, the narrator is male, and one of a trio whose sexual interconnections constitute the story of the book. But the principles by which the two narratives are organized don't resemble each other at all. "Jean de Berg" describes how something came to be known that was not known by the narrator; all the pieces of action are clues, bits of evidence; and the ending is a surprise. Bataille is describing an action which is really intrapsychic: three people sharing (without conflict) a single fantasy, the acting out of a collective perverse will. The emphasis in *The Image* is on behavior, which is opaque, unintelligible. The emphasis in *Histoire de l'Oeil* is on fantasy first, and then on its correlation with some spontaneously "invented" act. The development of the book follows the phases of acting out. Bataille is charting the stages of the gratification of an erotic obsession, which haunts a number of commonplace objects or things. The principle of organization is thus a spatial one: a series of objects, arranged in a definite sequence, are tracked down, used or used up in some convulsive erotic act. The obscene playing with or defiling of these objects, and of people in their vicinity, is the action of the novella. When the last object (the eye) is used up in a transgression more daring than any preceding, the narrative ends. There can be no revelation or surprises in the story, no new "knowledge," only further intensifications of what is already known. These seemingly unrelated elements really are related; in fact, all versions of the same thing. The egg in the first chapter is simply the first version of the eyeball plucked from the Spaniard in the last.

Each specific erotic fantasy is also a generic fantasy, of performing what is "forbidden," which generates a surplus atmosphere of excruciating restless sexual intensity. At times the reader seems to be witness to a heartless debauched fulfillment; at other times, simply in attendance at the remorseless progress of the negative. Bataille's works, better than any others I know of, indicate the esthetic possibilities of pornography as an art form. *Histoire de l'Oeil* is, in my opinion, the

most perfect artistically of all the pornographic prose fictions I've read; *Madame Edwarda,* the most original and powerful intellectually.

To speak of the esthetic possibilities of pornography as an art form and as a form of thinking may seem insensitive or grandiose when one thinks of the acute misery of those afflicted in real life with a full-time specialized sexual obsession. Still, I would argue that pornography yields more than the truths of individual nightmare. Convulsive and repetitive as this form of the imagination may be, it does generate a vision of the world that can claim the interest (speculative, esthetic) of those who are not erotomanes. Indeed, this claim resides in precisely what are customarily dismissed as the *limits* of pornographic thinking.

V

The prominent characteristic of all products of the pornographic imagination is their energy and their absolutism.

The books generally called pornographic are books whose primary, exclusive and overriding preoccupation is with the depiction of sexual "intentions" and "activities." One could also say sexual "feelings," except that the word seems redundant. For most of the personages deployed by the pornographic imagination, their "feelings" at any given moment are either identical with their "behavior" or else a preparatory phase, that of "intention," just about to break into "behavior" unless physically thwarted. There is a small crude vocabulary of feeling, all relating to the prospects of action. One feels that one would like to act (lust). One feels that one would not like to act (shame, fear). There are no gratuitous or nonfunctioning feelings; no musings, whether speculative or imagistic, which are irrelevant to the business at hand. Thus, the pornographic imagination inhabits a universe that is, however repetitive the incidents which occur within it, incomparably economical. The strictest possible criterion of relevance applies: everything must somehow bear upon the erotic situation.

The universe proposed by the pornographic imagination is a total universe. It has the power to ingest and metamorphose and translate all concerns that are fed into it, reducing everything into the one negotiable currency of the erotic imperative. All action is conceived of as a set of sexual *exchanges.* Thus, the reason why pornography refuses to make fixed distinctions between the sexes or allow any kind of sexual preference or sexual taboo to endure can be explained "structurally." The bisexuality, the disregard for the incest taboo and other similar features common to pornographic narratives function to multiply the possibilities of exchange. Ideally, it should be possible for everyone to have a sexual connection with everyone else.

Of course the pornographic imagination is hardly the only form of the imagination that proposes a total universe. Another example is the type of imagination that has generated modern symbolic logic. In the total universe proposed by the logician's imagination, all statements can be broken down or chewed up to make it possible to rerender them in the form of the logical language; those parts of ordinary language that don't fit are simply lopped off. Certain of the well-known states of the religious imagination, to take another example, operate in the same cannibalistic way, engorging all materials made available to them for retranslation into phenomena saturated with the religious polarities (sacred and profane, etc.).

The latter example, for obvious reasons, touches closely to the present subject. Religious metaphors abound in a good deal of modern erotic literature (in Genet,

among others) and in some works of pornographic literature, too. *Story of O,* particularly, is filled with religious metaphors for the ordeal that O undergoes. O "wanted to believe." Her drastic condition of total personal servitude to those who use her sexually is repeatedly described as a mode of salvation. With anguish and anxiety, she surrenders herself; and "henceforth there were no more hiatuses, no dead time, no remission." While she has, to be sure, entirely lost her freedom, O has gained the right to participate in what is described as virtually a sacramental rite.

> *The word "open" and the expression "opening her legs" were, on her lover's lips, charged with such uneasiness and power that she could never hear them without experiencing a kind of internal prostration, a sacred submission, as though a god, and not he, had spoken to her.*

Though she fears the whip and other cruel mistreatments before they are inflicted on her, "yet when it was over she was happy to have gone through it, happier still if it had been especially cruel and prolonged." The whipping, branding and mutilating are described (from the point of view of *her* consciousness) as ritual ordeals which test the faith of someone being initiated into an ascetic spiritual discipline. The "perfect submissiveness" that her original lover, and then Sir Stephen, demand of her seems to echo the extinction of the self explicitly required of a Jesuit novice or Zen pupil. O is "that absent-minded person who has yielded up her will in order to be totally remade," to be made fit to serve a will far more powerful and authoritative than her own.

As might be expected, the straightforwardness of the religious metaphors in *Story of O* has evoked some correspondingly straight readings of the book. The novelist Mandiargues, whose preface precedes Paulhan's in the American translation just published, doesn't hesitate to describe *Story of O* as "a mystic work," and therefore "not, strictly speaking, an erotic book." What *Story of O* depicts "is a complete spiritual transformation, what others would call an *ascesis.*" But the matter is not so simple. He's right to dismiss an analysis of O's state of mind in psychiatric terms that would reduce the book's subject to, say, "masochism." As Paulhan says, "the heroine's ardor" is totally inexplicable in terms of the conventional psychiatric vocabulary. The fact that the novel employs some of the conventional motifs and trappings of the theater of sadomasochism has itself to be explained. But then, Mandiargues has fallen into an error which is no less reductive and only slightly less vulgar. Surely, the only alternative to the psychiatric reductions is not the religious vocabulary. But that only these two foreshortened alternatives exist can, perhaps, be explained as yet one more echo of the bone-deep denigration of the range and seriousness of sexual experience that still rules this culture, for all its much-advertised new permissiveness.

My own view is that "Pauline Reage" wrote an erotic book. The notion implicit in *Story of O* that eros is a sacrament is not the "truth" behind the literal (erotic) sense of the book—the lascivious rites of enslavement and degradation performed upon O—but, exactly, a metaphor for it. Why say something stronger, when the statement can't really *mean* anything stronger? But despite the virtual incomprehensibility to most educated people today of the substantive experience behind religious vocabulary, there is a continuing piety toward the grandeur of emotions that went into that vocabulary. The religious imagination survives for most people as not just the primary, but virtually the only credible instance of an imagination working in a total way.

Obscenity as an Aesthetic Category

No wonder, then, that the new or radically revamped forms of the total imagination which have arisen in the past century—notably, those of the artist, the erotomane and the madman—have chronically tended to borrow from the prestige of the religious vocabulary. And total experiences, of which there are many kinds, tend again and again to be apprehended only as revivals or translations of the religious imagination. To try to make a fresh way of talking at the most serious, ardent and enthusiastic level, heading off the religious encapsulation, is one of the primary intellectual tasks of future thought. As matters stand, with everything from *Story of O* to Mao reabsorbed into the incorrigible survival of the religious impulse, all thinking and feeling gets devalued. (Hegel made perhaps the grandest attempt to create a post-religious vocabulary, out of philosophy, that would command the treasures of passion and credibility and emotive appropriateness that were gathered into the religious vocabulary. But his most interesting followers steadily undermined the abstract metareligious language in which he had bequeathed his thought, and concentrated instead on the specific social and practical applications of his revolutionary form of process-thinking, historicism. Hegel's failure lies like a gigantic disturbing hulk across the intellectual landscape. And no one has been big enough, pompous enough or energetic enough since Hegel to attempt the task again.)

And so we remain, careening among our overvaried choices of kinds of total imagination, of species of total seriousness. Perhaps the deepest spiritual resonance of the career of pornography in its "modern" Western phase under consideration here (pornography in the Orient or the Moslem world being a very different set of phenomena) is this vast frustration of human passion and seriousness since the old religious imagination, and its secure monopoly on the total imagination, began in the late eighteenth century to crumble. The ludicrousness and lack of skill of most pornographic writing, films, etc., is well known to everyone who has been exposed to them. What is less often remarked about the typical products of the pornographic imagination is their pathos. Most pornography—the books discussed here cannot be excepted—points to something more general than even sexual damage. I mean the traumatic failure of modern capitalist society to provide authentic outlets for the perennial human flair for high-temperature visionary obsessions, to satisfy the appetite for exalted self-transcending modes of concentration and seriousness. The need of human beings to transcend "the personal" is no less profound than the need to be a person, an individual. But this society serves that need poorly. It provides mainly demonic vocabularies in which to situate that need and from which to initiate action and construct rites of behavior. One is offered a choice among vocabularies of thought and action which are not merely self-transcending but self-destructive.

VI

But the pornographic imagination is not just to be understood as a form of psychic absolutism—some of whose products we might be able to regard (in the role of connoisseurs, rather than clients) with more sympathy or intellectual curiosity or esthetic sophistication.

Several times before in this essay I have alluded to the possibility that the pornographic imagination says something, albeit in a degraded and often unrecognizable form, worth listening to. I've suggested that this spectacularly cramped form of the human imagination has, nevertheless, its peculiar access to some truth. And this truth—about sensibility, about sex, about individual personality, about

despair, about limits—can be shared when it projects itself into art. (Everyone, at least in dreams, has inhabited the world of the pornographic imagination for some hours or days or even longer periods of his life; but it's the full-time residents who make the fetishes, the trophies, the art.) That something one might call the poetry of transgression is also knowledge. He who transgresses not only breaks a rule. He goes somewhere that the others are not; and he knows something the others don't know.

Pornography, considered as an artistic or art-producing form of the human imagination, is an expression of what William James called "morbid-mindedness." But James was surely right when he gave as part of the definition of morbid-mindedness that it ranged over "a wider scale of experience" than healthy-mindedness.

What can be said, though, to the many sensible and sensitive people who find depressing the fact that a whole library of pornographic reading material has been made, within the last few years, so easily available in paperback form to the very young? Probably one thing: that their apprehension is justified, but may not be in scale. I am not addressing the usual complainers, those who feel that since sex, after all, *is* dirty, so are books reveling in sex (dirty in a way that a genocide screened nightly on TV, apparently, is not). There still remains a sizeable minority of people who object to or are repelled by pornography not because they think it's dirty, but because they know how pornography can be a crutch for the psychologically deformed and a brutalization of the morally innocent. I dislike pornography for those reasons, too, and feel uncomfortable about the consequences of its increasing availability. But isn't the worry somewhat misplaced? What's really at stake? A concern about the uses of knowledge itself. There's a sense in which *all* knowledge is dangerous, the reason being that not everyone is in the same condition as knowers or potential knowers. Perhaps most people don't need "a wider scale of experience." It may be that, without subtle and extensive psychic preparation, any widening of experience and consciousness is destructive for most people. Then we must ask what justifies the reckless unlimited confidence we have in the present mass availability of other kinds of knowledge, in our optimistic acquiescence in the transformation of and extension of human capacities by machines. Pornography is only one item among the many dangerous commodities being circulated in this society; unattractive as it may be, it's probably one of the less lethal, the less costly to the community in terms of human suffering. Except perhaps in a small circle of writer-intellectuals in France, pornography is an inglorious and mostly despised department of the imagination. Its mean status is the very antithesis of the considerable spiritual prestige enjoyed by many items which are far more noxious.

In the last analysis, the place we assign to pornography depends on the goals we set for our own consciousness, our own experience. But the goal A subscribes to for his consciousness may *not* be the one he's pleased to see B adopt, because he judges that B isn't qualified or experienced or subtle enough. And B may be dismayed and even indignant at A's adopting goals that he himself professes; when A holds them, they become presumptuous or shallow. Surely this chronic mutual suspicion of our neighbor's capacities—suggesting, in effect, a hierarchy of competence with respect to human consciousness—won't ever be settled to everyone's satisfaction. When the quality of people's consciousness varies so greatly, how could it ever be?

In an essay on the subject some years ago, Paul Goodman wrote: "The question is not *whether* pornography, but the quality of the pornography." That's exactly right. One could extend the thought a good deal further. The question is not *whether* consciousness or *whether* knowledge, but the quality of the consciousness

and of the knowledge. And that invites consideration of the quality or fineness of the human subject—the most problematic standard of all. It doesn't seem inaccurate to say most people in this society who aren't actively mad are, at best, reformed or potential lunatics. But is anyone supposed to act on this knowledge, even genuinely live with it? If so many are teetering on the verge of murder, dehumanization, sexual deformity and despair, and we were to act on that thought, then censorship much more radical than the indignant critics of pornography ever envisage seems in order. For if that's the case, not only pornography but all forms of serious art and knowledge—in other words, all forms of truth—are suspect and dangerous.

Night Words

George Steiner

George Steiner (1929–), a well-known literary scholar, was born in Paris. Steiner studied at the University of Paris, Chicago, Harvard, and Oxford. He is a naturalized American citizen but, after a meteoric career in the United States, he became Fellow of Churchill College, Cambridge, in 1961. Steiner's literary reach is large: he has published Tolstoy or Dostoevsky *(1959),* The Death of Tragedy *(1961),* Anno Domini *(1964), as well as many articles and translations. The following article, although written well before Susan Sontag wrote "The Pornographic Imagination," is a frontal attack on her position.*

Is there any science-fiction pornography? I mean something *new*, an invention by the human imagination of new sexual experience? Science-fiction alters at will the co-ordinates of space and time; it can set effect before cause; it works within a logic of total potentiality—"all that can be imagined can happen." But has it added a single item to the repertoire of the erotic? I understand that in a forthcoming novel the terrestrial hero and explorer indulges in mutual masturbation with a bizarre, interplanetary creature. But there is no real novelty in that. Presumably one can use anything from sea-weed to accordions, from meteorites to lunar pumice. A galactic monster would make no essential difference to the act. It would not extend in any real sense the range of our sexual being.

The point is crucial. Despite all the lyric or obsessed cant about the boundless varieties and dynamics of sex, the actual sum of possible gestures, consummations, and imaginings is drastically limited. There are probably more foods, more undiscovered eventualities of gastronomic enjoyment or revulsion than there have been sexual inventions since the Empress Theodora resolved "to satisfy all amorous orifices of the human body to the full and at the same time." There just aren't that many orifices. The mechanics of orgasm imply fairly rapid exhaustion and frequent intermission. The nervous system is so organised that responses to simultaneous stimuli at different points of the body tend to yield a single, somewhat blurred sensation. The notion (fundamental to Sade and much pornographic art) that one can double one's ecstasy by engaging in *coitus* while being at the same time deftly

sodomised is sheer nonsense. In short: given the physiological and nervous complexion of the human body, the number of ways in which orgasm can be achieved or arrested, the total modes of intercourse, are fundamentally finite. The mathematics of sex stop somewhere in the region of *soixante-neuf*; there are no transcendental series.

This is the logic behind the *120 Days*. With the pedantic frenzy of a man trying to carry *pi* to its final decimal, Sade laboured to imagine and present the sum-total of erotic combinations and variants. He pictured a small group of human bodies and tried to narrate every mode of sexual pleasure and pain to which they could be subject. The variables are surprisingly few. Once all possible positions of the body have been tried—the law of gravity does interfere—once the maximum number of erogenous zones of the maximum number of participants have been brought into contact, abrasive, frictional, or intrusive, there is not much left to do or imagine. One can whip or be whipped; one can eat excrement or quaff urine; mouth and private part can meet in this or that commerce. After which there is the grey of morning and the sour knowledge that things have remained fairly generally the same since man first met goat and woman.

This is the obvious, necessary reason for the inescapable monotony of pornographic writing, for the fact well known to all haunters of Charing Cross or pre-Gaullist book-stalls that dirty books are maddeningly the same. The trappings change. Once it was the Victorian nanny in high-button shoes birching the master, or the vicar peering over the edge of the boys' lavatory. The Spanish Civil War brought a plethora of raped nuns, of buttocks on bayonets. At present, specialised dealers report a steady demand for "WS" (stories of wife-swapping, usually in a suburban or honeymoon resort setting). But the fathomless tide of straight trash has never varied much. It operates within highly conventionalised formulas of low-grade sadism, excremental drollery, and banal fantasies of phallic prowess or feminine responsiveness. In its own way the stuff is as predictable as a Boy Scout manual.

Above the pulp-line—but the exact boundaries are impossible to draw—lies the world of erotica, of sexual writing with literary pretensions or genuine claims. This world is much larger than is commonly realised. It goes back to Egyptian literary papyri. At certain moments in western society, the amount of "high pornography" being produced may have equalled, if not surpassed, ordinary *belles-lettres*. I suspect that this was the case in Roman Alexandria, in France during the *Regence*, perhaps in London around the 1890s. Much of this subterranean literature is bound to disappear. But anyone who has been allowed access to the Kinsey library in Bloomington, and has been lucky enough to have Mr. John Gagnon as his guide, is made aware of the profoundly revealing, striking fact that there is hardly a major writer of the 19th or 20th centuries who has not, at some point in his career, be it in earnest or in the deeper earnest of jest, produced a pornographic work. Likewise there are remarkably few painters, from the 18th century to post-Impressionism, who have not produced at least one set of pornographic plates or sketches. (Would one of the definitions of abstract, non-objective art be that it cannot be pornographic?)

Obviously a certain proportion of this vast body of writing has literary power and significance. Where a Diderot, a Crebillon *fils*, a Verlaine, a Swinburne, or an Appolinaire write erotica, the result will have some of the qualities which distinguish their more public works. Figures such as Beardsley and Pierre Louys are

minor, but their lubricities have a period charm. Nevertheless, with very few exceptions, "high pornography" is *not* of preeminent literary importance. It is simply *not* true that the locked cabinets of great libraries or private collections contain masterpieces of poetry or fiction which hypocrisy and censorship banish from the light. (Certain 18th-century drawings and certain Japanese prints suggest that the case of graphic art may be different; here there seems to be work of the first quality which is not generally available.) What emerges when one reads some of the classics of erotica is the fact that they too are intensely conventionalised, that their repertoire of fantasy is limited, and that it merges, almost imperceptibly, into the dream-trash of straight, mass-produced pornography.

In other words: the line between, say, *Therese Philosophe* or *Lesbia Brandon* on the one hand, and *Sweet Lash* or *The Silken Thighs* on the other, is easily blurred. What distinguishes the "forbidden classic" from under-the-counter delights on Frith Street is, essentially, a matter of semantics, of the level of vocabulary and rhetorical device used to provoke erection. It is not fundamental. Take the masturbating housemaid in a very recent example of the Great American Novel, and the housemaid similarly engaged in *They Called Her Dolly* (n.d., price 6 shillings). From the point of view of erotic stimulus, the difference is one of language, or more exactly—as verbal precisions now appear in high literature as well—the difference is one of narrative sophistication. Neither piece of writing adds anything new to the potential of human emotion; both add to the waste.

Genuine additions are, in fact, very rare. The list of writers who have had the genius to enlarge our actual compass of sexual awareness, who have given the erotic play of the mind a novel focus, an area of recognition previously unknown or fallow, is very small. It would, I think, include Sappho, in whose verse the western ear caught, perhaps for the first time, the shrill, nerve-rending note of sterile sexuality, of a libido necessarily, deliberately, in excess of any assuagement. Catullus seems to have added something, though it is at this historical distance nearly impossible to identify that which startled in his vision, which caused so real a shock of consciousness. The close, delicately plotted concordance between orgasm and death in Baroque and Metaphysical poetry and art clearly enriched our legacy of excitement, as had the earlier focus on virginity. The development in Dostoevsky, Proust, and Mann of the correlations between nervous infirmity, the psychopathology of the organism, and a special erotic vulnerability, is probably new. Sade and Sacher-Masoch codified, found a dramatic syntax for, areas of arousal previously diffuse or less explicitly realised. In *Lolita* there is a genuine enrichment of our common stock of temptations. It is as if Vladimir Nabokov had brought into our field of vision what lay at the far edge (in Balzac's *La Rabouilleuse*, for instance) or what had been kept carefully implausible through disproportion (*Alice in Wonderland*). But such annexations of insight are rare.

The plain truth is that in literary erotica as well as in the great mass of "dirty books" the same stimuli, the same contortions and fantasies, occur over and over with unutterable monotony. In most erotic writing, as in man's wet dreams, the imagination turns, time and time again, inside the bounded circle of what the body can experience. The actions of the mind when we masturbate are not a dance; they are a treadmill.

Mr. Maurice Girodias[1] would riposte that this is not the issue, that the interminable succession of fornications, flagellations, onanisms, masochistic

[1]Maurice Girodias (editor), *The Olympia Reader* (Grove Press, New York, 1965).

fantasies, and homosexual punch-ups which fill his *Olympia Reader* are inseparable from its literary excellence, from the artistic originality and integrity of the books he published at the Olympia Press in Paris. He would say that several of the books he championed, and from which he has now selected representative passages, stand in the vanguard of modern sensibility, that they are classics of post-war literature. If they are so largely concerned with sexual experience, the reason is that the modern writer has recognised in sexuality the last open frontier, the terrain on which his talent must, if it is to be pertinent and honest, engage the stress of our culture. The pages of the *Reader* are strewn with four-letter words, with detailed accounts of intimate and specialised sexual acts, precisely because the writer has had to complete the campaign of liberation initiated by Freud, because he has had to overcome the verbal taboos, the hypocrisies of imagination in which former generations laboured when alluding to the most vital, complex part of man's being. "Writing dirty books was a necessary participation in the common fight against the Square World ... an act of duty."

Mr. Girodias has a case. His reminiscences and polemics make sour reading (he tends to whine); but his actual publishing record shows nerve and brilliance. The writings of Henry Miller matter to the history of American prose and self-definition. Samuel Beckett's *Watt* appeared with Olympia, as did writings of Jean Genet (though not the plays or the best prose). *Fanny Hill* and, to a lesser degree, *Candy,* are mock-epics of orgasm, books in which any sane man will take delight. Lawrence Durrell's *Black Book* seems to me grossly overrated, but it has its serious defenders. Girodias himself would probably regard *Naked Lunch* as his crowning discernment. I don't see it. The book strikes me as a strident bore, illiterate and self-satisfied right to its heart of pulp. Its repute is important only for what it tells us of the currents of homosexuality, camp, and modish brutality which dominate present "sophisticated" literacy. Burroughs indicts his readers, but not in the brave, prophetic sense argued by Girodias. Nevertheless, there can be no doubt of the genuineness of Girodias' commitment or of the risks he took.

Moreover, two novels on his list *are* classics, books whose genius he recognised and with which his own name will remain proudly linked: *Lolita* and *The Ginger Man.* It is a piece of bleak irony—beautifully appropriate to the entire "dirty book" industry—that a subsequent disagreement with Nabokov now prevents Girodias from including anything of *Lolita* in his anthology. To all who first met Humbert Humbert in *The Traveller's Companion Series*, a green cover and the Olympia Press' somewhat mannered typography will remain a part of one of the high moments of contemporary literature. This alone should have spared Mr. Girodias the legal and financial harryings by which Gaullist Victorianism hounded him out of business.

But the best of what Olympia published is now available on every drug-store counter—this being the very mark of Girodias' foresight. The *Olympia Reader* must be judged by what it actually contains. And far too much of it is tawdry stuff, "doing dirt on life," with only the faintest pretensions to literary merit or adult intelligence.

It is almost impossible to get through the book at all. Pick it up at various points and the sense of *deja-vu* is inescapable ("This is one stag-movie I've seen before"). Whether a naked woman gets tormented in Sade's dungeons (*Justine*), during Spartacus' revolt (Marcus Van Heller: *Roman Orgy*), in a kinky French *chateau* (*The Story of O...*) or in an Arab house (*Kama Houri* by one Ataullah Mordaan) makes damn little difference. *Fellatio* and buggery seem fairly repetitive joys whether

enacted between Paris hooligans in Genet's *Thief's Journal*, between small-time hustlers and exprizefighters *(The Gaudy Image)*, or between lordly youths by Edwardian gaslight in *Teleny*, a silly piece attributed to Oscar Wilde.

After fifty pages of "hardening nipples," "softly opening thighs" and "hot rivers" flowing in and out of the ecstatic anatomy, the spirit cries out, not in hypocritical outrage, not because I am a poor Square throttling my libido, but in pure, nauseous *boredom*. Even fornication can't be as dull, as hopelessly predictable as all that!

Of course there are moments which excite. *Sin for Breakfast* ends on a subtle, comic note of lewdness. *The Woman Thin* uses all the four-letter words and anatomical exactitudes with real force; it exhibits a fine ear for the way in which sexual heat compresses and erodes our uses of language. Those (and I imagine it includes most men) who use the motif of female onanism in their own fantasy life will find a vivid patch. There may be other nuggets. But who can get through the thing? For my money, there is one sublime moment in the *Reader*. It comes in an extract (possibly spurious?) from Frank Harris' *Life and Loves*. Coiling and uncoiling in diverse postures with two naked Oriental nymphets and their British procuress, Harris is suddenly struck with the revelation that "there indeed is evidence to prove the weakness of so much of the thought of Karl Marx. It is only the bohemian who can be free, not the proletarian." The image of Frank Harris, all limbs and propensities ecstatically engaged, suddenly disproving *Das Kapital* is worth the price of admission.

But not really. For that price is much higher than Mr. Girodias, Miss Mary McCarthy, Mr. Wayland Young, and other advocates of total frankness seem to realise. It is a price which cuts deep not only into the true liberty of the writer, but into the diminishing reserves of feeling and imaginative response in our society.

The preface to the *Olympia Reader* ends in triumph:

Moral censorship was an inheritance from the past, deriving from centuries of domination by the Christian clergy. Now that it is practically over, we may expect literature to be transformed by the advent of freedom. Not freedom in its negative aspects, but as the means of exploring all the positive aspects of the human mind, which are all more or less related to, or generated by, sex.

This last proposition is almost unbelievably silly. What needs a serious look is the assertion about freedom, about a new and transforming liberation of literature through the abolition of verbal and imaginative taboos.

Since the *Lady Chatterley* case and the defeat of a number of attempts to suppress books by Henry Miller, the sluice gates stand open. Sade, the homosexual elaborations of Genet and Burroughs, *Candy*, *Sexus*, *L'Histoire d'O*...are freely available. No censorship would choose to make itself ridiculous by challenging the sadistic eroticism, the minutiae of sodomy (smell and all) which grace Mailer's *American Dream*. This is an excellent thing. But let us be perfectly clear why. Censorship is stupid and repugnant for two empirical reasons: censors are men no better than ourselves, their judgments are no less fallible or open to dishonesty. Secondly, the thing won't work: those who really want to get hold of a book will do so somehow. This is an entirely different argument from saying that pornography doesn't in fact deprave the mind of the reader, or incite to wasteful or criminal gestures. *It may, or it may not.* We simply don't have enough evidence either way. The question is far more intricate than many of our literary champions of total

freedom would allow. But to say that censorship won't work and should not be asked to, is *not* to say that there has been a liberation of literature, that the writer is, in any genuine sense, freer.

On the contrary. The sensibility of the writer is free where it is most humane, where it seeks to apprehend and re-enact the marvellous variety, complication, and resilience of life by means of words as scrupulous, as personal, as brimful of the mystery of human communication, as the language can yield. The very opposite of freedom is *cliche,* and nothing is less free, more inert with convention and hollow brutality than a row of four-letter words. Literature is a living dialogue between writer and reader only if the writer shows a twofold respect: for the imaginative maturity of his reader, and in a very complex but central way, for the wholeness, for the independence and quickness of life, in the personages he creates.

Respect for the reader signifies that the poet or novelist invites the consciousness of the reader to collaborate with his own in the act of presentment. He does not tell all because his work is not a primer for children or the retarded. He does not exhaust the possible responses of his reader's own imaginings, but delights in the fact that we will fill in from our own lives, from resources of memory and desire proper to ourselves, the contours he has drawn. Tolstoy is infinitely freer, infinitely more exciting than the new eroticists, when he arrests his narrative at the door of the Karenins' bedroom, when he merely initiates, through the simile of a dying flame, of ash cooling in the grate, a perception of sexual defeat which each of us can re-live or detail for himself. George Eliot is free, and treats her readers as free, adult human beings, when she conveys, through inflection of style and mood, the truth about the Casaubon honeymoon in *Middlemarch*, when she makes us imagine for ourselves how Dorothea has been violated by some essential obtuseness. These are profoundly exciting scenes, these enrich and complicate our sexual awareness, far beyond the douche-bag idylls of the contemporary "free" novel. There is no real freedom whatever in the compulsive physiological exactitudes of present "high pornography," because there is no respect for the reader whose imaginative means are set at nil.

And there is none for the sanctity of autonomous life in the characters of the novel, for that tenacious integrity of existence which makes a Stendhal, a Tolstoy, a Henry James tread warily around their own creations. The novels being produced under the new code of total statement shout at their personages: strip, fornicate, perform this or that act of sexual perversion. So did the S.S. guards at rows of living men and women. The total attitudes are not, I think, entirely distinct. There may be deeper affinities than we as yet understand between the "total freedom" of the uncensored erotic imagination and the total freedom of the sadist. That these two freedoms have emerged in close historical proximity may not be coincidence. Both are exercised at the expense of someone else's humanity, of someone else's most precious right—the right to a private life of feeling.

This is the most dangerous aspect of all. Future historians may come to characterise the present era in the West as one of a massive onslaught on human privacy, on the delicate processes by which we seek to become our own singular selves, to hear the echo of our specific being. This onslaught is being pressed by the very conditions of an urban mass-technocracy, by the necessary uniformities of our

economic and political choices, by the new electronic media of communication and persuasion, by the ever-increasing exposure of our thoughts and actions to sociological, psychological, and material intrusions and controls. Increasingly, we come to know real privacy, real space in which to experiment with our sensibility, only in extreme guises: nervous breakdown, addiction, economic failure. Hence the appalling monotony and *publicity*—in the full sense of the word—of so many outwardly prosperous lives. Hence also the need for nervous stimuli of an unprecedented brutality and technical authority.

Sexual relations are, or should be, one of the citadels of privacy, the nightplace where we must be allowed to gather the splintered, harried elements of our consciousness to some kind of inviolate order and repose. It is in sexual experience that a human being alone, and two human beings in that attempt at total communication which is also communion, can discover the unique bent of their identity. There we can find for ourselves, through imperfect striving and repeated failure, the words, the gestures, the mental images which set the blood to racing. In that dark and wonder ever-renewed both the fumblings and the light must be our own.

The new pornographers subvert this last, vital privacy; they do our imagining for us. They take away the words that were of the night and shout them over the roof-tops, making them hollow. The images of our love-making, the stammerings we resort to in intimacy, come prepackaged. From the rituals of adolescent petting to the recent university experiment in which faculty wives agreed to practise onanism in front of the researchers' cameras, sexual life, particularly in America, is passing more and more into the public domain. This is a profoundly ugly and demeaning thing whose effects on our identity and resources of feeling we understand as little as we do the impact on our nerves of the perpetual "sub-eroticism" and sexual suggestion of modern advertisement. Natural selection tells of limbs and functions which atrophy through lack of use; the power to feel, to experience and realise the precarious uniqueness of each other's being, can also wither in a society. And it is no mere accident (as Orwell knew) that the standardisation of sexual life, either through controlled licence or compelled puritanism, should accompany totalitarian politics.

Thus the present danger to the freedom of literature and to the inward freedom of our society is not censorship or verbal reticence. The danger lies in the facile contempt which the erotic novelist exhibits for his readers, for his personages, and for the language. Our dreams are marketed wholesale.

Because there were words it did not use, situations it did not represent graphically, because it demanded from the reader not obeisance but live echo, much of western poetry and fiction has been a school to the imagination, an exercise in making one's awareness more exact, more humane. My true quarrel with the *Olympia Reader* and the *genre* it embodies is not that so much of the stuff should be boring and abjectly written. It is that these books leave a man less free, less himself, than they found him; that they leave language poorer, less endowed with a capacity for fresh discrimination and excitement. It is not a new freedom that they bring, but a new servitude. In the name of human privacy, enough!

Part IIIB Concerning Gamekeepers

A Propos of
Lady Chatterley's Lover

D. H. Lawrence

One of the most powerful novelists and short story writers of our time, a man who became the center of what was nearly a cult, D. H. Lawrence (1885- 1930) was the son of a coal miner and had a hard time making his way. He was concerned to show that society, especially nineteenth century English society, repressed the deep, instinctual forces in men and women that could bring happiness to them. Sexuality was a basic theme, and one of his novels, Lady Chatterley's Lover *(1928), was first banned and then allowed public sale, making Lawrence, along with James Joyce (whose* Ulysses, *ironically, Lawrence considered an unclean book), a pioneer in altering censorship rules.*

Lawrence wrote poems as well as fiction, and one play. He exhibited paintings which also brought trouble with the censor. His other best-known novels are Sons and Lovers *(1913),* The Rainbow *(1915), and* Women in Love *(1920), all generally regarded as much superior to the book for which he is most famous. Lawrence wrote the essay from which the following comments are excerpted as an extension of the Introduction to the authorized 1929 Paris edition of* Lady Chatterley's Lover.

... in spite of all antagonism, I put forth this novel as an honest, healthy book, necessary for us to-day. The words that shock so much at first don't shock at all after a while. Is this because the mind is depraved by habit? Not a bit. It is that the words merely shocked the eye, they never shocked the mind at all. People without minds may go on being shocked, but they don't matter. People with minds realize that they aren't shocked, and never really were: and they experience a sense of relief.

And that is the whole point. We are today, as human beings, evolved and cultured far beyond the taboos which are inherent in our culture. This is a very important fact to realize. Probably, to the Crusaders, mere words were potent and

From *Sex, Literature and Censorship,* Harry T. Moore, ed., (New York: Twayne Publishers, 1953), pp. 91- 120. Reprinted by permission of Twayne Publishers, Inc.

evocative to a degree we can't realize. The evocative power of the so-called obscene words must have been very dangerous to the dim-minded, obscure, violent natures of the Middle Ages, and perhaps are still too strong for slow-minded, half-evoked lower natures to-day. But real culture makes us give to a word only those mental and imaginative reactions which belong to the mind, and saves us from violent and indiscriminate physical reactions which may wreck social decency. In the past, man was too weak-minded, or crude-minded, to contemplate his own physical body and physical functions, without getting all messed up with physical reactions that overpowered him. It is no longer so. Culture and civilization have taught us to separate the reactions. We now know the act does not necessarily follow on the thought. In fact, thought and action, word and deed, are two separate forms of consciousness, two separate lives which we lead. We need, very sincerely, to keep a connection. But while we think, we do not act, and while we act we do not think. The great necessity is that we should act according to our thoughts, and think according to our acts. But while we are in thought we cannot really act, and while we are in action we cannot really think. The two conditions, of thought and action, are mutually exclusive. Yet they should be related in harmony.

And this is the real point of this book. I want men and women to be able to think sex, fully, completely, honestly and cleanly.

Even if we can't act sexually to our complete satisfaction, let us at least think sexually, complete and clear. All this talk of young girls and virginity, like a blank white sheet on which nothing is written, is pure nonsense. A young girl and a young boy is a tormented tangle, a seething confusion of sexual feelings and sexual thoughts which only the years will disentangle. Years of honest thoughts of sex, and years of struggling action in sex will bring us at last where we want to get, to our real and accomplished chastity, our completeness, when our sexual act and our sexual thought are in harmony, and the one does not interfere with the other.

Far be it from me to suggest that all women should go running after gamekeepers for lovers. Far be it from me to suggest that they should be running after anybody. A great many men and women to-day are happiest when they abstain and stay sexually apart, quite clean: and at the same time, when they understand and realize sex more fully. Ours is the day of realization rather than action. There has been so much action in the past, especially sexual action, a wearying repetition over and over, without a corresponding thought, a corresponding realization. Now our business is to realize sex. To-day the full conscious realization of sex is even more important than the act itself. After centuries of obfuscation, the mind demands to know and know fully. The body is a good deal in abeyance, really. When people act in sex, nowadays, they are half the time acting up. They do it because they think it is expected of them. Whereas as a matter of fact it is the mind which is interested, and the body has to be provoked. The reason being that our ancestors have so assiduously acted sex without ever thinking it or realizing it, that now the act tends to be mechanical, dull and disappointing, and only fresh mental realization will freshen up the experience.

The mind has to catch up, in sex: indeed, in all the physical acts. Mentally, we lag behind in our sexual thought, in a dimness, a lurking, grovelling fear which belongs to our raw, somewhat bestial ancestors. In this one respect, sexual and physical, we have left the mind unevolved. Now we have to catch up, and make a balance between the consciousness of the body's sensations and experiences, and these sensations and experiences themselves. Balance up the consciousness of the act, and the act itself. Get the two in harmony. It means having a proper reverence for sex, and a proper awe of the body's strange experience. It means being able to

use the so-called obscene words, because these are a natural part of the mind's consciousness of the body. Obscenity only comes in when the mind despises and fears the body, and the body hates and resists the mind.

When we read of the case of Colonel Barker, we see what is the matter. Colonel Barker was a woman who masqueraded as a man. The "Colonel" married a wife, and lived five years with her in "conjugal happiness." And the poor wife thought all the time she was married normally and happily to a real husband. The revelation at the end is beyond all thought cruel for the poor woman. The situation is monstrous. Yet there are thousands of women to-day who might be so deceived, and go on being deceived. Why? Because they know nothing, they can't think sexually at all; they are morons in this respect. It is better to give all girls this book, at the age of seventeen.

The same with the case of the venerable schoolmaster and clergyman, for years utterly "holy and good": and at the age of sixty-five, tried in the police courts for assaulting little girls. This happens at the moment when the Home Secretary, himself growing elderly, is most loudly demanding and enforcing a mealy-mouthed silence about sexual matters. Doesn't the experience of that other elderly, most righteous and "pure" gentleman, make him pause at all?

But so it is. The mind has an old grovelling fear of the body and the body's potencies. It is the mind we have to liberate, to civilize on these points. The mind's terror of the body has probably driven more men mad than ever could be counted. The insanity of a great mind like Swift's is at least partly traceable to this cause. In the poem to his mistress Celia, which has the maddened refrain "But—Celia, Celia, Celia s***s," (the word rhymes with spits), we see what can happen to a great mind when it falls into panic. A great wit like Swift could not see how ridiculous he made himself. Of course Celia s***s! Who doesn't? And how much worse if she didn't. It is hopeless. And then think of poor Celia, made to feel iniquitous about her proper natural function, by her "lover." It is monstrous. And it comes from having taboo words, and from not keeping the mind sufficiently developed in physical and sexual consciousness.

In contrast to the puritan hush! hush!, which produces the sexual moron, we have the modern young jazzy ["swinging"?] and high-brow person who has gone one better, and won't be hushed in any respect, and just "does as she likes." From fearing the body, and denying its existence, the advanced young go to the other extreme and treat it as a sort of toy to be played with, a slightly nasty toy, but still you can get some fun out of it, before it lets you down. These young people scoff at the importance of sex, take it like a cocktail, and flout their elders with it. These young ones are advanced and superior. They despise a book like *Lady Chatterley's Lover*. It is much too simple and ordinary for them. The naughty words they care nothing about, and the attitude to love they find old-fashioned. Why make a fuss about it. Take it like a cocktail! The book, they say, shows the mentality of a boy of fourteen. But perhaps the mentality of a boy of fourteen, who still has a little natural awe and proper fear in fact of sex, is more wholesome than the mentality of the young cocktaily person who has no respect for anything and whose mind has nothing to do but play with the toys of life, sex being one of the chief toys, and who loses his mind in the process. Heliogabalus, indeed!

So, between the stale grey puritan who is likely to fall into sexual indecency in advanced age, and the smart jazzy person of the young world, who says: "We can do anything. If we can think a thing we can do it," and then the low uncultured person with a dirty mind, who looks for dirt—this book has hardly a space to turn in. But to them all I say the same: Keep your perversions if you like them—your

perversion of puritanism, your perversion of smart licentiousness, your perversion of a dirty mind. But I stick to my book and my position: Life is only bearable when the mind and the body are in harmony, and there is a natural balance between them, and each has a natural respect for the other.

And it is obvious, there is no balance and no harmony now. The body is at the best the tool of the mind, at the worst, the toy. The business man keeps himself "fit," that is, keeps his body in good working order, for the sake of his business, and the usual young person who spends much time on keeping fit does so as a rule out of self-conscious self-absorption, narcissism. The mind has a stereotyped set of ideas and "feelings," and the body is made to act up, like a trained dog: to beg for sugar, whether it wants sugar or whether it doesn't, to shake hands when it would dearly like to snap the hand it has to shake. The body of men and women to-day is just a trained dog. And of no one is this more true than of the free and emancipated young. Above all, their bodies are the bodies of trained dogs. And because the dog is trained to do things the old-fashioned dog never did, they call themselves free, full of real life, the real thing.

But they know perfectly well it is false. Just as the business man knows, somewhere, that he's all wrong. Men and women aren't really dogs: they only look like it and behave like it. Somewhere inside there is a great chagrin and a gnawing discontent. The body is, in its spontaneous natural self, dead or paralyzed. It has only the secondary life of a circus dog, acting up and showing off: and then collapsing.

What life could it have, of itself? The body's life is the life of sensations and emotions. The body feels real hunger, real thirst, real joy in the sun or the snow, real pleasure in the smell of roses or the look of a lilac bush; real anger, real sorrow, real love, real tenderness, real warmth, real passion, real hate, real grief. All the emotions belong to the body, and are only recognised by the mind. We may hear the most sorrowful piece of news, and only feel a mental excitement. Then, hours after, perhaps in sleep, the awareness may reach the bodily centres, and true grief wrings the heart.

How different they are, mental feelings and real feelings. To-day, many people live and die without having had any real feelings—though they have had a "rich emotional life" apparently, having showed strong mental feeling. But it is all counterfeit. In magic, one of the so-called "occult" pictures represents a man standing, apparently, before a flat table mirror, which reflects him from the waist to the head, so that you have the man from head to waist, then his reflection downwards from waist to head again. And whatever it may mean in magic, it means what we are to-day, creatures whose active emotional self has no real existence, but is all reflected downwards from the mind. Our education from the start has *taught* us a certain range of emotions, what to feel and what not to feel, and how to feel the feelings we allow ourselves to feel. All the rest is just non-existent. The vulgar criticism of any new good book is: Of course nobody ever felt like that!—People allow themselves to feel a certain number of finished feelings. So it was in the last century. This feeling only what you allow yourselves to feel at last kills all capacity for feeling, and in the higher emotional range you feel nothing at all. This has come to pass in our present century. The higher emotions are strictly dead. They have to be faked.

And by the higher emotions we mean love in all its manifestations, from genuine desire to tender love, love of our fellow-men, and love of God: we mean love, joy, delight, hope, true indignant anger, passionate sense of justice and injustice, truth and untruth, honour and dishonour, and real belief in *anything*: for belief is a

profound emotion that has the mind's connivance. All these things, to-day, are more or less dead. We have in their place the loud and sentimental counterfeit of all such emotion.

Never was an age more sentimental, more devoid of real feeling, more exaggerated in false feeling, than our own. Sentimentality and counterfeit feeling have become a sort of game, everybody trying to outdo his neighbour. The radio and the film are mere counterfeit emotion all the time, the current press and literature the same. People wallow in emotion: counterfeit emotion. They lap it up: they live in it and on it. They ooze with it.

The trouble with counterfeit emotion is that nobody is really happy, nobody is really contented, nobody has any peace. Everybody keeps on rushing to get away from the counterfeit emotion which is in themselves worst of all. They rush from the false feelings of Peter to the false feelings of Adrian, from the counterfeit emotions of Margaret to those of Virginia, from film to radio, from Eastbourne to Brighton, and the more it changes the more it is the same thing.

Above all things love is a counterfeit feeling to-day. Here, above all things, the young will tell you, is the greatest swindle. That is, if you take it seriously. Love is all right if you take it lightly, as an amusement. But if you begin taking it seriously you are let down with a crash.

There are, the young women say, no *real* men to love. And there are, the young men say, no *real* girls to fall in love with. So they go on falling in love with unreal ones, on either side; which means, if you can't have real feelings, you've got to have counterfeit ones: since some feelings you've *got* to have: like falling in love. There are still some young people who would *like* to have real feelings, and they are bewildered to death to know why they can't. Especially in love.

But especially in love, only counterfeit emotions exist nowadays. We have all been taught to mistrust everybody emotionally, from parents downwards, or upwards. Don't trust *anybody* with your real emotions: if you've got any: that is the slogan of to-day. Trust them with your money, even, but *never* with your feelings. They are bound to trample on them....

And with counterfeit emotions there is no real sex at all. Sex is the one thing you cannot really swindle; and it is the centre of the worst swindling of all, emotional swindling. Once come down to sex, and the emotional swindle must collapse. But in all the approaches to sex, the emotional swindle intensifies more and more. Till you get there. Then collapse.

Sex lashes out against counterfeit emotion, and is ruthless, devastating against false love. The peculiar hatred of people who have not loved one another, but who have pretended to, even perhaps have imagined they really did love, is one of the phenomena of our time. The phenomenon, of course, belongs to all time. But to-day it is almost universal. People who thought they loved one another dearly, dearly, and went on for years, ideal: lo! suddenly the most profound and vivid hatred appears. If it doesn't come out fairly young, it saves itself till the happy couple are nearing fifty, the time of the great sexual change—and then— cataclysm!...

The element of counterfeit in love at last maddens, or else kills, sex, the deepest sex in the individual. But perhaps it would be safe to say that it *always* enrages the inner sex, even if at last it kills it. There is always the period of rage. And the strange thing is, the worst offenders in the counterfeit-love game fall into the greatest rage. Those whose love has been a bit sincere are always gentler, even though they have been most swindled.

Now the real tragedy is here: that we are none of us all of a piece, none of us *all* counterfeit, or *all* true love. And in many a marriage, in among the counterfeit

there flickers a little flame of the true thing, on both sides. The tragedy is, that in an age peculiarly conscious of counterfeit, peculiarly suspicious of substitute and swindle in emotion, particularly sexual emotion, the rage and mistrust against the counterfeit element is likely to overwhelm and extinguish the small, true flame of real loving communion, which might have made two lives happy. Herein lies the danger of harping only on the counterfeit and the swindle of emotion, as most "advanced" writers do. Though they do it, of course, to counterbalance the hugely greater swindle of the sentimental "sweet" writers....

And the other, the warm blood-sex that establishes the living and re-vitalising connection between man and woman, how are we to get that back? I don't know. Yet get it back we must: or the younger ones must, or we are all lost. For the bridge to the future is the phallus, and there's the end of it. But not the poor, nervous counterfeit phallus of modern "nervous" love. Not that.

For the new impulse to life will never come without blood-contact; the true, positive blood-contact, not the nervous negative reaction. And the essential blood-contact is between man and woman, always has been so, always will be. The contact of positive sex. The homosexual contacts are secondary, even if not merely substitutes of exasperated reaction from the utterly unsatisfactory nervous sex between men and women....

All this is post-script, or afterthought, to my novel, *Lady Chatterley's Lover*. Man has little needs and deeper needs. We have fallen into the mistake of living from our little needs till we have almost lost our deeper needs in a sort of madness. There is a little morality, which concerns persons and the little needs of man: and this, alas, is the morality we live by. But there is a deeper morality, which concerns all womanhood, all manhood, and nations, and races, and classes of men. This greater morality affects the destiny of mankind over long stretches of time, applies to man's greater needs, and is often in conflict with the little morality of the little needs....

Now we have to re-establish the great relationships which the grand idealists, with their underlying pessimism, their belief that life is nothing but futile conflict, to be avoided even unto death, destroyed for us. Buddha, Plato, Jesus, they were all three utter pessimists as regards life, teaching that the only happiness lay in abstracting oneself from life, the daily, yearly, seasonal life of birth and death and fruition, and in living in the "immutable" or eternal spirit. But now, after almost three thousand years, now that we are almost abstracted entirely from the rhythmic life of the seasons, birth and death and fruition, now we realise that such abstraction is neither bliss nor liberation, but nullity. It brings null inertia. And the great saviours and teachers only cut us off from life. It was the tragic *excursus*.

The universe is dead for us, and how is it to come to life again? "Knowledge" has killed the sun, making it a ball of gas, with spots; "knowledge" has killed the moon, it is a dead little earth fretted with extinct craters as with smallpox; the machine has killed the earth for us, making it a surface, more or less bumpy, that you travel over. How, out of all this, are we to get back the grand orbs of the soul's heavens, that fill us with unspeakable joy? How are we to get back Apollo, and Attis, Demeter, Persephone, and the halls of Dis? How even see the star Hesperus, or Betelgeuse?

We've got to get them back, for they are the world our soul, our greater consciousness, lives in. The world of reason and science, the moon, a dead lump of earth, the sun, so much gas with spots: this is the dry and sterile little world the abstracted mind inhabits. The world of our little consciousness, which we know in our pettifogging *apartness*. This is how we know the world when we know it apart from ourselves, in the mean separateness of everything. When we know the world in

togetherness with ourselves, we know the earth hyacinthine or Plutonic, we know the moon gives us our body as delight upon us, or steals it away, we know the purring of the great gold lion of the sun, who licks us like a lioness her cubs, making us bold, or else, like the red, angry lion, dashes at us with open claws. There are many ways of knowing, there are many sorts of knowledge. But the two ways of knowing, for man, are knowing in terms of apartness, which is mental, rational, scientific, and knowing in terms of togetherness, which is religious and poetic. The Christian religion lost, in Protestantism finally, the togetherness with the universe, the togetherness of the body, the sex, the emotions, the passions, with the earth and sun and stars.

But relationship is threefold. First, there is the relation to the living universe. Then comes the relation of man to woman. Then comes the relation of man to man. And each is a blood-relationship, not mere spirit or mind. We have abstracted the universe into Matter and Force, we have abstracted men and women into separate personalities—personalities being isolated units, incapable of togetherness—so that all three great relationships are bodiless, dead.... This is the ugly fact which underlies our civilisation....

When the great crusade against sex and the body started in full blast with Plato, it was a crusade for "ideals," and for this "spiritual" knowledge in apartness. Sex is the great unifier. In its big, slower vibration it is the warmth of heart which makes people happy together, in togetherness. The idealist philosophies and religions set out deliberately to kill this. And they did it.... While "kindness" is the glib order of the day—everybody *must* be "kind"—underneath this "kindness" we find a coldness of heart, a lack of heart, a callousness, that is very dreary. Every man *is* a menace to every other man.

Men only know one another in menace. Individualism has triumphed. If I am a sheer individual, then every other being, every other man especially, is over against me as a menace to me. This is the peculiarity of our society to-day. We are all extremely sweet and "nice" to one another, because we merely fear one another.

The sense of isolation, followed by the sense of menace and of fear, is bound to arise as the feeling of oneness and community with our fellow-men declines, and the feeling of individualism and personality, which is existence in isolation, increases. The so-called "cultured" classes are the first to develop "personality" and individualism, and the first to fall into this state of unconscious menace and fear. The working-classes retain the old blood-warmth of oneness and togetherness some decades longer. Then they lose it too. And then class-consciousness becomes rampant, and class-hate. Class-hate and class-consciousness are only a sign that the old togetherness, the old blood-warmth has collapsed, and every man is really aware of himself in apartness. Then we have these hostile groupings of men for the sake of opposition, strife. Civil strife becomes a necessary condition of self-assertion.

This, again, is the tragedy of social life to-day. In the old England, the curious blood-connection held the classes together. The squires might be arrogant, violent, bullying and unjust, yet in some ways they were *at one* with the people, part of the same blood-stream. We feel it in Defoe or Fielding. And then, in the mean Jane Austen, it is gone. Already this old maid typifies "personality" instead of character, the sharp knowing in apartness instead of knowing in togetherness, and she is, to my feeling, thoroughly unpleasant, English in the bad, mean, snobbish sense of the word, just as Fielding is English in the good, generous sense.

So, in *Lady Chatterley's Lover* we have a man, Sir Clifford, who is purely a personality, having lost entirely all connection with his fellow-men and women, except those of usage. All warmth is gone entirely, the hearth is cold, the heart does

not humanly exist. He is a pure product of our civilisation, but he is the death of the great humanity of the world. He is kind by rule, but he does not know what warm sympathy means. He is what he is. And he loses the woman of his choice.

The other man still has the warmth of a man, but he is being hunted down, destroyed. Even it is a question if the woman who turns to him will really stand by him and his vital meaning.

I have been asked many times if I intentionally made Clifford paralysed, if it is symbolic. And literary friends say, it would have been better to have left him whole and potent, and to have made the woman leave him nevertheless.

As to whether the "symbolism" is intentional—I don't know. Certainly not in the beginning, when Clifford was created. When I created Clifford and Connie, I had no idea what they were or why they were. They just came, pretty much as they are. But the novel was written, from start to finish, three times. And when I read the first version, I recognised that the lameness of Clifford was symbolic of the paralysis, the deeper emotional or passional paralysis, of most men of his sort and class to-day. I realised that it was perhaps taking an unfair advantage of Connie, to paralyse him technically. It made it so much more vulgar of her to leave him. Yet the story came as it did, by itself, so I left it alone. Whether we call it symbolism or not, it is, in the sense of its happening, inevitable.

And these notes, which I write now almost two years after the novel was finished, are not intended to explain or expound anything: only to give the emotional beliefs which perhaps are necessary as a background to the book. It is so obviously a book written in defiance of convention that perhaps some reason should be offered for the attitude of defiance: since the silly desire to *épater le bourgeois,* to bewilder the commonplace person, is not worth entertaining. If I use the taboo words, there is a reason. We shall never free the phallic reality from the "uplift" taint till we give it its own phallic language, and use the obscene words. The greatest blasphemy of all against the phallic reality is this "lifting it to a higher plane...."

A Wreath for the Gamekeeper

Katherine Anne Porter

Katherine Anne Porter (1894-) is a distinguished American writer, especially of short stories. Miss Porter completed one novel, Ship of Fools *(1962), of which a film was made. Her volumes of short stories include* Flowering Judas *(1930),* Pale Horse, Pale Rider *(1939), and* The Leaning Tower *(1944). The elegance and precision of her prose style are noted, and she became a mentor and model for many younger writers. Edmund Wilson has commented that "Miss Porter writes English of a purity and precision almost unique in contemporary American fiction." Her opinions are strong and clear and in "A Wreath for the Gamekeeper," reprinted in a recently published volume,* The Collected Essays and Occasional Writings of Katherine Anne Porter *(1970), she made some of them known.*

From *Encounter* (February 1960), pp. 69–77. Copyright © 1960 by Katherine Anne Porter. Reprinted by permission of Cyrilly Abels, Literary Agent.

The dubious Crusade is over, anybody can buy the book now in hardback or papercover, expurgated or unexpurgated, in drugstores and railway stations as well as in the bookshops, and 'twas a famous victory for something or other, let's wait and see. Let us remark as we enter the next phase that we may hope this episode in the history of our system of literary censorship will mark the end of one of our most curious native customs—calling upon the police and the post office officials to act as literary critics in addition to all their other heavy duties. It is not right nor humane and I hope this is the end of it; it is enough to drive good men out of those services altogether.

When I first read *Lady Chatterley's Lover,* thirty years ago, I thought it a dreary, sad performance with some passages of unintentional hilarious low comedy, one scene at least simply beyond belief in a book written with such inflamed apostolic solemnity, which I shall return to later; and I wondered then at all the huzza and hullabaloo about suppressing it. I realise now there were at least two reasons for it—first, Lawrence himself, who possessed to the last degree the quality of high visibility; and second, the rise to power of a demagoguery of political and social censorship by unparalleled ignoramuses in all things, including the arts, which they regarded as the expression of peculiarly dangerous forms of immorality. These people founded organisations for the suppression of Vice, and to them nearly everything *was* Vice, and other societies for the promotion of Virtue, some of them very dubious, and their enthusiasms took some weird and dangerous directions. Prohibition was their major triumph, with its main result of helping organised crime to become big business; but the arts, and especially literature, became the object of a morbid purblind interest to those strange beings who knew nothing about any art, but knew well what they feared and hated.

It is time to take another look at this question of censorship and protest which has been debated intermittently ever since I can remember. Being a child of my time, naturally I was to be found protesting: I was all for freedom of speech, of action, of belief, of choice, in every department of human life; and for authors all this was to be comprehended in the single perfect right to express their thoughts without reserve, write anything they chose, with publishers to publish and booksellers to sell it, and the vast public gloriously at liberty to buy and read it by the tens of thousands.

It was a noble experiment, no doubt, an attempt to bring a root idea of liberty to flower; but in practice it soon showed serious defects and abuses, for the same reason that prohibition of alcohol could not be made to work: gangsters and crooks took over the business of supplying the human demand for intoxication and obscenity, which hitherto had been in the hands of respectable elements, who regulated it and kept it more or less in its place; but it still is a market that never fails no matter who runs it. (I have often wondered what were the feelings of the old-line pious prohibitionists when they discovered that their most powerful allies in the fight to maintain prohibition were the bootleggers.)

Publishers were certainly as quick to take advantage of the golden moment as the gangsters, and it did not take many of them very long to discover that the one best way to sell a book with "daring" passages was to get it banned in Boston, or excluded from the United States mails. Certain authors, not far behind the publishers, discovered that if they could write books the publisher could advertise as in peril from the censor, all the better. Sure enough, the censor would rise to the bait, crack down in a way that would be front-page news, the alarm would go out to all fellow writers and assorted lovers of liberty that one of the guild was being abused in his basic human rights guaranteed by our Constitution, by those hyenas

in Boston or the Post Office. The wave of publicity was on, and the sales went up. Like too many such precariously balanced schemes, it was wonderful while it lasted, but it carried the seeds of its own decay. Yet those were the days when people really turned out and paraded with flags and placards, provocative songs and slogans, openly inviting arrest and quite often succeeding in being hauled off to the police station in triumph, there to sit in a cell perfectly certain that somebody was going to show up and bail them out before night.

Writers—I was often one of them—did not always confine their aid to freedom of the word, though that was their main concern. They would sometimes find themselves in the oddest company, defending strange causes and weirdly biased viewpoints on the grounds that they most badly wanted defence. But we also championed recklessly the most awful wormy little books we none of us would have given shelf room, and more than once it came over us in mid-parade that this was no downtrodden citizen being deprived of his rights, but a low cynic cashing in on our high-minded application of democratic principles. I suppose for a good many of us, all this must just be chalked up to Experience. After some time, I found myself asking, "Why should I defend a worthless book just because it has a few dirty words in it? Let it disappear of itself and the sooner the better."

No one comes to that state of mind quickly, and it is dangerous ground to come to at all, I suppose, but one comes at last. My change of view began with the first publication in 1928 of *Lady Chatterley's Lover*. He has become, this lover of Lady Chatterley's, as sinister in his effect on the minds of critics as that of Quint himself on the children and the governess in *The Turn of the Screw*. I do not know quite what role Lady Chatterley should play to Quint-Mellors. She is not wicked, as Miss Jessel is, she is merely a moral imbecile. She is not intense, imaginative, and dazzled like the governess, she is stupid; and it is useless to go on with the comparison, for she is not the centre of the critics' attention as the Gamekeeper is, she has not that baneful fascination for them that he has. But there is one quality both books have in common and they both succeed in casting the same spell on plain reader and critic alike: the air of evil which shrouds them both, the sense of a situation of foregone and destined failure, to which there can be no outcome except despair. Only, the Lawrence book is sadder, because Lawrence was a badly flawed, lesser artist than James. He did not really know what he was doing, or if he did, pretended to be doing something else; and his blood-chilling anatomy of the activities of the rutting season between two rather dull persons comes with all the more force because the relations are precisely not between the vengeful seeking dead and living beings, but between the living themselves who seem to me deader than any ghost.

Yet for the past several months there has been a steady flood of extremely well-managed publicity in defence of Lawrence's motives and the purity of his novel, into which not only critics, but newspaper and magazine reporters, editorial writers, ministers of various religious beliefs, women's clubs, the police, postal authorities, and educators have been drawn, clamorously. I do not object to censorship being so loudly defeated again for the present. I merely do not approve of the way it was done. Though there were at this time no parades, I believe, we have seen such unanimity and solidarity of opinion among American critics, and many of them of our first order, as I do not remember to have seen before. What are we to think of them, falling in like this with this fraudulent crusade of raising an old tired Cause out of its tomb? For this is no longer just a book, and it never was a work of literature worth all this attention. It is no longer a Cause, if it ever was, but

a publicity device and a well-worn one by now, calculated to rouse a salacious itch of curiosity in the prospective customer. This is such standard procedure by now it seems unnecessary to mention it. Yet these hard-headed, experienced literary men were trapped into it once more, and lent a strong hand to it. There is something touching, if misguided, in this fine-spirited show of manly solidarity, this full-throated chorus in defence of Lawrence's vocabulary and the nobility of his intentions. I have never questioned either, I wish only to say that I think from start to finish he was about as wrong as can be on the whole subject of sex, and that he wrote a very laboriously bad book to prove it. The critics who have been carried away by a generous desire to promote freedom of speech, and give a black eye to prudes and nannies overlook sometimes—and in a work of literature this should not be overlooked, at least not by men whose profession it is to criticise literature—that purity, nobility of intention, and apostolic fervour are good in themselves at times, but at others they depend on context, and in this instance they are simply not enough. Whoever says they are, and tries to persuade the public to accept a book for what it is not, a work of good art, is making a grave mistake, if he means to go on writing criticism.

As for the original uproar, Lawrence began it himself, as he nearly always did, loudly and bitterly on the defensive, throwing out each book in turn as if he were an early Christian throwing himself to the lions. "Anybody who calls my novel a dirty, sexual novel is a liar." Further: "It'll infuriate *mean* people; but it will surely soothe decent ones." The *Readers' Subscription* (an American book-club) in its brochure offering the book, carries on the tone boldly: "Now, at long last, a courageous American publisher is making available the unexpurgated version of *Lady Chatterley's Lover*—exactly as the author meant it to be seen by the intelligent, sensitive reader." No, this kind of left-handed flattery won't quite do: it is the obverse of the form of blackmail used by publishers and critics to choke their ambiguous wares down our throats. They say in effect, "If you disapprove of this book, you are proved to be (1) illiterate, (2) insensitive, (3) unintelligent, (4) low-minded, (5) 'mean,' (6) a hypocrite, (7) a prude, and other unattractive things." I happen to have known quite a number of decent persons, not too unintelligent or insensitive, with some love and understanding of the arts, who were revolted by the book; and I do not propose to sit down under this kind of bullying.

Archibald MacLeish regards it as "pure" and a work of high literary merit. He has a few reservations as to the whole with which I heartily agree so far as they go; yet even Mr. MacLeish begins trailing his coat, daring us at our own risk to deny that the book is "one of the most important works of the century, or to express an opinion about the literature of our own time or about the spiritual history that literature expresses without making his peace in one way or another with D. H. Lawrence and with this work."

Without in the least making my peace with D. H. Lawrence or with this work, I wish to say why I disagree profoundly with the above judgments, and also with the following:

Harvey Breit: "The language and the incidents or scenes in question are deeply moving and very beautiful—Lawrence was concerned how love, how a relationship between a man and a woman can be most touching and beautiful, but only if it is uninhibited and total." This is wildly romantic and does credit to Mr. Breit's feelings, but there can be no such thing as a total relationship between two human beings—to begin with, what *is* total in such a changing, uncertain, limited state? and if there could be, just how would the persons involved know when they had reached it? Judging from certain things he wrote and said on this subject, I think

Lawrence would have been the first to protest at even an attempt to create such a condition. He demanded the right to invade anybody, but he was noticeably queasy when anyone took a similar liberty with him.

Edmund Wilson: "The most inspiriting book I have seen in a long time ... one of his best-written ... one of his most vigorous and brilliant...."

This reminds me that I helped parade with banners in California in defence of Mr. Wilson's *Memoirs of Hecate County*—a misguided act of guild loyalty and personal admiration I cannot really regret, so far as friendship is concerned. But otherwise the whole episode was deplorably unnecessary. My preference has not changed for his magnificent *To the Finland Station* and for almost any of his criticisms and essays on literary and public affairs.

Jacques Barzun: "I have no hesitation in saying that I do not consider Lawrence's novel pornographic." I agree with this admirably prudent statement, and again when Mr. Barzun notes Lawrence's ruling passion for reforming everything and everybody in sight. My quarrel with the book is that it really is not pornographic—the great, wild, free-wheeling Spirit of Pornography has here been hitched to a rumbling little domestic cart and trundled off to chapel, its ears pinned back and its mouth washed out with soap.

Mr. Schorer, who contributes the preface, even brings in Yeats to defend this tiresome book. Yeats, bless his memory, when he talked bawdy, knew what he was saying and why. He enjoyed the flavour of gamey words on his tongue, and never deceived himself for one moment as to the nature of that enjoyment; he never got really interestingly dirty until age had somewhat cooled the ardours of his flesh, thus doubling his pleasure in the thoughts of it in the most profane sense. Mr. Schorer reprints part of a letter from Yeats, written years ago, to Mrs. Shakespear: "These two lovers, the gamekeeper and his employer's wife, each separated from their class by their love and fate are poignant in their loneliness; the coarse language of the one accepted by both becomes a forlorn poetry, uniting their solitudes, something ancient, humble and terrible."

This comes as a breath of fresh air upon a fetid topic. Yeats reaches acutely into the muddlement and brings up the simple facts: the real disaster for the lady and the gamekeeper is that they face perpetual exile from their own proper backgrounds and society. Stale, pointless, unhappy as both their lives were before, due to their own deficiencies of character, it would seem, yet now they face, once the sexual furore is past, an utter aimlessness in life shocking to think about. Further, Yeats notes an important point I have not seen mentioned before—only one of the lovers uses the coarse language, the other merely accepts it. The gamekeeper talks his dirt and the lady listens, but never once answers in kind. If she had, the gamekeeper would no doubt have been deeply scandalised.

Yet the language needs those words, they have a definite use and value and they should not be used carelessly or imprecisely. My contention is that obscenity is real, is necessary as expression, a safety valve against the almost intolerable pressures and strains of relationship between men and women, and not only between men and women but between any human being and his unmanageable world. If we distort, warp, abuse this language which is the seamy side of the noble language of religion and love, indeed the necessary defensive expression of insult towards the sexual partner and contempt and even hatred of the insoluble stubborn mystery of sex itself which causes us such fleeting joy and such cureless suffering, what have we left for a way of expressing the luxury of obscenity which, for an enormous majority of men, by their own testimony, is half the pleasure of the sexual act?

I would not object, then, to D. H. Lawrence's obscenity if it were really that. I object to his misuse and perversions of obscenity, his wrong-headed denial of its true nature and meaning. Instead of writing straight, healthy obscenity, he makes it sickly sentimental, embarrassingly so, and I find that obscene sentimentality is as hard to bear as any other kind. I object to this pious attempt to purify and canonise obscenity, to castrate the Roaring Boy, to take the low comedy out of sex. We cannot and should not try to hallow these words because they are not hallowed and were never meant to be. The attempt to make pure, tender, sensitive, washed-in-the-blood-of-the-lamb words out of words whose whole intention, function, place in our language is meant to be exactly the opposite is sentimentality, and of a very low order. Our language is rich and full and I daresay there is a word to express every shade of meaning and feeling a human being is capable of, if we are not too lazy to look for it; or if we do not substitute one word for another, such as calling a nasty word—meant to be nasty, we need it that way—"pure," and a pure word "nasty." This is an unpardonable tampering with definitions, and, in Lawrence, I think it comes of a very deep-grained fear and distrust of sex itself; he was never easy on that subject, could not come to terms with it for anything....

His first encounter with dirty words, as he knew them to be, must have brought a shocking sense of guilt, especially as they no doubt gave him great secret pleasure; and to the end of his life he was engaged in the hopeless attempt to wash away that sense of guilt by denying the reality of its cause. He never arrived at the sunny truth so fearlessly acknowledged by Yeats, that "Love has pitched his mansion in the place of excrement"; but Yeats had already learned, long before in his own experience that love has many mansions and only one of them is pitched there—a very important one that should be lived in very boldly and in hot blood at its own right seasons; but to deny its nature is to vulgarise it indeed. My own belief is this, that anything at all a man and woman wish to do or say in their sexual relations, their love-making, or call it what you please, is exactly their own business and nobody else's. But let them keep it to themselves unless they wish to appear ridiculous at best, at worst debased and even criminal. For sex resembles many other acts which may in themselves be harmless, yet when committed in certain circumstances may be not only a sin, but a crime against human life itself, human feelings, human rights—I do not say against ethics, morality, sense of honour (in a discussion of the motives not of the author perhaps, but of the characters in this novel, such words are nearly meaningless), but a never-ending wrong against those elements in the human imagination which were capable of such concepts in the first place. If they need the violent stimulation of obscene acrobatics, ugly words, pornographic pictures, or even low music—there is a negro jazz trumpeter who blows, it is said, a famous aphrodisiac noise—I can think of no argument against it, unless it might be thought a pity their nervous systems are so benumbed they need to be jolted and shocked into pleasure. Sex shouldn't be that kind of hard work, nor should it, as this book promises, lead to such a dull future. For nowhere in this sad history can you see anything but a long, dull grey, monotonous chain of days, lightened now and then by a sexual bout. I can't hear any music, or poetry, or the voices of friends, or children. There is no wine, no food, no sleep nor refreshment, no laughter, no rest nor quiet—no love. I remember then that this is the fevered day-dream of a dying man sitting under his umbrella pines in Italy indulging his sexual fantasies. For Lawrence is a Romantic turned wrong side out, and like Swift's recently-flayed woman, it does alter his appearance for the worse—and his visions are easy, dream-like, not subject to any real interruptions and interferences—for like children they see the Others as the Enemy—a mixture of morning dew and

mingled body-secretions, a boy imagining a female partner who is nothing but one yielding, faceless, voiceless organ of consent.

An organ, and he finally bestows on those quarters his accolade of approval in the language and tone of praise he might give to a specially succulent scrap of glandular meat fresh from the butcher's. "Tha's a tasty bit of tripe, th'art," he says in effect, if not in just those words. And adds (these *are* his words), "Tha'rt real, even a bit of a bitch." Why a bitch is more real than other forms of life he does not explain. Climbing on his lap, she confirms his diagnosis by whispering, "Kiss me!"

Lawrence was a very gifted, distraught man who continually overreached himself in an effort to combine all the authorities of artist, prophet, messiah, leader, censor, and mentor, by use of an unstable and inappropriate medium, the novel. His poetry and painting aside, he should be considered first as a writer of prose, and as a novelist. If a novelist is going to be so opinionated and obstinate and crazed on so many subjects he will need to be a Tolstoy, not a Lawrence. Only Tolstoy could be so furiously and fiercely wrong. He can nearly persuade you by sheer overwhelming velocity of will to agree with him.... It takes Homer or Sophocles or Dante or Chaucer or Shakespeare, or, at rather a distance, Tolstoy, to silence us, to force us to listen and almost to believe in their version of things, lulled or exalted or outraged into a brief acceptance. Lawrence has no grandeur in wrath or arrogance or love; he buzzes and darts like a wasp, irritable and irritating, hovering and bedevilling with a kind of insect-like persistence—he nags, in a word, and that is intolerable from anyone but surely unpardonable in an artist.

This tendency to nag, to disguise poorly as fiction a political, sociological tract, leads Lawrence, especially in this book, into some scenes on the grisly-comic order; they remind me of certain passages in *The Grapes of Wrath,* and pretty much on the same level, regarded as literature. Yet Steinbeck's genius for bathos never exceeded a certain scene by Lawrence which I have never heard mentioned by anyone, in talk or in print, by any critic however admiring—certainly, I have not heard all the talk or seen all the print on this subject—but I sympathise with this omission for I hardly know where to begin with it. It is the unbelievably grotesque episode of this besotted couple weaving flowers in each other's pubic hair, hanging bouquets and wreaths in other strategic bodily spots, making feeble little dirty jokes, inventing double-meaning nicknames for their sexual organs, and altogether, though God knows it is of an imbecilic harmlessness, and is meant in all solemn God's-earnestness to illustrate true passion at lyric play, I for one feel that I have overheard talk and witnessed acts never meant for me to hear or witness. The act itself I could not regard as shocking or in any way offensive except for its lack of reserve and privacy. Love-making surely must be, for human beings at our present state of development, one of the more private enterprises. Who would want a witness to that entire self-abandonment and helplessness? So it is best in such a case for the intruder to tip-toe away quietly, and say nothing. I hold that this is not prudery nor hypocrisy; I still believe in the validity of simple respect and regard for the dark secret things of life—that they should be inviolable, and guarded by the two who take part, and that no other presence should be invited.

Let us go on with the scene in question. The lovers are in his gamekeeper's lodge, it is raining, the impulsive woman takes off to the woods stark naked except for a pair of rubbers, lifting her heavy breasts to the rain (she is constitutionally overweight), and doing eurythmic movements she had learned long ago in Dresden. The gamekeeper is so exalted by this spectacle he takes out after her, faunlike, trips her up, and they splash about together in the rilling rainwater.... It could, I suppose,

be funnier, but I cannot think how. And somewhere in these extended passages the gamekeeper pauses to give his lady a lecture on the working class and its dullness due to the industrial system. He blames everything on the mechanised life "out there," and his complaint recurs with variations: "Though it's a shame, what's been done to people these last hundred years: man turned into nothing but labour-insects, and all their manhood taken away, and all their real life." Hadn't Lawrence got any notion of what had been done to such people the hundred years before the last, and the hundred before that, and so on, back to the beginning?

Yet both the lovers did accept the standards of her world in appearances at least; over and over she observes that her gamekeeper is really quite elegant or self-possessed or looks "like a gentleman," and is pleased to think that she could introduce him anywhere. He observes the same thing of himself from time to time in an oblique way—he is holding his own among them, even now and again putting them down. Here are glimpses of Lady Chatterley sizing up Mellors on their first meeting: "He was a man in dark green velveteen and gaiters ... the old style, with a red face and red moustache and distant eyes...." And later, she noted that "he breathed rather quickly, through parted lips," while pushing his invalid employer's wheelchair uphill. "He was rather frail, really. Curiously full of vitality, but a little frail and quenched." Earlier she has been described as "a soft, ruddy, country-looking girl, inclined to freckles, with big blue eyes and curling hair, and a soft voice and rather strong, female loins"; in fact, "she was too feminine to be quite smart."

Essentially, these are fairly apt descriptions of Lawrence and Freida Lawrence, as one would need only to have seen photographs to recognise. This is relevant only because the artist's life is always his material and it seems pointless to look for hidden clues when they are so obviously on the surface. Lawrence the man and Lawrence the artist are more than usually inseparable: he is everywhere, and everywhere the same, in his letters, his criticism, his poetry, his painting, the uneasy, suffering, vociferous man who wanted to be All-in-All in all things, but never discovered what the All is, or if it exists indeed. This will to omniscience is most clearly seen in *Lady Chatterley's Lover*. In the entire series of sexual scenes, growing in heat and intensity quite naturally, with the language not coarsening particularly, it could not be coarser than it began, there is only more of it, with the man showing off his prowess as he perceives his success—all this is exposed from the point of view of the woman. Lawrence constantly describes what the man *did*, but tells us with great authority what the woman *felt*. Of course, he cannot possibly know—it is like a textbook of instructions to a woman as to how she should feel in such a situation. That is not his territory, and he has no business there. This shameless, incessant, nosy kind of poaching on the woman's nature as if determined to leave her no place of her own is what I find peculiarly repellent. The best he can ever do is to gather at second-hand, by hearsay, from women, in these matters; and though he had the benefit no doubt of some quite valid confidences and instruction from women entirely honest with him, it still just looks pretty fraudulent; somehow he shouldn't pretend he is the woman in the affair, too, as well as the man. It shows the obsessional nature of his self-centredness; he gives the nightmarish impression of the bi-sexual snail squeezed into its narrow house making love to itself—my notion of something altogether undesirable even in the lowest possible forms of life. We have seen in his writings his hatred and distrust of women—of the female principle, that is; with some of its exemplars he managed to get along passably—shown in his perpetual exasperated admonition to woman to be

what he wants her to be, without any regard to what she possibly may be—to stop having any will or mind or indeed any existence of her own except what he allows her. He will dole out to her the kind of sex he thinks is good for her, and allow her just the amount of satisfaction in it he wishes her to have—not much. Even Lady Chatterley's ration seems more in the head than in the womb.

Yet, where can it end? The gamekeeper, in spite of a certain fragility of appearance, seems to be the fighting-cock sort, wiry and tough enough, and he certainly runs through a very creditable repertory of sexual styles and moods. Yet he is a man of physical limitations like any other. Lady Chatterley is the largish, slow-moving, solid sort, and we know by her deeds and her words she is not worn down by an active mind. Such a woman often wears extremely well, physically. How long will it be before that enterprising man exhausts himself trying to be everything in that affair, both man and woman too, while she has nothing to do but be passive and enjoy whatever he wants her to have in the way he wants her to have it? It seems to me a hopelessly one-sided arrangement, it places all responsibility on him, and he will be the loser. Such a woman could use up half a dozen such men, and it is plain already that she will shortly be looking for another man; I give him two years at the rate he is going, if sex is really all he has to offer her, or all she is able to accept. For if sex alone is what she must have, she will not abide with him.

Jean Cocteau has told somewhere a terrible story of a priest in a hotel, who, hearing the death-rattle of a man in the next room, mistook it for animal noises of a successful intercourse and knocked censoriously on the wall. We should all be very careful not to make the same mistake.

Lawrence, who was prickly as a hedgehog where his own privacies were concerned, cannot in his mischievous curiosity allow to a woman even the privacy of her excremental functions. He has to tell her in so many words just where her private organs are located, what they are good for, and how praiseworthy he finds the whole arrangement. Nothing will do for him but to try to crawl into her skin; finding that impossible, at last he admits unwillingly a fact you would think a sensible person would have been born knowing, or would have learned very early: that we *are* separate, each a unique entity, strangers by birth, that our envelopes are meant as the perfect device for keeping us separate. We are meant to share, not to devour each other; no one can claim the privilege of two lives, his own and another's....

Huizinga, on page 199 of his book, *The Waning of the Middle Ages,* tells of the erotic religious visions of a late medieval monk, and adds: "The description of his numerous visions is characterised at the same time by an excess of sexual imagination and by the absence of all genuine emotion." Lawrence used to preach frantically that people must get sex out of their heads and back where it belongs; and never learned that sex lives in all our parts, and must have the freedom of the whole being—to run easily in the blood and nerves and cells, adding its glow of life to everything it touches. The ineptitudes of these awful little love-scenes seem heart-breaking—that a man of such gifts should have lived so long and learned no more about love than that!

| Part | Of Nakedness |
| IIIC | and Nudity |

The Naked and the Nude

Kenneth Clark

Lord Kenneth Clark (1903–) is one of the world's most distinguished art historians. Master of a fine prose style, Clark has had a career of teaching, museum work, and public service that has won him many honors. He has been Director of the National Gallery, London, (1934–1945), Slade Professor of Fine Art, Oxford (1946–1950), and Chairman of the Independent Television Authority (1954–1957). Clark has published important studies in art history, including The Gothic Revival *(1928),* Landscape into Art *(1949), and the book from which the following selection is drawn,* The Nude. *Since 1970, theaters and television stations have been showing a series of films with the overall title* Civilisation, *written and narrated by Sir Kenneth. The series deals with art through the ages and is the finest kind of popularization.*

The English language, with its elaborate generosity, distinguishes between the naked and the nude. To be naked is to be deprived of our clothes, and the word implies some of the embarrassment most of us feel in that condition. The word "nude," on the other hand, carries, in educated usage, no uncomfortable overtone. The vague image it projects into the mind is not of a huddled and defenseless body, but of a balanced, prosperous, and confident body: the body re-formed. In fact, the word was forced into our vocabulary by critics of the early eighteenth century to persuade the artless islanders that, in countries where painting and sculpture were practiced and valued as they should be, the naked human body was the central subject of art.

For this belief there is a quantity of evidence. In the greatest age of painting, the nude inspired the greatest works; and even when it ceased to be a compulsive subject it held its position as an academic exercise and a demonstration of mastery. Velasquez, living in the prudish and corseted court of Philip IV and admirably

From *The Nude: A Study in Ideal Form* by Kenneth Clark, number two in the A. W. Mellon Lectures in the Fine Arts, Bollingen Series XXXV, published by the Bollingen Foundation (Copyright © 1956 by the Trustees of the National Gallery of Art, Washington, D.C.), pp. 3–15, 22–29. Reprinted by permission of Princeton University Press and John Murray Ltd.

Of Nakedness and Nudity

incapable of idealization, yet felt bound to paint the *Rokeby Venus [1]*. Sir Joshua Reynolds, wholly without the gift of formal draftsmanship, set great store by his *Cymon and Iphigenia*. And in our own century, when we have shaken off one by one those inheritances of Greece which were revived at the Renaissance, discarded the antique armor, forgotten the subjects of mythology, and disputed the doctrine of imitation, the nude alone has survived. It may have suffered some curious transformations, but it remains our chief link with the classic disciplines. When we wish to prove to the Philistine that our great revolutionaries are really respectable artists in the tradition of European painting, we point to their drawings of the nude. Picasso has often exempted it from that savage metamorphosis which he has inflicted on the visible world and has produced a series of nudes [2] that might have walked unaltered off the back of a Greek mirror; and Henry Moore, searching in stone for the ancient laws of its material and seeming to find there some of those elementary creatures of whose fossilized bones it is composed, yet gives to his constructions the same fundamental character that was invented by the sculptors of the Parthenon in the fifth century before Christ.

These comparisons suggest a short answer to the question, "What is the nude?" It is an art form invented by the Greeks in the fifth century, just as opera is an art form invented in seventeenth-century Italy. The conclusion is certainly too abrupt, but it has the merit of emphasizing that the nude is not the subject of art, but a form of art.

It is widely supposed that the naked human body is in itself an object upon which the eye dwells with pleasure and which we are glad to see depicted. But anyone who has frequented art schools and seen the shapeless, pitiful model that the students are industriously drawing will know this is an illusion. The body is not one of those subjects which can be made into art by direct transcription—like a tiger or a snowy landscape. Often in looking at the natural and animal world we joyfully identify ourselves with what we see and from this happy union create a work of art. This is the process students of aesthetics call empathy, and it is at the opposite pole of creative activity to the state of mind that has produced the nude. A mass of naked figures does not move us to empathy, but to disillusion and dismay. We do not wish to imitate; we wish to perfect. We become, in the physical sphere, like Diogenes with his lantern looking for an honest man; and, like him, we may never be rewarded. Photographers of the nude are presumably engaged in this search, with every advantage; and having found a model who pleases them, they are free to pose and light her in conformity with their notions of beauty; finally, they can tone down and accentuate by retouching. But in spite of all their taste and skill, the result is hardly ever satisfactory to those whose eyes have grown accustomed to the harmonious simplifications of antiquity. We are immediately disturbed by wrinkles, pouches, and other small imperfections, which, in the classical scheme, are eliminated. By long habit we do not judge it as a living organism, but as a design; and we discover that the transitions are inconclusive, the outline is faltering. We are bothered because the various parts of the body cannot be perceived as simple units and have no clear relationship to one another. In almost every detail the body is not the shape that art had led us to believe it should be. Yet we can look with pleasure at photographs of trees and animals, where the canon of perfection is less strict. Consciously or unconsciously, photographers have usually recognized that in a photograph of the nude their real object is not to reproduce the naked body, but to imitate some artist's view of what the naked body should be. Rejlander was the most Philistine of the early photographers, but, perhaps without knowing it, he was a contemporary of Courbet [3], and with this splendid archetype somewhere in the

Figure 1. Velasquez. The Rokeby Venus.
Reproduced by courtesy of the Trustees, The National Gallery, London.

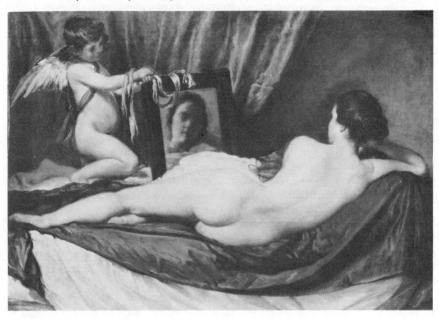

Figure 2. Picasso. Bathers.
Courtesy of the Fogg Art Museum, Harvard University, Bequest of Meta and Paul J. Sachs

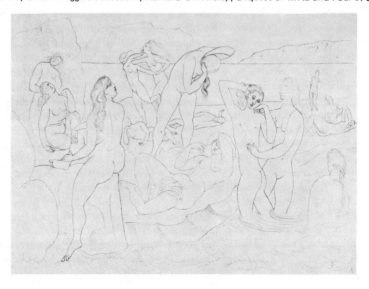

Of Nakedness and Nudity

Figure 3. Courbet. La Source.
Photo from Musees Nationaux.

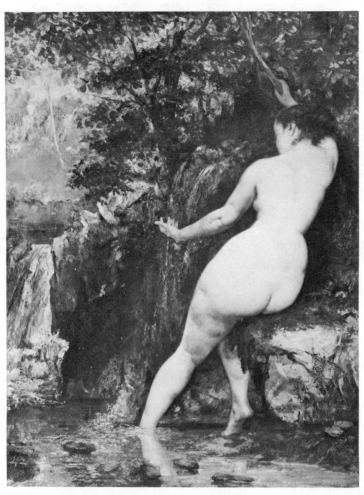

background he produced one of the finest (as well as one of the first) photographs of the nude [4]. He succeeded partly because his unconscious archetype was a realist. The more nearly ideal the model, the more unfortunate the photographs that try to imitate it—as those in the style of Ingres or Whistler prove.

So that although the naked body is no more than the point of departure for a work of art, it is a pretext of great importance. In the history of art, the subjects that men have chosen as nuclei, so to say, of their sense of order have often been in themselves unimportant. For hundreds of years, and over an area stretching from Ireland to China, the most vital expression of order was an imaginary animal biting its own tail. In the Middle Ages drapery took on a life of its own, the same life that had inhabited the twisting animal, and became the vital pattern of Romanesque art. In neither case had the subject any independent existence. But the human body, as a nucleus, is rich in associations, and when it is turned into art these associations are

Figure 4. Rejlander. Photograph.

not entirely lost. For this reason it seldom achieves the concentrated aesthetic shock of animal ornament, but it can be made expressive of a far wider and more civilizing experience. It is ourselves and arouses memories of all the things we wish to do with ourselves; and first of all we wish to perpetuate ourselves.

This is an aspect of the subject so obvious that I need hardly dwell on it; and yet some wise men have tried to close their eyes to it. "If the nude," says Professor Alexander, "is so treated that it raises in the spectator ideas or desires appropriate to the material subject, it is false art, and bad morals." This high-minded theory is contrary to experience. In the mixture of memories and sensations aroused by Rubens' *Andromeda* or Renoir's *Bather* are many that are "appropriate to the material subject." And since these words of a famous philosopher are often quoted, it is necessary to labor the obvious and say that no nude, however abstract, should fail to arouse in the spectator some vestige of erotic feeling, even though it be only the faintest shadow—and if it does not do so, it is bad art and false morals. The desire to grasp and be united with another human body is so fundamental a part of our nature that our judgment of what is known as "pure form" is inevitably influenced by it; and one of the difficulties of the nude as a subject for art is that these instincts cannot lie hidden, as they do, for example, in our enjoyment of a piece of pottery, thereby gaining the force of sublimation, but are dragged into the foreground, where they risk upsetting the unity of responses from which a work of

art derives its independent life. Even so, the amount of erotic content a work of art can hold in solution is very high. The temple sculptures of tenth-century India are an undisguised exaltation of physical desire; yet they are great works of art because their eroticism is part of their whole philosophy.

Apart from biological needs, there are other branches of human experiences of which the naked body provides a vivid reminder—harmony, energy, ecstasy, humility, pathos; and when we see the beautiful results of such embodiments, it must seem as if the nude as a means of expression is of universal and eternal value. But this we know historically to be untrue. It has been limited both in place and in time. There are naked figures in the paintings of the Far East; but only by an extension of the term can they be called nudes. In Japanese prints they are part of *ukioye*, the passing show of life, which includes, without comment, certain intimate scenes usually allowed to pass unrecorded [5]. The idea of offering the body for its own sake, as a serious subject of contemplation, simply did not occur to the Chinese or Japanese mind, and to this day raises a slight barrier of misunderstanding. In the Gothic North the position was fundamentally very similar. It is true that German painters in the Renaissance, finding that the naked body was a respected subject in Italy, adapted it to their needs, and evolved a remarkable convention of their own. But Durer's struggles show how artificial this creation was. His instinctive responses were curiosity and horror, and he had to draw a great many circles and other diagrams before he could brace himself to turn the unfortunate body into the nude.

Only in countries touching on the Mediterranean has the nude been at home; and even there its meaning was often forgotten.... The nude had ceased to be the subject of art almost a century before the official establishment of Christianity. And during the Middle Ages there would have been ample opportunity to introduce it both into profane decoration and into such sacred subjects as show the beginning and the end of our existence.

Why, then, does it never appear? An illuminating answer is to be found in the notebook of the thirteenth-century architect, Villard de Honnecourt. This contains

Figure 5. Kyonaga. Color Print.

many beautiful drawings of draped figures, some of them showing a high degree of skill. But when Villard draws two nude figures [6] in what he believes to be the antique style the result is painfully ugly. It was impossible for him to adapt the stylistic conventions of Gothic art to a subject that depended on an entirely different system of forms. There can be few more hopeless misunderstandings in art than his attempt to render that refined abstraction, the antique torso, in terms of Gothic loops and pothooks. Moreover, Villard has constructed his figures according to the pointed geometrical scheme of which he himself gives us the key on another page. He evidently felt that the divine element in the human body must be expressed through geometry. Cennino Cennini, the last chronicler of medieval practice, says, "I will not tell you about irrational animals, because I have never learned any of their measurements. Draw them from nature, and in this respect you will achieve a good style." The Gothic artists could draw animals because this involved no intervening abstraction. But they could not draw the nude because it was an idea: an idea that their philosophy of form could not assimilate.

As I have said, in our Diogenes search for physical beauty our instinctive desire is not to imitate but to perfect. This is part of our Greek inheritance, and it was formulated by Aristotle with his usual deceptive simplicity. "Art," he says, "completes what nature cannot bring to a finish. The artist gives us knowledge of nature's unrealized ends." A great many assumptions underlie this statement, the chief of which is that everything has an ideal form of which the phenomena of experience are more or less corrupted replicas. This beautiful fancy has teased the minds of philosophers and writers on aesthetics for over two thousand years, and although we need not plunge into a sea of speculation, we cannot discuss the nude without considering its practical application, because every time we criticize a

Figure 6. Villard de Honnecourt. Antique Figures.
Courtesy Bibliothèque Nationale.

Of Nakedness and Nudity

figure, saying that a neck is too long, hips are too wide or breasts too small, we are admitting, in quite concrete terms, the existence of ideal beauty. Critical opinion has varied between two interpretations of the ideal, one unsatisfactory because it is too prosaic, the other because it is too mystical. The former begins with the belief that although no individual body is satisfactory as a whole, the artist can choose the perfect parts from a number of figures and then combine them into a perfect whole. Durer went so far as to say that he had "searched through two or three hundred." The argument is repeated again and again for four centuries, never more charmingly than by the French seventeenth-century theorist, De Fresnoy, whom I shall quote in Mason's translation:

> For tho' our casual glance may sometimes meet
> With charms that strike the soul and seem complete,
> Yet if those charms too closely we define,
> Content to copy nature line for line,
> Our end is lost. Not such the master's care,
> Curious he culls the perfect from the fair;
> Judge of his art, thro' beauty's realm he flies,
> Selects, combines, improves, diversifies;
> With nimble step pursues the fleeting throng,
> And clasps each Venus as she glides along.

Naturally, the theory was a popular one with artists: but it satisfies neither logic nor experience. Logically, it simply transfers the problem from the whole to the parts.... And even admitting that we do find certain individual limbs or features that, for some mysterious reason, seem to us perfectly beautiful, experience shows us that we cannot often recombine them. They are right in their setting, organically, and to abstract them is to deprive them of that rhythmic vitality on which their beauty depends.

To meet this difficulty the classic theorists of art invented what they called "the middle form." They based this notion on Aristotle's definition of nature, and in the stately language of Sir Joshua Reynolds' *Discourses* it seems to carry some conviction. But what does it amount to, translated into plain speech? Simply that the ideal is composed of the average and the habitual. It is an uninspiring proposition, and we are not surprised that Blake was provoked into replying, "All Forms are Perfect in the Poet's Mind but these are not Abstracted or compounded from Nature, but are from the Imagination." Of course he is right. Beauty is precious and rare, and if it were like a mechanical toy, made up of parts of average size that could be put together at will, we should not value it as we do. But we must admit that Blake's interjection is more a believer's cry of triumph than an argument, and we must ask what meaning can be attached to it. Perhaps the question is best answered in Crocean terms. The ideal is like a myth, in which the finished form can be understood only as the end of a long process of accretion. In the beginning, no doubt, there is the coincidence of widely diffused desires and the personal tastes of a few individuals endowed with the gift of simplifying their visual experiences into easily comprehensible shapes. Once this fusion has taken place, the resulting image, while still in a plastic state, may be enriched or refined upon by succeeding generations. Or, to change the metaphor, it is like a receptacle into which more and more experience can be poured. Then, at a certain point, it is full. It sets. And, partly because it seems to be completely satisfying, partly because the mythopoeic faculty has declined, it is accepted as true. What both Reynolds and

Figure 7. Sansovino. Apollo.

Of Nakedness and Nudity

Blake meant by ideal beauty was really the diffused memory of that peculiar physical type developed in Greece between the years 480 and 440 B.C., which in varying degrees of intensity and consciousness furnished the mind of Western man with a pattern of perfection from the Renaissance until the present century.

Once more we have returned to Greece, and it is now time to consider some peculiarities of the Greek mind that may have contributed to the formation of this indestructible image.

The most distinctive is the Greek passion for mathematics. In every branch of Hellenic thought we encounter a belief in measurable proportion that, in the last analysis, amounts to a mystical religion; and as early as Pythagoras it had been given the visible form of geometry. All art is founded on faith, and inevitably the Greek faith in harmonious numbers found expression in their painting and sculpture; but precisely how we do not know.... There is, however, one short and obscure statement in Vitruvius that, whatever it meant in antiquity, had a decisive influence on the Renaissance. At the beginning of the third book, in which he sets out to give the rules for sacred edifices, he suddenly announces that these buildings should have the proportions of a man. He gives some indication of correct human proportions and then throws in a statement that man's body is a model of proportion because with arms or legs extended it fits into those "perfect" geometrical forms, the square and the circle. It is impossible to exaggerate what this simple-looking proposition meant to the men of the Renaissance. To them it was far more than a convenient rule: it was the foundation of a whole philosophy. Taken together with the musical scale of Pythagoras, it seemed to offer exactly that link between sensation and order, between an organic and a geometric basis of beauty, which was (and perhaps remains) the philosopher's stone of aesthetics. Hence the many diagrams of figures standing in squares or circles that illustrate the treatises on architecture or aesthetics from the fifteenth to the seventeenth century....

So our surmise that the discovery of the nude as a form of art is connected with idealism and faith in measurable proportions seems to be true, but it is only half the truth. What other peculiarities of the Greek mind are involved? One obvious answer is their belief that the body was something to be proud of, and should be kept in perfect trim.

The Greeks attached great importance to their nakedness. Thucydides, in recording the stages by which they distinguished themselves from the barbarians, gives prominence to the date at which it became the rule in the Olympic games, and we know from vase paintings that the competitors at the Panathenaic festival had been naked ever since the early sixth century. Although the presence or absence of a loincloth does not greatly affect questions of form, and in this study I shall include figures that are lightly draped, psychologically the Greek cult of absolute nakedness is of great importance. It implies the conquest of an inhibition that oppresses all but the most backward people; it is like a denial of original sin. This is not, as is sometimes supposed, simply a part of paganism: for the Romans were shocked by the nakedness of Greek athletes, and Ennius attacked it as a sign of decadence. Needless to say, he was wide of the mark, for the most determined nudists of all were the Spartans, who scandalized even the Athenians by allowing women to compete, lightly clad, in their games. He and subsequent moralists considered the matter in purely physical terms; but, in fact, Greek confidence in the body can be understood only in relation to their philosophy. It expresses above

all their sense of human wholeness. Nothing that related to the whole man could be isolated or evaded; and this serious awareness of how much was implied in physical beauty saved them from the two evils of sensuality and aestheticism.

At the same party where Kritobalos brags about his beauty Xenophon describes the youth Autolykos, victor of the Pankration, in whose honor the feast was being given. "Noting the scene," he says, "the first idea to strike the mind is that beauty has about it something regal; and the more so if it chance to be combined (as now in the person of Autolykos) with modesty and self-respect. Even as when a splendid object blazes forth at night, the eyes of men are riveted, so now the beauty of Autolykos drew on him the gaze of all; nor was there one of those onlookers but was stirred to his soul's depth by him who sat there. Some fell into unwonted silence, while the gestures of the rest were equally significant."

This feeling, that the spirit and body are one, which is the most familiar of all Greek characteristics, manifests itself in their gift of giving to abstract ideas a sensuous, tangible, and, for the most part, human form. Their logic is conducted in the form of dialogues between real men. Their gods take visible shape, and on their appearance are usually mistaken for half-familiar human beings—a maidservant, a shepherd, or a distant cousin. Woods, rivers, even echoes are shown in painting as bodily presences, solid as the living protagonists, and often more prominent. Here we reach what I take to be the central point of our subject: "Greek statues," said Blake, in his *Descriptive Catalogue*, "are all of them representations of spiritual existences, of gods immortal, to the mortal, perishing organ of sight; and yet they are embodied and organised in solid marble." The bodies were there, the belief in the gods was there, the love of rational proportion was there. It was the unifying grasp of the Greek imagination that brought them together. And the nude gains its enduring value from the fact that it reconciles several contrary states. It takes the most sensual and immediately interesting object, the human body, and puts it out of reach of time and desire; it takes the most purely rational concept of which mankind is capable, mathematical order, and makes it a delight to the senses; and it takes the vague fears of the unknown and sweetens them by showing that the gods are like men and may be worshiped for their life-giving beauty rather than their death-dealing powers.

To recognize how completely the value of these spiritual existences depends on their nudity, we have only to think of them as they appear, fully clothed, in the Middle Ages or early Renaissance. They have lost all their meaning. When the Graces are represented by three nervous ladies hiding behind a blanket [8], they no longer convey to us the civilizing influence of beauty. When Herakles is a lumbering *Landsknecht* weighed down by fashionable armor, he cannot increase our sense of well-being by his own superabundant strength. Conversely, when nude figures, which had been evolved to express an idea, ceased to do so, and were represented for their physical perfection alone, they soon lost their value. This was the fatal legacy of neoclassicism, and Coleridge, who lived through the period, summed up the situation in some lines he added to the translation of Schiller's *Piccolomini:*

> *The intelligible powers of ancient poets,*
> *The fair humanities of old religion,*
> *The Power, the Beauty and the Majesty,*
> *That had their haunts in dale or piney mountain,*
> *. . . all these have vanished.*
> *They live no longer in the faith of reason.*

Figure 8. Austrian ms., 12th century. Three Graces.

The academic nudes of the nineteenth century are lifeless because they no longer embodied real human needs and experiences. They were among the hundreds of devalued symbols that encumbered the art and architecture of the utilitarian century.

The nude had flourished most exuberantly during the first hundred years of the classical Renaissance, when the new appetite for antique imagery overlapped the medieval habits of symbolism and personification. It seemed then that there was no concept, however sublime, that could not be expressed by the naked body, and no object of use, however trivial, that would not be the better for having been given human shape. At one end of the scale was Michelangelo's *Last Judgment*; at the other the door knockers, candelabra, or even handles of knives and forks. To the first it might be objected—and frequently was—that nakedness was unbecoming in a representation of Christ and His saints. This was the point put forward by Paolo Veronese when he was tried by the Inquisition for including drunkards and Germans in his picture of the marriage of Cana: to which the chief inquisitor gave his immortal reply, "Do you not know that in these figures by Michelangelo there is nothing that is not spiritual—*non vi e cosa se non de spirito?*" And to the second it might be objected—and frequently is—that the similitude of the naked Venus is not what we need in our hand when we are cutting up our food or knocking at a door, to which Benvenuto Cellini would have replied that since the human body is the

most perfect of all forms we cannot see it too often. In between these two extremes was that forest of nude figures, painted or carved, in stucco, bronze, or stone, which filled every vacant space in the architecture of the sixteenth century.

Such an insatiable appetite for the nude is unlikely to recur.[1] It arose from a fusion of beliefs, traditions, and impulses very remote from our age of essence and specialization. Yet even in the new self-governing kingdom of the aesthetic sensation the nude is enthroned. The intensive application of great artists has made it into a sort of pattern for all formal constructions, and it is still a means of affirming the belief in ultimate perfection. "For soule is forme, and doth the bodie make," wrote Spenser in his *Hymne in Honour of Beautie,* echoing the words of the Florentine Neoplatonists, and although in life the evidence for the doctrine is inconclusive, it is perfectly applicable to art. The nude remains the most complete example of the transmutation of matter into form.

Nor are we likely once more to cut ourselves off from the body, as in the ascetic experiment of medieval Christianity. We may no longer worship it, but we have come to terms with it. We are reconciled to the fact that it is our lifelong companion, and since art is concerned with sensory images the scale and rhythm of the body is not easily ignored. Our continuous effort, made in defiance of the pull of gravity, to keep ourselves balanced upright on our legs affects every judgment on design, even our conception of which angle shall be called "right." The rhythm of our breathing and the beat of our hearts are part of the experience by which we measure a work of art. The relation of head to body determines the standard by which we assess all other proportions in nature. The disposition of areas in the torso is related to our most vivid experiences, so that abstract shapes, the square and the circle, seem to us male and female; and the old endeavor of magical mathematics to square the circle is like the symbol of physical union. The starfish diagrams of Renaissance theorists may be ridiculous, but the Vitruvian principle rules our spirits, and it is no accident that the formalized body of the "perfect man" became the supreme symbol of European belief. Before the *Crucifixion* of Michelangelo [9] we remember that the nude is, after all, the most serious of all subjects in art; and that it was not an advocate of paganism who wrote, "The Word was made flesh, and dwelt among us ... full of grace and truth."

[1]Editors' note: Sir Kenneth was a better art critic than he was a prophet.

Figure 9. Michelangelo. Crucifixion.

Not Funny—Just Naked

Walter Kerr

Walter Kerr (1913–), drama critic of the New York Times, *came to that newspaper after the sad end of the* Herald-Tribune. *His position on the now dominant* Times *is said to give him the power of life or death over Broadway productions. At one time a professor of drama and professional director, he has written plays and numerous books about the theater in addition to his widely read column. Among his publications are* How Not to Write a Play *(1955),* Criticism and Censorship *(1957),* Pieces at Eight *(1958),* The Decline of Pleasure *(1962),* The Theatre in Spite of Itself *(1963), and* Tragedy and Comedy *(1967).*

Sir Kenneth Clark could not have anticipated that his distinction between the naked and the nude would find new application in the 1960s. Mr. Kerr deals here with the same theme in the context of the theater and sex pranks such as "Oh! Calcutta," in which intimate sex-play combines with nudity to provide new titillations for voyeurs and fresh novelty for the curious. Even if this creaky vehicle lingers by this time only as a pleasant or unpleasant memory, the tendencies discussed by Mr. Kerr are likely to be with us for some time, and his remarks are therefore pertinent. After all, not even his vaunted power to impose death sentences on theatrical productions prevented "Oh! Calcutta" from enjoying an extended run.

When I was a young man and altogether inexperienced, I read a borrowed sex manual (I was too shy to buy one) that began its instructions with a small, kindly caution. The caution went something like this: "You may, as you turn these pages, find your fingers trembling a bit, your heart starting to race. Don't be worried about this, it is quite naturally so, the very subject of sex is apt to set the whole man a-quiver." I remember being a bit skeptical about the fatherly warning. I don't think my own fingers began to tremble until I was told that they should. But I do begin to wonder, now that I have seen "Oh! Calcutta!," whether that wasn't a wise little manual, after all, to have wished to alert us to the possibly unsteady hand. Certainly something has happened to Kenneth Tynan's hand as he has approached the tricky wonderland of sex.

Mr. Tynan's hand is normally an exemplary one—cool, restrained, meticulous in motion and suave in repose. When he is using it to write, he is a most admirable critic, an impeccable stylist. When he is using it to select plays for the repertory of the British National Theater, he is a judicious adviser, idealist and realist at once. Coming to "Oh! Calcutta!," though, a revue of his own devising designed to play with sex on the stage without robe or reservation, he is suddenly a fevered butterfingers, so agog with a promised glee that he has entirely neglected to notice what is *on* the pages he has, with a racing heart, handed his director and his so willing actors.

Of Nakedness and Nudity

Taste, an ear for wit, an eye for form, a heart that insists upon being pleased only in the highlands, have all vanished. The clumsiest, most labored of jokes are permitted to succeed one another in obsessive monotony. Language no longer matters, structure no longer matters, inspiration no longer matters. Anything will do so long as it meets two requirements: that the actors undress and that they engage in simulated sex play.

The evening is so entranced at having discovered the fact of masturbation that it includes *two* sketches displaying the act. Children are recognized as sexual beings: Jack rapes Jill on a pile of translucent building blocks. Victorian or Edwardian ladies are revealed—the astonishment of it!—as less than virgins, as possessors of very real backsides. A wide-eyed wife stuffs Fritos into her mouth while watching her husband copulate with a swinging acquaintance, then dives into the melee herself, top girl on a phallic totem pole. A man cries out "Role reversal time!" as he slips into his paramour's panties and leaps for the bed.

Words are pressed upon us repeatedly, in lieu of humor: "I will be removed from my position at the head of society and placed directly in its crotch!" cries an upper-class wench about to be ravished. Lines do not have to be funny nor ideas in any way fresh to pass muster. The people on stage are not engaged in being amusing or pertinent or impertinent or imaginative. They are engaged in being naked. It is an exclusive occupation.

The matter is important because it sweeps straight across the board. If Mr. Tynan's vision has been blurred in every other way by its absolute focus upon sex, the authors from whom he has drawn material have lost all steadiness as well. They have in fact, lost character. Samuel Beckett, Jules Feiffer, John Lennon, Leonard Melfi, Sam Shepard and Mr. Tynan himself are among the writers credited with sketches. The program does not choose to say which writer wrote which sketch. The significant thing is that we cannot say. Though the writers are all men whose work we know, whose personalities and stylistic habits are real to us, there is no way at all of distinguishing one from another by the activity or the language on stage. We can make guesses. We can seek out inside information. But there is never any little leap of recognition in the theater that says, on the spot, that we have found our man. All plod to the same beat and in the plodding all blur. The preoccupation with visual, literal, immediate sex has wiped out not only quality, but also identity.

We should pause to notice how odd that is. "Oh! Calcutta!" is really a very good test case for the validity, or the inadvisibility, of extensive nudity and intimate sex play on stage. The show isn't the work of a clumsy and probably untalented amateur, as "Che!" is. It isn't a mere bid for money put together by flesh-peddlers. It is the work of intelligent and gifted professionals, the work of men who should be able to make the materials work if they can be made to work. The evening also, most carefully, removes some of the objections regularly made to nude performing: The bodies of the company are good bodies, in the case of Margo Sappington—who dances the event's only truly erotic passage—genuinely beautiful. An attempt at quality has been made, in writing and performing both. In which case the over-all failure must mean something. What I think it means is that the stage as such is hostile to the effort being made.

Most people who arrive at this conclusion arrive at it on the grounds that sex is essentially a private act, whereas the theater is a public place. *"Why* need sex be a private act?" is the immediate and obvious rejoinder, and, to tell the truth, we haven't yet found an absolute answer to that. Sex is public for animals; it might be,

with some inhibitions shed, for men. I'm inclined to come at the matter in another way. Literal sex is wrong for the theater, I suspect, because it is an exclusive act.

Sex, as I believe Sophocles once said, is a tyrant. It does not brook interference, it does not acknowledge equals. There are many things we do in life that we find it possible to do in tandem. We read a newspaper while we are eating our breakfast. We carry on coherent conversations while we are driving cars. We smoke while we talk on the telephone (how many times have you taken pains to light up before dialing?), dance with one girl while keeping an eye on another. Actors can count houses while they are actually saying their lines; most of us are ambidextrous most hours of the day.

Not with sex. Sex belongs to another kingdom, really to no kingdom except its own. We don't read and have sex, don't smoke and have sex, don't drive and have sex (not safely, surely), don't converse intelligently and have sex (converse yes; God forbid intelligently). Sex is a total act, rather as my sex manual suggested, absorbing and obliterating, standing jealous guard over its rites. No foreigners need apply. Sex, for its little time, takes full possession of the flesh and the psyche, is law unto itself, solitary in its splendor, single-minded, uncompanioned. Thinking ruins it. *Any* companion, any intrusion, ruins it. (I rather imagine it became private because of its autonomous quality, not the other way around.) Sex cannot be had inattentively, or part-time. It is its own unity.

Taken into the theater, where it must instantly acquire a thousand collaborators, it tends to behave as it always has: ruthlessly and unilaterally. It is not going to care much about a writer's words; it will dominate them and maybe discard them. It is not going to care much about actors' temperaments or personalities; where all are nude, a great effort must be made to keep them from becoming interchangeable. It does not ask questions of Mr. Tynan's taste, or of yours or mine; it rejects the concept of taste as being irrelevant to its goal. This is not to say that it becomes tasteless, merely that it *is* autonomous. Where theatrical sex is actual rather than described or intimated or formally imitated, it tends to usurp all other roles, to put down any counterclaims, whether they be claims to wit or style or structure. These things are puny beside it, easily broken. Sex is simply too powerful a presence to be so conveniently tamed.

Now at the same time that literal sex is tending to ride roughshod over values that might impede or modify it, another perverse thing is happening. The erotica onstage is becoming anti-erotic. The phenomenon has been commented on before. So much on stage sex seems not to praise sex but to discourage it, to be harsh with it. Audiences are not much embarrassed by what they see, but they are often repelled by it, as I think you probably would be repelled by a sketch in "Oh! Calcutta!" in which we are almost savagely forced to look at a girl's backside while we are just as savagely—venomously, really—told that the girl is exposing herself by her own choice.

What is less often mentioned is that the experience is clearly anti-erotic for the actors, too. In the original production of "Che!" before "Che!" decided to dress for the evening, the genitals of two men were subjected to every conceivable stimulus over the course of two and one-half hours. Neither man ever became potent. Nor does anyone become potent, even when engaging in the actions of intercourse, in "Oh! Calcutta!" Some male performer must have been aroused somewhere, sometime; I have been in fairly faithful attendance at these experiments, and I have never seen it happen.

I suppose that, medically and psychologically, various reasons can be advanced for the sustained impotence. (We must take note of the fact that impotence is what is finally celebrated in all of these ventures.) I find myself wondering if it is not the result of simply being in a theater, in a place where the exclusiveness of sex cannot be honored because the actors are doing something else at the same time (acting). The actors are working, adopting mental sets that relate them to an audience, to a stage, to a building, to a script. Is sex thus ruined again?

I am, of course, not speaking of sex as material but of sex as a physical presence. It is possible for "Portnoy's Complaint" to be some kind of masterpiece, which I think it is, because in it sex is robbed of its exclusiveness by not being directly present at all. It is represented only by words, permitting words to retain control. "I Am Curious (Yellow)" seems to me no masterpiece at all, though its playful sex sequences are occasionally touching in a funny-dumb way. But in film the idea of form is still protected: by the fact that the players are not present when we are, by the fact that everything we see is subject to the management of an editor. The theater, however, is an open and total confrontation; that is its distinguishing mark and chief glory. Sex, introduced into this arena without any disguise of form or reduction to metaphor, asserts itself for what it is, exclusive, and thereby ruptures the nature of the event.

Or so it seems to me at present inventory.

On Explicitness

E. H. Gombrich

The aphorism that pictures speak louder than words is overworked, but it applies superbly to the problem of distinguishing between the naked and the nude. The reproductions which follow convey the message so eloquently that only a few words, if even these, are needed to explain why the nude is a proper subject of high art and the naked, a device of pornographers. In the end, whatever its other failings, it is the sheer explicitness of pornography that excludes it from becoming an aesthetic category, Susan Sontag notwithstanding.[1]

E. H. Gombrich, whose comments and illustrations follow, is an eminent art historian. Among his best-known contributions are The Story of Art *(1950),* Art and Illusion *(1960),* Norm and Form *(1966), and the volume of essays from which these comments are taken. He is director of the Warburg Institute and Professor of the History of the Classical Tradition at the University of London.*

[The Birth of Venus] is a nineteenth-century treatment of our theme of Venus rising from the sea—by that most successful of masters of French nineteenth-century *Art Officiel*, Bouguereau (Fig. 1). Let us admit right away that Bouguereau

From *Meditations on a Hobby Horse* by E. H. Gombrich (London: Phaidon Press Ltd., 1963), pp. 37 and 40. Copyright 1963 by E. H. Gombrich. Reprinted by permission of the publisher.
[1]Cf. above, pp. 166–187.

has made further progress in the direction of representational accuracy—beyond Raphael, whom he exploits (Fig. 2), and beyond Titian (Fig. 3). Aided by the successive conquests of appearance made during two centuries and by the mechanical device of photography, he places before us a most convincing image of a nude model. Why, then, does it make us rather sick? I think the reason is obvious. This is a pin-up girl rather than a work of art. By this we mean that the erotic appeal is on the surface—is not compensated for by this sharing in the artist's imaginative process. The image is painfully easy to read, and we resent being taken for such simpletons. We feel somewhat insulted that we are expected to fall for such cheap bait—good enough, perhaps, to attract the vulgar, but not such

sophisticated sharers in the artist's secrets as we pride ourselves on being. But this resentment, I submit, only screens a deeper disturbance; we could hardly feel so ill at ease if we did not have to put up a certain amount of resistance against the methods of seduction practised on us. And so it is small wonder that works of this kind coincided with a retrograde movement of taste; the sophisticated looked out for more difficult gratifications and found them in the cult of the primitive. For the refined connoisseurs of Bouguereau's age it is Botticelli's Venus (Fig. 4) which becomes the haunting image of chaste and childlike appeal. Its very awkwardness in construction endeared it to the art lover, who wanted to make his own discoveries, his own conquests, rather than to yield to seduction.

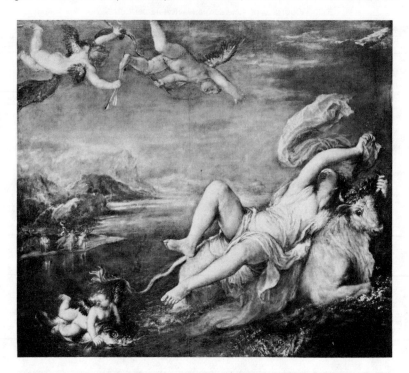

... What makes us sick in art is perhaps an insinuation of passivity which is increasingly resented the higher the brow. For in a way the highbrow, the sophisticate, the critic, is a frustrated artist, and if he cannot satisfy his standards by creating, he wants at least to project; this is a craving, it seems, that easily increases with its satisfaction. How much of it is due to narcissism, the need to be able to enjoy what is inscrutable to the rest, it would be interesting to know. But one thing is important here. The enjoyment itself is not merely pretended. It is as genuine as the revulsion from the cheap and vulgar. I should ask your permission to support this contention with another little experiment *ad hominem.* Again I must beg your forgiveness for inflicting yet another work of *Art Officiel* on you. This atrocity is a painting of the *Three Graces* by Bonnencontre (Fig. 5). I will spare you an analysis of all that makes it odious. Let us rather see whether we can perhaps improve the sloppy mush by adding a few crunchy breadcrumbs. (Fig. 6) is the photograph of the same picture seen through a wobbly glass. You will agree that it looks a little more respectable. We have to become a little more active in reconstituting the image, and we are less disgusted. (Fig. 7) shows the same painting seen at a greater distance through the same glass. By now, I think, it deserves the epithet 'interesting.' Our own effort to reintegrate what has been wrenched apart makes us project a certain vigour into the image which makes it quite crunchy. I'd like to patent that invention, for it has great economic potentialities. In future, when you find a picture in your attic of 'The Monarch of the Glen' or of 'Innocence in Danger,' you need not throw it away or give it to the charwoman. You can put it behind a wobbly glass and make it respectable.

Of Nakedness and Nudity

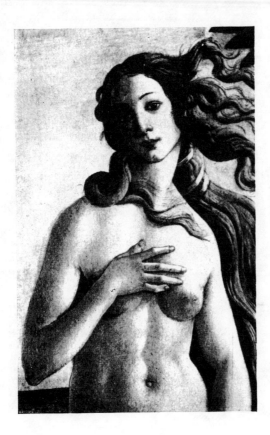

For you must have noticed that this artificial blurring repeats in a rather surprising way the course that painting actually took when the wave of revolt from the Bouguereau phase spread through the art world.

Figure 5. Bonnencontre (E. Courtois). The Three Graces. About 1900.

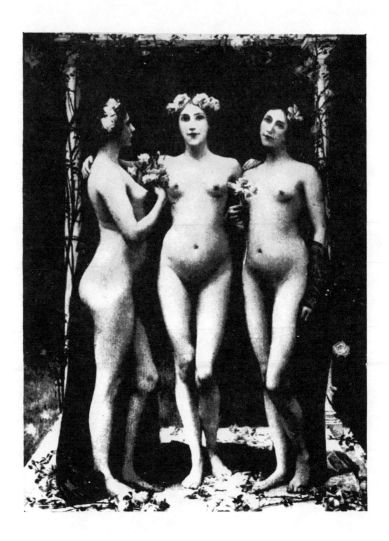

Figures 6 & 7. Bonnencontre. The Three Graces (seen through rolled glass).

Part IV Art and the Artist

In the controversy over the award of the Bollingen Prize to Ezra Pound, Clement Greenberg, a distinguished critic, commented:

I am sick of the art-adoration that prevails among cultured people, more in our time than in any other: that art silliness which condones almost any moral or intellectual failing on the artist's part as long as he is or seems a successful artist.

Greenberg went on to observe that "psychopathology has become endemic among artists and writers in whose company the moral idiot is tolerated as perhaps nowhere else in society."[1] The issue raised by him concerns the relative immunity from criticism enjoyed by artists for eccentricities, shortcomings, and vices that would be condemned in others. Such immunity has taken many forms, from the amused patronage of impertinent court jesters and the mild tolerance of Bohemian and hippie peccadillos to substituting, in the case of Pound and (with striking similarity) the Frenchman Charles Maurras, the quarters of a mental institution for a presumably bleaker prison cell. The phenomenon involves issues in sociology rather than aesthetics. Nevertheless, it has its own intrinsic interest and can hardly be ignored in a discussion of art and morality. It is necessary to distinguish, of course, between the flouting of conventional morality, with its emphasis on superficial conformity and its confusion of morals and manners, and immorality of a more fundamental kind.

It is also necessary to distinguish between the integrity of the artist *qua* artist and the integrity with which he performs his other roles—as spouse, parent, friend, neighbor, citizen. Some artists—the less sophisticated—will say that morality for them consists solely in obligation to their art, to make it as good as possible, and that this all-absorbing commitment leaves no room for ordinary morality. More sophisticated artists may agree that *qua* man they have the same obligations as others, but insist that *qua* artist they have *only* to concern themselves with the integrity of their art. What does such integrity imply?

Just as the nature of a scientist's obligations are determined by the requirements of the scientific enterprise—so that he must seek truth to the best of his ability, avoid tampering with the evidence, and follow the evidence even if this goes contrary to his predispositions and preconceptions—so the artist's obligations derive from the nature of art. Immorality in the artist consists in reporting a world he does

[1] "The Question of Ezra Pound," *Partisan Review* (May 1949), p. 58; Cf. above, p. 88.

not see, feel, or believe in, as when he resorts to "formulas" or cliches to give people what he thinks they want and deliberately does not report his own fresh vision. Immorality consists in misrepresenting what he means, in persuading others that he is what he is not, in violating his aesthetic conscience for the sake of money or acclaim.

To be sure, one must distinguish between artist and entertainer, and between artist and publicist. A distinguished English novelist, Graham Greene, labels his books entertainments or novels. He has two roles which he keeps separate, entertainer and artist. Somerset Maugham thought of himself as writing for entertainment. Irving Berlin doubtless never thought of himself as artist at all, but George Gershwin adopted two roles, like Graham Greene. Book illustrators sometimes are just that, illustrators with no artistic pretensions. The propagandist, if he is just a "P.R." man writing entertainingly, is one thing; the artist saying in a hackneyed way what is not his own thought, is another.

There is no artistic immorality in the sheer entertainer, song writer, or illustrator when they are not artists and make no such claims. But there is artistic immorality when the man of talent claims to be an artist and belies his art. There is no immorality in Greene's writing entertainments when they are described as such. There would be if his novels were false to himself as artist. This, perhaps, is one key to artistic immorality: when the artist, for whatever adventitious reasons, is being false to himself, his gifts, and his vision. Is it the only key?

Can the several selves of an artist—or, indeed, of anyone else—be kept separate, as the foregoing comments assume? Can we say that the good or evil done by people of talent has no important bearing on the works of art they create? An affirmative answer is, of course, the unarticulated premise of those disposed to overlook the personal morality or immorality of the artist. As we have seen, Karl Shapiro, well-known poet and critic, argued the contrary, contending that a moral philosophy like Ezra Pound's "ultimately vitiates his poetry and lowers its standard as literary work." So, too, did Orwell, Viereck, Winters, and even Eliot in his later years.

But all this is part of a much larger question, and it cannot be settled until the larger question is resolved. To what extent, if any, must we reckon with the artist as a person in order to achieve a full appreciation of his work? To be sure, "appreciation" is a notoriously vague term, but at the very least it implies understanding, evaluation, and (in the broadest sense) enjoyment. If, as Thomas Mann once said, the artist's task is to endow the world with spiritual meaning, in the course of which "he uses thought, word, and image to set down his own life and, figuratively, life as a whole," is it not essential that we learn something about his life, his view of life, and the honesty and sincerity with which he performs this task? Granted that, as Mann suggests, for literary or art critics an artist's virtuosity must take precedence over his virtue, are the two easily separable in the broader and deeper sense of both?

However, if, as some believe, the biography of the artist is in fact relevant, the question may well be asked: what part of his biography? The fact that, like Philip Roth, he had a possessive Jewish mother? That, like T. S. Eliot, he was notably shy? Or, like Dylan Thomas, an alcoholic? Many have questioned the worth, from the point of view of art criticism, of such inquiry. They would concede the relevance of the biographical approach if it were possible to predict a man's work from the study of his life. We can say things about the relation of Keats' poems to the status of his affair with Fanny Brawne, but, they would ask, can we predict from the latter alone anything about poems we have not already read? Can we even

predict that Keats would write poetry if, as a matter of fact, we did not know that he had? What has the battle of Lepanto to do with *Don Quixote*? Knowing the book's existence, anyone can guess; Chesterton guessed that Don John of Austria was the model for the sorrowful knight. But there is no reason, on the basis of Cervantes' part in the battle, to predict that there would be a Quixote at all.[2]

However this may be, some will agree with William Barrett that "there is no escape from ourselves."

> *Existence is a dense plenum into which we are plunged, and every thought, wish, and fear is "overdetermined," coming to be under the infinite pressures within that plenum of all other thoughts, wishes, and fears. Fingerprints and footprints are our own, and Darwin has pointed out that our inner organs differ from person to person as much as our faces. The signature of ourselves is written over all our dreams like the criminal's fingerprints across his crime. The writer, no more than any other man, can hope to escape this inescapable density of particularity. But his difference is that he does not merely submit but insists upon this as his fate. It is his own voice which he wishes to resound in the arena of the world. He knows that the work must be his, and to the degree that it is less than his, to the degree that he has not risked the maximum of his being in it, he has missed the main chance, his only chance.[3]*

On the other side, W. K. Wimsatt and Monroe Beardsley have described what they call "The Intentional Fallacy," i.e., "a confusion between the poem and its origins, a special case of what is known to philosophers as the Genetic Fallacy."[4] To affirm that a designing intellect is "a *cause* of a poem is not to grant the design or intention as a *standard* by which the critic is to judge the worth of the poet's performance." Accordingly, they reject inquiries into the motives and purposes behind a creative work. This, of course, goes far beyond rejecting the relevance of such motives and intentions as artists have in their other roles as fathers, husbands, citizens. Even those intentions directly related to the work are excluded:

> *One must ask how a critic expects to get an answer to the question of intention. How is he to find out what the poet tried to do? If the poet succeeded in doing it, then the poem itself shows what he was trying to do. And if the poet did not succeed, then the poem is not adequate evidence, and the critic must go outside the poem—for evidence of an intention that did not become effective in the poem.[5]*

Now, whatever verdict we pronounce on this position from a *theoretical* point of view, in *practice* a vast amount of comment *is* concerned with the "intentions" of the artist and the antecedent conditions of such intentions, enough interest to justify great hesitation before we dismiss so strong and persistent a tendency as idle

[2]An important qualification of these arguments about life and work is that, when they are both known, either may be *useful* in understanding the other.

[3]"Writers and Madness," *Partisan Review*, January-February 1947, pp. 6–7.

[4]*The Verbal Icon* (Lexington, Ky.: University of Kentucky Press, 1954), p. 21.

[5]*Ibid.*, p. 4.

curiosity, or literary and gallery gossip, or mere prying into the private lives of celebrities.[6]

The intentions of an author may vary, to be sure. They may have to do with strictly technical devices and their consequences in the event of which their relevance to an aesthetic evaluation may be accepted more readily. A playwright may wish to make his audiences weep and misuse a device so as to make them laugh; he may be spoofing only to find himself taken seriously; an abstract-actionist may literally throw paint on a canvas only to produce something representational. But "intentions," as suggested earlier, may be of a different order having nothing to do with the use or misuse of technique. A writer may intend to gull his readers, he may surreptitiously proselytise for his religion, he may pretend to be serving the requirements of his art when he is interested only in grubbing for money, toadying for favor, or playing for easy applause, he may be a disgruntled misfit looking for a scapegoat or blaming society for his failings, he may, in Nietzsche's words, be "taking revenge with [his] works for some inner contamination." Typical terms in the lexicon of the critic who takes the latter considerations seriously will be "sincerity," "authenticity," "maturity," "honesty," "integrity."

Also, we have learned that intentions lie at different levels of consciousness, so that we must reckon with "unconscious" as well as conscious intentions. That, of course, is why (apart from suspicions about his honesty) we are sometimes not content to accept at face value what the artist *says* are his intentions; we want to know about *him* so that we can judge his intentions for ourselves. The artist may *say* that he intended to contribute, and he might well believe he was contributing, to a better understanding of love as a relationship between man and woman. If he were a homosexual, or had been consistently frustrated in his relations with women, this might not be a decisive disqualification, but some would say that it should cause us to examine his claims and beliefs carefully, as well as the work through which he sought to realize them.

In a more general way the issue is joined in a memorable debate, reprinted here, between two distinguished scholars and critics. If, as one of them (C. S. Lewis) says, the poet does not express his personality in his work, if "the objects ... which we contemplate in reading poetry are not the private furniture of the poet's mind,"[7] then we can forget about his motives and morals, since they will not affect his poetry. If on the other hand, we hold with E. M. W. Tillyard that we read Keats "in some measure because his poetry gives a version of a remarkable personality," and that part of the value of poetry consists in "gaining contact with the ... personality of the poet,"[8] his moral character becomes *critically* relevant in all senses of the term.

The issue takes on added meaning when we consider differences over the use of biographical material in literary or art criticism as they occur in a controversial area such as the relation of the homosexual artist to his work. Two selections have therefore been included in which Stanley Kauffmann and Benjamin DeMott take opposing views.

[6]Sometimes the historical context of a work is not known by later readers, and they may completely misinterpret what they read until they learn the author's intent. The same sentences then take on a different meaning. A splendid example is Edmund Burke's early book *A Vindication of Natural Society,* which was a satire and was understood as a satire. But a later age, unaware of this, assumed for years that Burke had outdone Rousseau in praising nature and denouncing civilization. Need one add that the satire was subtle?

[7]*The Personal Heresy* (London: Oxford University Press, 1939), p. 27. Cf. below.

[8]*Ibid.,* p. 35; Cf. below.

Central to all such discussions has been the work of Freud, whose contributions to our understanding of art and literature are evaluated here in a noted essay by Lionel Trilling. Freud assumes that artists are neurotic or have "not far to go," although he held them in high esteem and candidly attributed many of his important ideas to dramatists, poets, and novelists. His program calls for the interpretation of creative works by reference to the narcissism of artists and their unsatisfied longings in the real world which lead them to fantasy wish-fulfillment and substitute gratification. Accordingly, following a suggestion of Freud, his distinguished disciple, Dr. Ernest Jones, sought to solve the much-discussed problems posed by *Hamlet* by using Freudian concepts and techniques (*sans* the free associations evoked from a living patient) to discover what Shakespeare intended to say when he wrote *Hamlet*;[9] Dr. Franz Alexander more recently found the Freudian concepts of the ego, id, and super ego fully exemplified in all their dynamic relationships in *Henry IV,* and Freud himself sought a solution to the (now cliche) enigma of the Mona Lisa smile in Leonardo's early infatuation with his mother. The formidable weight of Freudian psychology, whether or not we question its techniques and its results, has thus been thrown on the side of looking to the artist for a proper understanding of his work.

Meanwhile, a massive phenomenon of our time now commonly known as *alienation* moves us in the same direction as Freudian psychology to concentrate on the artist himself. Alienation, as now commonly understood, is the condition of those who find themselves drifting in a world that has no meaning for them, crushed by a mass society, repelled by the materialism of a totalitarian or pecuniary culture, disillusioned by the disparity between the promise of their society and its performance, overwhelmed by the sheer absurdity of the human "predicament." The alienated individual feels isolated, manipulated, deracinated. He is bewildered, disoriented, the victim of unfocussed worries, in a word, *estranged*.

Alienation, long regarded by Marxists as an outcome of capitalist exploitation,[10] has a venerable history extending beyond the young Marx of the *Economic and Philosophic Manuscripts* at least as far as Hegel's "Contrite Consciousness." For different reasons, elitists from Carlyle to Eliot and Ortega y Gasset have proclaimed their alienation, as when Carlyle sourly called the "Mammon-Gospel of Supply-and-Demand" one of the "shabbiest ... ever preached."[11] Ortega found that "the mass crushes beneath it everything that is different, everything that is excellent, individual, qualified and select,"[12] and Eliot deplored "the tendency of unlimited industrialism ... to create bodies of men and women—of all classes—detached from tradition, alienated from religion and susceptible to mass suggestion; in other words, a mob."[13]

Freud notwithstanding, not all alienation is neurotic. On the contrary, since the appearance of the *professional* artist, alienation from society may help him establish his identity and thus avoid alienation from himself and thereby the divided self that breeds (or is) neurosis. The words of Jung seem especially apt: "The artist's relative lack of adaptations becomes his real advantage; for it enables him to keep aloof from the high-ways, the better to follow his own yearning and to

[9]Cf. *Hamlet and Oedipus* (London: Gollancz, 1949; republished by Doubleday in paperback, 1954).

[10]Cf. Marx's *Economic and Philosophic Manuscripts of 1844.*

[11]*Past and Present* (London, 1843), p. 8.

[12]*Revolt of the Masses.*

[13]"The Idea of a Christian Society," *Christianity and Culture* (New York: Harvest, 1940), p. 17.

find those things of which the others are deprived without noticing it."[14] Auden has observed that "every artist feels himself at odds with modern civilization."[15] But such an artist is not therefore without a home; he has his own subculture, centered in Greenwich Village, Chelsea, the Left Bank, North Beach and, increasingly for American artists, the campuses of our universities.

However, much of today's alienation is different, distinguished by its intensity and the inclusiveness of its condemnation of the contemporary world, by its vengeful, apocalyptic visions, its sheer vituperativeness. And the discontent is a peculiar variety removed, if not entirely from war, then from hunger, storm, plague, and the other immemorial disasters which have brought men grief. As Kenneth Keniston has pointed out, "Formerly imposed *upon* men by the world around them estrangement increasingly is chosen *by* them as their dominant reaction to the world." The result is that in our society, "alienation characteristically takes the new form of rebellion without a cause, of rejection without a program, of refusal of what is without a vision of what should be."[16]

The world of arts and letters has been deeply affected by this malaise, with responses that vary from moral ennui to wild utopian visions, from resigned and lonely despair to militant collective protest. And, as Eric and Mary Josephson have noted, "the artist's revolt is directed not only toward the atomized world of men and its values, but *toward art itself* which ... becomes deliberately nihilistic, meaningless, even anti-art and 'ugly.' "[17] And Keniston points out the painfully evident when he observes that "The prevailing images of our culture are images of disintegration, decay, and despair; our highest art involves the fragmentation and distortion of traditional realities; our best drama depicts suffering, misunderstanding, and breakdown; our worthiest novels are narratives of loneliness, searching, and unfulfillment; even our music is, by earlier standards, dissonant, discordant, and inhuman."[18] Alienation may be a personal or a social problem—there is strong support for both approaches. Granted the flawed world they deplore—a world that seems even more flawed to those who have embraced the "cult of the present"—alienation these days may have become for some, including many artists, a bandwagon[19] on which they ride away from their own inadequacies. But, social or personal, escape mechanism or valid social criticism, the phenomenon of alienation greatly strengthens the thesis of those who hold that art cannot be adequately evaluated without reference to the value judgments of the artist—in this case an overwhelming hostility to the world in which he lives. Accordingly, alienation as it affects the arts will be discussed in the concluding section of this volume.

[14]*Contributions to Analytical Psychology* (London: Routledge and Kegan Paul, Ltd., 1928), p. 349.

[15]"The Poet and the City" in *The Dyer's Hand and Other Essays* (New York: Random House, 1948), p. 88.

[16]*The Uncommitted* (New York: Harcourt, Brace, Jovanovich, 1960), pp. 3, 6.

[17]*Man Alone* (New York: Dell, 1962), p. 45. My emphasis.

[18]*Op. cit.,* p. 4.

[19]It may yet become avant garde to urge that our world is better than it used to be. There is, of course, no way of finding out if, having rejected the study of history as "irrelevant," we have no way of making comparisons.

The Personal Heresy I

C. S. Lewis

C. S. Lewis (1898-1963), a British writer and scholar, was born in Belfast, Ireland. He taught English at Magdalen College, Oxford, of which he was a Fellow, since 1925. In a series of witty and unusual books, he defended Christianity and its basic doctrines through dialogue, story, and argument. The greatest of his successes, The Screwtape Letters (1942), was a dialogue between devils, in hell and on earth. Other books include Out of the Silent Planet (1938), The Great Divorce (1945), and Miracles (1947). Like G. K. Chesterton before him, Lewis defended orthodoxy in a most unorthodox fashion. His preoccupation with religion attracted more public notice than his professional interest in literature and aesthetics (as A. E. Housman is thought of as poet, not a classical scholar). Lewis' other interests are argued here with rare felicity of style.

During the war I saw an anthology which contained the work of some 'young soldier poets', as we used to call them. The advertisement on the wrapper promised that if you bought the book these young men would tell you things about themselves which they had never told to 'their fathers, or their sweethearts, or their friends'. The assumption was that to read poetry means to become acquainted with the poet, as we become acquainted with a man in intimate conversation, to steep ourselves in his personality; and the appeal based on this assumption was an appeal to curiosity. When that appeal is put so crudely, it endangers no educated reader's judgement; and if that assumption were made only in advertisements, it would not be worth consideration. But it is impossible not to recognize in the passage which I have quoted the logical conclusion of a tendency from which, in our own day, even reputable criticism is not always exempt. Few will deny that the role of biography in our literary studies is steadily increasing; and if we look into the most popular literary biographies of the last decade or so, we shall find that in them the poet's life is connected with his work after a fashion quite alien from the methods of Johnson. Poetry is widely believed to be the 'expression of personality': the end

which we are supposed to pursue in reading it is a certain contact with the poet's soul; and 'Life' and 'Works' are simply two diverse expressions of this single quiddity. In a work published by His Majesty's Stationery Office we are urged to use English literature as 'a means of contact with great minds'. This seems innocent enough, but there is more behind. In Dr. Tillyard's *Milton* ... [he] complains that such matters as style 'have concerned the critics far more than what [*Paradise Lost*] is really about, the true state of Milton's mind when he wrote it'.[1] The concealed major premiss is plainly the proposition that all poetry is *about* the poet's state of mind.... More difficult to interpret is Mr. T. S. Eliot's statement that 'The rage of Dante ... the deep surge of Shakespeare's general cynicism and disillusionment, are *merely* gigantic attempts to metamorphose private failures and disappointments.[2] Of this it would, perhaps, carry us too far to say that what we most desire to know of an 'attempt' is whether it failed or succeeded, and that 'metamorphosis' is a dark conception till we have asked 'Metamorphosis *into what?*' It concerns our present purpose more to notice the assumed, and concealed, major premiss that the cynicism and disillusionment put into the mouths of some Shakespearian characters are Shakespeare's. Even dramatic poetry is tacitly assumed to be the expression of the poet's personality.... I shall maintain that when we read poetry as poetry should be read, we have before us no representation which claims to be the poet, and frequently no representation of a *man*, a *character*, or a *personality* at all.

I shall begin by tackling the problem on a very shallow and popular level. Dismissing all the more ambiguous senses in which the word 'personality' can be used, and in which we can be said to *meet* or *come into touch* with it, I shall try to show that there is at least one very obvious sense in which it is certain that the object offered to us by a good poem is not the poet's personality. My position—in this obvious sense, which will suffice at the present stage—is so simple that a few examples will make it good. I read, for instance,

> *Whenas in silks my Julia goes,*
> *Then, then, methinks how sweetly flows*
> *That liquefaction of her clothes.*

If the theory which I am attacking, taken in its crudest sense, were true, it ought to be true that what I derive from these lines is the impression of a certain personality. My pleasure ought to consist in the perception of that personality, and the permanent result of the poem ought to be an enrichment of my conception of human nature. Now there is no doubt that I can extract from the poem the idea of a humorous nature, amorous yet dainty, dowered with an almost feminine sensibility to the qualities of clothes. The question is whether that is presented to me as part of my poetical experience. For, of course, any and every result which may follow from my reading of a poem cannot be included in my poetical apprehension of it, and cannot, therefore, belong to the poem as a poem. Thus, for example, I can learn from reading these lines that the pronunciation 'clo'es' for *clothes* is at least as old as the date at which the poem was written. That piece of philological knowledge is a result of the poem; but clearly philological truths do not make part of the poem, nor do I encounter them so long as I am apprehending it with my imagination, but only when I come to reflect upon it, later, and in a very different light. The problem, therefore, is whether my perception of the poet's

[1]*Milton*, E. M. W. Tillyard, 1930, p. 237.
[2]*Selected Essays*, T. S. Eliot, 1923, p. 137. Italics mine.

character is part of my direct experience of the poem, or whether it is simply one of those later and unpoetical results. I think this is answered as soon as it is asked. I know that the poet was sensitive to the qualities of silk. How? Plainly because he has conveyed them so vividly. But then he must have conveyed or expressed them to me *before* I can know that he was thus sensitive, and to say that he has conveyed them to me means that I myself, in reading the poem, became conscious of silk in a new way. I know that his expression is good only because that expression has already wrought its effect on me. I see that 'liquefaction' is an admirably chosen word; but only because I have already found myself seeing silk as I never saw it before. The first object presented to me is an idea of silk. To account for the unusual vividness of that idea, I may then analyse the poem and conclude 'It is the word *liquefaction* that does the trick'; and only then, by a third step, can I conclude 'With what eyes he must have seen silk to think of such a word', and thence 'He must have been that sort of man'. In other words, my idea of the poet presupposes that the poem has already had its effect on my imagination, and cannot, therefore, be part of that effect. The only experience which has any claim to be poetical experience is an apprehension, not of the poet, but of silk. Perception of the poet's skill comes later, and could not come at all unless I had first and foremost apprehended the silk; and perception of the personality implied by such skill comes later yet. It is twice removed from the essential poetic experience.

But perhaps I seem to have chosen, unfairly, an example in which the poetry is of an unusually sensuous and simple type. In fact, however, the more subtle types of poetry differ only by being less manageable for purposes of exposition.

Very old are we men;
Our dreams are tales
Told in dim Eden
By Eve's nightingales.

Here it is very much harder to indicate by prose pointers the nature of the object presented to me. But at least we may be quite certain what it is not. It is not a picture of the poet. It is something extended interminably in time, shrouded in mystery, and yet, for all its age, carrying still about it some hint of the dewy freshness of primeval myth. That may not be a good description of the thing, but it would be a much worse description of Mr. De la Mare. If I try to imagine Mr. De la Mare, I can imagine him only as an individual living in a particular time and place, with other times and places forming a sort of context that stretches away indefinitely on all sides of him. But what I look towards in reading the poem is that context itself—the ages of human history. How could the object be the idea of a man who himself is inside that context? Where the thing presented already contains the poet as one of its last important details, how could it also *be* the poet himself?

To be sure there are poems in which the thing that we attend to is unmistakably a human being in a certain state of emotion. Thus, for example,

I breathe again.
Trances of thought and mountings of the mind
Come fast upon me. It is shaken off,
That burthen of my own unnatural self,
The heavy weight of many a weary day
Not mine, and such as were not made for me.

Such lines might seem to support the case of my opponents; for beyond question what they convey to me is the keener awareness of a certain kind of human feeling—just as Herrick's poem enabled me to see the liquid quality of silk as I had never seen it before. But the difficulty is only apparent. It is easy to suppose that we do not know whether these lines come from a work where the poet is speaking in his own person or from a speech by one of the characters in a play. And it is clear that if they came from a play they would not directly present us with the poet's character. The Drama is, in fact, the strongest witness for my contention. Even my convinced opponents would falter in dealing with the Drama, for there the poet is manifestly out of sight, and we attend not to him but to his creations. How far any of them may resemble him is, no doubt, an interesting question; but to ask that question, still more to answer it, is clearly to have turned from imaginative apprehension to later and unpoetic reflection. The objective or impersonal theory of poetry which I am defending finds its easiest application in the drama and the epic. And if we return, with this in our minds, to the passage under consideration, we must surely agree that there is nothing in the poetry itself to show whether it is dramatic or not. We happen to know that it is from Wordsworth's *Prelude.* But we do not know that by imaginative experience. Or if we take the *Prelude* as a whole, the appreciation of it as poetry does not include the knowledge that it is autobiographical. A process of human development, that is, a particular man growing up, is presented to us; that this man is, or is intended to be, Wordsworth himself, we learn from literary history—unless we are so simple as to suppose that the use of the first person settles the question. The same holds good of all poetry. We do not know whether the story of the sonnets was Shakespeare's own story or not; we do not know whether Milton really grieved for the death of Mr. King or not; and if we know that Shelley had really met Keats, we do not know it in and by appreciating *Adonais.* So that at the very best, all we can mean by claiming to find the poet's personality in a poem is that we find some personality, which may, on quite other grounds, be discovered to be that of the poet. I submit that this is not what is ordinarily meant by *knowing* or *getting into touch with* a man. If I have the idea of a particular character, and it just happens that a man, say, in Timbuctoo exists who does, as a matter of fact, bear that character—a man I have never heard of—it would be a very odd use of language to say that I knew, or was in touch with, the man as soon as I had the idea. At best, therefore, we meet the poet, even in the most personal lyric poetry, only in a strained and ambiguous sense. But we can go much farther than this.... The characteristic of a poet is, after all, that he is a poet; and if poems put us into touch with him, the characters presented to us in all poems, however diverse they may be, ought, at least, to have this in common, that they are all poets. But the great crowd of lovers, mourners, fighters, and the like whom we meet in sonnets and songs are not poets. They may be spoken of in the first person, but they differ from their creators by this very fact that they are merely loving, mourning, and being angry; whereas the real poet is writing poetry about love, or sorrow, or anger....

It follows, then, at least in the crudest and most obvious sense of the words, that the thing presented to us in any poem is not and never can be the personality of the poet. It is the liquid movement of silk, or the age and mystery of man, or a particular man escaping from a long period of constraint—never Wordsworth, or De la Mare, or Herrick. But here a distinction must be made. Poetry, after all, is not science or history; and the silks are not described in the manner of the mercer, nor the history of man after the manner of the anthropologist. It is, in fact, these things, not as they are, but as they seem to be, which poetry represents to me; or so I shall be told. It may be true that what I am aware of in reading Herrick's poem is

silk, but it is not silk as an object *in rerum natura*. I see it as Herrick saw it; and in so doing, it may be argued, I do come into contact with his temperament in the most intimate—perhaps in the only possible—way. For the moment I not only accept but embrace this view of the matter. It introduces a point of the last importance which the crudest form of the personal theory had overlooked. Let it be granted that I do approach the poet; at least I do it by sharing his consciousness, not by studying it. I look with his eyes not at him. He, for the moment, will be precisely what I do not see; for you can see any eyes rather than the pair you see with, and if you want to examine your own glasses you must take them off your own nose. The poet is not a man who asks me to look at *him*; he is a man who says 'look at that' and points; the more I follow the pointing of his finger the less I can possibly see of *him*....

Having grasped this truth, I proceed to a second question. What is the nature of this consciousness which I come to share but not to study, to look *through* but not look *at*, in appreciating a poem? The personal theory will hold that the consciousness in question is that of the poet, considered as an individual, contingent, human specimen. Mr. Smith sees things in one way; Mr. Jones sees them in another; Mr. Wordsworth sees them in a third. What we share in reading Wordsworth is just Wordsworth's point of view as it happens to exist in him as a psychological fact; and that is why modern criticism attends so willingly to psychology and biography. And as long as we are dealing with romantic poets not far removed from us in time, this view of the matter is not unplausible. It cannot, however, have escaped any one's attention that there is a whole class of poetical experiences in which the consciousness that we share cannot possibly be attributed to any single human individual. Let us consider an example.

And Babylon, the glory of kingdoms, the beauty of the Chaldees' excellency, shall be as when God overthrew Sodom and Gomorrah. It shall never be inhabited, neither shall it be dwelt in from generation to generation: neither shall the Arabian pitch tent there; neither shall the shepherds make their fold there. But wild beasts of the desert shall lie there; and their houses shall be full of doleful creatures; and owls shall dwell there, and satyrs shall dance there. And the wild beasts of the islands shall cry in their desolate houses, and dragons in their pleasant palaces.

It does not greatly matter how highly the reader values the imaginative impression produced upon him by these words: that they produce some imaginative impression, that he comes to enjoy a new and heightened mode of consciousness in reading them, will not be denied. The question arises whose consciousness it is. Who was the man to whom this mode belonged, the man whose personality or temperament we are coming to share?

Very little argument suffices to show that it cannot have been the original author. The mood to which we are introduced by these lines was not only not normal in the Hebrew writer; it did not and could not exist in him at all. To begin with 'doleful creatures', 'owls', 'satyrs', 'wild beasts of the islands', and 'dragons' are mere mistranslations. Whatever they evoke or express was wholly absent from the mind of the author, and, what is worse, other things were there in its place. Only the crudest view of the relations between language and imagination could lead us to suppose that the experience which lacked these words and used others in their place was at all like the experience of the modern reader. But that is not all. The theme of the whole passage is Babylon and the fall of Babylon. Now the *sound* Babylon did not exist in the original: yet that sound counts for a great deal in our

Biographical Criticism

experience of the passage. Babylon: the very word is like a bell. But Isaiah—or whoever it was—never heard that bell toll. He may have heard a better bell, but that is nothing to the purpose. If we turn from the sound to the idea—we may grant that false abstraction for the argument's sake—the rift between our mood and that of the original becomes even wider. For us Babylon is far away and long ago; it comes to us through the medium of centuries of poetry about the East and about antiquity; it comes to us as descendants of those Germanic poets who had from the first a romantic and elegiac delight in the ruin and decay of greatness. We have read of Troy, too, and perhaps, in our salad days, we loved the courts where Jamshid gloried and drank deep. Now Babylon, to the writer, was neither long ago nor far away. Its greatness was not the cloudy greatness of old empires fallen in the past, but the oppressive greatness of an enemy and a neighbour. He felt about Babylon not as we feel about Troy and Nineveh, but as some Indian nationalists may feel about London. The poetry of Babylon, for us, belongs to the same world as

> But all about the rugged walls were hung
> With riven moniments of time forepast.

The poetry, for him, belonged rather to the world of

> When we've wound up the watch on the Rhine.

And with this, presumably, analysis may rest. It is obvious that no two experiences could be more grotesquely unlike than that of the writer, and that of the modern reader, of this passage. Nor shall we fare much better if we turn from the original writer to the translator. No one who has himself ever tried to translate will doubt that what was uppermost in the mind of the translator as he wrote was the problem of translation itself. When he wrote 'dragons' he was not inquiring whether this completed the picture or expressed his emotion, but whether it rendered the Hebrew. Nor did he look at the Hebrew itself aesthetically; he worked in fear and trembling to transmit without loss what he believed to be the literal record of the word of God. Even if some imaginative element crept in amidst his philological and theological preoccupations, it must have differed essentially from that which we enjoy; for as his English version grew he had the Hebrew always before him, and was thus inevitably involved in a work of comparison which has no parallel in our experience of the passage.

The result, then, is this. Such a passage gives us imaginative experience. In having that experience we do come to share or enjoy a new kind of consciousness, but that consciousness is not the consciousness of any single individual. And it will be plain that the passage I have chosen is only one of a very large class.... Every work of art that lasts long in the world is continually taking on these new colours which the artist neither foresaw nor intended. We may, as scholars, detect, and endeavour to exclude, them. We may, as critics, decide that such adventitious beauties are in a given case meretricious and trivial compared with those which the artist deliberately wrought. But all that is beside the purpose. Great or small, fortunate or unfortunate, they have been poetically enjoyed. And that is enough for my purpose. There can be poetry without a poet. We can have poetic experience which does not consist in sharing the 'personality' of a poet. To be encrusted with such poetless poetry is the reward, or the penalty, of every poem that endures....

What now remains of the personal dogma? We have seen reason to reject the view that in reading poetry we were presented with some object that could be described

as 'the poet's personality'. At best we 'shared' or 'looked through' his personality *at* something else. But even this would not serve as a description of poetry in general; for we saw that in many cases the personality—if you still want to call it so—which we came to share was not that of any single human being. It was not, in fact, the personality of a person. More explicitly, it was not a personality at all. It was a mood, or a mode of consciousness, created temporarily in the minds of various readers by the suggestive qualities which certain words and ideas have taken on in the course of human history, and never, so far as we know, existing normally or permanently—never constituting the *person*—in any one....

To ask in general if poets express their personality in their poetry is to ask whether they habitually lived clothed in all that panoply of metaphor and rhythm which they use for their work: whether the dancer, as Sir Toby suggested, goes to church in a sink-a-pace and comes home in a coranto. The poets themselves supply the answer. From Homer invoking the Muse down to Herrick prosaically noting that every day is not good for verses—from the romantic talking of his 'genius' to Emerson declaring that there was a great deal of inspiration in a chest of good tea—they all unequivocally declare that the words (and a perception expressed in other words is another perception) will not come for the asking, are rare and wooed with hard labour, are by no means the normal furniture of the poet's mind, are least of all his own possession, his daily temper and habitual self....

I do not ask that those who agree with me should deny the essential difference between the poetry of Shakespeare and the poetry of Racine. I do not even object to their talking of it, when convenience so dictates, as a difference of personality. I will even consent to speak of the Racinity of Racine, and the Shakespearianity of Shakespeare: only, let us remember what we mean. Let us remember that their poethood consists not in the fact that each approached the universal world from his own angle (all men do that), but in their power of telling us what things are severally to be seen from those angles. To use their poetry is to attend to what they show us, to look, as I have said before, not at them, but through them at the world. To say that they show us different things is not to say that they are creating what they show us, out of their personalities, but only that they are both finite....

A poet does what no one else can do: what, perhaps, no other poet can do; but he does not express his personality. His own personality is his starting-point, and his limitation.... If he remains at his starting-point he is no poet: as long as he is (like the rest of us) a mere personality, all is still to do. It is his business, starting from his own mode of consciousness, whatever that may happen to be, to find that arrangement of public experiences, embodied in words, which will admit him (and incidentally us) to a new mode of consciousness. He proceeds partly by instinct, partly by following the tradition of his predecessors, but very largely by the method of trial and error; and the result, when it comes, is for him, no less than for us, an acquisition, a voyage beyond the limits of his personal point of view, an annihilation of the brute fact of his own particular psychology rather than its assertion.

The objects, then, which we contemplate in reading poetry are not the private furniture of the poet's mind. The mind through which we see them is not his. If you ask whose it is, I reply that we have no reason to suppose that it is any one's. It comes into existence, here and there, for moments, in varying degrees: that it exists anywhere permanently and as a whole—that it anywhere forms a *person*—is an unnecessary hypothesis.... It will add faith to the refutation if we can ascribe causes for the error. One cause is not far to seek. In an age when many have to talk of poetry, this personal view offers obvious advantages. Very few care for beauty; but any one can be interested in gossip. There is always the great vulgar anxious to

know what the famous man ate and drank and what he said on his deathbed; there is always the small vulgar greedy to lick up a scandal, to find out that the famous man was no better than he should be. To such people any excuse for shutting up the terrible books with all the lines and lines of verse in them and getting down to the snug or piquant details of a human life, will always be welcome....

The Personal Heresy II

E. M. W. Tillyard

E. M. W. Tillyard (1889–1962), a widely read literary scholar, has exerted great influence on the teaching of English literature. Although he worked in archeology as a young man, he devoted himself almost entirely to English literature later. He was a fellow of Jesus College, Cambridge University, at three separate times, and from 1945–1959, Master of Jesus College. He published some seventeen books, of which perhaps the most noted are Milton *(1930),* Shakespeare's Last Plays *(1936),* The Elizabethan World Picture *(1943),* Shakespeare's History Plays *(1944),* The English Epic and Its Background *(1954), and* The Muse Unchained *(1958). The following is his response to C. S. Lewis' comments on the relation of the poet to his poetry.*

In his brilliant essay on *The Personal Heresy in Criticism* Mr. C. S. Lewis mentioned my *Milton* as a book in which poetry was treated as the expression of personality. And up to a point he may have been right. But as he is hostile to my supposed way of thinking, and as I agree with a good deal of his essay, it seems either that I did not make myself clear or that Mr. Lewis is not entirely right. So I welcome this opportunity of saying what I mean by personality in literature. However, though certain cross-purposes may be straightened by further discussion, I do not say that much of Mr. Lewis's essay is not extremely provocative and controversial. With some of it I disagree; and as the matters of disagreement seem to me well worth dwelling on, I offer the comments that follow. I hope that my being stirred to argue the point with Mr. Lewis may be taken as my warm tribute to his essay's excellence.

As a preliminary, I must express surprise that Mr. Lewis considers the Personal Heresy, as he calls it, a sign of modernity. I should have thought it slightly shop-soiled. Mr. Lewis quotes an ambiguous passage from Mr. T. S. Eliot as supporting it: yet what weight can this passage have in the face of so uncompromising an attack on the Personal Heresy as that author's essay on *Tradition and the Individual Talent?* Here Mr. Eliot says that 'the progress of an artist is a continual self-sacrifice, a continual extinction of personality', and that 'honest criticism and sensitive appreciation is directed not upon the poet but upon the poetry'. And he comes to the conclusion that for the poet the mind of Europe and of his own country is much more important than his own private mind. Now these sentiments are not only close to Mr. Lewis's but they agree with a strong

From *The Personal Heresy* by E. M. W. Tillyard and C. S. Lewis (London: Oxford University Press, 1965), pp. 31–48. Copyright 1939 by E. M. W. Tillyard and C. S. Lewis. Reprinted by permission of the publisher, Oxford University Press.

modern tendency, whose limits are not easily drawn, to belittle the individual in comparison with the race, the personal in comparison with the abstract, the Renaissance in comparison with Byzantium. Whatever the fate of this tendency—it may peter out in a few years for all we can tell—at the moment it is modern, and the opposite tendency to cling to the personal, even if fated shortly to prevail, just fails to be modern....

To turn now to the words 'personal' and 'personality', it is plain how easy misunderstanding may be if we consider the following sentence of Mr. Lewis's. In commenting on the passage from Keats's *Hyperion* beginning—

> *As when, upon a tranced summer-night,*
> *Those green-rob'd senators of mighty woods,*
> *Tall oaks ...*

he writes:

> *It is not relevant that Keats first read about senators (let us say) in a little brown book, in a room smelling of boiled beef, the same day that he pulled out a loose tooth; it is relevant that the senators sat still when the invading Gauls entered the Senate House; it is relevant that Rome really established an empire.*

In this passage Mr. Lewis implies that 'personal' as a critical term includes every accident however trivial connected with the author. No one can complain that he does so, but I should guess that not a few supporters of the 'personal heresy' would simply ignore such trivialities in their conception of personality. They would attach them to the sphere of literary gossip, not to that of criticism. Certainly I should never dream of giving them any critical value in themselves and I should agree that to recall such things when reading poetry would be grossly inappropriate....

If Mr. Lewis in attacking the personal heresy is wishing to point out that some of the labour spent in recent years on Johnson and Lamb, for instance, is anecdotal rather than critical, and that to confound the two spheres is a heresy, then he has my support.

Of course Mr. Lewis does not confine 'personal' to this trivial or accidental sense. He grants that it is possible through poetry to come into contact with a poet's temperament in the most intimate way. The reader shares the poet's consciousness. But, according to Mr. Lewis, even so the personal contact involved is relatively unimportant: first, because the personality with which the reader achieves contact is not the poet's normal personality but a heightened, temporary, perhaps alien, personality; secondly, because that personality is a means of vision rather than the thing ultimately seen. The personal heresy consists in the reader's seeing the poet's *normal* personality in his poetry, and in focusing his eyes on that personality instead of letting them contemplate the universe in a particular way.

Now if it is heretical to hold that part of the value of poetry consists in gaining contact with the normal personality of the poet, then I am a heretic. But I shall probably be using the word 'normal' in a way Mr. Lewis would disclaim. When he imagines Keats reading about senators in a little brown book in a room smelling of boiled beef he attaches these supposed facts to Keats's normal personality. I should do nothing of the sort, but call them as irrelevant to his normal personality as to the passage of *Hyperion* under discussion. In other words by 'personality' or 'normal personality' I do not mean practical or everyday personality, I mean rather some mental pattern which makes Keats Keats and not Mr. Smith or Mr. Jones.

(Pattern is of course a bad word because it implies the static, whereas personality cannot remain fixed: the poet's personality is in the pattern of the sea rather than in that of a mosaic pavement.) And I believe we read Keats in some measure because his poetry gives a version of a remarkable personality of which another version is his life. The two versions are not the same but they are analogous. Part of our response to poetry is in fact similar to the stirring we experience when we meet some one whose personality impresses us. Such a person may startle us by the things he does, but quite outside anything he does there will be a distinction about him which, though difficult to define, we prize and which has the faculty of rousing us to some extent from our quotidian selves. This person may be subject to accidents, such as toothache, irregular habits, or an uncertain temper, which interfere with our enjoying this distinguished mental pattern of his; yet we know that the pattern is there. Though subject to change it is definite enough to be called habitual; it can indeed be looked on as his normal self underlying the accidents of quotidian existence.

One of the readiest ways of pointing to the function of personality in poetry is by means of the word style. 'Style' readily suggests the mental pattern of the author, the personality realized in words. Style in poetry is partly a matter of rhythm; and rhythm, Dr. Richards says very truly in *Science and Poetry*, 'is no matter of tricks with syllables, but directly reflects personality'. Mr. Lewis would probably define style as the poet's credentials certifying him a person whom you can trust in the quest of bringing back true reports on the universe; and consider the report far more important than the credentials. But I should assert myself that experience shows how directly personality revealed through style can constitute the major appeal of poetry. It is pleasant to choose an example from a modern poet who considers poetry an escape from personality rather than an expression of it. In Mr. T. S. Eliot's latest work, *The Rock*, the most successful passages are those where the author's characteristic rhythms and word-arrangements have freest scope, where his style is most obviously recognizable, in other words when he is most himself.

> *A Cry from the North, from the West and from the South:*
> *Whence thousands travel daily to the timekept City;*
> *Where My Word is unspoken,*
> *In the land of lobelias and tennis flannels*
> *The rabbit shall burrow and the thorn revisit,*
> *The nettle shall flourish on the gravel court,*
> *And the wind shall say: 'Here were decent godless people:*
> *Their only monument the asphalt road*
> *And a thousand lost golf balls.'*

Here the style *is* the poetry. The rhythm has a tense pregnant hush, simple in seeming, however subtle in the attainment, that sets off, that exploits to the utmost, the startling mixture of biblical reference and golf balls. It is entirely individual to the author, it reflects a poetical personality that quickens our pulses, and we value it far more than any heightened apprehension the passage may give us of the things of which it speaks. Mr. Lewis might retort by attacking Mr. Eliot, for all his professions of classicism, to the romantic tradition, and by pointing to his admission that for that tradition the personal theory does not work too badly. So I had better choose a second example not open to this retort; and I cannot do better in illustrating how widely I differ from Mr. Lewis in my conception of the personal

sphere in literature than choose the passage from Isaiah to which he refuses all personal quality whatsoever:

And Babylon, the glory of kingdoms, the beauty of the Chaldees' excellency, shall be as when God overthrew Sodom and Gomorrah. It shall never be inhabited, neither shall it be dwelt in from generation to generation: neither shall the Arabian pitch tent there: neither shall the shepherds make their fold there. But wild beasts of the desert shall lie there; and their houses shall be full of doleful creatures; and owls shall dwell there, and satyrs shall dance there. And the wild beasts of the islands shall cry in their desolate houses, and dragons in their pleasant palaces.

First, I am willing to admit with Mr. Lewis that we do not through this passage get in touch with the personality of the original author, or at least, if we see him, it is at best through a mist. But with his remarks on the translator I disagree. Mr. Lewis considers that he was so preoccupied with philological and theological matters that his own personality could find no entrance. This to my mind is to misunderstand not only translation but any art that appears to consist in getting a job of work done. Rule out the possibility of the translator mediating his own self, and you turn much early painting and sculpture, where the artist is fighting to render (as he thinks) a convincing likeness, into a mere technical exercise. On the contrary, it is precisely when a translator has worked himself up into an excited desire to do justice to a fine passage or a primitive sculptor is growing triumphant at surmounting a technical difficulty that his own mental pattern has the chance of manifesting itself. The artist will probably think his personality is lost in his non-personal activity, but the result may quite belie his own expectations. The sculptor of the Delphic Charioteer would have been incredulous if he had been told that his 'personality' had in any way entered into the figure of that impassive, severely draped young man; he probably thought he had done a good job of work and made a good imitation of the sort of driver who ought to win a chariot race for an illustrious prince. Yet the statue is like no other statue on earth, and I believe this unlikeness to be both an important element in the statue's excellence and to be connected with the sculptor's personality. Similarly the passage from Isaiah has a quite individual ferocity of rhythm which, if we heed it, will make the passage far less remote and romantic than Mr. Lewis would have it be, and incidentally, not too far removed from the immediacy which he very justly postulates for the original. 'For us', says Mr. Lewis, 'Babylon is far away and long ago': possibly, but was it so for a Protestant divine writing not long after the Gunpowder Plot? Not that the translator consciously or literally thought the passage a prophecy of the fall of the Papacy, and that he believed dragons would writhe in the ruined halls of the Vatican, but I suspect that Babylon evoked the Protestant fervour which was a motive in the translator's mental pattern. Of course a modern reader may let his mind be guided by the associations that the various evocative words in the passage have got for him: but this is rather an indulgence of the reader's own personal proclivities than a proper reading; 'personal' in a far less legitimate sense than in that of trying to establish contact with the mental pattern of the author.

When I spoke of the sculptor of the Delphic Charioteer having no notion that his own personality had anything to do with a statue, I was hinting at a paradox that may go a good way to explaining why people who may agree at bottom appear to think so differently about personality in literature. When Mr. Eliot calls poetry 'an escape from personality', he means more than an escape from the accidents that attend a person in everyday life. He is trying to describe what it feels like when a

Biographical Criticism

man succeeds in writing poetry. The feeling (and other poets confirm Mr. Eliot) brings with it the impression of a complete abandonment of personality, analogous to the feeling of 'getting out of yourself' that may occur in many non-literary contexts. Mr. Eliot speaks of the poet 'surrendering himself wholly to the work to be done'. The paradox consists in the poet often producing the most characteristic and personal work through this very process of self-surrender. The more the poet experiences this abandonment of personality, the more likely is the reader to hail the poet's characteristic, unmistakable self....

However, granted the paradox, there remains another critical sense of the word personal. It is best set forth through Coleridge's comparison of Shakespeare and Milton in the fifteenth chapter of the *Biographia Literaria:*

While the former darts himself forth, and passes into all the forms of human character and passion, the one Proteus of the fire and blood; the other attracts all forms and things to himself, into the unity of his own ideal. All things and modes of action shape themselves anew in the being of Milton; while Shakespeare becomes all things, yet for ever remaining himself.

Now in a sense Shakespeare was just as thorough as Milton in impressing his own personality on the reader. But just because Shakespeare's own mental pattern largely consisted of an almost unexampled power of adapting itself to the shifting experiences of life so as to extract the utmost mental nourishment from them, his personality makes a much less precise effect on us than does the more rigid personality of Milton. When then we talk of the poetry of Milton or of Wordsworth being more personal than that of Shakespeare or of Keats we may be meaning that it expresses a more austerely rigid nature. Now these fluid and rigid natures, although they may both be transmuted into poetry and become thereby accessible, do react differently on the relation between the poet's life and the poet's art. The fluid, adaptable, receptive natures, granted power, are likely to be pure artists and to empty their lives for the sake of their art. Their power, their fierceness go to solving their artistic problems. Flaubert is habitually quoted as an author of this kind. The more rigid natures, who insist, for all their sensibility to impressions, on imposing their own very definite patterns on the world of their vision are likely to be interesting persons in their private lives, apt to do more notable things and to impress themselves on those around them. Thus Wordsworth must needs poke his nose into the French Revolution.

Before drawing some critical deductions from these statements, I wish to say that the above general division of authors into the fluid and empty-lived on the one hand, and the rigid and full-lived on the other, does not invalidate the analogy I postulated above between the mind-pattern as expressed in art and the mind-pattern as expressed in life. True, the analogy between a biography composed of a few dry facts supplemented by a few trivial anecdotes and a beautifully proportioned body of poetry can appear ridiculous. But it may be that the two versions differ less in kind than in completeness. One is a perfect volume; the other consists of a few mutilated pages. The mind-pattern is fully revealed in the poetry; from the biographical material its main lines are indecipherable. And yet the fact that we cannot decipher them does not prove that their trend is not similar to that purged, clarified, and intensified pattern that shows up in the poetry. Even when an author distils almost the whole of himself into his writing (as Flaubert did), what is left of the man, ghost-like and bloodless as it may be, can repeat in some vague sort the mental pattern that has been presented so perfectly in the works. Contact with

him might inform us that here is a remarkable personality, but so abstracted from active living as to be unprofitable to pursue. In other words, even the author most depersonalized or sucked dry by his art is potentially a man of note ouside the literary sphere.

Still, though the life of the man who has yielded himself to his art should present some analogy with that art, it may, however closely scrutinized, be entirely useless in heightening the appreciation of that art. In fact biographical study will in this case insist on staying on the hither side of criticism in the province of literary anecdotage. It is very likely that Shakespeare's biography, even with the fullest knowledge, would remain as at present in that province. But with the other class, the biography, the *facts* of personality, the data for the mental pattern of the man's life, may substantially help our understanding of the mental pattern as revealed in his art. An extreme example would be William Morris, a much less extreme one, Milton. And if, in writing of Milton, I have forsaken the safe Johnsonian example of not confounding biography and criticism, I would say in defence that I did so because I was writing of Milton, not because I thought they should invariably be so confounded. Yet I grant that the mixture of biography and criticism, even when most justified by the nature of the author, has its besetting danger: it is all too easy for the reader to use biography as an illegitimate short cut into the poet's mental pattern as revealed in his poems. He may arrive thereby at what seems a place higher up on the more difficult road of intensive study of the isolated word, but he will have missed the essential revelation that could only be obtained by the very journey he has shirked. He will, in fact, have been doing something like looking up the answers to a problem when tired of trying to solve it, or using a crib when reading a foreign text. It is when a man believes that the intensive study of the isolated word has gone astray or has been brought to a standstill that he is justified in seeking guidance from biography.

Mr. Lewis's essay raises the whole question of what poetry is about.... I find Mr. Lewis too rigidly concerned with things and too little heedful of states of mind when he discusses his examples. My disagreement from him can best be illustrated by discussing one of his own instances, Herrick's *Upon Julia's Clothes*. Mr. Lewis discusses half the poem. It may be fairer to take the whole:

> *Whenas in silks my Julia goes,*
> *Then, then, methinks, how sweetly flows*
> *That liquefaction of her clothes.*
> *Next, when I cast mine eyes, and see*
> *That brave vibration each way free;*
> *Oh, how that glittering taketh me!*

Commenting on the first three lines, Mr. Lewis calls them 'poetry of an unusually sensuous and simple type', and says that in them 'the only experience which has any claim to be poetical experience is an apprehension not of the poet, but of silk'. The poet has presented an idea of silk and one of unusual vividness. Now Mr. Lewis expressly excludes from the poetic value of the lines the notion, 'With what eyes the poet must have seen silk': that is merely an irrelevant afterthought. I can only conclude that in his opinion the lines concern not a state of mind but a substance called silk, and that they reveal hitherto unapprehended qualities of silk. What are these qualities? Mr. Lewis suggests that the word liquefaction is responsible for the vividness with which the silk is apprehended. In other words Herrick has made the discovery that compared with certain other textures (felt, for instance) silk

resembles in its suppleness a liquid rather than a solid. I cannot believe that Mr. Lewis really holds that the poem's virtue can reside in so elementary an observation, an observation in the power of so many people and not at all requiring the superior penetration of poetic genius....

What I cannot accept in Mr. Lewis's interpretation of the poem is the value he puts on 'things'. I do not say that the poem does not tell us something, but I do say that what it tells us about silk has a very subordinate share in the poem's total meaning. Silk may have considerable importance as a means, as an end it is negligible. Even the claim of temporal priority made for silk (a claim whose importance I do not admit) is not justified; for before the silk is made vivid to us, we are given through the excited repetition of the words 'then, then', the statement of the speaker's excitement at the sight of his Julia in motion. Far from containing the virtue of the poem, the apprehension of silk is but one of a number of factors that go to express a state of mind which readers have somehow shared, and which they have considered in some way valuable. Here are a few of these factors. A fresh and unaffected sensuality pervades the poem. Not only is the speaker's excitement expressed by 'then, then', but from the flow of the clothes and their vibration the hint of the body beneath is not absent. The full emphasis and the fall of the third line express how well the spectator's excitement is satisfied by the downward flow of the silk. We may even derive from 'liquefaction' a hint of the word 'satisfaction'. 'Liquefaction' is a sophisticated word, and as such is more important than as describing a quality of silk which (incidentally) had been already indicated in the word 'flows'. More important, probably, than any of the factors noted above is the contrast on which the poem is constructed. The spectator first sees the downward flow of Julia's silks and he experiences satisfaction. He then sees the silks vibrating, perhaps moving in little horizontal eddies, and he is captivated. Even if this contrast means no more than a sense of balance or decorum it is not unimportant in the poem; and anyhow it is something very different from an isolated apprehension of silk.

Now few readers will accept all these observations on Herrick's poem, but I hope most of them will agree that it is complicated and not so very simple and sensuous. And I should be glad to think that they found it initially more reasonable to consider that poem in terms of a state of mind than in terms of a substance called silk. For it is not by any laborious process of induction *after* we have read the poem that we apprehend the qualities of unaffected sensuality, keen observation, sophistication, and sense of decorum. We apprehend them from the rhythm, the vocabulary, the word-arrangement, the pattern of the poem, in fact from the poem's most intimate poetical features. And the fact that such an enumeration is critically only of the most trivial value does not preclude its being on sounder lines than seeing the poem in terms of 'things'.

To go further, to describe the state of mind these qualities compose is luckily not necessary to my argument, nor need I reopen the question of how far it is the poet's personality we get in touch with through the poem....

Homosexual Drama and
Its Disguises

Stanley Kauffmann

Stanley Kauffmann (1916–), film editor and contributing editor of the New Republic, *previously served as editor for several publishing companies. He was drama editor of the* New York Times *at the time the following selection was written. He has published* The Hidden Hero *(1949),* The Tightrope *(1952),* A Change of Climate *(1954), and* Man of the World *(1956). The issue raised here by Kauffmann extends beyond the theater to all the arts. His candor required considerable boldness; critics have generally avoided the issue lest they be branded as philistines.*

A recent Broadway production raises again the subject of the homosexual dramatist. It is a subject that nobody is comfortable about. All of us admirably "normal" people are a bit irritated by it and wish it could disappear. However, it promises to be a matter of continuing, perhaps increasing, significance.

The principal complaint against homosexual dramatists is well-known. Because three of the most successful American playwrights of the last twenty years are (reputed) homosexuals and because their plays often treat of women and marriage, therefore, it is said, postwar American drama presents a badly distorted picture of American women, marriage, and society in general. Certainly there is substance in the charge; but is it rightly directed?

The first, obvious point is that there is no law against heterosexual dramatists, and there is no demonstrable cabal against their being produced. If there are heterosexuals who have talent equivalent with those three men, why aren't these "normal" people writing? Why don't they counterbalance or correct the distorted picture?

But, to talk of what is and not of what might be, the fact is that the homosexual dramatist is not to blame in this matter. If he writes of marriage and of other relationships about which he knows or cares little, it is because he has no choice but

From *The New York Times,* January 23, 1966, Section II, p. 1. © 1966 by The New York Times Company. Reprinted by permission.

to masquerade. Both convention and the law demand it. In society the homosexual's life must be discreetly concealed. As material for drama, that life must be even more intensely concealed. If he is to write of his experience, he must invent a two-sex version of the one-sex experience that he really knows. It is we who insist on it, not he.

Two Alternatives

There would seem to be only two alternative ways to end this masquerading. First, the Dramatists' Guild can pass a law forbidding membership to those who do not pass a medico-psychological test for heterosexuality. Or, second, social and theatrical convention can be widened so that homosexual life may be as freely dramatized as heterosexual life, may be as frankly treated in our drama as it is in contemporary fiction.

If we object to the distortion that homosexual disguises entail and if, as civilized people, we do not want to gag these artists, then there seems only one conclusion. The conditions that force the dissembling must change. The homosexual dramatist must be free to write truthfully of what he knows, rather than try to transform it to a life he does not know, to the detriment of his truth and ours.

The cries go up, perhaps, of decadence, corruption, encouragement of emotional-psychological illness. But is there consistency in these cries? Are there similar objections to "The Country Wife," "Inadmissible Evidence," "The Right Honourable Gentleman" on the ground that they propagandize for the sexually unconventional or "corruptive" matters that are germane to them? Alcoholism, greed, ruthless competitiveness are equally neurotic, equally undesirable socially; would any of us wish to bar them arbitrarily from the stage?

Only this one neurosis, homosexuality, is taboo in the main traffic of our stage. The reasons for this I leave to psychologists and to self-candor, but they do not make the discrimination any more just.

Fault Is Ours

I do not argue for increased homosexual influence in our theater. It is precisely because I, like many others, am weary of *disguised* homosexual influence that I raise the matter. We have all had very much more than enough of the materials so often presented by the three writers in question: the viciousness toward women, the lurid violence that seems a sublimation of social hatreds, the transvestite sexual exhibitionism that has the same sneering exploitation of its audience that every club stripper has behind her smile. But I suggest that, fundamentally, what we are objecting to in all these plays is largely the result of conditions that we ourselves have imposed. The dissimulations and role-playings are there because we have made them inevitable.

Homosexuals with writing ability are likely to go on being drawn to the theater. It is the quite logical consequence of the defiant and/or protective histrionism they must employ in their daily lives. So there is every reason to expect more plays by talented homosexuals. There is some liberty for them, limited, in cafe theaters and Off Broadway; if they want the full resources of the professional theater, they must dissemble. So there is every reason to expect their plays to be streaked with vindictiveness toward the society that constricts and, theatrically, discriminates against them.

To me, their distortion of marriage and femininity is not the primary aspect of this matter; for if an adult listens to these plays with a figurative transistor-radio

simultaneously translating, he hears that the marital quarrels are usually homosexual quarrels with one of the pair in costume and that the incontrovertibly female figures are usually drawn less in truth than in envy or fear. To me, there is a more important result of this vindictiveness—its effect on the basic concept of drama itself and of art in general.

Homosexual artists, male and female, tend to convert their exclusion into a philosophy of art that glorifies their exclusion. They exalt style, manner, surface. They decry artistic concern with the traditional matters of theme and subject because they are prevented from using fully the themes of their own experience. They emphasize manner and style because these elements of art, at which they are often adept, are legal tender in their transactions with the world. These elements are, or can be, esthetically divorced from such other considerations as character and idea.

Thus we get plays in which manner is the paramount consideration, in which the surface and the *being* of the work are to be taken as its whole. Its allegorical relevance (if any) is not to be anatomized, its visceral emotion (if any) need not be validated, and any judgment other than a stylistic one is considered inappropriate, even censorious. Not all artists and critics who advance this theory of style-as-king are homosexuals, but the camp has a strong homosexual coloration.

What is more, this theory can be seen, I believe, as an instrument of revenge on the main body of society. Theme and subject are important historical principles in our art. The arguments to prove that they are of diminishing importance—in fact, ought never to have been important—are cover for an attack on the idea of social relevance. By adulation of sheer style, this group tends to deride the whole culture and the society that produced it, tends to reduce art to a clever game which even that society cannot keep them from playing.

But how can one blame these people? Conventions and puritanisms in the Western world have forced them to wear masks for generations, to hate themselves, and thus to hate those who make them hate themselves. Now that they have a certain relative freedom, they vent their feelings in camouflaged form.

Doubtless, if the theater comes to approximate the publishing world's liberality, we shall re-trace in plays—as we are doing in novels—the history of heterosexual romantic love with an altered cast of characters. But that situation would be self-amending in time; the present situation is self-perpetuating and is culturally risky.

A serious public, seriously interested in the theater, must sooner or later consider that, when it complains of homosexual influences and distortions, it is complaining, at one remove, about its own attitudes. I note further that one of the few contemporary dramatists whose works are candidates for greatness—Jean Genet—is a homosexual who has never had to disguise his nature.

"But He's a Homosexual. . ."

Benjamin DeMott

Benjamin DeMott (1924–) is Professor of English at Amherst College. After receiving his Ph.D. from Harvard he became a newspaperman and free-lance writer and later a columnist for The American Scholar *and* Harper's. *In addition to numerous stories he has written a novel,* The Body's Cage *(1959).* Hells and Benefits *(1962) is a collection of his essays, as is* Supergrow *(1969), in which DeMott discusses such contemporary phenomena as student rebels, "rock," Masters and Johnson, and homosexuality in the arts. His newest book is* Surviving the Seventies.

In the following essay DeMott deplores what he calls the harassment of homosexual writers by some critics who thereby shut us off from an important source of insight.

That the subject of homosexual influence in the arts should engage attention at this moment isn't mysterious. American interest in matters cultural and aesthetic is on the rise. New levels of candor about sexual behavior seem to be achieved every other week. And, most important, the national reserves of credulity have not diminished much over the years. If this were not so, baiters of homosexual art probably would pull smaller audiences. For their charges are rooted in the belief that centralized control of the arts can be achieved by a nonpolitical, essentially nonideological nonorganization—and only the credulous can rest comfortably in such faith. Tyrannies of taste do occur, to be sure—they are inevitable whenever a professionally practiced art lacks multiple centers of power. (Serious music is the sector of the arts that most nearly meets the latter description at this moment. Outlets for the work of living American composers are extremely few, which means that homosexual cliquishness could—some informed people say it does—throttle free musical expression.) And homosexual centers of power do exist—a cluster of art galleries here, a group of experimental moviemakers there. (One famous Fifty-seventh Street gallery has even been, in fairly recent days, a center of homosexual poetry as well as of painting and sculpture.)

But countless other galleries flourish that are nothing of the sort, and a half-dozen, low-budget, cinematic experimenters continue to produce—and exhibit—films untouched by what is called homosexual fantasy. And in other sectors of the arts mixed situations seem generally the rule. Cliquishness cannot be abolished and, as just indicated, it can cause damage in fields of artistic endeavor where opportunities for professional hearing are subject to autocratic control. But, while complacency about these fields is inexcusable, they are less numerous than scourgers of "homosexual tyranny"—and the more gullible of their readers—profess to believe. And the heralded culture-explosion should reduce their number, not increase it, in the future.

But if the homosexual himself isn't a serious threat to cultural vigor and variety, the same can't be said of those who harass him in print. The point at issue here isn't, true enough, easy to grasp. A piece writer who beats up "the fairies" for a few thousand words would seem, on the face of it, only another harmless canny profiteer. It's plain, after all, that complaints about "homosexual art" will never mobilize hostility and frustration at the destructive levels sustained in yesteryear by the Red-baiters. And conceivably "frank talk" in this area, no matter how woolly and superstitious, can have beneficial effects.... Why turn hypercritical toward characters who, whatever their own personal cynicism, may function as nourishers of American sophistication?

The answer is simple: at the center of most talk about "homosexual art" lies the assumption that books, pictures, poems created by homosexuals are private documents, narrow in range, incapable of speaking truly to anyone not himself a homosexual. The prime effect of this already widely disseminated idea has been to neutralize or denature several of the most provocative critical images of contemporary life to win mass audiences since World War II. And from this it follows that the self-appointed enemy of "homosexual art" isn't just a nuisance: he is a pernicious waster of an invaluable cultural resource.

As might be guessed, the ways of waste—the means by which commentators cheat the work of homosexuals and torture it out of strength—are nothing if not ingenious. Chief among them is a trick of medical inside-dopesterism that transforms texts clear enough on their surface into complex codes or allegories—productions whose deepest truths yield themselves only to psychoanalytic exegesis. Consider for instance the operations of clinical exegetes on Edward Albee's *Who's Afraid of Virginia Woolf?* In both the stage and film versions, the ending of this work seems a moment of poignance. Weary beyond fury, blasted (almost) into kindness, George and Martha have arrived at a nowhere world in which combat is pointless. The audience knows that cosy murmurs about reconciliation, forgiveness, happiness ahead would be puerile, but is nevertheless aware of a passage into an atmosphere of feeling less ridden by fantasy, more open, more yielding. Nobody has "won," but a loss has been suffered jointly: pity is in the room.

Enter the clinical exegete and every "simplistic" reading of the play is laved with scorn. (Exegetes of this brand are printed in psychoanalytic journals as well as in magazines of art.) *Virginia Woolf*, wrote Dr. Donald M. Kaplan (a psychoanalyst) in a recent issue of *Tulane Drama Review*, is in its essence a predictable homosexual claim that "genitality is...an unnecessary burden"; the closing scene is a moment of triumph, it signifies that a married man "can prevail through the tactics of pregenital perversity" and need not grow up to his role:

> *The sexuality of the parental bedroom [Nick and Martha offstage] is no match for the multifarious derivatives of George's oral aggression, anality, voyeurism, masochism and procreative reluctance. In the end, Martha returns to George, as she so often has in the past. The enfant terrible again triumphs over the cocksmen of the outside world, and the nursery is preserved...*

Fitted into this pattern of homosexual aggression and glee, Albee's play is easily dismissed as a projection of dementia—a set of remarks about Rorschach cards, a collection of symptoms, nothing a "straight" could even begin to take straight.

Clinical exegesis isn't of course the harshest line of critique found in discussion of so-called homosexual art. Traditional American manliness makes itself heard in

Fact and *Ramparts* ("I *like* women," Gene Marine said stoutly) and even in tonier periodicals—witness Philip Roth's famous attack on Albee's "pansy prose" that appeared in the *New York Review* following the opening of *Tiny Alice*.[1] But the survival of tough-guyism is less interesting—and less regrettable—than the nearly universal acceptance of the central assumption just mentioned, namely that art produced by homosexuals is irrelevant to life as lived by nonhomosexuals. Early last year the Sunday theater section of the *New York Times* printed a pair of articles by Stanley Kauffmann, then the newspaper's drama critic, on the "subject of the homosexual dramatist." A liberal, humane man, Kauffmann clearly had no terror of "perverts," no desire to suppress the work of the artists he was discussing. His articles, seen by many as another heroic breakthrough for frankness, dealt in passing with the matter of "homosexual style," and with the supposed tendency of the homosexual writer to treat theme and subject as immaterial and surface as all-important. They were partly conceived as defenses of the homosexual's right to freedom of expression, and they offered several telling observations about uses and abuses of that right.

Yet everywhere in his comments this critic signified his conviction that plays by homosexual dramatists should be regarded as codes to be deciphered, disguises to be seen through, private languages requiring continuous acts of translation by the audience...Kauffmann blamed this situation upon society—not upon the homosexual writer. And he argued forcibly for an end to the repression and inhibition that harries these writers into deceit... But, like the psychoanalyst quoted earlier, Kauffmann was committed to the notion that a homosexual's image of life is necessarily an expression of "homosexual truth"; the man has no choice except to "transform [what he knows] to a life he does not know, to the detriment of his truth and ours."

Even those critics whose avowed purpose is to make a case *for* "homosexual art"—as it is—to rescue it from vulgar attack and place it in a dignified light—fall into modes of discourse that are reductive and evasive in discussing its meaning. Consider the approach adopted in Susan Sontag's "Notes on Camp." This critic announces herself to be "strongly drawn" to the kind of art she is setting out to describe; yet throughout her essay she speaks of that art always as a phenomenon of style alone; the worth of its statement, the nature of its view of life, even its cultural associations and origins are passed off as boring matters. ("One feels," says the critic, "if homosexuals hadn't more or less invented Camp, someone else would.") What counts about this art is its *tonality*, not the total experience offered and the meanings created through that experience:

> *Camp and tragedy are antitheses. There is seriousness in Camp (seriousness in the degree of the artist's involvement), and, very often, pathos. The excruciating is also one of the tonalities of Camp; it is the quality of excruciation in much of Henry James...that is responsible for the large element of Camp in his writings. But there is never, never tragedy.*

[1] Editors' note: In this review Philip Roth condemns Albee for vulgarizing and sentimentalizing the themes of male weakness and female strength in *Virginia Woolf* and *Tiny Alice* and characterizes the latter as a "homosexual daydream." "How long," Roth asks, "before a play is produced on Broadway in which the homosexual hero is presented as a homosexual, and not as an *angst*-ridden priest, or an angry Negro, or an aging actress; or worst of all, Everyman?" *The New York Review*, February 25, 1965, p. 4.

The obvious question is: given the nature of the life represented in a so-called "Camp novel," is the quality of excruciation tendentious or appropriate? Can a man learn or confirm any truth of experience through a confrontation with Camp? When such questions aren't asked, much less answered, the implication is that this art may truly be empty of substance.

The point at stake bears restating. Dumb-ox or tough-guy or Philistine versions of works of art produced by homosexuals tend to be crudely dismissive—too crudely dismissive, often, for educated audiences to accept. But other dismissive lines have now become available. There is chic psychoanalytical chatter that evades the truth of a scene by seeing the scene as a symptom. There is a liberal critique that evades the truth of a scene by tolerantly viewing the scene not as an image of life but as a product of indirect censorship. And there is a brand of aesthetic criticism that evades the truth of a scene by focusing solely on matters of form. None of the approaches mentioned appears hostile to the so-called homosexual artist; each embodies different values and assumptions. But all are alike in espousing, or else in refusing to challenge, the dogma that the homosexual's representation of life can only be an expression of homosexual truth—"his truth" as opposed to "ours," as Kauffmann put it. And that dogma, while comforting to the majority, is quite without foundation.

It is probable that most readers and theatergoers—peace to the scandalmongers who shriek about homosexual tyranny—will accept the claim that the most intense accounts of domestic life and problems in recent years, as well as the few unembarrassedly passionate love poems, have been the work of writers who are not heterosexual. The problem of compulsive promiscuity, or Don Juanism—one that Jose Ortega y Gasset described as the most delicate and abstruse in contemporary human relations—has been examined with extraordinary force and directness by Tennessee Williams in several plays. And that intensity has time and time over proved to be an illumination of a kind. Some of the writers in question can be overpraised, to be sure. There is phony elegance and needless obfuscation in Albee's current manner, total dishevelment in the bulk of Ginsberg, too much self-indulgence in Williams, who seems bent on writing the same play four hundred times.

Yet a fair assessment of these writers, or of any of their relevant superiors—Genet and Auden for two—can hardly be wholly negative. With a few other poets and dramatists, they are the only compelling writers of the postwar period who seem to know anything beyond the level of cliche about human connectedness, whose minds break through the stereotypes of existential violence or Nietzschean extravagance into recognizable truths and intricacies of contemporary feeling. They are not purveyors of situation comedy or Bond banalities or *Playboy* virility or musical-marital bliss (*I Do! I Do!*) or mate-murders. A steady consciousness of a dark side of love that is neither homo- nor heterosexual but simply human pervades much of their work; they are in touch with facts of feeling that most men do not or cannot admit to thought. They know what Catullus knew about *odi et amo*—simultaneities of hatred and its opposite—and they know the special terms and strains of these simultaneities in modern experience, wherein prohibitions against self-indulgence have lost force. They know that love and suffering are near allied, and that love ought not to be confused with the slumbrous affection or habitual exploitation that is the rule in numberless households. They know that the lover's demand for exclusive possession has vanity as one of its roots.

They have in mind, not as aphorisms but as potential behavior and gesture, knowledge of the kind compressed in Mme. de Stael's remark that love equals

self-love *a deux,* or in Proust's claim that there are people for whom there is no such thing as reciprocated love, and that these people are by no means the most insensitive among us. They know that instability is a fact of love, as of human personality generally. And the tensions and furies arising from contradictory desires and impulses seem to them proper subjects for intelligence to probe....

"To be free is to have one's freedom perpetually on trial." It isn't necessary to endorse every line of existential scripture to see the application of this text from Sartre to the intelligent, responsive homosexual who has a gift for the formed re-creation of experience. The latter gift is, as everyone knows, distributed according to no visible plan; sexuality conceived as a pure and separable essence is not its determinant. But the homosexual who possesses it does have special occasion to exercise and refine it in fundamental, as well as in craft or professional, areas of life, owing to the peculiarities of his situation in the general culture. If I am a Citizen, Husband, Straight-Arrow, I easily can put myself on trial. I can speak for a troubling cause, enter upon a bout of promiscuity, teach in a turtleneck, grow my hair long in back. But I cannot escape the promise of ease, the possibility of subsiding into the accepted and the respectable; always an oasis of habitual, unexamined, unjudged life awaits me.

The intelligent homosexual, however, is in another situation. A tide of suspicion flows toward him, perpetually demanding that he justify his difference; relaxation into unthinking self-acceptance in the presence of other eyes is prohibited. If he is rich and shrewd, he may manage to create for himself the illusion of a life unexposed to antipathetic scrutiny—but sustaining that illusion is hard work. If he isn't rich and shrewd, his immediate confrontations with hostility—the interruptions of his taken-for-granted daily existence—will be numberless. And these interruptions will induce in him a heightened awareness of the feelings and assumptions of others—an immediate living consciousness of the fragility of the shields that hide human cruelty from general view....

Everyone knows about homosexual arrogance; everyone knows that aristocratic poses fend off "nights of insult"; everyone knows that flights of defensive scorn or resentment—the familiar gestures of mediocrity—are common in homosexual conversation.

But self-deception and mediocrity are, after all, everywhere the rule—and the writers and artists spoken of publicly as homosexuals, and thus looked down upon, are by and large not mediocrities. They are men who have been *provoked* into dwelling on the relative emptiness and unthinkingness of most men's commitments to the terms of their own lives. They are people whom we put on endless trial, because our manner declares that no condition of moral being except our own can be approved, because our explicit claim is that love can only be a permanent attachment, and because we dare not detach ourselves from our "institutions" even though we know they derive in great part from superstition. They are people forced to face up to the arbitrariness of cultural patterns—arbitrariness that we insist on regarding as altogether unarbitrary, a logical bidding of nature, a sane, wholly explicable pattern, like the movement of the earth. The fury that lifts James Baldwin's prose to eloquence, when that writer has before him the cruelty of cultural arbitrariness, stems not alone from Baldwin's experience as a Negro. And the racking power of those moments in Genet, when this writer has the same spectacle in sight, arises not only from a career as thief. The usefulness of the instruction offered through this eloquence and power doesn't vary in accordance with the condition of the reader's sexuality....

The case I am urging is, needless to say, open to a hundred misunderstandings. Someone says: you pretend that you aren't claiming that the homosexual is more

sensitive to certain aspects of human relations than the heterosexual. But haven't you just been saying that homosexuals have insights that are denied to heterosexuals? Answer: not quite. The notion of denial oversimplifies the issue, leaves out important parts of the full context. The difference between what the homosexual sees and what the heterosexual sees can't be explained in narrow physiological terms. Neither kind of sexuality can be separated from the culture and regarded as a physical or neurological thing-in-itself determining degrees of insight. Homosexuality like heterosexuality is a situation, a complex set of relations between self and society: the nature of these relations determines to some extent the special quality of the perceptions that each perceptive man can have. The relations vary with time and place; surely there are few significant likenesses between the situations of homosexuals in the arts in New York City in 1967 and the situations of their counterparts in, say, Paris in 1815 or London in 1600. There isn't, in short, any abstract entity properly called homosexual or heterosexual insight; there are only differences in the kinds of life-situations in which intelligence tests itself. And these are the differences that shape the artist's vision....

One more hostile question: you ask for pity, understanding, admiration for homosexual artists—thus suggesting that these are the badly mistreated people of this day. Are they? Aren't they in reality all the cry just now? If we put them under pressure, they, for their part, do find excellent means of freeing themselves. And, finally: suppose it *is* granted that the best "homosexual art" is indeed art—art without modifier; are we obliged to be decent to the worst? When we go off for a night at the theater and encounter something amounting simply to a play in drag, must we smother resentment?

The answer is that of course homosexual artists, like other ones, can be inferior, and that of course these artists have invented ways of easing the pressure we put them under. They do on occasion compose fantasies. They do on occasion express *their* resentment. They do on occasion revenge themselves through sexual disguises in plays and poems. They mock our solemnities with Happenings and joke pictures and weirdo flicks. They parody the ceaseless commercial agitation of "straight" sexual appetites. They create an art heavily dependent (see Genet) on magic and metamorphosis, an art usually thin in political content, relatively unconcerned with what are called public issues. And they can give themselves over to glee at the thought that whatever we think of them, few among us match them in brio or brilliance.

But these satisfactions can scarcely outweigh all torments—and, in any event, the fact that an achievement has earned a reward usually is not thought of as ground for discounting the achievement. And there are achievements here—this is the point of moment. A portrait of a man exacerbated by a woman need not be only a thrust at a generalized Enemy; in at least one American play such a portrait faced a mass audience with truths about the new world of sexual equality and universal self-absorption quite inexpressible either in Ibsen or Bernard Shaw. An image of egos dependent upon a fantasy child can be more than a faggish leer: in one American play such an image showed mean uses of the family and, in addition, the vapidities of the doctrine that procreation in itself equals fulfillment. And, by the same token, artists with extensive experience of respectable marriage and childrearing may write with seeming authority about subjects the homosexual can "never know," and yet be worthless—because they are blind to the truth that the acceptable life, the embrace of heterosexuality, can become a cliche, an automatized rather than freely created value.

The canard that negation is not necessarily stupidity and affirmation not necessarily illumination does, in fine, need summoning once more—in discussion of "homosexual art." Nobody is obliged to accept Nietzsche's claim that "every good thing, even a good book which is against life, is a powerful stimulant to life." But the sort of mind that seeks to place all hostility to established institutions as proof of disease does dirt on the revolution of candor that we claim to prize. Failure to hear out the homosexual artist with a seriousness matching his own, overeagerness to dismiss him as ignorant or perverse, assurance that we know what we are—this behavior at a time when Don Juans by the thousand jam the week-night motels and divorce rates soar and children everywhere are flogged into meaningless ambition—this is worse than senseless. It is a mockery not only of art and of the suffering that art rises out of and seeks to comprehend: it is a mockery of our famous, preening, new liberation as well.

The Alienation of the Artist

Ralph Ross

It is a commonplace that the artist is alienated; too much of a commonplace because it is true only of some artists and not of others, even in our day. Some say that it is the nature of the artist to be alienated from which it would follow that artists have been alienated throughout history. This is not so and yet those who believe that alienation is a condition peculiar to twentieth century society, should recall Wordsworth's famous lines:

> *The world is too much with us; late and soon,*
> *Getting and spending, we lay waste our powers:*
> *Little we see in Nature that is ours.*

Whatever virtues alienation has, it is sad to find an alienated art because that is often an unhealthy art, and we always need a healthy art, doing what a healthy art has always done.

Thus, art has a special importance for the student of society and social ethics. Social norms and values are for the most part implicit, and people who try to state them often do so incorrectly. The arts do not state explicitly; they preserve the very perceptions and the perspectives in which norms and values are implicit. They thereby constitute a perhaps unique record of any culture.

Art communicates, but it is more than communication. It conserves and reinforces social norms, but it also destroys them. It is highly traditional and depends on the skills and techniques, the forms and patterns of the past, but it is good only when it is individual, fresh, and novel. It conveys meanings about all of human experience, but its worth is judged to a considerable extent by its internal structure. Finally, art is probably indispensable to society and yet is always a danger to the accepted, the established, and the static, so much so that it is always censored. These are paradoxes that bedevil art criticism and the sociology of art.

Art at its best explores the great problems of love and hate, life and death, peace and war, civilization and barbarism, and brings us to confront them. At the least, art that works puts us in the presence of another, usually more individuated human being, with his subjective feelings and his perspective on the world, and tests us

against him. In the sense that these matters make up the moral quality of life, art has a profound moral dimension: through it we may come to terms with ourselves, other selves, and our communal bonds.

Art is not alone in doing this—there are other ways, through love and the religious experience in which love is sometimes exalted, through philosophical reflection—but art does it in its own way, a way that adds feeling to thought, and the rich concreteness of particulars to the abstractness of moral principles. Thus, when art is genuinely alienated it may fail in many of its functions. If it is genuine art, it does not fail completely, but it loses its centrality in life and society, and it deals more with peripheral selves and views than a healthy art does. An alienated art may speak for a relatively unimportant coterie, and it may explore the fringes and byways of the larger society. These are important, too, and pose deeply moral issues, but they lack the significance of the central.

All genuine art, again, shows what it is like to be someone or something and reveals the nature of the men or things about which we make moral judgments. In so doing, it may lead us to change our judgments. It is not true that to know all is to forgive all, but it is usually true that to know more is to judge better. One may in general judge adultery harshly, but what he learns about Anna Karenina may make him want to help Anna rather than punish her, or may bring him to improve laws rather than enforce them.

The alienated vision may be a peripheral one; yet it may be focal to a society on the way to greater estrangement. How alienated Dostoievsky was is hard to say, but the protagonist in his *Notes from Underground* could scarcely be more alienated. The result is an insight of genius into the moral shambles of a society relying on progress and technology as a cure for life's ills. When the alienated man merely licks his wounds in public and howls, even revels in, his misery, what he reveals is less significant of the life of his time and has less aesthetic and moral import. An entire art of this sort deprives life of much of its value and insight.

Alienation grows in societies like ours, and artists, among other sensitive people, are more likely to be alienated than men were, and are, in other societies. There is nothing inherently alienating in a commitment to art or the nature of the artist; alienation is primarily a function of the kind of society in which we live. Art was religious at a time when societies were more easily identifiable by their religions than by their nations. Artists, then, were unalienated. Their work was part of ritual, and it tended to be anonymous.

Generally, it is common for art, even when it is first separated from ritual, to be collective, at least in the sense that individual names are not associated with it. The cathedrals of the Middle Ages were collective efforts in this sense, as were folk songs and folk epics—the Norse sagas, the Mabinogion, the Nibelungenlied, the Song of Roland. Collective art is close to ritual—if not the ritual of institutional religion, then the ritual of communal traditions and folkways.

At a further remove from ritual is individual art, each work being made by one man and recognized as such. The contrast between ritual art and individual art is a sharp one. Once a ritual form is set it remains as definitively the same as succeeding generations can keep it. Even the quality of performance in each presentation of the ritual is as little varied as possible. New interpretations are not permitted and the training of performers is relatively unchanging. After all, ritual is not just a presentation or dramatic performance. It is sanctioned by religion and is usually thought to have some efficacy to insure a good harvest, or success in battle, or some other sign of the gods' favor.

One kind of individual art, probably the earliest in time, is the occasional: art produced for a specific place or occasion—the death of a king, a triumphal

procession, a state holiday. Court music was usually occasional, and so was classical Greek sculpture, which was made for a particular place: a public square, a temple, the scene of a battle.

Occasional art celebrated or commemorated *this* event at *this* time. Ritual was more general; it celebrated a *kind* of event—birth, not *a* birth; marriage, not *a* marriage. Ritual was repeated more or less identically at specified intervals. Occasional art might be repeated, as in the case of a play, but that was because of its merit or popularity; it was made for a single occasion. Yet occasional art was a substitute for religious ritual or an extension of it. It dramatized or celebrated a secular event not incorporated in religion or a particular event which was celebrated in ritual only as a type and so did not include reference to an actual person or date. The drama of ancient Greece was occasional art which contained the ritual forms but developed them in original ways. It was performed at religious festivals which included the entire community, but new plays were written every year; Greek drama was like a ritual created afresh annually by individual artists. The dramatic poet was highly individuated, but he had a function in the community which was for the sake of the community. Even if he was critical of his own land, like the tragic poet Euripides or the comic poet Aristophanes, it was to instruct the community, of which he felt himself fully a member.

Individuality easily passes into eccentricity when it is severed from the social ties which give it relevance to the life of its time. The artist of our own day is no more individual than Euripides or Aristophanes, but he is less sustained by common bonds and roots; he is, indeed, too often alienated. Daily book reviewers and writers of articles for Sunday supplements make easy scandal of the distance between what they think of as the common man and the artist. When the United States Information Service chooses American books for its libraries abroad, questions are raised about the image of America put before foreign eyes. Faulkner's Snopeses and Bundrens, Steinbeck's Okies, Nabokov's Humbert Humbert are not God's noblest creatures and the land they inhabit no longer seems the last best hope of earth. But much more than mere images are at stake. Is this the sense of their country and its people that our best writers have of us? Surely it is a far cry from Aeschylus' radiant hopes for Athens and Sophocles' passion for her. And how strange in contrast to our writers' words are Shakespeare's:

> *This happy breed of men, this little world,*
> *This precious stone set in the silver sea,*
> *Which serves it in the office of a wall*
> *Or as a moat defensive to a house*
> *Against the envy of less happier lands—*
> *This blessed plot, this earth, this realm,*
> *this England.*

But the alienated man always sees his country as if from the outside; he is in it, but not of it. And he is, almost by nature, critical of it, with no touch of celebration. Whatever blame—if any is to exist—that can be attributed to the artist is slight compared with the blame attaching to what should be his public. Yet what has happened is the result of a social upheaval, so blame is irrelevant. The audience for serious art is very small, it is distributed over a large country, it is not cohesive, and (except for art collectors, who are often mere investors) it is not extremely wealthy. Surrounding this audience is an ocean of the merely literate, the philistine, and the apathetic, products not of schooling but of an education too often subordinated to narrowly utilitarian ends.

Neurosis and Alienation

Universal literacy combined with money and leisure have produced a bottomless market for entertainment and, in consequence, entertainment is the largest industry in the United States today. The difference in the market for, say, literary art and for literary entertainment can be seen in sales figures like these: a truly distinguished American poet in his middle years may have all his verse published in one volume as Collected Poems, and sell 3,000 copies; a superficially entertaining novel may sell half a million copies. And even in our colleges, where the study of English is required, and there are more students in English classes than in any other single study, it is the literature of the past that is read, almost to the exclusion of the literature of the present.

The more thorough the estrangement of the artist, the more likely that artists will make a sub-culture of their own. And this can only widen the breach between artist and public, making the artist more critical and the public more resentful. But even the alienation of the artist, hard as it is for him to bear, serves a function. Instead of expressing the major values of his culture, in the manner of so many of his forebears, the contemporary artist becomes the conscience of his time, crying havoc, and illuminating the gap between avowed ideals and sordid practice. Behind the figure of Flem Snopes is the towering shadow of Thomas Jefferson. T. S. Eliot writes these lines:

> *The person in the Spanish cape*
> *Tries to sit on Sweeney's knees*
>
> *Slips and pulls the table cloth*
> *Overturns a coffee cup,*
> *Reorganized upon the floor*
> *She yawns and draws a stocking up*

and ends the same poem:

> *The nightingales are singing near*
> *The Convent of the Sacred Heart,*
>
> *And sang within the bloody wood*
> *When Agamemnon cried aloud,*
> *And let their liquid siftings fall*
> *To stain the stiff dishonoured shroud.*

Demands made on the serious artist today often overlook the industrial revolution, the mushrooming of population, mass education, and all else that has come between him and Dante. He is expected to be seer, prophet, and teacher, not just another human who worries about paying the rent. And he is mistakenly expected to amuse or delight, which he is often capable of doing in part, but not entirely. For unlike the work of writers, painters, and composers who are in the entertainment industry, the work of the genuine artist today, as always, is difficult and requires serious attention. The entertainer does not see a world uniquely and afresh, but concocts a world out of the stereotypes of his time. His audience understands him even when it is half asleep. But the perspectives and values of the artist are sufficiently his own that his audience must struggle to grasp a novel world. And the concerns of the artist are fundamental to life, not mere play with its surface, so the audience is faced with life, which it must see as its own. It is not a light and pleasant prospect to sit alone in a room with *King Lear*; it is terrifying, however wonderful.

The additional difficulties, beyond those of art itself, of some of today's alienated artists are real enough, but they are probably less the cause of the small size of the serious audience than the conditioning of the public. For the public is so used to the banal and the stereotyped as it flickers on theatre and home screens, comes across the footlights, screams from the jukeboxes, and is ground out by the presses, that it is not willing to give to art the discipline and effort that it reserves for work and money.

And in the stereotyped and banal there is no moral dimension, for the audience is not challenged to see freshly, wrestle with values not its own, and remake itself. The reduction of art to entertainment—and the value in money and prestige placed on the entertainer shows how important that is to society—is not only a reduction of the aesthetic to the commonplace, but also a reduction of reflective morality to convention, of moral thought to custom. What happens is what one might guess: people of great artistic gifts seek careers other than art, some who choose art do so because of increased alienation and even exhibitionism, and the talented few, who may make a healthy art again, struggle against an alienation more tempting than ever.

Art and Neurosis

Lionel Trilling

Lionel Trilling (1905–), Woodberry Professor of Literature and Criticism at Columbia University, is a distinguished American writer and teacher. He has long been regarded as one of our subtlest and most scholarly critics and his appraisals of literature bear this out. He has also written highly-regarded short fiction, and a novel, The Middle of the Journey *(1947). He has written books on Matthew Arnold and E. M. Forster and many articles of comment and criticism, some of which are brought together in* The Liberal Imagination, *from which the following selections are taken.*

Lionel Trilling has written and lectured extensively on the subject of Freudiansim, and he has edited Freudian materials. He brings to his work on Freud the qualities that distinguish him as scholar and critic. [1]

The question of the mental health of the artist has engaged the attention of our culture since the beginning of the Romantic Movement. Before that time it was commonly said that the poet was "mad," but this was only a manner of speaking, a

Two essays, "Freud and Literature" and "Art and Neurosis," have been combined in this selection. From *The Liberal Imagination* by Lionel Trilling. "Freud and Literature" copyright 1940, 1947, copyright© renewed 1968 by Lionel Trilling. "Art and Neurosis" copyright 1945 by Lionel Trilling. Reprinted by permission of The Viking Press, Inc. and Martin Secker & Warburg Ltd.

[1]Limitations of space prevent the inclusion of pertinent selections from Freud's writings. Readers may wish to consult "The Relation of the Poet to Day-Dreaming" in Freud's *Collected Papers* (IV, pp. 173–183), his *A General Introduction to Psychoanalysis* (pp. 327–328), and, for a *tour de force* in the application of the psychoanalytical method, his *Leonardo da Vinci: A Study in Psycho-sexuality.* Carl G. Jung's chapter, "On the Relation of Analytical Psychology to Poetic Art" in his *Contributions to Analytical Psychology* (pp. 225–249) is a brilliant comment on the Freudian approach by a critic who enjoys increasing stature among writers and aestheticians.

way of saying that the mind of the poet worked in different fashion from the mind of the philosopher; it had no real reference to the mental hygiene of the man who was the poet. But in the early nineteenth century, with the development of a more elaborate psychology and a stricter and more literal view of mental and emotional normality, the statement was more strictly and literally intended. So much so, indeed, that Charles Lamb, who knew something about madness at close quarters and a great deal about art, undertook to refute in his brilliant essay, "On the Sanity of True Genius," the idea that the exercise of the imagination was a kind of insanity. And some eighty years later, the idea having yet further entrenched itself, Bernard Shaw felt called upon to argue the sanity of art, but his cogency was of no more avail than Lamb's. In recent years the connection between art and mental illness has been formulated not only by those who are openly or covertly hostile to art, but also and more significantly by those who are most intensely partisan to it. The latter willingly and even eagerly accept the idea that the artist is mentally ill and go on to make his illness a condition of his power to tell the truth.

This conception of artistic genius is indeed one of the characteristic notions of our culture. I should like to bring it into question. To do so is to bring also into question certain early ideas of Freud's.... Freud...ultimately did more for our understanding of art than any other writer since Aristotle; and this being so, it can only be surprising that in his early work he should have made the error of treating the artist as a neurotic who escapes from reality by means of "substitute gratifications."

As Freud went forward he insisted less on this simple formulation.... And psychoanalysis has inherited from him a tenderness for art which is real although sometimes clumsy, and nowadays most psychoanalysts of any personal sensitivity are embarrassed by occasions which seem to lead them to reduce art to a formula of mental illness. Nevertheless Freud's early belief in the essential neuroticism of the artist found an all too fertile ground—found, we might say, the very ground from which it first sprang, for, when he spoke of the artist as a neurotic, Freud was adopting one of the popular beliefs of his age. Most readers will see this belief as the expression of the industrial rationalization and the bourgeois philistinism of the nineteenth century. In this they are partly right. The nineteenth century established the basic virtue of "getting up at eight, shaving close at a quarter-past, breakfasting at nine, going to the City at ten, coming home at half-past five, and dining at seven." The Messrs. Podsnap who instituted this scheduled morality inevitably decreed that the arts must celebrate it and nothing else. "Nothing else to be permitted to these...vagrants the Arts, on pain of excommunication. Nothing else To Be—anywhere!"...

The excommunication of the arts, when it was found necessary, took the form of pronouncing the artist mentally degenerate.... In the history of the arts this is new. The poet was always known to belong to a touchy tribe—*genus irritabile* was a tag anyone would know—and ever since Plato the process of the inspired imagination, as we have said, was thought to be a special one of some interest, which the similitude of madness made somewhat intelligible. But this is not quite to say that the poet was the victim of actual mental aberration. The eighteenth century did not find the poet to be less than other men, and certainly the Renaissance did not. If he was a professional, there might be condescension to his social status, but in a time which deplored all professionalism whatever, this was simply a way of asserting the high value of poetry, which ought not to be compromised by trade. And a certain good nature marked even the snubbing of the professional. At any rate, no one was likely to identify the poet with the weakling. Indeed, the Renaissance ideal held poetry to be, like arms or music, one of the signs of manly competence.

The change from this view of things cannot be blamed wholly on the bourgeois or philistine public. Some of the "blame" must rest with the poets themselves. The Romantic poets were as proud of their art as the vaunting poets of the sixteenth century, but one of them talked with an angel in a tree and insisted that Hell was better than Heaven and sexuality holier than chastity; another told the world that he wanted to lie down like a tired child and weep away this life of care; another asked so foolish a question as "Why did I laugh tonight?"; and yet another explained that he had written one of his best poems in a drugged sleep. The public took them all at their word—they were not as other men. Zola, in the interests of science, submitted himself to examination by fifteen psychiatrists and agreed with their conclusion that his genius had its source in the neurotic elements of his temperament. Baudelaire, Rimbaud, Verlaine found virtue and strength in their physical and mental illness and pain. W. H. Auden addresses his "wound" in the cherishing language of a lover, thanking it for the gift of insight it has bestowed. "Knowing you," he says, "has made me understand." And Edmund Wilson in his striking phrase, "the wound and the bow," has formulated for our time the idea of the characteristic sickness of the artist, which he represents by the figure of Philoctetes, the Greek warrior who was forced to live in isolation because of the disgusting odor of a suppurating wound and who yet had to be sought out by his countrymen because they had need of the magically unerring bow he possessed.

The myth of the sick artist, we may suppose, has established itself because it is of advantage to the various groups who have one or another relation to art. To the artist himself the myth gives some of the ancient powers and privileges of the idiot and the fool, half-prophetic creatures, or of the mutilated priest. That the artist's neurosis may be but a mask is suggested by Thomas Mann's pleasure in representing his untried youth as "sick" but his successful maturity as senatorially robust. By means of his belief in his own sickness, the artist may the more easily fulfill his chosen, and assigned, function of putting himself into connection with the forces of spirituality and morality; the artist sees as insane the "normal" and "healthy" ways of established society, while aberration and illness appear as spiritual and moral health if only because they controvert the ways of respectable society.

Then too, the myth has its advantage for the philistine—a double advantage. On the one hand, the belief in the artist's neuroticism allows the philistine to shut his ears to what the artist says. But on the other hand it allows him to listen. For we must not make the common mistake—the contemporary philistine does want to listen, at the same time that he wants to shut his ears. By supposing that the artist has an interesting but not always reliable relation to reality, he is able to contain (in the military sense) what the artist tells him. If he did not want to listen at all, he would say "insane"; with "neurotic," which hedges, he listens when he chooses....

The early attempts of psychoanalysis to deal with art went on the assumption that, because the artist was neurotic, the content of his work was also neurotic, which is to say that it did not stand in a correct relation to reality. But nowadays, as I have said, psychoanalysis is not likely to be so simple in its transactions with art. A good example of the psychoanalytical development in this respect is Dr. Saul Rosenzweig's well-known essay, "The Ghost of Henry James."[1] This is an admirable piece of work, marked by accuracy in the reporting of the literary fact and by respect for the value of the literary object. Although Dr. Rosenzweig explores the element of neurosis in James's life and work, he nowhere suggests that this element in any way lessens James's value as an artist or moralist. In effect he

[1]First published in *Character and Personality*, December 1943, and reprinted in *Partisan Review*, Fall, 1944.

says that neurosis is a way of dealing with reality which, in real life, is uncomfortable and uneconomical, but that this judgment of neurosis in life cannot mechanically be transferred to works of art upon which neurosis has had its influence. He nowhere implies that a work of art in whose genesis a neurotic element may be found is for that reason irrelevant or in any way diminished in value. Indeed, the manner of his treatment suggests, what is of course the case, that every neurosis deals with a real emotional situation of the most intensely meaningful kind.

Yet as Dr. Rosenzweig brings his essay to its close, he makes use of the current assumption about the causal connection between the psychic illness of the artist and his power. His investigation of James, he says, "reveals the aptness of the Philoctetes pattern." He accepts the idea of "the sacrificial roots of literary power" and speaks of "the unhappy sources of James's genius." "The broader application of the inherent pattern," he says, "is familiar to readers of Edmund Wilson's recent volume *The Wound and the Bow....* Reviewing the experience and work of several well-known literary masters, Wilson discloses the sacrificial roots of their power on the model of the Greek legend. In the case of Henry James, the present account...provides a similar insight into the unhappy sources of his genius...."

This comes as a surprise. Nothing in Dr. Rosenzweig's theory requires it. For his theory asserts no more than that Henry James, predisposed by temperament and family situation to certain mental and emotional qualities, was in his youth injured in a way which he believed to be sexual; that he unconsciously invited the injury in the wish to identify himself with his father, who himself had been similarly injured—"castrated": a leg had been amputated—and under strikingly similar circumstances; this resulted for the younger Henry James in a certain pattern of life and in a preoccupation in his work with certain themes which more or less obscurely symbolized his sexual situation. For this I think Dr. Rosenzweig makes a sound case. Yet I submit that this is not the same thing as disclosing the roots of James's power or discovering the sources of his genius. The essay which gives Edmund Wilson's book its title and cohering principle does not explicitly say that the roots of power are sacrificial and that the source of genius is unhappy. Where it is explicit, it states only that "genius and disease, like strength and mutilation, may be inextricably bound up together," which of course, on its face, says no more than that personality is integral and not made up of detachable parts; and from this there is no doubt to be drawn the important practical and moral implication that we cannot judge or dismiss a man's genius and strength because of our awareness of his disease or mutilation. The Philoctetes legend in itself does not suggest anything beyond this. It does not suggest that the wound is the price of the bow, or that without the wound the bow may not be possessed or drawn. Yet Dr. Rosenzweig has accurately summarized the force and, I think, the intention of Mr. Wilson's whole book; its several studies do seem to say that effectiveness in the arts does depend on sickness.

An examination of this prevalent idea might well begin with the observation of how pervasive and deeply rooted is the notion that power may be gained by suffering. Even at relatively high stages of culture the mind seems to take easily to the primitive belief that pain and sacrifice are connected with strength. Primitive beliefs must be treated with respectful alertness to their possible truth and also with the suspicion of their being magical and irrational, and it is worth noting on both sides of the question, and in the light of what we have said about the ambiguous relation of the neurosis to reality, that the whole economy of the neurosis is based exactly on this idea of the *quid pro quo* of sacrificial pain: the neurotic person unconsciouly subscribes to a system whereby he gives up some pleasure or power,

or inflicts pain on himself in order to secure some other power or some other pleasure.... There is even a certain validity to the belief that the individual has a fund of undifferentiated energy which presses the harder upon what outlets are available to it when it has been deprived of the normal number.

...In further defense of the belief that artistic power is connected with neurosis, we can say that there is no doubt that what we call mental illness may be the source of psychic knowledge. Some neurotic people, because they are more apprehensive than normal people, are able to see more of certain parts of reality and to see them with more intensity. And many neurotic or psychotic patients are in certain respects in closer touch with the actualities of the unconscious than are normal people. Further, the expression of a neurotic or psychotic conception of reality is likely to be more intense than a normal one.

Yet when we have said all this, it is still wrong, I believe, to find the root of the artist's power and the source of his genius in neurosis. To the idea that literary power and genius spring from pain and neurotic sacrifice there are two major objections. The first has to do with the assumed uniqueness of the artist as a subject of psychoanalytical explanation. The second has to do with the true meaning of power and genius.

One reason why writers are considered to be more available than other people to psychoanalytical explanation is that they tell us what is going on inside them. Even when they do not make an actual diagnosis of their malaises or describe "symptoms," we must bear it in mind that it is their profession to deal with fantasy in some form or other. It is in the nature of the writer's job that he exhibit his unconscious. He may disguise it in various ways, but disguise is not concealment. Indeed, it may be said that the more a writer takes pains with his work to remove it from the personal and subjective, the more—and not the less—he will express his true unconscious, although not what passes with most for the unconscious.

Further, the writer is likely to be a great hand at personal letters, diaries, and autobiographies: indeed, almost the only good autobiographies are those of writers. The writer is more aware of what happens to him or goes on in him and often finds it necessary or useful to be articulate about his inner states, and prides himself on telling the truth. Thus, only a man as devoted to the truth of the emotions as Henry James was would have informed the world, despite his characteristic reticence, of an accident so intimate as his. We must not of course suppose that a writer's statements about his intimate life are equivalent to true statements about his unconscious, which, by definition, he doesn't consciously know; but they may be useful clues to the nature of an entity about which we can make statements of more or less cogency, although never statements of certainty; or they at least give us what is surely related to a knowledge of his unconscious—that is, an insight into his personality....

It is the basic assumption of psychoanalysis that the acts of *every* person are influenced by the forces of the unconscious. Scientists, bankers, lawyers, or surgeons, by reason of the traditions of their professions, practice concealment and conformity; but it is difficult to believe that an investigation according to psychoanalytical principles would fail to show that the strains and imbalances of their psyches are not of the same frequency as those of writers, and of similar kind. I do not mean that everybody has the same troubles and identical psyches, but only that there is no special category for writers.

If this is so, and if we still want to relate the writer's power to his neurosis, we must be willing to relate all intellectual power to neurosis. We must find the roots of Newton's power in his emotional extravagances, and the roots of Darwin's power in his sorely neurotic temperament, and the roots of Pascal's mathematical genius in

the impulses which drove him to extreme religious masochism—I choose but the classic examples. If we make the neurosis-power equivalence at all, we must make it in every field of endeavor. Logician, economist, botanist, physicist, theologian—no profession may be so respectable or so remote or so rational as to be exempt from the psychological interpretation.[2]

Further, not only power but also failure or limitation must be accounted for by the theory of neurosis, and not merely failure or limitation in life but even failure or limitation in art. Thus it is often said that the warp of Dostoevski's mind accounts for the brilliance of his psychological insights. But it is never said that the same warp of Dostoevski's mind also accounted for his deficiency in insight. Freud, who greatly admired Dostoevski, although he did not like him, observed that "his insight was entirely restricted to the workings of the abnormal psyche. Consider his astounding helplessness before the phenomenon of love; he really only understands either crude, instinctive desire or masochistic submission or love from pity."[3] This, we must note, is not merely Freud's comment on the extent of the province which Dostoevski chose for his own, but on his failure to understand what, given the province of his choice, he might be expected to understand.

And since neurosis can account not only for intellectual success and for failure or limitation but also for mediocrity, we have most of society involved in neurosis. To this I have no objection—I think most of society is indeed involved in neurosis. But with neurosis accounting for so much, it cannot be made exclusively to account for one man's literary power.

We have now to consider what is meant by genius when its source is identified as the sacrifice and pain of neurosis.

In the case of Henry James, the reference to the neurosis of his personal life does indeed tell us something about the latent intention of his work and thus about the reason for some large part of its interest for us. But if genius and its source are what we are dealing with, we must observe that the reference to neurosis tells us nothing about James's passion, energy, and devotion, nothing about his architectonic skill,

[2]In his interesting essay, "Writers and Madness" (*Partisan Review*, January-February 1947), William Barrett has taken issue with this point and has insisted that a clear distinction is to be made between the relation that exists between the scientist and his work and the relation that exists between the artist and his work. The difference, as I understand it, is in the claims of the ego. The artist's ego makes a claim upon the world which is personal in a way that the scientist's is not, for the scientist, although he does indeed want prestige and thus "responds to one of the deepest urges of his ego, it is only that his prestige may come to attend his person through the public world of other men; and it is not in the end his own being that is exhibited or his own voice that is heard in the learned report to the Academy." Actually, however, as is suggested by the sense which mathematicians have of the *style* of mathematical thought, the creation of the abstract thinker is as deeply involved as the artist's—see *An Essay on the Psychology of Invention in the Mathematical Field* by Jacques Hadamard, Princeton University Press, 1945—and he quite as much as the artist seeks to impose *himself* to *express* himself. I am of course not maintaining that the processes of scientific thought are the same as those of artistic thought, or even that the scientist's creation is involved with his total personality *in the same way* that the artist's is—I am maintaining only that the scientist's creation is as *deeply* implicated with his total personality as is the artist's.

This point of view seems to be supported by Freud's monograph on Leonardo. One of the problems that Freud sets himself is to discover why an artist of the highest endowment should have devoted himself more and more to scientific investigation, with the result that he was unable to complete his artistic enterprises. The particular reasons for this that Freud assigns need not be gone into here; all that I wish to suggest is that Freud understands these reasons to be the working out of an inner conflict, the attempt to deal with the difficulties that have their roots in the most primitive situations. Leonardo's scientific investigations were as necessary and "compelled" and they constituted as much of a claim on the whole personality as anything the artist undertakes; and so far from being carried out for the sake of public prestige, they were largely private and personal, and were thought by the public of his time to be something very like insanity.

[3]From a letter quoted in Theodor Reik's *From Thirty Years with Freud*, p. 175.

nothing about the other themes that were important to him which are not connected with his unconscious concern with castration. We cannot, that is, make the writer's inner life exactly equivalent to his power of expressing it. Let us grant for the sake of argument that the literary genius, as distinguished from other men, is the victim of a "mutilation" and that his fantasies are neurotic.[4] It does not then follow as the inevitable next step that his ability to express these fantasies and to impress us with them is neurotic, for that ability is what we mean by his genius. Anyone might be injured as Henry James was, and even respond within himself to the injury as James is said to have done, and yet not have his literary power.

The reference to the artist's neurosis tells us something about the material on which the artist exercises his powers, and even something about his reasons for bringing his powers into play, but it does not tell us anything about the source of his power, it makes no causal connection between them and the neurosis. And if we look into the matter, we see that there is in fact no causal connection between them. For, still granting that the poet is uniquely neurotic, what is surely not neurotic, what indeed suggests nothing but health, is his power of using his neuroticism. He shapes his fantasies, he gives them social form and reference. Charles Lamb's way of putting this cannot be improved. Lamb is denying that genius is allied to insanity; for "insanity" the modern reader may substitute "neurosis." "The ground of the mistake," he says, "is, that men, finding in the raptures of the higher poetry a condition of exaltation, to which they have no parallel in their own experience, besides the spurious resemblance of it in dreams and fevers, impute a state of dreaminess and fever to the poet. But the true poet dreams being awake. He is not possessed by his subject but has dominion over it.... Where he seems most to recede from humanity, he will be found the truest to it. From beyond the scope of nature if he summon possible existences, he subjugates them to the law of her consistency. He is beautifully loyal to that sovereign directress, when he appears most to betray and desert her.... Herein the great and the little wits are differenced; that if the latter wander ever so little from nature or natural existence, they lose themselves and their readers.... They do not create, which implies shaping and consistency. Their imaginations are not active—for to be active is to call something into act and form—but passive as men in sick dreams."

The activity of the artist, we must remember, may be approximated by many who are themselves not artists. Thus, the expressions of many schizophrenic people have the intense appearance of creativity and an inescapable interest and significance. But they are not works of art, and although Van Gogh may have been schizophrenic he was in addition an artist....

Nothing is so characteristic of the artist as his power of shaping his work, of subjugating his raw material, however aberrant it be from what we call normality, to the consistency of nature. It would be impossible to deny that whatever disease or mutilation the artist may suffer is an element of his production which has its effect on every part of it, but disease and mutilation are available to us all—life provides them with prodigal generosity. What marks the artist is his power to shape the material of pain we all have.

At this point, with our recognition of life's abundant provision of pain, we are at the very heart of our matter, which is the meaning we may assign to neurosis and

[4]I am using the word *fantasy*, unless modified, in a neutral sense. A fantasy, in this sense, may be distinguished from the representation of something that actually exists, but it is not opposed to "reality" and not an "escape" from reality. Thus the idea of a rational society, or the image of a good house to be built, as well as the story of something that could never really happen, is a fantasy. There may be neurotic or non-neurotic fantasies.

the relation we are to suppose it to have with normality. Here Freud himself can be of help, although it must be admitted that what he tells us may at first seem somewhat contradictory and confusing.

Freud's study of Leonardo da Vinci is an attempt to understand why Leonardo was unable to pursue his artistic enterprises, feeling compelled instead to advance his scientific investigations. The cause of this Freud traces back to certain childhood experiences not different in kind from the experiences which Dr. Rosenzweig adduces to account for certain elements in the work of Henry James. And when he has completed his study Freud makes this *caveat:* "Let us expressly emphasize that we have never considered Leonardo as a neurotic.... We no longer believe that health and disease, normal and nervous, are sharply distinguished from each other. We know today that neurotic symptoms are substitutive formations for certain repressive acts which must result in the course of our development from the child to the cultural man, that we all produce such substitutive formations, and that only the amount, intensity, and distribution of these substitutive formations justify the practical conception of illness...." The statement becomes the more striking when we remember that in the course of his study Freud has had occasion to observe that Leonardo was both homosexual and sexually inactive. I am not sure that the statement that Leonardo was not a neurotic is one that Freud would have made at every point in the later development of psychoanalysis, yet it is in conformity with his continuing notion of the genesis of culture. And the *practical,* the quantitative or economic, conception of illness he insists on in a passage in the *Introductory Lectures.* "The neurotic symptoms," he says, "...are activities which are detrimental, or at least useless, to life as a whole; the person concerned frequently complains of them as obnoxious to him or they involve suffering and distress for him. The principal injury they inflict lies in the expense of energy they entail, and, besides this, in the energy needed to combat them. Where the symptoms are extensively developed, these two kinds of effort may exact such a price that the person suffers a very serious impoverishment in available mental energy which consequently disables him for all the important tasks of life. This result depends principally upon the amount of energy taken up in this way; therefore you will see that 'illness' is essentially a practical conception. But if you look at the matter from a theoretical point of view and ignore this question of degree, you can very well see that we are all ill, i.e., neurotic; for the conditions required for symptom-formation are demonstrable also in normal persons."

We are all ill: the statement is grandiose, and its implications—the implications, that is, of understanding the totality of human nature in the terms of disease—are vast. These implications have never been properly met (although I believe that a few theologians have responded to them), but it is not the place to attempt to meet them. I have brought forward Freud's statement of the essential sickness of the psyche only because it stands as the refutation of what is implied by the literary use of the theory of neurosis to account for genius. For if we are all ill, and if, as I have said, neurosis can account for everything, for failure and mediocrity—"a very serious impoverishment of available mental energy"—as well as for genius, it cannot uniquely account for genius.

This, however, is not to say that there is no connection between neurosis and genius, which would be tantamount, as we see, to saying that there is no connection between human nature and genius. But the connection lies wholly in a particular and special relation which the artist has to neurosis.

In order to understand what this particular and special connection is we must have clearly in mind what neurosis is. The current literary conception of neurosis as a *wound* is quite misleading. It inevitably suggests passivity, whereas, if we follow

Freud, we must understand a neurosis to be an *activity,* an activity with a purpose, and a particular kind of activity, a *conflict.* This is not to say that there are no abnormal mental states which are not conflicts. There are; the struggle between elements of the unconscious may never be instituted in the first place, or it may be called off. As Freud says in a passage which follows close upon the one I last quoted, "If regressions do not call forth a prohibition on the part of the ego, no neurosis results; the libido succeeds in obtaining a real, although not a normal, satisfaction. But if the ego...is not in agreement with these regressions, conflict ensues." And in his essay on Dostoevski Freud says that "there are no neurotic complete masochists," by which he means that the ego which gives way completely to masochism (or to any other pathological excess) has passed beyond neurosis; the conflict has ceased, but at the cost of the defeat of the ego, and now some other name than that of neurosis must be given to the condition of the person who thus takes himself beyond the pain of the neurotic conflict. To understand this is to become aware of the curious complacency with which literary men regard mental disease. The psyche of the neurotic is not equally complacent; it regards with the greatest fear the chaotic and destructive forces it contains, and it struggles fiercely to keep them at bay.[5]

We come then to a remarkable paradox: we are all ill, but we are ill in the service of health, or ill in the service of life, or, at the very least, ill in the service of life-in-culture. The form of the mind's dynamics is that of the neurosis, which is to be understood as the ego's struggle against being overcome by the forces with which it coexists, and the strategy of this conflict requires that the ego shall incur pain and make sacrifices of itself, at the same time seeing to it that its pain and sacrifice be as small as they may.

But this is characteristic of all minds: no mind is exempt except those which refuse the conflict or withdraw from it; and we ask wherein the mind of the artist is unique. If he is not unique in neurosis, is he then unique in the significance and intensity of his neurosis? I do not believe that we shall go more than a little way toward a definition of artistic genius by answering this question affirmatively. A neurotic conflict cannot ever be either meaningless or merely personal; it must be understood as exemplifying cultural forces of great moment, and this is true of any neurotic conflict at all. To be sure, some neuroses may be more interesting than others, perhaps because they are fiercer or more inclusive; and no doubt the writer who makes a claim upon our interest is a man who by reason of the energy and significance of the forces in struggle within him provides us with the largest representation of the culture in which we, with him, are involved; his neurosis may thus be thought of as having a connection of concomitance with his literary powers. As Freud says in the Dostoevski essay, "the neurosis...comes into being all the more readily the richer the complexity which has to be controlled by his ego." Yet even the rich complexity which his ego is doomed to control is not the definition of the

[5]In the article to which I refer in footnote 2, William Barrett says that he prefers the old-fashioned term "madness" to "neurosis." But it is not quite for him to choose—the words do not differ in fashion but in meaning. Most literary people, when they speak of mental illness, refer to neurosis. Perhaps one reason for this is that the neurosis is the most benign of the mental ills. Another reason is surely that psychoanalytical literature deals chiefly with the neurosis, and its symptomatology and therapy have become familiar; psychoanalysis has far less to say about psychosis, for which it can offer far less therapeutic hope. Further, the neurosis is easily put into a causal connection with the social maladjustments of our time. Other forms of mental illness of a more severe and degenerative kind are not so widely recognized by the literary person and are often assimilated to neurosis with a resulting confusion. In the present essay I deal only with the conception of neurosis, but this should not be taken to imply that I believe that other pathological mental conditions, including madness, do not have relevance to the general matter of the discussion.

artist's genius, for we can by no means say that the artist is pre-eminent in the rich complexity of elements in conflict within him. The slightest acquaintance with the clinical literature of psychoanalysis will suggest that a rich complexity of struggling elements is no uncommon possession. And that same literature will also make it abundantly clear that the devices of art—the most extreme devices of poetry, for example—are not particular to the mind of the artist but are characteristic of mind itself.

But the artist is indeed unique in one respect, in the respect of his relation to his neurosis. He is what he is by virtue of his successful objectification of his neurosis, by his shaping it and making it available to others in a way which has its effect upon their own egos in struggle. His genius, that is, may be defined in terms of his faculties of perception, representation, and realization, and in these terms alone. It can no more be defined in terms of neurosis than can his power of walking and talking, or his sexuality. The use to which he puts his power, or the manner and style of his power, may be discussed with reference to his particular neurosis, and so may such matters as the untimely diminution or cessation of its exercise. But its essence is irreducible. It is, as we say, a gift.

We are all ill: but even a universal sickness implies an idea of health. Of the artist we must say that whatever elements of neurosis he has in common with his fellow mortals, the one part of him that is healthy, by any conceivable definition of health, is that which gives him the power to conceive, to plan, to work, and to bring his work to a conclusion. And if we are all ill, we are ill by a universal accident, not by a universal necessity, by a fault in the economy of our powers, not by the nature of the powers themselves. The Philoctetes myth, when it is used to imply a causal connection between the fantasy of castration and artistic power, tells us no more about the source of artistic power than we learn about the source of sexuality when the fantasy of castration is adduced, for the fear of castration may explain why a man is moved to extravagant exploits of sexuality, but we do not say that his sexual power itself derives from his fear of castration; and further the same fantasy may also explain impotence or homosexuality....

"The layman," [Freud] says, "may expect perhaps too much from analysis...for it must be admitted that it throws no light upon the two problems which probably interest him the most. It can do nothing toward elucidating the nature of the artistic gift, nor can it explain the means by which the artist works—artistic technique."

What, then, does Freud believe that the analytical method can do? Two things: explain the "inner meanings" of the work of art and explain the temperament of the artist as man.

A famous example of the method is the attempt to solve the "problem" of *Hamlet* as suggested by Freud and as carried out by Dr. Ernest Jones, his early and distinguished follower. Dr. Jones's monograph is a work of painstaking scholarship and of really masterly ingenuity. The research undertakes not only the clearing up of the mystery of Hamlet's character, but also the discovery of "the clue to much of the deeper workings of Shakespeare's mind." Part of the mystery in question is of course why Hamlet, after he had so definitely resolved to do so, did not avenge upon his hated uncle his father's death. But there is another mystery to the play—what Freud calls "the mystery of its effect," its magical appeal that draws so much interest toward it. Recalling the many failures to solve the riddle of the play's charm, he wonders if we are to be driven to the conclusion "that its magical appeal rests solely upon the impressive thoughts in it and the splendor of its language." Freud believes that we can find a source of power beyond this.

We remember that Freud has told us that the meaning of a dream is its intention, and we may assume that the meaning of a drama is its intention, too. The Jones research undertakes to discover what it was that Shakespeare intended to say about Hamlet. It finds that the intention was wrapped by the author in a dreamlike obscurity because it touched so deeply both his personal life and the moral life of the world; what Shakespeare intended to say is that Hamlet cannot act because he is incapacitated by the guilt he feels at his unconscious attachment to his mother. There is, I think, nothing to be quarreled with in the statement that there is an Oedipus situation in *Hamlet;* and if psychoanalysis has indeed added a new point of interest to the play, that is to its credit.[6] And, just so, there is no reason to quarrel with Freud's conclusion when he undertakes to give us the meaning of *King Lear* by a tortuous tracing of the mythological implications of the theme of the three caskets, of the relation of the caskets to the Norns, the Fates, and the Graces, of the connection of these triadic females with Lear's daughters, of the transmogrification of the death goddess into the love goddess and the identification of Cordelia with both, all to the conclusion that the meaning of *King Lear* is to be found in the tragic refusal of an old man to "renounce love, choose death, and make friends with the necessity of dying." There is something both beautiful and suggestive in this, but it is not *the* meaning of *King Lear* any more than the Oedipus motive is *the* meaning of *Hamlet.*

It is not here a question of the validity of the evidence, though that is of course important. We must rather object to the conclusions of Freud and Dr. Jones on the ground that their proponents do not have an adequate conception of what an artistic meaning is. There is no single meaning to any work of art; this is true not merely because it is better that it should be true, that is, because it makes art a richer thing, but because historical and personal experience show it to be true. Changes in historical context and in personal mood change the meaning of a work and indicate to us that artistic understanding is not a question of fact but of value. Even if the author's intention were, as it cannot be, precisely determinable, the meaning of a work cannot lie in the author's intention alone. It must also lie in its effect. We can say of a volcanic eruption on an inhabited island that it "means terrible suffering," but if the island is uninhabited or easily evacuated it means something else. In short, the audience partly determines the meaning of the work. But although Freud sees something of this when he says that in addition to the author's intention we must take into account the mystery of *Hamlet's* effect, he nevertheless goes on to speak as if, historically, *Hamlet's* effect had been single and brought about solely by the "magical" power of the Oedipus motive to which, unconsciously, we so violently respond. Yet there was, we know, a period when *Hamlet* was relatively in eclipse, and it has always been scandalously true of the French, a people not without filial feeling, that they have been somewhat indifferent to the "magical appeal" of *Hamlet.*

I do not think that anything I have said about the inadequacies of the Freudian method of interpretation limits the number of ways we can deal with a work of art. Bacon remarked that experiment may twist nature on the rack to wring out its secrets, and criticism may use any instruments upon a work of art to find its meanings. The elements of art are not limited to the world of art. They reach into

[6]However, A. C. Bradley, in his discussion of Hamlet (*Shakespearean Tragedy*), states clearly the intense sexual disgust which Hamlet feels and which, for Bradley, helps account for his uncertain purpose; and Bradley was anticipated in this view by Loning. It is well known, and Dover Wilson has lately emphasized this point, that to an Elizabethan audience Hamlet's mother was not merely tasteless, as to a modern audience she seems, in hurrying to marry Claudius, but actually adulterous in marrying him at all because he was, as her brother-in-law, within the forbidden degrees.

Neurosis and Alienation

life, and whatever extraneous knowledge of them we gain—for example, by research into the historical context of the work—may quicken our feelings for the work itself and even enter legitimately into those feelings. Then, too, anything we may learn about the artist himself may be enriching and legitimate. But one research into the mind of the artist is simply not practicable, however legitimate it may theoretically be. That is, the investigation of his unconscious intention as it exists apart from the work itself. Criticism understands that the artist's statement of his conscious intention, though it is sometimes useful, cannot finally determine meaning. How much less can we know from his unconscious intention considered as something apart from the whole work? Surely very little that can be called conclusive or scientific. For, as Freud himself points out, we are not in a position to question the artist; we must apply the technique of dream analysis to his symbols, but as Freud says with some heat, those people do not understand his theory who think that a dream may be interpreted without the dreamer's free association with the multitudinous details of his dream.

We have so far ignored the aspect of the method which finds the solution to the "mystery" of such a play as *Hamlet* in the temperament of Shakespeare himself and then illuminates the mystery of Shakespeare's temperament by means of the solved mystery of the play. Here it will be amusing to remember that by 1935 Freud had become converted to the theory that it was not Shakespeare of Stratford but the Earl of Oxford who wrote the plays, thus invalidating the important bit of evidence that Shakespeare's father died shortly before the composition of *Hamlet*. This is destructive enough to Dr. Jones's argument, but the evidence from which Dr. Jones draws conclusions about literature fails on grounds more relevant to literature itself. For when Dr. Jones, by means of his analysis of *Hamlet*, takes us into "the deeper workings of Shakespeare's mind," he does so with a perfect confidence that he knows what *Hamlet* is and what its relation to Shakespeare is. It is, he tells us, Shakespeare's "chief masterpiece," so far superior to all his other works that it may be placed on "an entirely separate level." And then, having established his ground on an entirely subjective literary judgment, Dr. Jones goes on to tell us that *Hamlet* "probably expresses the core of Shakespeare's philosophy and outlook as no other work of his does." That is, all the contradictory or complicating or modifying testimony of the other plays is dismissed on the basis of Dr. Jones's acceptance of the peculiar position which, he believes, *Hamlet* occupies in the Shakespeare canon. And it is upon this quite inadmissible judgment that Dr. Jones bases his argument: "It may be expected *therefore* that anything which will give us the key to the inner meaning of the play will *necessarily* give us the clue to much of the deeper workings of Shakespeare's mind." (The italics are mine.)

I should be sorry if it appeared that I am trying to say that psychoanalysis can have nothing to do with literature. I am sure that the opposite is so. For example, the whole notion of rich ambiguity in literature, of the interplay between the apparent meaning and the latent—not "hidden"—meaning, has been reinforced by the Freudian concepts, perhaps even received its first impetus from them. Of late years, the more perceptive psychoanalysts have surrendered the early pretensions of their teachers to deal "scientifically" with literature. That is all to the good, and when a study as modest and precise as Dr. Franz Alexander's essay on *Henry IV* comes along, an essay which pretends not to "solve" but only to illuminate the subject, we have something worth having. Dr. Alexander undertakes nothing more than to say that in the development of Prince Hal we see the classic struggle of the ego to come to normal adjustment, beginning with the rebellion against the father, going on to the conquest of the super-ego (Hotspur, with his rigid notions of honor and glory), then to the conquests of the *id* (Falstaff, with his anarchic

self-indulgence), then to the identification with the father (the crown scene) and the assumption of mature responsibility. An analysis of this sort is not momentous and not exclusive of other meanings; perhaps it does no more than point up and formulate what we all have already seen. It has the tact to *accept* the play and does not, like Dr. Jones's study of *Hamlet,* search for a "hidden motive" and a "deeper working," which implies that there is a reality to which the play stands in the relation that a dream stands to the wish that generates it and from which it is separable; it is this reality, this "deeper working," which, according to Dr. Jones, produced the play. But *Hamlet* is not merely the product of Shakespeare's thought, it is the very instrument of his thought, and if meaning is intention, Shakespeare did not intend the Oedipus motive or anything less than *Hamlet;* if meaning is effect then it is *Hamlet* which affects us, not the Oedipus motive. *Coriolanus* also deals, and very terribly, with the Oedipus motive, but the effect of the one drama is very different from the effect of the other.

If, then, we can accept neither Freud's conception of the place of art in life nor his application of the analytical method, what is it that he contributes to our understanding of art or to its practice? In my opinion, what he contributes outweighs his errors; it is of the greatest importance, and it lies in no specific statement that he makes about art but is, rather, implicit in his whole conception of the mind.

For, of all mental systems, the Freudian psychology is the one which makes poetry indigenous to the very constitution of the mind. Indeed, the mind, as Freud sees it, is in the greater part of its tendency exactly a poetry-making organ. This puts the case too strongly, no doubt, for it seems to make the working of the unconscious mind equivalent to poetry itself, forgetting that between the unconscious mind and the finished poem there supervene the social intention and the formal control of the conscious mind. Yet the statement has at least the virtue of counterbalancing the belief, so commonly expressed or implied, that the very opposite is true, and that poetry is a kind of beneficient aberration of the mind's right course.

Freud has not merely naturalized poetry; he has discovered its status as a pioneer settler, and he sees it as a method of thought. Often enough he tries to show how, as a method of thought, it is unreliable and ineffective for conquering reality; yet he himself is forced to use it in the very shaping of his own science, as when he speaks of the topography of the mind and tells us with a kind of defiant apology that the metaphors of space relationship which he is using are really most inexact since the mind is not a thing of space at all, but that there is no other way of conceiving the difficult idea except by metaphor. In the eighteenth century Vico spoke of the metaphorical, imagistic language of the early stages of culture; it was left to Freud to discover how, in a scientific age, we still feel and think in figurative formations, and to create, what psychoanalysis is, a science of tropes, of metaphor and its variants, synecdoche and metonymy.

Freud showed, too, how the mind, in one of its parts, could work without logic, yet not without that directing purpose, that control of intent from which, perhaps it might be said, logic springs. For the unconscious mind works without the syntactical conjunctions which are logic's essence. It recognizes no *because,* no *therefore,* no *but;* such ideas as similarity, agreement, and community are expressed in dreams imagistically by compressing the elements into a unity. The unconscious mind in its struggle with the conscious always turns from the general to the

concrete and finds the tangible trifle more congenial than the large abstraction. Freud discovered in the very organization of the mind those mechanisms by which art makes its effects, such devices as the condensations of meanings and the displacement of accent....

Alienation as a Dominant Theme

Roy McMullen

Roy McMullen has contributed articles on painting, music, and literature to numerous journals, including Realities, Connaissance des Arts, *and* Horizon. *He has also been a contributing editor to* Art News *and European editor for* High Fidelity *and* Musical America. *He is consultant on fine arts for the* Encyclopaedia Britannica *and, before that was a member of the staff of the International Edition of the* New York Herald Tribune.

In the following essay McMullen notes the growing emphasis on alienation in the contemporary novel and discusses whether this results from an attempt to reflect life more faithfully or is a reflection of the authors' own growing estrangement.

I

Bellow's Moses Herzog is a Jewish college professor who has been emotionally routed in his career and his two marriages, has felt himself going half insane, and has taken to writing letters "endlessly, fanatically, to the newspapers, to people in public life ... to the dead, his own obscure dead, and finally the famous dead." Salinger's young Holden Caulfield, who finds nearly everyone and everything phony, is a school truant and finally a case for psychoanalytical treatment. Humbert Humbert, the middle-aged narrator in Vladimir Nabokov's *Lolita,* is a lover of "nymphets"—girls between the ages of nine and fourteen—and finally an unrepentant murderer; he begins writing his story in a psychopathic ward and finishes it in prison. In the same author's *Pale Fire* the main character is Charles Kinbote, alias King Charles Xavier II of Zembla, an exiled and obviously potty scholar and homosexual. In Jean Genet's *Our Lady of the Flowers* the characters are thieves, murderers, pimps, stool pigeons, and male prostitutes; and the narrator, Genet himself, is a convict indulging in masturbation fantasies. Oskar Matzerath, the lecherous dwarf in Gunter Grass's *The Tin Drum,* writes, or drums out, his picaresque tale of death, bawdiness, and Hitlerism from the barred bed of a lunatic. The characters in William S. Burroughs' *Naked Lunch* are drug addicts and victims or practitioners of sexual perversion.

Camus' Meursault finds no meaning, in fact no reality, in such middle-class emotions as filial piety, romantic love, and contrition after murder, and goes to his death as if he were someone else. Roquentin, the narrator in Sartre's *Nausea,* has

From *Art, Affluence, and Alienation* by Roy McMullen (New York: Frederick A. Praeger, 1968), pp. 206–212. Copyright © 1968 by Encyclopaedia Britannica, Inc. Reprinted by permission of Frederick A. Praeger, Inc. and Pall Mall Press Ltd.

bouts of violent sickness and giddy solitude after discovering what seems to him a meaningless factuality in the objects around him—a rock, a bench, a beer glass, a blue shirt against a brown wall. The title personage in Samuel Beckett's *Watt* has a parallel difficulty with a simple object like a pot: "It resembled a pot, it was almost a pot, but it was not a pot of which one could say, Pot, pot, and be comforted."

The hero of Ralph Ellison's *Invisible Man* is a Negro in search of his identity who lives symbolically in a deserted basement lit by "exactly 1,369 lights," for which he steals the electricity. In Norman Mailer's *An American Dream* the hero is a half-Jewish war veteran, professor, television performer, drunkard, and occasional sodomite who has a recurring impulse to kill himself but strangles his wife instead. Old Gulley Jimson, in Joyce Cary's *The Horse's Mouth,* is a hilariously unsuccessful painter and saboteur of the right-thinking world. Jim Dixon, the hero of Kingsley Amis' *Lucky Jim,* is a square peg who finds that all the holes British society offers him are round. Geoffrey Firmin, in Malcolm Lowry's *Under the Volcano,* is an admirable person destroyed by alcohol. The priest in Greene's *The Power and the Glory* is a drinking man and literally a father. Athos Fadigati, in Giorgio Bassani's *The Gold-Rimmed Spectacles,* is a homosexual doctor driven from his practice and finally to suicide; his story is told by a young Jew who comes to realize that he too is being rejected by society. Alex, the narrator in Anthony Burgess' *A Clockwork Orange,* is a 15-year-old hoodlum in a superstate of the future; after a career of rape and murder he is temporarily reformed by a conditioning of his reflexes that has the defect, from a Christian point of view, of destroying moral choice. In Golding's *Lord of the Flies* children revert to savagery. Frank Alpine, in Bernard Malamud's *The Assistant,* is a reformed holdup man who has himself circumcised and becomes a Jew. George Caldwell, the dying high-school teacher in John Updike's *The Centaur,* is a clumsy failure in all of life's tests except that of sympathy. Half the personages in Joseph Heller's *Catch-22* are insanely engaged in making nonsense of the American effort in World War II, and the other half are lucidly engaged in the same operation.

This listing of persons, situations, and stories—of "material," since in a novel people are of the same stuff as predicaments and action—had better be halted before it gets out of control. It had also better be qualified right away; many of the novels mentioned are bound to fade in coming years, and there are trends which are not sampled, or at any rate not adequately. These shortcomings need not, however, rule out some general remarks. All of the books have been praised by competent judges. On the record one can guess that those which fade rapidly will be rapidly replaced by something similar in content. Allowing for substitutions to suit a reader's personal taste, one can say that the listing is representative of the sort of material favoured by two-thirds of the better novelists writing since 1939 in the technologically advanced nations. Novelists in Marxist countries are omitted out of a desire to be fair; their art is just getting under way after the disaster of Stalinism and Zhdanovism and cannot yet stand comparison with the best work in the non-Communist Occident (Pasternak was more a survivor than a contemporary).

A comparison of this material with a sampling from 22 typical novels of the 18th and 19th centuries would bring out something everybody knows, although the evidence is sometimes forgotten. One of the most common stories of a hundred years or more ago is that of the fundamentally sound young man or woman who makes a few mistakes about appearance and reality, who may even rebel against the code of the majority, but who is at last gathered into the fold of community values and familiar certitudes—a satisfactory marriage being the usual sign of the completion of the process. It is a story of education leading to initiation and integration. Along the way there may be some criticism of society and conventional

Neurosis and Alienation

reality, but this usually boils down to nothing stronger than charges of hypocrisy or myopia; the system is merely being told to be more faithful to its own nature. Even when the hero or heroine fails to learn fast enough and winds up as an outsider, the author comments from a point of view within the community. In short—and to be rather abstract about an art that is never abstract—a dominant theme in these old novels is acculturation (there are other themes, naturally, and "acculturation" must be allowed a broad meaning). The theme is developed by writers belonging to very different categories, by James and Flaubert as well as by Tolstoi, George Eliot, Jane Austen, Fielding, and Richardson. These great novelists are too much artists to be preachers; they see to it that the moral to a tale is more enacted than pointed. But over and over it is the same moral: grow up, face reality, adapt yourself, and be integrated.

Something close to an exact reversal of this moral can be found in post-1939 fiction. In a sense, I suppose, the grand theme of acculturation is still being orchestrated; it can scarcely be avoided, since all novels are about people learning to live in society and adjust to reality. But it is orchestrated in such an atonal fashion, with so much dissonance and such a violent displacement of author sympathy, that we are likely to feel it as antiacculturation. And so, since there are more than enough anti-terms around, we may as well retreat into commonplaces and say, as every critic does sooner or later, that the dominant (again, not the only) theme in the contemporary novel is alienation.

To be sure, this theme did not make its first appearance in 1939. Any scolding of contemporary novelists for using it ought to begin with an admission that they are in good historical company. Alienation is of course evident in the work of such diverse between-the-wars writers as Ernest Hemingway, F. Scott Fitzgerald, Andre Gide, Evelyn Waugh, and Louis Ferdinand Celine (my sampling is still aleatory). It is also evident in the work of such standard Americans as Nathaniel Hawthorne, Herman Melville, and Mark Twain: Huck Finn does not think at all highly of either adulthood or community values. It appears, with variations, in the novels of Fedor Dostoevski, Stendhal, and Cervantes; the operas of Wagner; the poetry of Rimbaud and Baudelaire; the thinking of Hegel, Marx, Freud, and Jung. Hamlet is alienated, as are all of the mad or apparently mad revengers in Elizabethan and Jacobean plays. Faust is alienated, and so are many of the personages in Greek myths. A full history would have to begin with the story of the Fall in *Genesis,* or perhaps with the first indications that Satan was not going to face reality and settle down in heavenly society.

Nevertheless, it is hard to think of any past period in which the theme was as dominant as it has been during roughly the last thirty years, particularly in the novel. Admittedly, it has many kinds and degrees. One can even detect national styles.... But the word "alienation" spans the differences; evidently the novelists are all talking about the same sentiment. Why are they doing so?

[The same question applies to] poetry, the theatre, and the general feel of the modern era. The obvious answer a novelist can give is that he is committed, more than other artists, to "an exploration of the variety of life" and is simply reporting facts. A lot of 20th-century people are indeed apt to feel like exiles, to lose their sense of identity, and to have trouble with the nature of reality. Many feel cut off from the humanistic past and yet incapable of integration with the present as represented by modern art, science, and technology; they worry about becoming cultural zombies. Democracy and industrialization have weakened the social classes and professional groups which enable a man to know who he is without asking himself. It has become difficult to belong to God and difficult, even for professed atheists, not to want to. You can start a day feeling poorly adapted to the new

materialism and go to bed feeling that mind has inundated matter and you are at sea in selfhood. Marxists are not alone in feeling that under capitalism whatever a person produces with his hands or brain is immediately made alien, somehow hostile, to him. Existentialists are not alone in their anguished conviction that every individual has got to create Man, without a blueprint. And nearly everyone is nagged by a hunch that he is forbidden to become, in a phrase of Ortega's, his "programmatic personage," his own vital design, his authentic "I"; nearly everyone is a sort of sane schizophrenic.

All this is true. But that it is the whole truth about modern life can be violently contested by any non-novelist. Moreover, it does not explain the enthusiasm contemporary novelists have for writing about alienation. They like the theme; they are not just dutiful reporters carrying out an assignment. They are nearly always impatient with ideas of assimilation and acculturation; their sympathies and talents are reserved for racial or religious minorities and madmen, fools, homosexuals, alcoholics, adolescents, criminals, failures, addicts, and clowns. The recurring moral, taken literally, is that maybe the world would be better off if we all refused to grow up and join up. Of course it is not to be taken literally, and often there is no moral, in the sense of a guide for conduct; there is only an assertion that this is how things are. Most of these writers would probably argue that literature is a wisdom, not an ethic. That argument, however, merely brings up the question again: Why are they so devoted to this particular sort of wisdom?

II

The answer to that question, I am afraid, is another commonplace—and a Romantic one. Alienation is notoriously congenial to artists. It helps them to create worlds within the world. It does part of their work for them.

To say this is not to underestimate talent and seriousness. No reader of *Herzog*, for example, can doubt the complete sincerity, and the erudition, with which Bellow explores the problems of the modern sensibility. Nobody can doubt either that Jewishness and a touch of lunacy make Moses Herzog a more intense representative of the modern world's outsiders than a perfectly sane Gentile might have been. Consider, however, the opening sentence of the book: "If I am out of my mind, it's all right with me...." The reader soon comes to realize that it's all right too with Bellow the artist, as is the fact that the hero is a "big-city Jew." Herzog's unhinged mind, supplied as it is with memories partly in Yiddish, could be appreciated in real life as a work of art; it has ready-made arbitrary structures and aesthetic distance. In the novel it serves as a theater-in-the-round, brilliantly lit and carefully sealed off from linear time (the story, like *Finnegans Wake*, ends where it begins), within which all the characters—Herzog included—exist and the action occurs.

The fiercely alienated convict's mind of Genet, narrating *Our Lady of the Flowers*, produces a similar—one might almost say automatic—aesthetic effect, heightened by the choice of material: the unholy integrity, futility, and absolute apartness of the Montmartre milieu of pimps and perverts add up to a real-life parody of a work of art, a world within the world. I do not wish to discount the artistry of Genet, nor the large symbolical significance of his work. But it is plain that he begins the process of artistic creation with an advantage over the novelists who do not write about outsiders.

The same advantage comes into play for Salinger when he gives his young hero the apartness of a teen-age subculture, for Nabokov when he makes Humbert and Kinbote perverse and potty, for Grass when he makes Oskar Matzerath a

self-created dwarf, for Sartre when he has Roquentin develop that strange allergy to physical reality, for Bassani when he chooses a homosexual protagonist and a Jewish narrator, for Ellison when he makes his Negro narrator go through an initiation in reverse, an initiation into ostracism. The reader can continue the examples. Once again, my point is not meant as a slight on the sincerity of these novelists. In creating their worlds within the world they do not have the crude intentions of the potboiler author who throws his characters into an Atlantic luxury liner, or a grand hotel isolated by a blizzard. But is it not clear that the alienation theme may be dangerously attractive?

All artists, of course, impose apartness and set up arbitrary little worlds. There are, however, distinctions worth noting. Take one of the fine acculturation novels of the past, say James's *The Portrait of a Lady* (even the title is acculturative). James does make us aware of a work of art. But the arbitrary "little" world he creates is nothing less than a complex working model of Atlantic-basin civilization above a certain income level, within which the independent—not alienated—young Isabel Archer is forced to learn to find her way. The material, in other words, is structured and given a quality of apartness, is aestheticized, only at a relatively late stage in the creative process, a stage late enough to let the novelistic facts ripen into a broadly varied simulacrum of social reality. On the other hand, in a typical post-1939 alienation novel, even such a mild one as *The Catcher in the Rye,* the little world apart can be said to exist at the very beginning of the creative process—in fact, before the beginning. James selects a broad slice of life and works it up into a form. Salinger selects a narrow slice which has a form already. His novel, like many of those under consideration, is made of pre-aestheticized material.

Here, as in the similar problems posed by modern meta-theatre and absurd drama, critical temperament is apt to govern judgment, and so I must offer some of my promised tentativeness. Alienation seems to provide the novelist with an alarmingly Romantic facility for confusing reality with art. Used as a dominant theme, it even seems to weaken the very essence of the genre, of novelry, for it discourages "an exploration of the variety of life" and fosters a premature kind of apartness in material. It is ultimately amoral, as all opting out is. At its worst it becomes intolerably snug and smug, an excuse for a literature of opposition to something which cannot actually be opposed, about which nothing can be done. All too frequently it turns the protagonist into a portrait of the artist. And yet the day is past when a novelist, with a straight face, could simply tell people to join up. Join up with what? The acculturation theme supposes a confidence in community values which a contemporary writer cannot assume exists (except possibly in Communist countries). Alienation is an important fact in modern society, and it will probably become more important everywhere in the near future—its prevalence in an advanced country like the United States is prophetic. It cannot be avoided by serious novelists. They must learn to live with this rather antinovelistic theme, must get out their long spoons and sup with their devil. My tentative conclusion is that great novels are likely to get even harder to write than they evidently are already.

Of course we should remember that alienation, although of top importance, is not the only theme in post-1939 fiction. There is a chilling indictment of racial prejudice in *Invisible Man*; there are pleas for tolerance and fraternity in *The Gold-Rimmed Spectacles* and other books; *The Tin Drum* is about war, politics, and, ultimately, good and evil; *The Power and the Glory* is about faith and charity; *A Clockwork Orange* is about tyranny and the human dignity that goes with free will; *Lolita* is about old-fashioned romantic love of the Poe sort, and not entirely a spoof of the subject, whatever Nabokov intended. There is no room for an adequate

account of the variety of these themes, and they do not lend themselves to generalization. The fact, however, that the books I have just mentioned are among the best of the lot might be read as a warning to novelists against overindulgence in straight alienation.

The Culture of Modernism

Irving Howe

Irving Howe (1920–), author, historian, and critic, taught English at Brandeis and Stanford and now teaches at Hunter College. He has written critical studies of Sherwood Anderson and William Faulkner, and his Politics and the Novel: A World More Attractive *(1963) reflects his broader interests. He is the editor of* Dissent *and is known as an independent radical polemicist as well as an able literary scholar.*

In the following essay Howe discusses the alienation associated with what he calls the "modernist" outlook of present-day writers, artists, and composers, and the impact of this alienation on the moral and aesthetic standards of our time. He predicts for nihilistic practitioners of modernism the worst of all fates—acceptance, approval, indulgence, and, horribile dictu, *imitation and popularization.*

In the past hundred years we have had a special kind of literature. We call it modern and distinguish it from the merely contemporary; for where the contemporary refers to time, the modern refers to sensibility and style, and where the contemporary is a term of neutral reference, the modern is a term of critical placement and judgment. Modernist literature seems now to be coming to an end, though we can by no means be certain and there are critics who would argue that, given the nature of our society, it cannot come to an end.

The kind of literature called modern is almost always difficult: that is a sign of its modernity. To the established guardians of culture, the modern writer seems willfully inaccessible. He works with unfamiliar forms; he chooses subjects that disturb the audience and threaten its most cherished sentiments; he provokes traditionalist critics to such epithets as "unwholesome," "coterie," and "decadent."

The modern must be defined in terms of what it is not, the embodiment of a tacit polemic, an inclusive negative. Modern writers find that they begin to work at a moment when the culture is marked by a prevalent style of perception and feeling; and their modernity consists in a revolt against this prevalent style, an unyielding rage against the official order. But modernism does not establish a prevalent style of its own; or if it does, it denies itself, thereby ceasing to be modern. This presents it with a dilemma which in principle may be beyond solution but in practice leads to formal inventiveness and resourceful dialectic—*the dilemma that modernism must always struggle but never quite triumph, and then, after a time, must struggle in order not to triumph....* Modernism, despite the precursors

From *Commentary* (November 1967), pp. 48–59. Copyright © 1967 by the American Jewish Committee. Reprinted by permission of the publisher and the author.

Neurosis and Alienation

one can find in the past, is, I think, a novelty in the development of Western culture. What we do know, however, is that modernism can fall upon days of exhaustion, when it appears to be marking time and waiting for new avenues of release.

At certain points in the development of a culture, usually points of dismay and restlessness, writers find themselves affronting their audience, and not from decision or whim but from some deep moral and psychological necessity. Such writers may not even be aware that they are challenging crucial assumptions of their day, yet their impact is revolutionary; and once this is recognized by sympathetic critics and a coterie audience, the avant garde has begun to emerge as a self-conscious and combative group. Paul Goodman writes:

... there are these works that are indignantly rejected, and called not genuine art, but insult, outrage, blague, fumiste, willfully incomprehensible.... And what is puzzling is not that they are isolated pieces, but some artists persistently produce such pieces and there are schools of such "not genuine" artists. What are they doing? In this case, the feeling of the audience is sound—it is always sound—there is insult, willful incomprehensibility, experiment; and yet the judgment of the audience is wrong—it is often wrong—for this is a genuine art.

Why does this clash arise? Because the modern writer can no longer accept the claims of the world. If he tries to acquiesce in the norms of the audience, he finds himself depressed and outraged. The usual morality seems counterfeit; taste, a genteel indulgence; tradition, a wearisome fetter. It becomes a condition of being a writer that he rebel, not merely and sometimes not at all against received opinions, but against the received ways of doing the writer's work.

A modernist culture soon learns to respect, even to cherish, signs of its division. It sees doubt as a form of health. It hunts for ethical norms through underground journeys, experiments with sensation, and a mocking suspension of accredited values. Upon the passport of the Wisdom of The Ages, it stamps in bold red letters: *Not Transferable.* It cultivates, in Thomas Mann's phrase, "a sympathy for the abyss." It strips man of his systems of belief and his ideal claims, and then proposes the one uniquely modern style of salvation: a salvation by, of, and for the self....

Subjectivity becomes the typical condition of the modernist outlook.... Behind this extreme subjectivity lurks an equally extreme sense of historical impasse, the assumption that something about the experience of our ages is unique, a catastrophe without precedent. The German novelist Herman Hesse speaks about "a whole generation caught ... between two ages, two modes of life, with the consequence that it loses all power to understand itself and has no standards, no security, no simple acquiescence." Above all, no simple acquiescence.

Whether all of this is true matters not nearly so much as the fact that modernist writers, artists, and composers—Joyce, Kafka, Picasso, Schoenberg—have apparently worked on the tacit assumption that it is true. The modernist sensibility posits a blockage, if not an end, of history: an apocalyptic *cul de sac* in which both teleological ends and secular progress are called into question, perhaps become obsolete. Man is mired—you can take your choice—in the mass, in the machine, in the city, in his loss of faith, in the hopelessness of a life without anterior intention or terminal value. By this late date, these disasters seem in our imaginations to have merged into one.

"On or about December 1910 human nature changed." Through this vivid hyperbole Virginia Woolf meant to suggest that there is a frightening discontinuity

between the traditional past and the shaken present; that the line of history has been bent, perhaps broken. Modernist literature goes on the tacit assumption that human nature has indeed changed, probably a few decades before the date given by Mrs. Woolf; or, as Stephen Spender remarks, the circumstances under which we live, forever being transformed by nature, have been so radically altered that people feel human nature to have changed and thereby behave as though it has. Commenting on this notion Spender makes a keen distinction between the "Voltairean I" of earlier writers and the "I" of the moderns:

The "Voltairean I" of Shaw, Wells, and others acts upon events. The "modern I" of Rimbaud, Joyce, Proust, Eliot's Prufrock is acted upon by events.... The faith of the Voltairean egoists is that they will direct the powers of the surrounding world from evil into better courses through the exercise of the superior social or cultural intelligence of the creative genius, the writer-prophet. The faith of the modernists is that by allowing their sensibility to be acted upon by the modern experience as suffering, they will produce, partly as the result of unconscious processes, and partly through the exercise of critical consciousness, the idioms and forms of new art.

The consequences are extreme: a breakup of the traditional unity and continuity of Western culture, so that the decorums of its past no longer count for very much in determining its present, and a loosening of those ties which, in one or another way, had bound it to the institutions of society over the centuries.... Culture [in the form of art and literature] now goes to war against itself....

In much modernist literature one finds a bitter impatience with the whole apparatus of cognition and the limiting assumption of rationality. Mind comes to be seen as an enemy of vital human powers. Culture becomes disenchanted with itself, sick over its endless refinements. There is a hunger to break past the bourgeois proprieties and self-containment of culture, toward a form of absolute personal speech, a literature deprived of ceremony and stripped to revelation. In the work of Thomas Mann both what is rejected and what is desired are put forward with a high, ironic consciousness: the abandoned ceremony and the corrosive revelation.

But if a major impulse in modernist literature is a choking nausea before the idea of culture, there is another in which the writer takes upon himself the enormous ambition not to remake the world (by now seen as hopelessly recalcitrant and alien) but to reinvent the terms of reality. [The German poet Gottfried Benn remarks] ... that "there is only human consciousness ... rebuilding new worlds out of its own creativity." In a similar vein, the painter Klee once said that his wish was "not to reflect the visible, but to make visible."...

A modernist culture is committed to the view that the human lot is inescapably problematic. Problems, to be sure, have been noticed at all times, but in a modernist culture the problematic as a style of existence and inquiry becomes imperious: men learn to find comfort in their wounds. Nietzsche says: "Truth has never yet hung on the arm of an absolute." The problematic is adhered to, not merely because we live in a time of uncertainty when traditional beliefs and absolute standards, having long disintegrated, give way to the makeshifts of relativism—that is by now an old, old story. The problematic is adhered to because it comes to be considered good, proper, and even beautiful that men should live in discomfort. Again Nietzsche: "Objection, evasion, joyous distrust, and love of irony are signs of health; everything absolute belongs to pathology."

Neurosis and Alienation

One consequence of this devotion to the problematic, not always a happy consequence, is that in modernist literature there is a turn from truth to sincerity, from the search for objective law to a desire for authentic response. The first involves an effort to apprehend the nature of the universe, and can lead to metaphysics, suicide, revolution, and God; the second involves an effort to discover our demons within and makes no claim upon the world other than the right to publicize the aggressions of candor. Sincerity becomes the last-ditch defense for men without belief, and in its name absolutes can be toppled, morality dispersed, and intellectual systems dissolved. But a special kind of sincerity: where for the romantics it was often taken to be a rapid motion into truth, breaking past the cumbersomeness of intellect, now for the modernists it becomes a virtue in itself, regardless of whether it can lead to truth or whether truth can be found. Sincerity of feeling and exact faithfulness of language—which often means a language of fragments, violence, and exasperation—become a ruling passion. In the terrible freedom it allows the modernist writer, sincerity shatters the hypocrisies of bourgeois order; in the lawlessness of its abandonment, it can become a force of darkness and brutality.

Disdainful of certainties, disengaged from the eternal or any of its surrogates, fixated upon the minute particulars of subjective experience, the modernist writer regards settled assumptions as a mask of death, and literature as an agent of metaphysical revolt. Restlessness becomes the sign of sentience, anxiety the premise of responsibility, peace the flag of surrender—and the typewriter a Promethean rock....

Forming a permanent if unacknowledged and disorganized opposition, the modernist writers and artists constitute a special caste within or at the margin of society, an avant garde marked by aggressive defensiveness, extreme self-consciousness, prophetic inclination, and the stigmata of alienation. "Bohemia," writes Flaubert, "is my fatherland," bohemia both as an enclave of protection within a hostile society and as a place from which to launch guerrilla raids upon the bourgeois establishment, frequently upsetting but never quite threatening its security. The avant garde abandons the useful fiction of "the common reader"; it demands instead the devotions of a cult. The avant garde abandons the usual pieties toward received aesthetic assumptions; "no good poetry," writes Ezra Pound in what is almost a caricature of modernist dogma, "is ever written in a manner twenty years old." The avant garde scorns notions of "responsibility" toward the audience; it raises the question of whether the audience exists—of whether it should exist.[1] The avant garde proclaims its faith in the self-sufficiency, the necessary irresponsibility, and thereby the ultimate salvation of art.

As a device of exposition I write in the present tense; but it seems greatly open to doubt whether by now, a few decades after World War II, there can still be located in the West a coherent and self-assured avant garde. Perhaps in some of the arts, but probably not in literature. (Only in the Communist countries is there beyond question a combative and beleaguered avant garde, for there, as a rule, the state persecutes or seriously inconveniences modern writers and artists, so that it forces them into a self-protective withdrawal, sometimes an "internal emigration.")

In the war between modernist culture and bourgeois society, something has happened recently which no spokesman for the avant garde quite anticipated. Bracing enmity has given way to wet embraces, the middle class has discovered that the fiercest attacks upon its values can be transposed into pleasing entertainments,

[1]Editors' note: Cf. above.

and the avant-garde writer or artist must confront the one challenge for which he has not been prepared: the challenge of success. Contemporary society is endlessly assimilative, even if it vulgarizes what it has learned, sometimes foolishly, to praise. The avant garde is thereby no longer allowed the integrity of opposition or the coziness of sectarianism; it must either watch helplessly its gradual absorption into the surrounding culture or try to preserve its distinctiveness by continually raising the ante of sensation and shock—itself a course leading, perversely, to a growing popularity with the bourgeois audience. There remains, to be sure, the option for the serious writer that he go his own way regardless of fashion or cult....

The metaphor lodged in the term "avant garde" can be seriously misleading if it suggests a structured phalanx or implies that the modernist writers, while momentarily cut off from society at large, were trying to lead great numbers of people into a new aesthetic or social dispensation. Not at all. When we refer to the avant garde we are really speaking of isolated figures who share the burdens of intransigence, estrangement, and dislocation; writers and artists who are ready to pay the costs of their choices. And as both cause and effect of their marginal status, they tend to see the *activity* of literature as self-contained, as the true and exalted life in contrast to the life of contingency and mobs. (When now and again they make a foray into political life, it is mainly out of a feeling that society has destroyed the possibility of a high culture and that to achieve such a culture it is necessary to cleanse or bleed society.) Joyce demands a reader who will devote a lifetime to his work; Wallace Stevens composes poems endlessly about the composition of poetry. These are not mere excesses or indulgences; they are, at one extreme, programs for creating quasi-religious orders or cults of the aesthetic, and at the other extreme, ceremonies for the renewal and rediscovery of life—and then, in the boldest leap of all, for the improvisation of a realm of being which will simply dispense with the gross category of "life."

The crucial instance of the effort to make the literary work self-sufficient is Symbolist poetry. Symbolism moves toward an art severed from common life and experience—a goal perhaps unrealizable but valuable as a "limit" for striving and motion. The Symbolists, as Marcel Raymond remarks, "share with the Romantics a reliance upon the epiphany, the moment of intense revelation; but they differ sharply about its status in nature and its relation to art. Wordsworth's spiritual life is founded on moments of intense illumination, and his poetry describes these and relates them to the whole experience of an ordered lifetime." For the Symbolist poet—archetypal figure in modernism—there is no question, however, of *describing* such an experience; for him the moment of illumination occurs only through the action of the poem, only through its thrust and realization as a particular form. Nor is there any question of relating it to the experience of a lifetime, for it is unique, transient, available only in the matter—perhaps more important, only in the moment—of the poem. Not transmission but revelation is the poet's task. And thereby the Symbolist poet tends to become a *magus,* calling his own reality into existence and making poetry into what Baudelaire called "suggestive magic."...

Stretched to its theoretic limit, symbolism proposes to disintegrate the traditional duality between the world and its representation. It finds intolerable the connection between art and the flaws of experience; it finds intolerable the commonly-accepted distance between subject and act of representation; it wishes to destroy the very program of representation, either as objective mimesis or subjective outcry. It is equally distant from realism and expressionism, faithfulness to the dimensions of the external and faithfulness to the distortions of the eye.

Neurosis and Alienation

Symbolism proposes to make the poem not merely autonomous but hermetic, and not merely hermetic but sometimes impenetrable. Freed from the dross of matter and time, poetry may then regain the aura, the power, of the mysterious. Passionately monistic, Symbolism wishes finally that *the symbol cease being symbolic* and become, instead, an act or object without "reference," sufficient in its own right. Like other extreme versions of modernism, Symbolism rebels against the preposition "about" in statements that begin "art is about...." It yearns to shake off the burden of meaning, the alloy of idea, the tyranny and coarseness of opinion; it hopes for sacrament without faith....

Heroic as this effort may have been, the Symbolist aesthetic is inadequate in principle, a severe reduction of the scope and traditional claims of literature, and beyond sustaining in practice for more than a few moments. It cannot survive in daylight or the flatness of time. The fierce dualism it proposes cannot be maintained for long; soon the world contaminates the poem and the poem slides back into the world. Symbolism is a major element in modernist consciousness but more, I suspect, as a splendid drama to invoke than a fruitful discipline to follow.

As European civilization enters the period of social disorder and revolt that runs parallel to the life of literary modernism, there is really no possibility for maintaining a hermetic aestheticism. What follows from the impact of social crisis upon modernist literature is quite without that order and purity toward which Symbolism aspires—what follows is bewildering, plural, noisy. Into the vacuum of belief left by the collapse of Romanticism there race a number of competing world views, and these are beyond reconciling or even aligning. That is one reason it is quite impossible to sum up the central assumptions of modernism, as one can for Romanticism, by listing a sequence of beliefs and visions. Literary modernism is a battle of internal conflicts more than a coherent set of theories or values. It provides a vocabulary through which the most powerful imaginations of the time can act out a drama of doubt. Yet this commitment to the problematic is terribly hard to maintain, it requires nerves of iron; and even as the great figures of modernism sense that for them everything depends on keeping a firm grip on the idea of the problematic, many of them cannot resist completely the invading powers of ideology and system. It is at this point that there arises the famous, or but recently famous, problem of belief, perhaps the most discussed topic in the literary criticism of the past fifty years....

We read the late novels of D. H. Lawrence or the cantos of Ezra Pound, aware that these are works of enormously gifted writers yet steadily troubled by the outpouring of authoritarian and Fascist ideas. We read Bertolt Brecht's "To Posterity," in which he offers an incomparable evocation of the travail of Europe in the period between wars—"we changed our country more often than our shoes"—yet simultaneously weaves in a justification of the Stalin dictatorship. How are we to respond to all this? The question is crucial in our experience of modernist literature. We may say that the doctrine is irrelevant, as many critics do say, and that would lead us to the impossible position that the commanding thought of a poem need not be seriously considered in forming a judgment of its value. Or we may say that the doctrine, being obnoxious, destroys our pleasure in the poem, as some critics do say, and that would lead us to the impossible position that our judgment of the work is determined by our opinion concerning the author's ideology. There is, I think, no satisfactory solution in the abstract, and we must learn to accept the fact that modernist literature is often—not in this way alone!—"unacceptable." It forces us into distance and dissociation; it denies us

wholeness of response; it alienates us from its own powers of statement even when we feel that it is imaginatively transcending the malaise of alienation....

Yet no matter what impasse it encounters in its clashes with the external world, modernism is ceaselessly active within its own realm, endlessly inventive in destruction and improvisation. Its main enemy is, in one sense, the culture of the past, even though it bears within itself a marvelously full evidence of that culture. Literature now thrives on assaulting the traditional rules, modes, and limits of literature; the idea of aesthetic order is abandoned or radically modified.

To condemn modernist literature for a failure to conform to traditional criteria of unity, order, and coherence is, however, quite to miss the point, since, to begin with, it either rejects these criteria or proposes radical new ways of embodying them. When the critic Yvor Winters attacks the "fallacy of imitative form" (e.g., literary works dealing with the chaos of modern life themselves take on the appearance and sometimes the substance of chaos), he is in effect attacking modernist writing as such, since much of it cannot dispense with this "fallacy." In its assumption that the sense of the real has been lost in conventional realism, modern writing yields to an imperative of distortion. A "law" could be advanced here: *modernist literature replaces the traditional criteria of aesthetic unity with the new criterion of aesthetic expressiveness, or perhaps more accurately, it downgrades the value of aesthetic unity in behalf of even a jagged and fragmented expressiveness.*

The expectation of formal unity implies an intellectual and emotional, indeed a philosophic composure; it assumes that the artist stands above his material, controlling it and aware of an impending resolution; it assumes that the artist has answers to his questions or that answers can be had. But for the modern writer none of these assumptions holds, or at least none of them can simply be taken for granted. He presents dilemmas; he cannot and soon does not wish to resolve them; he offers his *struggle* with them as the substance of his testimony; and whatever unity his work possesses, often not very much, comes from the emotional rhythm, the thrust toward completion, of that struggle. After Kafka it becomes hard to believe not only in answers but even in endings.

In modernist literature nature ceases to be a central subject and symbol.... Perversity—which is to say: surprise, excitement, shock, terror, affront—becomes a dominant motif. I borrow from G. S. Fraser a charming contrast between a traditional poet:

> *Love to Love calleth,*
> *Love unto Love replieth—*
> *From the ends of the earth, drawn by invisible bands,*
> *Over the dawning and darkening lands*
> *Love cometh to Love.*
> *To the heart by courage and might*
> *Escaped from hell,*
> *From the torment of raging fire,*
> *From the signs of the drowning main,*
> *From the shipwreck of fear and pain*
> *From the terror of night.*

Neurosis and Alienation

—and a modern poet:

> *I hate and love*
> *You ask, how can that be?*
> *I do not know, but know it tortures me.*

The traditional poet is Robert Bridges, who lived as far back as the early 20th century; the modern poet, our twin, is Catullus.

The modernist writer strives for sensations, in the serious sense of the term; his epigones, in the frivolous sense. The modernist writer thinks of subject matter not as something to be rehearsed or recaptured but rather to be conquered and enlarged. He has little use for wisdom; or if he does, he conceives of it not as something to be dug out of the mines of tradition, but to be won for himself through an exercise in self-penetration, sometimes self-disintegration. He becomes entranced with depths—whichever you choose: the depths of the city, or the self, or the underground, or the slums, or the extremes of sensation induced by sex, liquor, drugs; or the shadowed half-people crawling through the interstices of society: *Lumpen*, criminals, hipsters; or the drives at the base of consciousness. Only Joyce, among the modernist writers, negotiates the full journey into and through these depths while yet emerging into the commonplace streets of the city and its ongoing commonplace life: which is, I think, one reason he is the greatest of the modernist writers, as also perhaps the one who points a way beyond the liberation of modernism.

The traditional values of decorum, both in the general ethical sense and the strictly literary sense, are overturned. Everything must now be explored to its outer and inner limits; but more, there are to be no limits....

A plenitude of sophistication narrowing into decadence—this means that primitivism will soon follow. The search for meaning through extreme states of being reveals a yearning for the primal: for surely man cannot have been bored even at the moment of his creation! I have already spoken of the disgust with culture, the rage against cultivation, that is so important a part of modernism: the turning-in upon one's primary characteristics, the hatred of one's gifts, the contempt for intelligence, which cuts through the work of men so different as Rimbaud, Dostoevsky, and Hart Crane. For the modern sensibility is always haunted by the problem of succession: what, after such turnings and distensions of sensibility, can come next? One of the seemingly hopeful possibilities is a primitivism bringing a vision of new manliness, health, blood consciousness, a relief from enervating rationality. A central text is Lawrence's story, "The Woman Who Rode Away"—that realistic fable, at once so impressive and ridiculous—in which a white woman seeks out an Indian tribe to surrender her "quivering nervous consciousness" to its stricken sun god and thereby "accomplish the sacrifice and achieve the power." But within the ambiance of modernism there is another, more ambiguous and perhaps sinister kind of primitivism: the kind that draws us with the prospect not of health but of decay, the primitive as atavistic, an abandonment of civilization and thereby, perhaps, of its discontents. The central fiction expressing this theme is Conrad's *Heart of Darkness* in which Marlow the narrator and *raissonneur* does not hesitate to acknowledge that the pull of the jungle for Kurtz and also, more ambiguously, for himself is not that it seems to him (I am

quoting Lionel Trilling) "noble or charming, or even free but ... base and sordid—and for *that* reason compelling: he himself feels quite overtly its dreadful attraction." In this version of primitivism, which is perhaps inseparable from the ennui of decadence, the overwhelming desire is to shake off the burdens of social restraint, the disabling and wearisome moralities of civilized inhibition....

If technical experiment and thematic surprise characterize modernist poetry, there are equivalent changes in the novel: a whole new sense of character, structure, and the role of its protagonist or hero. The problematic nature of experience tends to replace the experience of human nature as the dominant subject of the modern novel.... Character, for modernists like Joyce, Virginia Woolf, and Faulkner, is regarded not as a coherent, definable, and well-structured entity, but as a psychic battlefield, or an insoluble puzzle, or the occasion for a flow of perceptions and sensations. This tendency to dissolve character into a stream of atomized experiences, a kind of novelistic *pointillisme,* gives way, perhaps through extreme reaction, to an opposite tendency (yet one equally opposed to traditional concepts of novelistic character) in which character is severed from psychology and confined to a sequence of severely objective events.

Similar radical changes occur in the modernist treatment of plot. The traditional 18th-or 19th-century novel depends upon a plot which reveals a major destiny, such as Henchard's in *The Mayor of Casterbridge.* A plot consists here of an action purposefully carved out of time, that is, provided with a beginning, sequence of development, and climax, so that it will create the impression of completeness.... When a writer works out a plot, he tacitly assumes that there is a rational structure in human conduct, that this structure can be ascertained, and that doing so he is enabled to provide his work with a sequence of order. But in modernist literature these assumptions come into question. In a work written on the premise that there is no secure meaning in the portrayed action, or that while the action can hold our attention and rouse our feelings, we cannot be certain, indeed must remain uncertain, as to the possibilities of meaning—in such a characteristically modern work what matters is not so much the plot but a series of *situations,* some of which can be portrayed statically, through tableaux, set-pieces, depth psychology, and others dynamically, through linked episodes, stream of consciousness, etc. Kafka's fiction, Joyce's novels, some of Faulkner's—these all contain situations rather than plot.

Still more striking are the enormous changes which the modern novel brings about in its treatment of the fictional hero....

The modern hero ... knows that the hero can act with full power only if he commands, for his followers and himself, an implicit belief in the meaningfulness of the human scheme. But the more he commits himself to the gestures of heroism, the more he is persuaded of the absurdity of existence. Gods do not speak to him, prophets do not buoy him, nor doctrines assuage him.

The classical hero moved in a world charged with a sense of purpose. In the early bourgeois era, the belief in purpose gave way to a belief in progress. This the hero managed to survive, if only because he often saw through the joke of progress. But now his problem is to live in a world that has moved beyond the idea of progress; and that is hard....

The modern hero discovers that he cannot be a hero. Yet only through his readiness to face the consequences of this discovery can he salvage a portion of the heroic.

Neurosis and Alienation

In its multiplicity and brilliant confusion, its commitment to an aesthetic of endless renewal—in its improvisation of "the tradition of the new," a paradox envisaging the limit of *limitlessness*—modernism is endlessly open to portraiture and analysis. For just as some of its greatest works strain toward a form freed from beginning or end, so modernism strains toward a life without fixity or conclusion. If, nevertheless, there is in literary modernism a dominant preoccupation which the writer must either subdue or by which he will surely be destroyed, that is the specter of nihilism.

Nihilism is a term not only wide-ranging in reference but heavily charged with historical emotion. It signifies at least some of the following:

A specific doctrine, positivist in stress, of an all-embracing rebellion against traditional authority which appeared in mid-19th-century Russia;

A consciously affirmed and accepted loss of belief in transcendent imperatives and secular values as guides to moral conduct, together with a feeling that there is no meaning resident—or, at least, further resident—in human existence;

A loss of those tacit impulsions toward an active and striving existence which we do not even know to be at work in our consciousness until we have become aware of their decline.

In Western literature nihilism is first and most powerfully foreshadowed by Dostoevsky: there is nothing to believe in but the senses and the senses soon exhaust themselves. God is impossible but all is impossible without him. Dostoevsky is maliciously witty, maliciously inventive in his perception of the faces of nihilism. He sees it, first, as a social disorder without boundary or shame: Pyotr Verhovensky in an orgy of undoing, mocking the very idea of purpose, transforming the ethic of modernist experiment into an appeal for collective suicide, seizing upon the most exalted words in order to hollow them out through burlesque. "If there's no God, how can I be a captain then," asks an old army officer in *The Possessed,* and in the derision that follows one fancies that Dostoevsky joins, in half-contempt, half-enchantment. Nihilism appears in moral guise through the figures of Kirillov and Ivan Karamazov, the first a man of purity and the second a man of seriousness; that both are good men saves them not at all, for the demon of emptiness, says Dostoevsky, lodges most comfortably in the hearts of the disinterested. And in Stavrogin, that "subtle serpent" stricken with metaphysical despair and haunted by "the demon of irony," nihilism achieves an ultimate of representation: nothingness in flesh, flesh that would be nothing. "We are all nihilists," says Dostoevsky in the very course of his struggle to make himself into something else. His great achievement is to sense, as Nietzsche will state, the intrinsic connection between nihilism as doctrine and nihilism as experience of loss. Just as Jane Austen saw how trivial lapses in conduct can lead to moral disaster, so Dostoevsky insisted that casual concessions to boredom can drive men straight into the void.

Flaubert, though not concerned with the problem abstractly, writes: "Life is so horrible that one can only bear it by avoiding it. And that can be done by living in the world of Art." The idea of Art as a sanctuary from the emptying-out of life is intrinsic to modernism: it is an idea strong in Nietzsche, for whom the death of God is neither novelty nor scandal but simply a given fact. The resulting disvaluation of values and the sense of bleakness which follows, Nietzsche calls nihilism. He sees it as connected with the assertion that God exists, which robs the world of ultimate significance, and with the assertion that God does not exist, which robs everything of significance.

The destruction of the moral interpretation of the world, which has no sanction anymore after it has attempted to flee into some beyond, ends in nihilism. "All is senseless...." Since Copernicus man rolls from the center into "X".... What does nihilism mean? That the highest values disvalue themselves. The goal is lacking; the answer is lacking to our "Why?"

Fundamentally, then, nihilism comes to imply a loss of connection with the sources of life, so that both in experience and in literature it is always related to, while analytically distinguishable from, the blight of boredom.

Recognizing all this, Dostoevsky tries to frighten the atheist both within himself and within his contemporaries by saying that once God is denied, everything—everything terrible—has become possible. Nietzsche gives the opposite answer, declaring that from the moment man believes neither in God nor immortality, "he becomes responsible for everything alive, for everything that, born of suffering, is condemned to suffer from life." And thus for Nietzsche, as later for the existentialists, a confrontation with the nihilist void becomes the major premise of human recovery.

With remarkable powers of invention and variation, this theme makes its way through all of modernist literature. In Kafka's work negation and faith stand forever balanced on the tip of a question-mark; there are no answers, there are no endings, and whether justice can be found at the trial, or truth in the castle, we never know for certain. The angel with whom Kafka wrestles heroically and without letup is the angel of nothingness. Proust constructs a social world marvelously thick and rich in texture yet a shadow too, which a mere wind blows away; and the only hope we have that some meaning may be salvaged is through the power of art, that thin cloak between men and the beyond which nevertheless carries "the true last judgment." This very power of art is seen by Mann as a demon of nihilism trailing both himself and his surrogate figures from novel to novel, as a portent of disease in "Death in Venice" and as a creator-destroyer in *Doctor Faustus* who disintegrates everything through parody. Brecht leers at the familiar strumpet of city nihilism, vomits with disgust when she approaches too closely, and then kidnaps her for a marriage with the authoritarian idea: the result endears him to the contemporary world. But it is Joyce who engages in the most profound modern exploration of nihilism, for he sees it everywhere, in the newspaper office and the church, on the street and in bed, through the exalted and the routine. Exposing his characters to every version of nausea and self-disgust, bringing Stephen Dedalus to his outcry of *"Nothung"* in the brothel, Joyce emerges, as William Troy remarks, with "an energetic and still uncorrupted affirmation of life that is implicit in every movement of his writing." As for those who follow these masters, they seem to have relaxed in the death-struggle with the shapeless demon and some, among the more fashionable of the moment, even strike a pleasant truce with him. But the power of example remains a great one and if a writer like Norman Mailer does not choose to wrestle with the angel Kafka encountered, there are moments when he is prepared to challenge it to a bit of amiable hand-wrestling.

Nihilism lies at the center of all that we mean by modernist literature, both as subject and symptom, a demon overcome and a demon victorious. For the terror which haunts the modern mind is that of a meaningless and eternal death. The death of the gods would not trouble us if we, in discovering that they have died, did not have to die alongside them. Heroically the modern sensibility struggles with its passion for eternal renewal, even as it keeps searching for ways to secure its own end.

Neurosis and Alienation

But no, it will not die, neither heroically nor quietly, in struggle or triumph. It will live on, beyond age, through vulgar reincarnation and parodic mimesis. The lean youth has grown heavy; he chokes with the approval of the world he had dismissed; he cannot find the pure air of neglect. Not the hostility of those who came before but the patronage of those who come later—that is the torment of modernism.

How, come to think of it, do great cultural movements reach their end? It is a problem our literary historians have not sufficiently examined, perhaps because they find beginnings more glamorous, and a problem that is now especially difficult because there has never been, I think, a cultural period in Western history quite like the one we call modern. But signs of a denouement begin to appear. A lonely gifted survivor, Beckett, remains to remind us of the glories modernism once brought. Meanwhile, the decor of yesterday is appropriated and slicked up; the noise of revolt, magnified in a frolic of emptiness; and what little remains of modernism, denied so much as the dignity of opposition.

How enviable death must be to those who no longer have reason to live yet are unable to make themselves die! Modernism will not come to an end; its war chants will be repeated through the decades. For what seems to await it is a more painful and certainly less dignified conclusion than that of earlier cultural movements: what awaits it is publicity and sensation, the kind of savage parody which may indeed be the only fate worse than death.